THE GREAT BOOK OF FRENCH IMPRESSIONISM

HORST KELLER

THE GREAT BOOK OF FRENCH IMPRESSIONISM

HUDSON HILLS PRESS, INC. NEW YORK

First American Edition

First published as *Die Kunst der französischen Impressionisten* by Verlag Herder
KG. Translated from the German by Alexis Brown

© 1975 by Smeets Offset BV, Weert, The Netherlands and Verlag Herder KG,
Freiburg im Breisgau, West Germany
Translation © 1980 by Phaidon Press Limited
Illustrations © 1980 Beeldrecht, Amsterdam
All rights reserved under International and Pan American Copyright
Conventions. No part of this publication may be transmitted in any form or by
any means, electronic, mechanical, photocopying, recording or otherwise,
without the prior permission of the publisher

Published in the United States by Hudson Hills Press, Inc., Suite 4323,
30 Rockefeller Plaza, New York, N.Y. 10112. Trade distribution by Simon &
Schuster, a division of Gulf & Western Corporation, New York

Publisher: Paul Anbinder

Printed in the Netherlands by Smeets Offset BV, Weert

Library of Congress Cataloging in Publication Data

 Keller, Horst.
 The great book of French impressionism.
 Translation of Kunst der französischen Impressionisten.
 Bibliography: p. 268.
 Includes index.
 1. Impressionism (Art) – France.
 2. Painting, Modern – 19th century – France.
 I. Title.
 ND547.5.I4K4413 1980 759.4 80-13206

 ISBN 0-933920-11-3

CONTENTS

A hundred years on

Just over a hundred years ago, a group of French painters found an idyllic spot on the north bank of the Seine, where the river slowly winds its way north-westward beyond Paris. There, almost midway between two great bends of the river, lies the village of Argenteuil. It was a very peaceful place at that time, deep in the countryside. The name of no other place in the world can recall with equal vividness that period when the French *plein-air* painters first set up their easels in the meadows and country lanes, or in houseboats gently rocking on the Seine. Manet's picture of a summer's day on the water, with warm white light overhead and the familiar activity of country life all around, sets the scene perfectly (pl. 65). Here too is a good place to begin these remarks on the paintings of the Impressionists, here in Argenteuil, which also marked a turning-point in Manet's attitude to his work. Such remarks can only be a guideline to the countless examples which remain for the spectator of today from this uniquely significant period in art. They are comments from our own time, made a hundred years after the events, and do not attempt any new interpretation. All they seek is to select some individual pictures and point out their characteristic beauty, with the help of the reproductions and of notes made over a number of years.

Manet joined the Impressionist painters in the early summer of 1874 at Argenteuil, where the young artists first assembled in common activity and interchange of ideas of great significance for the future. Here Manet, one of the greatest painters of his time and recognized by the younger men as a leader, received a new source of inspiration for his work which brought about a change of style.

The scene we are describing took place little more than a hundred years ago. It was to be followed in quick succession by other evolutions in the field of art, such as Symbolism and Fauvism, Cubism, and other new movements developed by artists of the time working singly or in groups, whose style has had world-wide influence. Over decades, Paris has been the birthplace and testing ground of these new creations.

The first great, even spectacular exhibition by that group of painters so frequently rejected by the Salon (the young Monet, Pissarro, Sisley, Renoir, Cézanne, Degas, Guillaumin, Berthe Morisot, and a few others) had been held that April in the old studio of the celebrated photographer Nadar on the Boulevard des Capucines. Having failed to sell any of their pictures, with no money and hardly any paint left, Monet, whose brain-child this exhibition had been, together with Renoir (then aged 34 and 33 respectively) decided to move to the country, to Argenteuil, in order to start working again.

Manet, who had not participated in the exhibition but whose own work was frequently ill-received by the critics, made up his mind to follow them. So he left the subdued light of his studio behind him for a few weeks in order to paint in the open, on the banks of the Seine. An eventful decision which created a human bond between Manet and the younger painters.

It was Théodore Duret who, soon after Manet's early death in 1883, first wrote *The Story of Edouard Manet*, as he himself called it. Here Duret talked about Manet as he knew him

from personal experience, in a frank and affectionate manner, in an account which remains an authentic source-book to Manet's life and work. Duret tells the real story behind Manet's painting, *Argenteuil* (pl. 65), in simple words, far surpassing later, over-embellished or rehashed versions of the same situation by other authors. Anyone lucky enough to possess a copy of Duret's beautiful book (published in 1902 by Floury in Paris and dedicated, by the way, to Monet) is intrigued to discover how the Argenteuil picture came about, that visible sign that Manet adopted the thesis of his painter friends without much hesitation. Only a year earlier, in 1873, he had 'tried it out' in the picture *Gare Saint-Lazare* (pl. 61–2). But from now on he made this style of painting his own, so that his assertion that '. . . the shadows are coloured' only becomes intelligible from this point forward. As early as 1856 he had made the same declaration to his teacher, Couture, when the latter upbraided him for refusing to see those middle tones which lead from light to shade. Manet maintained that light itself has such overwhelming force that it needs but one single tone to reproduce it on the canvas, and that it is far better to pass directly from light to shadow instead of imposing tones which the eye does not see, and which not only weaken the power of the light but also diminish the colouring of the shadows, which absolutely must be brought out. In his own words: '. . . for the shadows are coloured, and emphatically not of even, but very varied hues.'

According to Duret, thus it was that Manet, 42 years old at the time, and who had already painted, amongst many others, such major pictures as *Olympia* (pl. 55) and *Le Déjeuner sur l'herbe* (pl. 54) as self-evident proof of his genius, embarked without hesitation on a further renewal of his art.

Duret's report, here somewhat freely rendered, is as follows. 'Now he would paint a picture where the figures would reach their natural stature, and it would be so characteristic of its kind there could be no longer any doubt as to his artistic purpose . . . He engages a suitable young woman and persuades his brother-in-law Rudolph Leenhoff to model for him. He takes them to Argenteuil, puts them into a boat, sitting side by side, with the blue waters of the river as background and one of the riverbanks to round off the horizon. And' – Duret goes on – 'he begins to paint them – *en plein soleil*.'

But not before he had looked at the canvases of Monet and Renoir, somewhat amused, but encouraged at the same time. Manet lived on the left bank of the Seine, in a tiny hamlet called Gennevilliers just across the river from Argenteuil and so a little cut off from the younger Monet and Renoir, although they painted each other on several occasions in their gardens or on the Seine. But even here Manet's brushstroke remained long and compact, and was not loosened into the mobile dabs with which his friends laid paint on the canvas. And yet this picture, *Argenteuil*, has perhaps the greatest fullness of light of them all. Its radiance is undivided, just as Manet had conceived it: '. . . arriving from light to shade without gradation.' He exhibited the picture a year later at the Salon, so the Jury evidently found it acceptable.

This scene of the couple on the Seine, associated as it is with the birth of Impressionism (although the rigorous construction of the composition goes beyond that of the Impression-

8

ists) calls to mind the overwhelming impact of the first sight of the original. A travel-notebook, written on a first visit to Tournai in western Belgium in 1954, evokes the scene. In a dismal pink hall looking like a wartime relic with its rough floorboards and threadbare carpet, with mediocre panelling and the busts of long-forgotten local bigwigs looking down from ornate pedestals, there, suddenly, hanging on the wall between utterly insignificant pictures, was Manet's *Argenteuil*, right beside the light-switch with its naked wiring. And not far away, another splendidly impressive painting by Manet, *Chez le père Lathuille*, from the year 1879. In 1974 the latter painting was to be seen at the Centenary Exhibition of Impressionism in Paris. What a sight it was, back in 1954, as if the pictures had fallen out of the blue! And the twenty-year-old notes of the event, made to forestall the effect of reproductions with an eye-witness account:

'. . . very blue water, a pale, faint landscape, Corot-like, in the background. The houses light and delicately-coloured. The lady's costume: grey, blue, and rose-grey; shading only below the knee. The face more fully modelled, with grey, broken tones. In her lap a vivid, tomato-red flower. The red band round his yellow straw hat not too warm. His hand distinctly differentiated from hers. His shirt has fawn-brown stripes. In the boat behind him is an unbroken sand-coloured patch; to her left is the darkest part of the whole picture; above it, an absolutely lovely sky.'

Which may sound like 'instructions to the colour-engraver', but was simply meant to jog the memory and for comparison on seeing the painting again.

So much for the introduction to the theme, which might well be called: 'Manet and the Impressionists'.

9

THE PRECURSORS

In the observations which follow, our attention shifts from this memorable scene, this turning-point in art recalled by Manet's picture of the summer of 1874, as we look back to the generation of Corot and forwards to the turn of the century up to the death of Cézanne (1906), sometimes leaving Impressionism itself out of the discussion. Ranging from the art of Turner and Constable to that of van Gogh and Gauguin, the field is vast, even though much has been omitted, artists outside the movements being set aside or only briefly mentioned, and other contemporary trends left out in order to restrict the theme.

Two paintings by Gustave Moreau (pl. 14 and 15) have been chosen to represent the many different artistic perceptions and aspirations occurring at the same time as the Impressionist movement. These pictures suggest a style of decadence, as Moreau himself called it, far removed from the smooth, fresco-like paintings of another contemporary, Puvis de Chavannes. Moreau's elaborate fantasies flattered and fitted in well with prevailing taste, of which they were a sophisticated refinement. As an authentic comment of the times we have the judgement of Manet, quoted by Antonin Proust in his *Recollections of Edouard Manet*:

'... I have a good deal of sympathy for him, but he is going the wrong way; society is in ecstasy about his *Jacob with the Angel*. Gustave Moreau carries conviction, and he will have a regrettable influence on our times. He leads us back into the regions of the unintelligible, whereas we are struggling to make all things clear ...'

Literary subjects (fables, mythology, and religious themes) occupied Moreau; today, after a long period of distrust, these inspirations are being reappraised as stylistic phenomena of an epoch, at a time when the nineteenth century is being rediscovered.

For the purposes of our discussion, Moreau's pictures must stand as the visible antithesis of Impressionism, which can be seen as the triumph, in the last decades of the nineteenth century, of pure painting over music and literature, and, perhaps for the last time, as a homogeneous style in the history of art.

The endeavour to describe the precursors of this movement towards painting in the open air and full sunlight leads to earlier and quite different regions of art, to the English landscapists of the first half of the nineteenth century, especially John Constable and J.M.W. Turner. Constable's paintings are now only to be seen in England and America; in them he pays homage to his native countryside in the south-east of England, with scenes such as that of Hampstead Heath (pl. 5), with its fresh windy sky full of silvery light, or the clouds above Weymouth Bay (pl. 4). The pictures are all done lovingly, with an open mind and poetic power, with an intimate, homely quality about them. This is very much in contrast to his countryman and contemporary, J.M.W. Turner, who looked at things in a different light and during his long life as a painter made the wide world his pictorial stage. Turner was always seeking a 'mood', the fantastic heightening of perception, which he found in Venice (pl. 3) as well as at home: the whole world is subject to his visions and dissolves in yellow-grey mist.

10

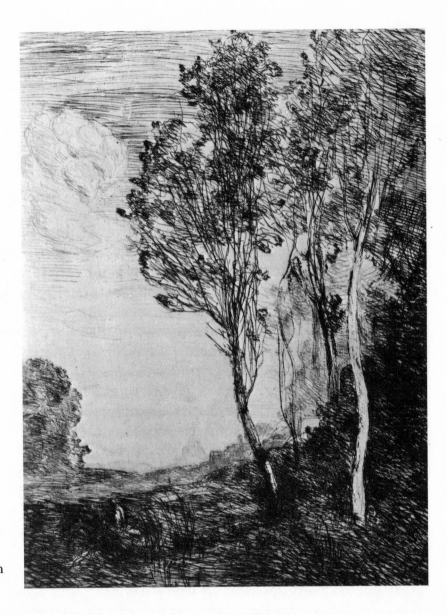

CAMILLE COROT: *Landscape* (Recollection of Italy). Etching.

It is an art of atmosphere, which fascinated Turner's public then as it does today. Turner is a singular phenomenon; an admirer of Claude Lorraine, but an artist in the long run not wholly easy to understand, for all his persuasiveness as a painter. But it is just these pictures, quite different from his early water-colours, which were his tribute to the romantic outlook, which still mesmerize the spectator of today, as a recent exhibition of his work demonstrated. His 'translation' of the earthly into the transcendental succeeds even where a solid locomotive comes puffing on to the scene.

In his late work Turner makes the painting of the unpaintable into his own individual style, and his dissolving of the subject in atmosphere comes closest to certain late studies of Monet, such as those of water-lilies (pl. 96 ff.) and the pictures of Rouen Cathedral (pl. 93–4). He will probably always be seen as a forefather of Impressionism even though he had something quite different in mind, namely the dramatic elevation of light to its complete triumph over earthly matter.

Different and less orientated towards the cosmic are the artistic efforts of Corot's more down-to-earth generation; painters who, like the Impressionists later on, turned their backs on official painting in France and unfolded their art in the countryside far away from the metropolis, living impoverished and sectarian in their rural retirement, though not without a desirous glance in the direction of proud Paris, which refused to recognize them. These painters sketched from nature, and finished their work on canvas back in their simple studios, really nothing more than two empty barns belonging to the inn at Barbizon. Here, near this village which earned them the name 'Barbizon School', on the edge of the great Forest of Fontainebleau, they reverently rendered scenes of nature such as the blissful painting of *Willowtrees* (pl. 7). In the work of Rousseau (pl. 7 and 8), Daubigny (pl. 9), and a few others, this mode of painting emerged as a strictly-observed principle of style. Corot's eminence and his acknowledged influence on the younger generation could not prevent this 'summer-painting' at Barbizon, this art of the *paysage intime*, from remaining an episode, though yielding works of value.

An episode then – despite some delightful, sensitive, and nowadays highly-prized pictures; despite the distinctive brushwork of some of them and the link with the much freer Renoir; and, last but not least, despite Daubigny, who in 1865 was described by one critic as 'the leading figure of the School of Impression'.

We have known for a long time that it was not only a blissful holiday atmosphere that pervaded this idyll at Barbizon. What united the painters was also an anachronism, and the writer Julius Meier-Graefe said of them later, somewhat over-severely: 'This whole "Nazarene"-type of retreat was just a summer resort.' Barbizon is also characterized by other trends: François Millet's scenes of peasants at their labours anticipate the zealous efforts of the young van Gogh.

But let us turn to the pictures themselves, as their history has already been fully documented, every month and every day of it, and most accurately by John Rewald in his *History of Impressionism*; there have been many others since.

Corot, who had been startled by Paris, came to Barbizon. He did not come as a seeker, but with the composure of a self-assured and lately-accomplished artist, with the uplifting experience of Italy already behind him. He had travelled widely, and his pensive or wistful muses, Dianas and nymphs, together with quite simple young rustic women, emerging from sober earthy tones, delicately coloured without being too charming, appeared not only by the wooded pools of Barbizon. And wherever they appeared, the painter's sensitive treatment made them part of nature itself, neither peasant girls nor goddesses (pl. 11).

His sensitive approach to nature, his rare poetic power, had a far more convincing effect on the generation of young Impressionists – as indeed it has on today's viewers – than the work of contemporary landscapists. His form was sure and precise, his silver tone of purest quality. Renoir and Sisley were impressed by him, whereas Monet concentrated his admiration upon Millet. This was in the late sixties. The superiority of such a painter and teacher as Corot, an artist admired through all later decades up to the present day and before whose studies and

12

pictures in the upper storey of the Louvre one can lose all sense of time, may be gathered from a remark he made in the course of conversation with the much younger Pissarro: 'As a painter, you don't need any advice except this: above all, one must study tonal values.'

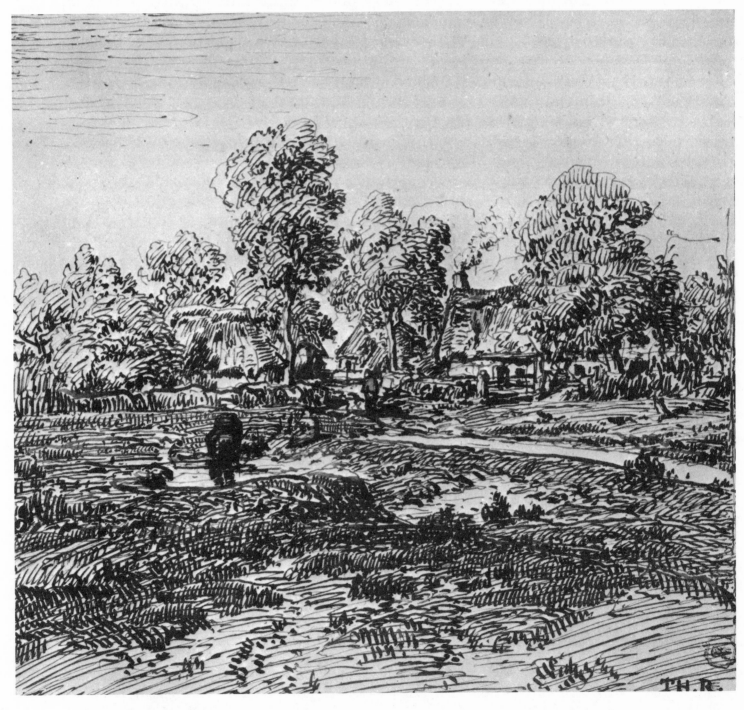

13 THÉODORE ROUSSEAU: *Landscape* – Wallraf-Richartz Museum, Cologne

Corot was born shortly before the beginning of the nineteenth century. Dignified, unhurried, poetic, he turned out to be a draughtsman and painter without heroizing trends or romantically confused vision, a master seeking the balanced composition of a broadly-constructed landscape, always perceived in such a way that the atmosphere of the situation was retained. He is truly the genius of the first generation, and, again following the path of Claude Lorraine, admired the world over as well as in France.

In the National Gallery in Washington his wonderful *View from the Farnese Gardens*, a picture filled with the breath of life, rivets the attention; in Philadelphia one notes him as a figure-painter; in Hartford (Conn.) he is seen as a somewhat less felicitous painter of animals in his *View of Rouen*, where a team of horses is toiling up the hill. But what a delight awaits one in the Boston Art Museum! 'The incomplete figure of a woman with a rose-coloured shawl, in a spring-like landscape with trees, rocks, a pond, and cows: the Forest of Fontainebleau! Light green upon dark, the sky as if embroidered.' And finally, in Cleveland (together with a small-scale drawing of the same): 'a great Campagna landscape (approx. 110 × 140cms.) with a blue sky dappled by a magnificent confusion of clouds. To the left, sunlit rocks; to the right, as *staffage*, a rider and a man. In the background, a mounted herdsman. The smoke-plume is legitimate, a shepherd's fire was always burning somewhere at the time. Wondrously fresh, without being green. The traveller, far away from Europe, suddenly comes to think: "How strange that Achenbach[1] has never been able to attain this – love, tranquillity, full freedom of art." '

Such observations do not lead into the style, pausing often as they do in sheer delight, and are but informative jottings for the individual for future reference. And out of them one assembles a picture of Corot's art.

Works of art produced long ago are no longer sheltered in the ateliers of their creators; they have been separated and isolated for decades, their collective power dispersed, and comparisons made difficult in consequence. Comments on these works are thus like a chain of greetings from one picture to others far away, once belonging to the same intellectual region and even coming from the same brush. With some degree of exaggeration it might be said that what does not attract the attention of the traveller does not seem noteworthy. And a history of the rejected pictures, unsuccessful from the start, is not written, whatever opportunities the critics may have had concerning the last generation and especially with regard to the Impressionists; for these masters and their precursors were under suspicion of expressing beautiful 'superficialities', or rather, of painting them.

1. German painter (1827–1905). Specialized in the study of nature, of light and shade effects; his subjects ranged from dawn, twilight and moonlight to landscapes painted in brilliant sunshine. His work represents a complete break from the classical approach of the Düsseldorf School to which he had belonged for some twelve years before adopting his new style. (Editor's note)

JOHAN BARTHOLD JONGKIND: *Trading-barge*. Etching, 1862—A. Schwarz Collection. Amsterdam.

What Corot succeeded in doing, and with lasting effect, is something reflected to a certain extent, now and then, in the work of Monticelli (pl. 16 and 17), who was an exact contemporary of Eugène Boudin and a little younger than Jongkind. Where he differed from these two as a landscapist was in his enthusiasm for rich colours, with a tendency towards theatrical emphasis, reminiscent but falling short of the brilliant and adventurous colour schemes of a Delacroix. He still has his admirers even today, when more often than not his work is associated with Abstract Art on account of his wild flecks of colour (pl. 16).

15

Jongkind was, like van Gogh, a Dutchman who went to live in France. Like those artists working in the rural quietness of Barbizon on the edge of the great Forest of Fontainebleau, he prepared the way, with his windmill picture (pl. 18) and above all with his street scene of Avignon (pl. 19), for the great hour of the Impressionists. He was chiefly a painter of deep-spaced landscapes on the water, vanishing in haze, painted in dabs of grey-green and brown. He never used oils out of doors, and was perhaps at his best in the drawings and water-colours he made on the spot, which most happily reflect his impetuous brushwork, as a successful exhibition in Enschede four years ago demonstrated.

Jongkind spent most of his later years (he lived from 1819 to 1891) in the neighbourhood of Paris and in the south of France. His strength lay in the spontaneous grasp of a scene by means of his extraordinary powers of observation. His draughtsmanship was superb, everything seeming to come out right without effort.

As far as freedom of perception and the rendering of things seen are concerned, however, he was surpassed by Eugène Boudin. Born in Normandy and a teacher of Monet, his fame, like that of Corot, is still constantly growing. He was the master of beach and coastal scenes both in northern and southern settings, executed with not too fine a brushstroke, modest in format but always striking in effect. His pictures have a firmness and decisiveness of structure independent of the lively and colourful scene in the foreground. Here boats, figures, beach fixtures and paraphernalia are set out in no very great detail but with the painter's inborn sense of what is visually effective. One sees this, for example, in those brilliant chequered shapes of little figures on the beach at Trouville (pl. 25), where amongst a crowd of white-clad people some darker shapes stand out for the eye to rest on, while the structure of the picture as a whole often anticipates Manet's shore studies.

Only recently, the author came across a picture in a private collection, showing the Fort d'Antibes with the distant coastal landscape of Nice behind it. The rocky fortress is precisely but not fussily outlined, and in front are gaily-coloured fishingboats at the quayside. Here again one feels the enchantment of the calm and liberal style of an artist who sent a pupil like Monet out into the world, that is to say, to Paris, knowing the limits of his own guidance and how much more Paris would achieve for him.

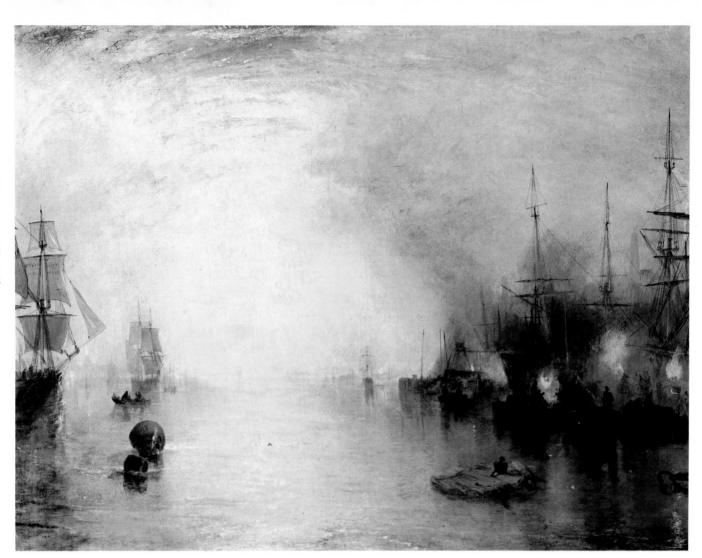

1 WILLIAM TURNER
Keelmen heaving in coals by moonlight, 1835.
National Gallery of
Art, Widener collection,
Washington D.C.

2 WILLIAM TURNER
Landscape, 1835.
Musée du
Louvre, Paris.

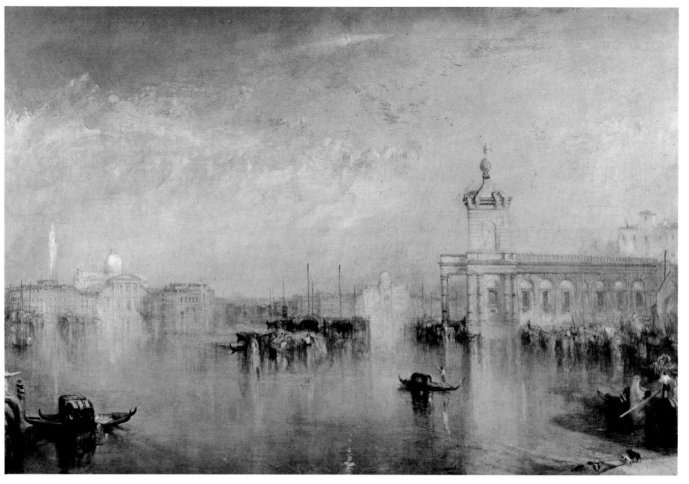

3 WILLIAM TURNER
*The Dogana, San
Giorgio, Citella from
the steps of the
Europa*, 1842.
Tate Gallery, London.

4 JOHN CONSTABLE
*View of Weymouth
Bay, c.* 1816.
Musées Royaux des
Beaux-Arts,
Brussels.

Opposite

5 JOHN CONSTABLE
Hampstead Heath, 1825.
Oskar Reinhart
collection, Winterthur.

6 JOHN CONSTABLE
*Brighton beach
with colliers*, 1827.
Victoria and Albert
Museum, London.

7 THEODORE ROUSSEAU
Willow trees, 1856.
Musée d'Art et
d'Histoire, Geneva.

8 THEODORE ROUSSEAU
Landscape with rainbow.
Národní Galerie, Prague.

Opposite

9 CHARLES DAUBIGNY
Coastal landscape.
Musée Cantonal des
Beaux-Arts, Lausanne.

10 CAMILLE COROT
*View of Dunkirk from a
fishing basin*, 1873.
Oskar Reinhart
collection, Winterthur.

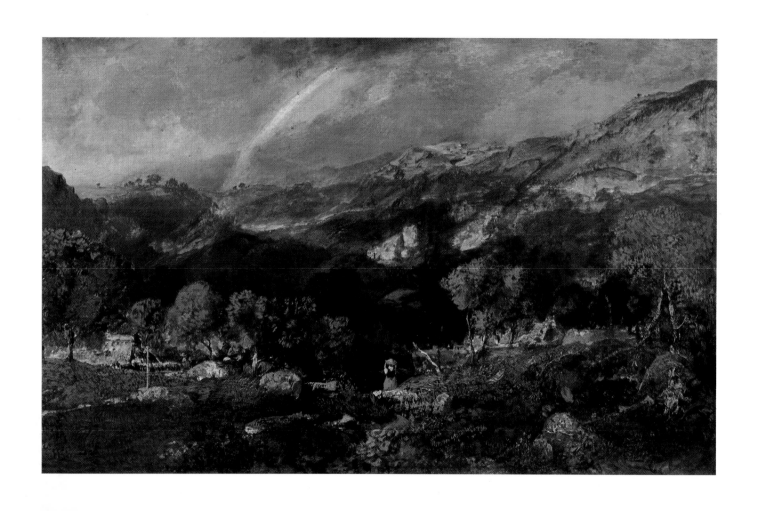

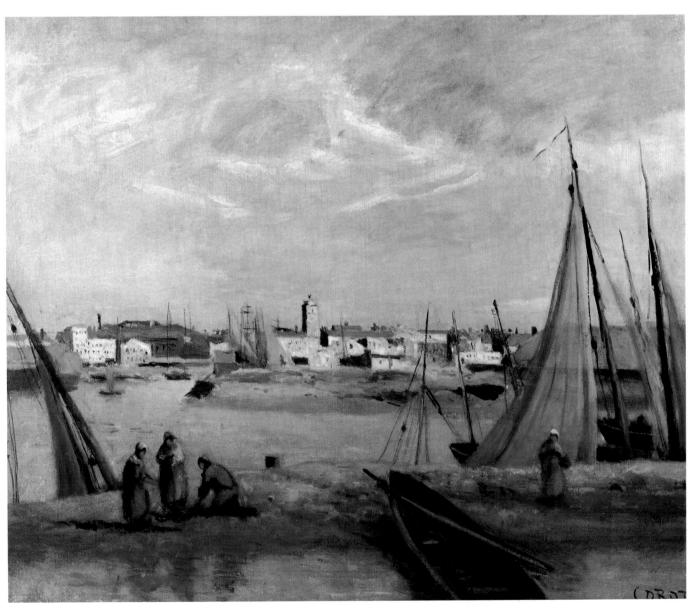

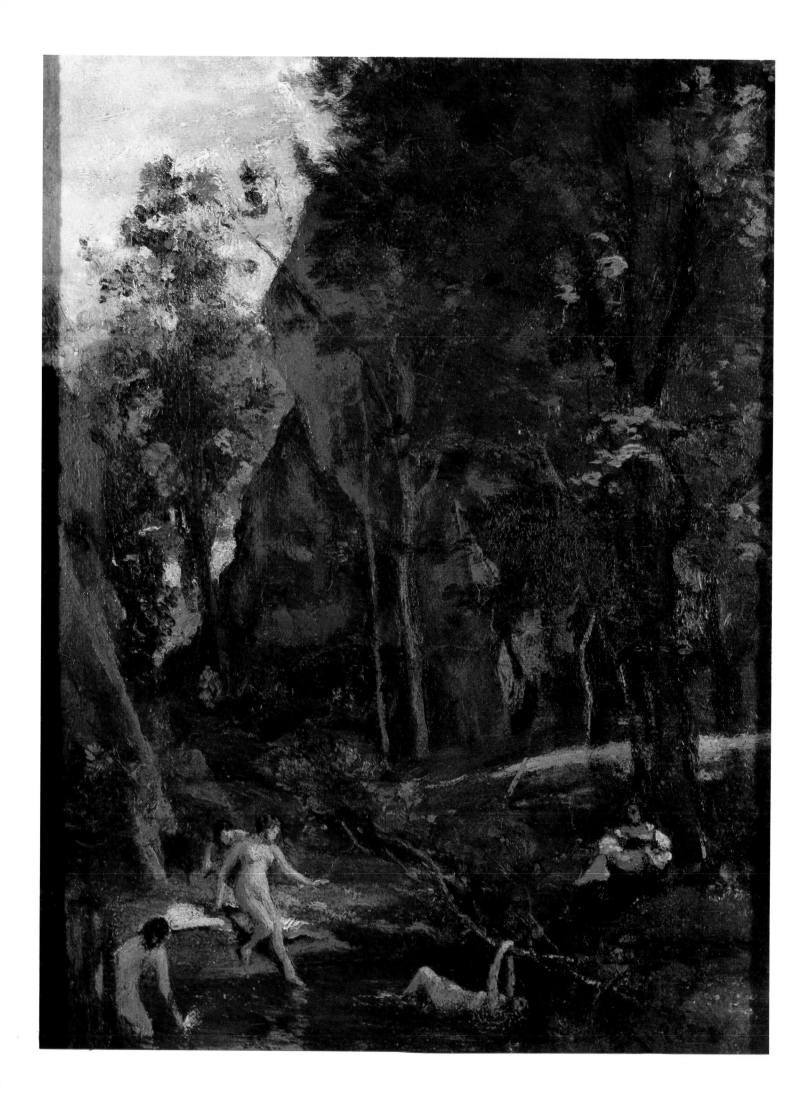

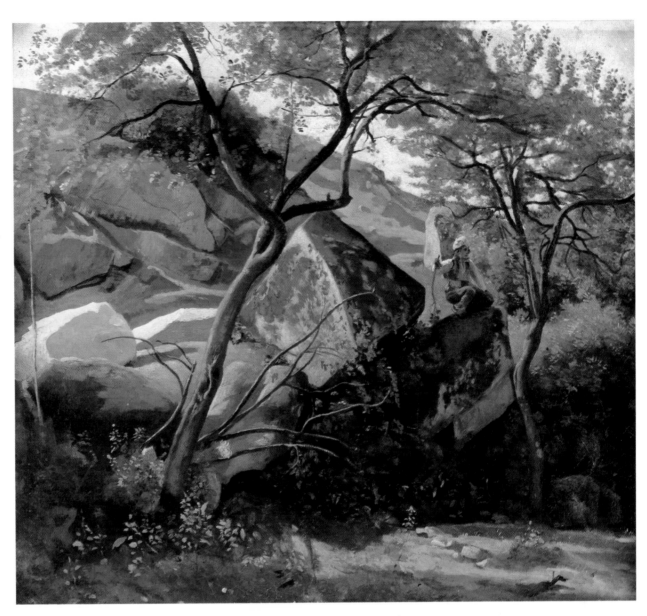

Opposite

11 CAMILLE COROT
Diana bathing, 1835
Musée Saint-Denis, Rheims.

12 CAMILLE COROT
The rocks at Fontainebleau.
Národní Galerie, Prague.

13 CAMILLE COROT
The bridge at Narni, *c.* 1826.
Musée du Louvre, Paris.

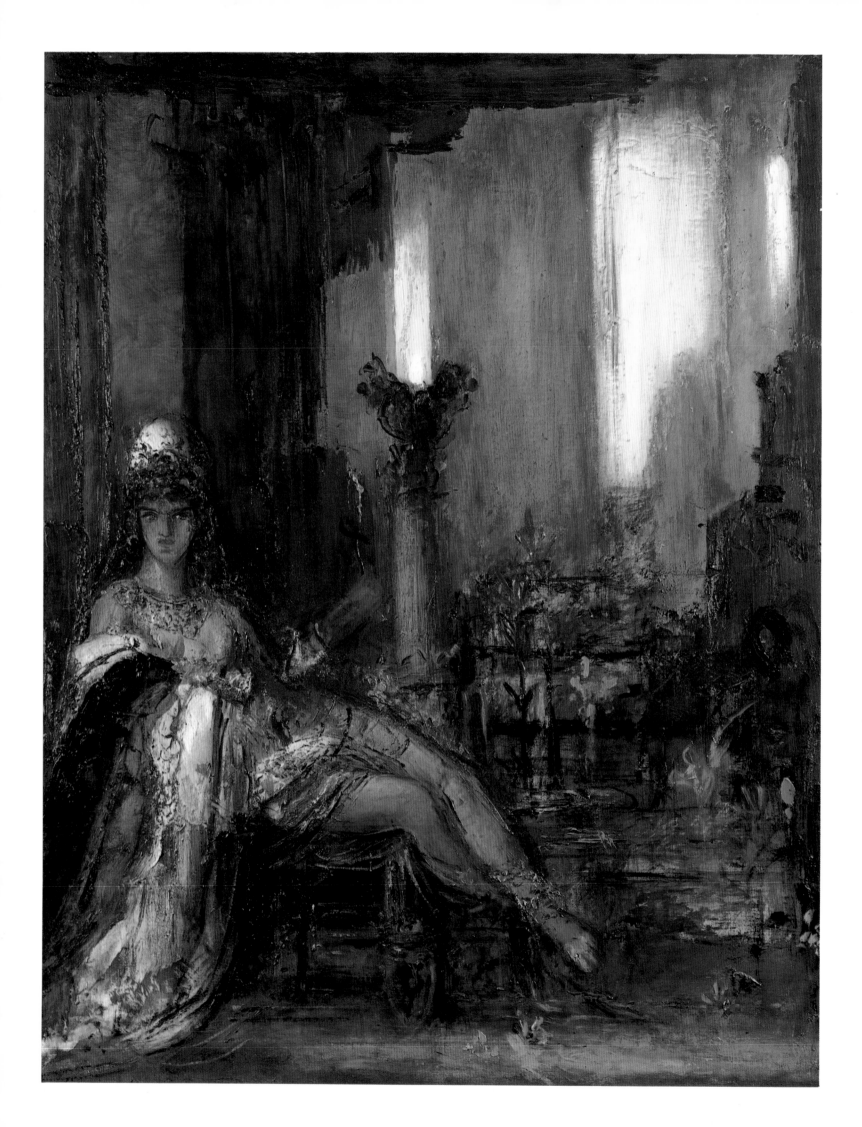

Opposite

14 GUSTAVE MOREAU
Delilah.
Musée Gustave Moreau, Paris.

15 GUSTAVE MOREAU
Helen.
Musée Gustave Moreau, Paris.

16 ADOLPHE
MONTICELLI
Les Précieuses, 1883.
Private collection,
Paris.

Opposite

17 ADOLPHE
MONTICELLI
*The Dezaumes'
country seat, c.* 1878.
Cailleux collection,
Paris.

18 JOHAN BARTHOLD
JONGKIND
*River with mill and
sailing-ships,
Holland,* 1868.
Musée du Louvre,
Paris.

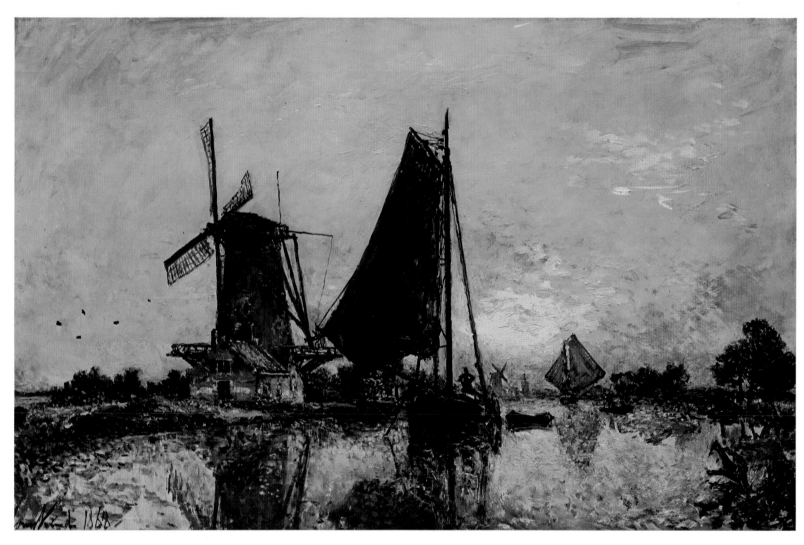

Opposite

19 JOHAN BARTHOLD JONGKIND
Avignon, 1873.
Musée Marmottan, Paris.

20 GUSTAVE CAILLEBOTTE
Street scene in the rain, 1877.
Musée Marmottan, Paris.

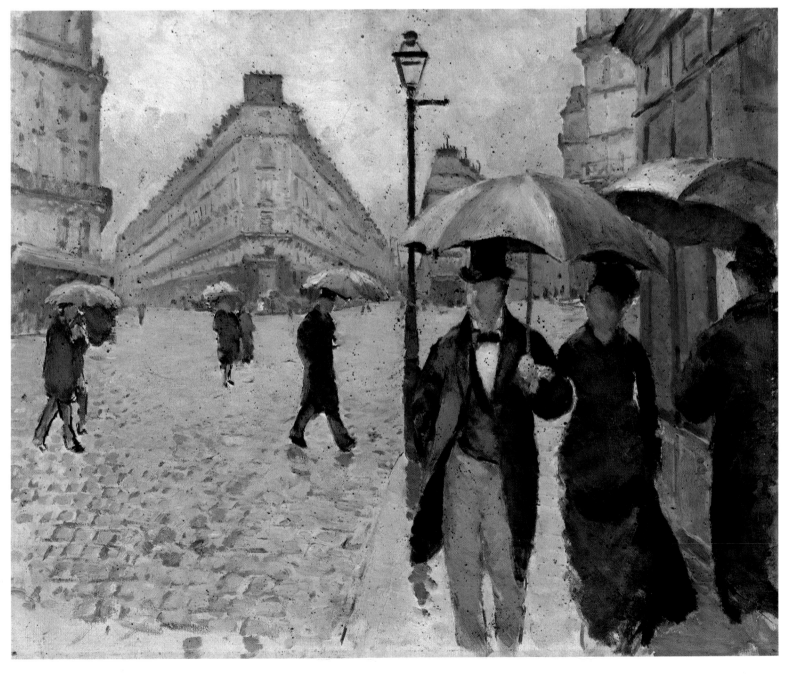

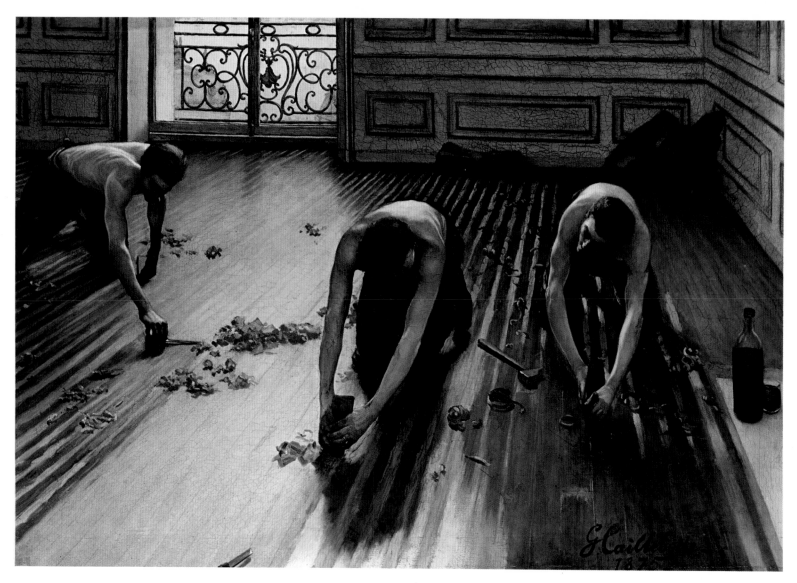

21 GUSTAVE CAILLEBOTTE
The parquet planers, 1875
Musée du Louvre, Paris.

22 JEAN-FRÉDÉRIC BAZILLE
La Toilette, 1870.
Musée Fabre, Montpellier.

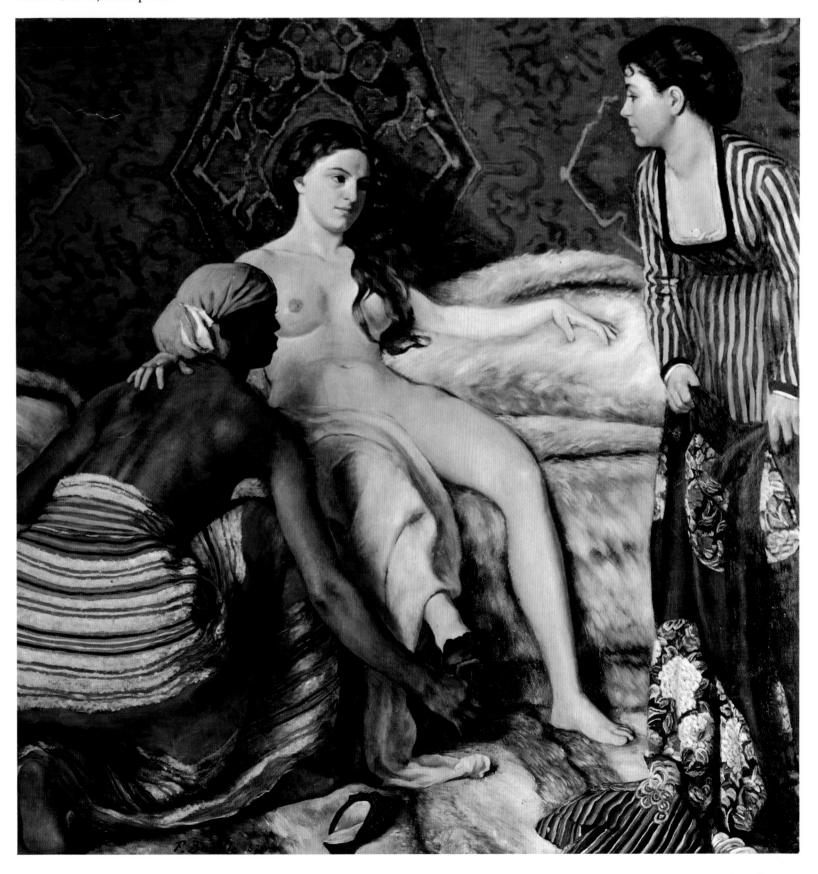

23 EUGÈNE BOUDIN
Breton coastal landscape, 1890.
Musée des Beaux-Arts, Le Havre.

THE IMPRESSIONISTS

The epoch of French Impressionism is difficult for the historian to deal with for several reasons. Just to mention a few of these, there is, for one thing, the host of questions which arise out of the simultaneous appearance of photography, and for another there is the fascination of the emergent industrial age and its 'miracles' of steel, those puffing locomotives with their clouds of steam. One thinks of Monet's attraction to the new railway station at Saint-Lazare (pl. 91) and of Manet's famous picture (pl. 61) of the same station: sheer movement, restlessness, and change. A panorama beneath the open skies, and a novelty to the eyes of the painters, the many steel constructions decked with glass seemed to exalt the heaviness of the material. And for the artist all this was mingled with the haze of the atmosphere, the steam like a 'new cloud'. One has only to bear in mind the remark of Manet's quoted earlier, in which he criticized Moreau's mystification as leading the public astray, 'whereas we are struggling to make all things clear,' in order to realize how the Impressionists' approach to subject-matter differed from that of 'official' art. Then finally there is the generation question: who was working when? In the sequence of notes on individual artists, their contemporaneousness is frequently overlooked. Pissarro was only nine years older than Cézanne, who was born in the same year as Sisley (1839); the birthdates of Manet and Degas fall between Pissarro and Cézanne; as far as age goes, Monet was not the founding-father of the movement, as he was born in 1840. Renoir followed in 1841, Gauguin somewhat later, in the year of revolution, 1848. Monet outlived them all, living well into the twentieth century (he died in 1926).

But if one allows comments about pictures, about these works of art distributed all over the world and overcoming all language barriers by the intensity of their effect, to swing back and forth too much (as for example John Rewald has done in his meritorious but too detailed and therefore confusing *History of Impressionism: the Fate and Work of the Painters of a Great Epoch in Art*, with its comprehensive information and research into all possible sources) then only an enormous catalogue is on offer after all. Rewald's book is crammed so full of important information about every step in the artists' lives and their every significant movement, from here to there and back again, that no narrative thread can be traced. In Rewald's case this is pardonable because of all the great and valuable material the book provides, but the reader tends to find himself, to put it figuratively, before an organ with ten keyboards, which he doesn't know how to play.

Here then we shall be content to consider the artists in the order in which their works are illustrated, introducing them with little preamble and with many a reference to the accompanying colour plates, so as to bring the originals to mind as far as possible. It is not the aim here to describe and elucidate every one of the pictures, as this would be tedious, even when nearly all of them are old acquaintances which over many years have been disclosing ever new proofs of the individual vision and feeling which inspired their creation.

This is especially true of Manet, who is represented in this book by twentyone works; Monet, represented by twentysix; and Renoir, by as many as twentynine. One must bear in mind that the *oeuvre* of each individual artist represented here was a substantial one,

including innumerable drawings, in some cases a considerable amount of sculpture, and in nearly all cases some form of printed graphic art. By this last is meant the printed, often coloured, copies of etchings and lithographs controlled by the artist, *i.e.* 'painterly' graphic techniques. The woodcut in its uncompromising black-and-white manner was not so popular during this epoch. Only Manet was also master of wood-engraving, somewhat in the manner of Adolph Menzel.

In the earlier description of Manet's picture *Argenteuil* (pl. 65) and the summer scene of 1874, mention was made of an exhibition which took place in the spring of that year in Paris, and which, exactly a hundred years later, received its tribute in the *Centenaire de l'Impressionnisme* at the Grand Palais in the same city, a great exhibition in celebration of the once-derided artists.

In April 1874, Monet, Pissarro, Sisley, Renoir, Cézanne, Degas, Guillaumin, Berthe Morisot, and others had banded together in a group which called itself the *Société Coopérative des artistes, peintres, sculpteurs, graveurs, etc.* (Artists' Cooperative Society of Painters, Sculptors, Engravers, etc.). The aim was to hold their own exhibitions, as this seemed the only way they could present their newly created paintings to the Parisian public, because in the *Salon*, the annual art event of Paris, they were either so badly placed that nobody could notice them or they were rejected by the Jury from the start.

This first exhibition and its date (15 April–15 May) are notable as signifying a new kind of initiative, not for being a turning-point towards recognition of the artists. Out of the raving chorus of the critics of the day we will merely pick the voice of Albert Wolff, a newcomer in the Parisian art world, who expressed his opinions in the *Figaro* thus:

'... it is startling to see how far astray human vanity can go, even to the point of total madness. Try to explain to M. Pissarro that branches are not violet, that the sky is not the colour of fresh butter, that in no country on earth can one see those objects he paints, and that no intelligent human being can take such deviations seriously ...'

And so the exhibition was a failure, but only outwardly, for these young unsuccessful artists were as much to be admired for their irrepressible courage as for what they painted. Nothing of the moments of despair, the hopelessness of finding patrons, friends, or buyers, can be detected in the pictures of the 'seventies when they were 'under suspicion', merely painting for their own pleasure and giving their pictures away to each other like souvenir photographs. Only Manet was secure, together with the rich boatbuilder-turned-painter, Caillebotte (pl. 21), who was a bachelor, and Bazille (pl. 22), who came from a well-to-do family. Both these last-named painters were influenced in their artistic development by early figure-paintings by Monet and Manet, with considerable success, as the Centenary Exhibition of 1974 showed. As for Renoir, he sold a picture now and then, but nevertheless was the poorest amongst them all.

What was their common theme? As if bewitched by the world around them, in a kind of 'innocence of vision', they saw the landscape bathed in light, whether in the streets of the capital, or in the social scene, regattas on the Seine, sometimes a race meeting or an

impressive sporting event, or just the gentle idleness of a pleasant summer's day in the meadows. Even Pissarro spent his life painting under the changing light of the skies for as long as his health allowed him, then, in later years, painted from windows high above the Paris boulevards (pl. 36–8), looking down into the seething crowds below him.

CAMILLE PISSARRO. What did it comprise, this new method of work which Pissarro and his friends developed 'with amazing lack of preliminaries', as it was often said, and an audacity such as only Delacroix had been noted for until then? To put it briefly: instead of following the conventional method of painting, in which sketches from nature were finished off in the studio, with the subject-matter often regrouped in the final composition to accord with artistic inspiration, they on the other hand went outdoors to paint directly from nature, laying the colours from their large arm-palettes directly on to their white-primed canvasses in the form of broken dabs and strokes. The picture was usually completed in one session before the subject, a procedure catching the light and fleeting impression as it presented itself at a given moment in time and place, just as implied by the term 'Impressionist', originally coined as a nickname, and particularly closely associated with Monet.

The subjects which lent themselves to such a way of painting were chiefly verdant scenes in parks, gardens, and along the country roads around Paris, in addition to the city itself, whose radiant beauty was now revealed, not with topographical fidelity, but in all its fleeting, ever-moving shapes and forms, its bustling animation. This allowed and required the theory lying behind this mode of painting, namely, that atmospheric impressions of light and air should urge the painter to go to work at a given moment, that the contours of solid objects should be allowed to disintegrate, that what matters should be the painter's vision at that moment alone. As Paul Bourget has pointed out concerning the literary style of his epoch, one page should grip the reader more than a book – and one sentence more than a page . . .

To paint quickly or slowly may have been immaterial to the artists; it was however the criterion of the baffled public of the day confronted by what seemed to them unfinished work.

Eight group exhibitions were held up to the year 1886, with a changing cast of participating artists (including two women, Berthe Morisot and Mary Cassatt) and a flexibility permitting great independence for each individual within a certain unity of purpose. During this time, the art-form reached its maturity, to be subsequently replaced by other new forms of painting.

This may be enough, for the present, to indicate the self-chosen form of existence of impressionistic creativity. Each individual painter was affected by it differently, according to his temperament. And their cooperation over the years in the exhibitions and at work in the gardens, meadows and country lanes was seen as an act of solidarity arising out of common need and also as a protest against 'official' art, the only art recognized in Paris.

How little this concerted creativity affected the individuality of each painter can best be seen in the Musée du Jeu de Paume, now part of the Louvre; and to see how those artists

went their own separate ways in their later works is another indication that this association could only last for a certain length of time. One can compare the old Pissarro painting from his window (pl. 40), the old Renoir discovering a southern paradise in Provence (pl. 125), or the old Monet, drowning in his colour-dreams of water-lilies (pl. 96–102). With that, we have already reached the turn of the century.

Camille Pissarro, born on an island in the Antilles and ten years older than Monet, was already twenty-five when eventually he came to live in France for good; he admired Corot and later made the acquaintance of Manet. Pissarro's motifs were found in the suburbs of Paris, in Louveciennes, and in Pontoise. His finest inspiration lay in views such as the *Street scene in Pontoise* (pl. 32), in a rural world, in cabbage-fields and gardens, where he watched and painted the peasants at their work (pl. 41), without setting them up as monuments in the manner of Millet. All was painted with great naturalness, and even in his most beautiful and most admired pictures one feels it is the 'unobtrusive' subject which has inspired him to paint, a sign of his sure and sensitive way of looking at things before painting them.

Pissarro's gift was a cheerful temperament; he saw everything with a painter's eye, and almost year by year his palette became brighter and lighter, especially during the early 'eighties. We can still look at a spring landscape with his eyes (pl. 33). A transitory 'moment of nature', before the wet snow falls off the trees a few hours later (to name only one of those inspired moments) is preserved by Pissarro in his *Snow in Louveciennes* (pl. 28). Although the human figure plays a certain part in his works, it is often introduced only to enliven the landscape (pl. 34), and is merged into the composition even when its presence suggests the scale of the whole (pl. 31, 33). The attitudes and activities of the figures look natural and unposed. All is achieved by the harmony of colours (pl. 35).

When in later years he became afflicted by eye trouble, he went into town – as mentioned before – and, sitting at his window looking down into the streets, painted what he was able to see. These were not just any suburban streets, as in the Paris views Utrillo was later to paint, but the Grands Boulevards of the capital city. And he returned many times to the lovely bridges spanning the Seine, with their splendid lights, solid parapets and sculptures. This painting of architecture (pl. 40) led unexpectedly to those brilliant studies of the sparkling daily life of the metropolis, still much admired today and also taken up by his painter friends at the time. His favourite season is when the trees are still leafless, thrusting out their tangle of prickly naked branches above the streets, which swarm with sauntering pedestrians on the sidewalks and with little black carriages jogging along the thoroughfare, sometimes in full sunlight, sometimes in the rain, with the world mirrored in the wet pavement. To be sure, the figures are too small, often nothing more than unconnected coloured dots. Coloured dots tell nothing about a social situation, nor are they intended to! Above it all is the luminous sky of Paris. The boundary between the scene below and the soft, whitish-blue air above is drawn by the frieze of chimney-pots picturesquely sticking out all along the hipped roofs (pl. 36–8).

37 This then was a homage to Paris such as no other city in the world has received, unless one

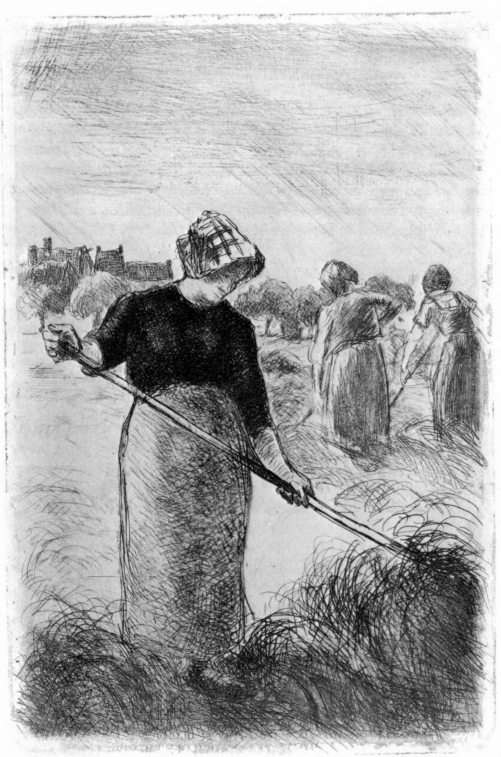

CAMILLE PISSARRO:
Haymaking. Etching

38

counts Canaletto's *vedute* of Venice; that however was a hundred years earlier, and the topographical interest in a unique city built among the lagoons was a fashion.

The interest in 'street views' did not prevent the Impressionists, especially Monet, from turning their new style to important buildings, as if, with pardonable curiosity, to try it out on masses of fixed dimensions, such as cathedrals, churches, or public squares surrounded by buildings, played on by light in all its intensities. Here again the impressionistic vision has saved for us the 'great moments' of architecture in illumination, as also in those views of anonymous streets somewhere in the provinces, which otherwise would not have been handed down to us. In the Museum in Toledo (USA) one is struck by a painting of the Cathedral of St. Jacques in Dieppe. Once again it is evident that whatever the motif of the village painter on the Seine, it served only the purpose of conveying atmosphere.

ALFRED SISLEY. It was only after his death in 1899 that Alfred Sisley, even more a landscapist of the Impressionist group than Pissarro, began to be truly appreciated. His works are best represented in the Musée du Jeu de Paume in Paris, now the home of Impressionist art, which is situated up the sloping drive which rounds off the Tuileries gardens towards the Place de la Concorde, with the corresponding building of the Orangerie facing it across the gardens. Since the famous Moreau-Nélaton and Count Isaac de Camondo collections have been moved to the Louvre, the Musée de l'Impressionnisme founded at the Jeu de Paume houses the most complete collection.

In his early work Sisley was influenced by Corot and Daubigny, but by the 'seventies he had become one of the most important and exclusive painters of the Île-de-France (pl. 47 and 49), constantly seeking the beauty of changing light on the banks of the Seine (pl. 44), with the gentle rise of the green northern hills in the background, the modest houses of the townspeople (pl. 48), and a few passers-by. All is relaxed, with a breath of country air about it, even when the Seine has burst its banks and the people have to punt from house to house. The flooding at Port-Marly inspired him to paint a series of his perhaps most beautiful pictures. His unceasing enthusiasm for this flooded little world is comparable to that of Monet for the railway station of Saint-Lazare in Paris; in the one case, the fascination of the colourful mirror of gently-moving water (pl. 50), in the other, of light blue clouds of steam (pl. 91).

Water is Sisley's element. There is no haste, no dramatization here. His finest motif: the Seine, risen right to the walls of the rose-coloured houses, the rows of pruned plane-trees seemingly rootless yet not displaced, caught in the magic reflection along with the poles and posts and landing-stages – a motif such as only a natural phenomenon like this can provide. And the painter was quick to take full advantage of it, just as he glimpsed it from his attic window.

In his *Regatta at Molesey* (pl. 43), set against a mottled green background of trees, the focal event of the picture is the mighty flags, gently blown by the wind, which dominate the

scene below. In general, the subject-matter is of no great significance to Sisley. The ceaseless flow of light, the breeze softening the hard contours of objects, this is his theme (pl. 45–6). Before his *Flood at Port-Marly*, one made this note: 'Sisley's painting of landscapes is probably the most beautiful of all, because he does not venture too far into the "incomprehensible".' And in Boston: 'Sisley's *First Snow in Louveciennes*, with wonderful green trees, a perfect harmony.' And yet another note from the Jeu de Paume: 'Furthermore, he loves to stroll beside park walls with a painter's eye . . .'

With their fresh, glowing colours and their unbiassed vision, Pissarro and Sisley achieved a sensitive, spiritual handling of landscaping, which as a theme had already been discovered somewhat earlier but whose evanescent charm only became fully appreciated under the reign of impressionistic painting. The Academies tended to despise landscape painting. For centuries it had been the tradition that the function of landscape was to serve as fixed scenery around and behind the figures. But now the landscapist came into his own. For him, the fascination lay in that moment when the sun breaks through, or when the sky is dappled with gathering cotton-wool clouds; in their manifold reflections sparkling in the water below, and in shadows. It was the calm expanse of a landscape always open to the light, with gardens and country lanes, or winding tree-lined streets, or scenes along the shore, all bathed in brightness which spills out on to the canvas. The extraordinary thing is that this constantly fresh self-renewal of vision gives these simple motifs a new pictorial meaning; it signifies a graceful withdrawal from the sober artistic earnestness of the Barbizon painters. John Rewald says on this point: 'The artists of the new generation realized that the Barbizon painters ran less risk of their art becoming conventional and stylized the closer they stayed to their impressions of nature, by which means they could best preserve their originality.' And this was a lesson which Monet, Sisley and Pissarro took to heart.

ÉDOUARD MANET. Any commentary on the development of French art in the latter decades of the nineteenth century has to pause for a moment of respectful silence when it comes to the pre-eminent artistic genius of Manet. Manet and his work are the concentrated embodiment of all the creative power of the fine arts in mid-century; less intellectualized than that of Delacroix, whose art was also deeply admired by his generation, the importance of Manet's work became apparent in his group-pictures, which can be seen today in the Jeu de Paume in Paris. Manet, the ever-increasing painter, close to the earth and humanity even while maintaining an intellectual detachment, so that his human figures gaze trance-like out of his pictures, would not participate when the great moment of the Exhibition arrived, a moment whose influence has now lasted for more than a hundred years. And during the period before impressionistic influence lightened his palette and brought him out into the sunshine, he was perhaps even greater, more compact, showing even more consummate mastery in the cool assurance of his grey tones.

It is Manet who arrests the attention and stays longest in one's mind, who also raises most questions about artistic sources, combining in himself the epochs of painting since Velazquez and Frans Hals as he steps brusquely yet with the self-composure of a *grand seigneur* before the canvas, there to describe the human condition as it has never been done before, not by Ingres nor by Delacroix, those two rivals occupied with their own ambitious plans and spending their energy in trying to realize them.

Big, silently-enquiring eyes gaze out from the palely-bright faces of Manet's figures (pl. 58). There is a trace of wordless astonishment, even of gentle challenge, and then again of intense inner activity about them; their wonderfully-modelled eyes look directly at the spectator (pl. 53) no matter how Manet represents his figures – clothed or nude, upright, leaning, sitting, standing or lying, in full-figure or half-figure or cut in half by the edge of the picture, or in shadow, so leaving more to suggestion, like the hatted man in the enclosed room (pl. 58), seemingly ready to leave but lingering, haughty, silent, but intense. The inner feeling is kindred to paintings of the seventeenth century, expressive of wakeful intelligence, and not to those pictures of the Reformation period with their furious rhetoric.

Silently eloquent too are those delightful still-life pieces on tables and lawns, which appear with the sudden full brightness and orchestral impact of glorious colour, and which, once seen, are unforgettable in their free composition springing forth from the darkness: clothes, flowers, blossom, fruit – preferably half-peeled. Again it is the transitory, changing moment of the *nature morte* submitting to Manet's painterly inspiration, through which things material lose their value and become artistically transformed, so that their substance need only be suggested. And Manet always stopped short deliberately at this 'abbreviation', and in so doing came so close to one of his precursors, namely the Spaniard, Diego Velazquez, even before he had seen any of his pictures, that he could be taken for a belated brother of his.

This detachment from the motif applies even in the picture of the pretty Victorine Meurend, a favourite model of his, and the child who clasps the iron safety-barrier as she turns to watch the station of Saint-Lazare (pl. 61–2). The sensitively-portrayed woman pauses in her reading, her features completely relaxed as she looks up; this is an unhurried gesture, which belies the frequent and mistaken imputation of 'ephemerality' in this art and indeed suggests lasting continuity. This is certainly the impression communicated to the spectator who stands in front of the original in Washington.

The serious, silent confrontation remained Manet's theme up to the time of *Argenteuil* (pl. 65) and his discovery that he too could paint in the open light of day, which of itself impelled him to decide the new course his art was to take, as we described in the story of how this picture came into being.

When Manet actually painted what he saw, his was 'seeing' of a special kind, incomparable. Admittedly, his calmly discerning eye was aided by an unbelievably sure hand which enabled him to work quickly, with the freedom and immediacy to be seen in the paintings of Velazquez in the Prado or in the works of Frans Hals. But this by no means explains Manet's interest in the world, in this modern elegant scene of Parisian society in the 'sixties, which

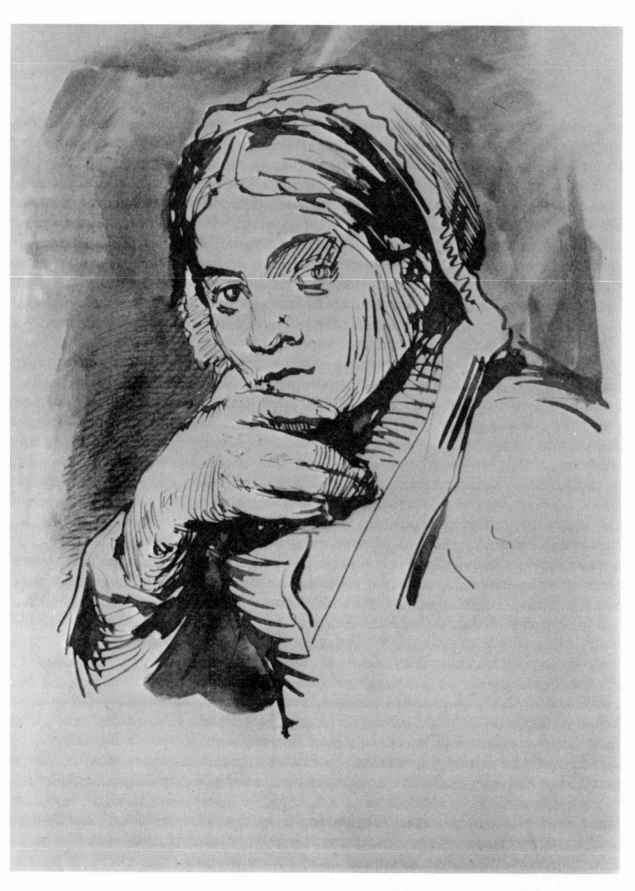

EDOUARD MANET: *Portrait of Victorine Meurend*. Pen-and-ink drawing, washed with brown ink.

however could not recognize itself in his pictures with any pleasure, whether in bohemian isolation at a picnic in the woods (pl. 54) or in a crowded social gathering at a concert in the Tuileries (pl. 52).

Le Déjeuner sur l'herbe (pl. 54), painted in 1863 and originally entitled *The Bath,* shows how different and how far removed his art was from what the public expected of him. To understand what went on in Manet's mind before he painted this picture, which has such a striking effect even today, this little scene described by Antonin Proust may be of some help. 'Shortly before he painted *Le Déjeuner sur l'herbe*, we were in Argenteuil. It was a Sunday, and we lay there stretched out on the bank watching the white sailing-boats cruising on the Seine, leaving glittering trails behind them as they cut through the dark blue water. Some women were bathing in the river. Manet observed their naked bodies as they came out of the water. "It seems to me," he said, "that I must paint a nude. All right then, it shall be done! Back there in the studio I have a copy of Giorgione's women, the one with the musicians in it. The picture is dark, the ground is too heavy. I will do it again and this time with the translucency of the air, and nudes like those over there in it." '

What initially suggested this composition to him, then, was Giorgione's *Country Concert* in the Louvre, where he went to copy, and also Raphael's *Judgement of Paris.* And one of the first reactions of the critics (Castagnary in this case) to this masterpiece of the thirtyone-year-old Manet was this: 'Now we know what a bad picture really is.'

Two years later when he went to the Prado and actually saw the pictures of Velazquez, Manet felt even more inclined to paint single figures rather than a multi-coloured crowd like the one at the Tuileries concert (pl. 52). These single figures are presented in such a way that they seem to be musing about what they are doing rather than actually doing it, caught in an almost indolent attitude. The little *Fifer* (pl. 59) 'pauses' in an attentive manner in his simple melody, without having to strike a pose, and stands like a deep-coloured islet against the scarcely-differentiated grey of the background. As far as the baggy red trousers and the white spats over big clumsy boots are concerned, coming from any other painter these would be taken for clowning, whereas Manet raises them to the sublime.

The conversation between thoughtful natures has its meaningful pause (pl. 69), or else its substance is imponderable (pl. 58). And work is done with zeal and comes naturally, as in the case of the waitress with the full lips and unaffected gaze (pl. 71), that *serveuse de Bock*, who makes no advances, offers no anecdotes, and is in no mood to flirt with the onlooker. This picture in particular seems to be full of realism, but for the painter it is in fact a study of light and shade, of many reflexes flashing from one rounded surface to another, from figure to figure.

Théodore Duret recounts that a new establishment had been opened on the Boulevard de Clichy under the name of 'de Reichshoffen', where the beer was served by waitresses, which was a novelty in places of entertainment. Manet did not want to paint just any waitress in this pose, and therefore went to his favourite café, where even then the waitress was only ready to model for him if she was allowed to bring along a 'protector' with her. So Manet had to pay

two models, the other one being the pipe-smoking man in the extreme foreground of the picture.

Now let me say a few words about some other types of pictures painted by Manet, including the large, statuesque motif of that charming barmaid mysteriously reflected in the mirrors behind her, in the London picture, *The bar at the Folies-Bergère*. More about this later on. Observations of a general kind often overlook the fact that the already mentioned change in Manet's painting technique, brought about by his interest in the work of the much younger Impressionists, also influenced his choice of motif. Manet had an innate interest in human subjects, and his outdoor scenes are almost always enlivened with figures or are used as a framework for them (pl. 65). Now, working from nature under the open sky, he could express his impressions in all their immediacy, using the prismatic colours of the Impressionists and banishing the asphalt from his palette. From this time on his method of painting was almost always *alla prima*, the colours being laid directly on a pure white ground without any underpainting.

Just one more comment before we consider individual cases. The traveller can experience the art of Manet the world over. Its magic is the centre of attraction everywhere, be it in Paris or Munich, in Bremen or London, in New York, Washington, or other places where great art can be seen. His compositions have spread all over the world, and thus have been seen by innumerable spectators holding very different points of view. But spectators surely find that they have one thing in common when looking at the pre-Impressionistic pictures of Manet: they are immediately and unexpectedly engaged by these paintings, whose quality inevitably compels recognition. This directness of communication diminished considerably during those few active years still left to him after the Argenteuil picture of 1874, for reasons which include the onset of ill-health.

Out of all the notes made in front of individual pictures at many places, we shall use only what directly concerns those illustrated here. Both *Le Déjeuner sur l'herbe* (pl. 54) and *Olympia* (pl. 55) were painted some time before the first encounter with Monet and his friends. *Le Déjeuner* (in which, according to old painting tradition, naked female and clothed male figures make up the composition) has raised innumerable questions ever since it was exhibited at the *Salon des Refusés* in 1863. It also clearly exemplifies Manet's method of work: 'to model the pale brightness of the naked body with only the faintest shading, while at the same time setting it out against the dark surroundings' (Wescher, *La Prima Idea*). In this way the bodily forms are given full importance, dominate the green locality of the woods, and yet are portrayed with that characteristic mixture of nearness and detachment which makes them remain part and parcel of the natural scene envisaged by the artist with equal clarity. This detachment from anything which is not part of the picture itself is constantly emphasized by the things that surround the figures. Never in this region of Manet's art is any transitory gesture or indiscreet visual reference allowed to disturb the composition. Although the main character looks straight at the spectator, as does the *Olympia*, this stare does not make her any less a part of the scene. How coolly modelled she is, yet how down-to-earth! 44

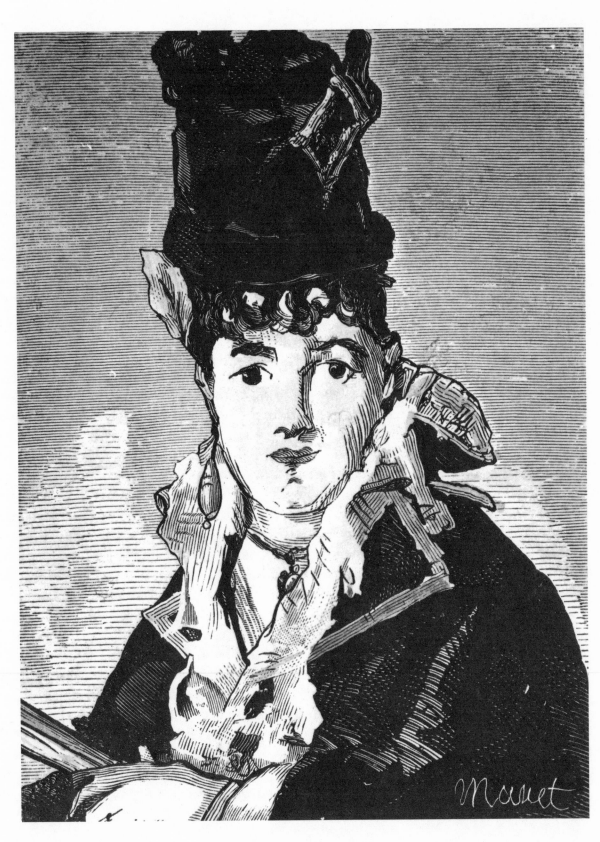

EDOUARD MANET:
*Portrait of Berthe
Morisot.* Woodcut.

On the subject of *Olympia*, seen by her first public of 1865 as the scandal-picture of all time, let me quote my notes of nearly twentyfive years ago when the painting was before my eyes after a long interval. 'An overall impression of richness from the sumptuous bed-coverings in cool white, grey, and blue. Upon which lies Olympia, in very pale flesh-tone. Fine cracks have appeared on the left breast and thigh. The pink on the Negress and the ivory of the shawl are the only variations on this paleness. The bouquet, together with the flowers on the shawl, must be seen as minor accessories. The background is warmly dark; the flower in her hair seems insignificant before the loveliness of this petite girl, a beauty from top to toe. Nothing frivolous or open to misinterpretation here, flawless, simple – the only coquettish touch, the neckband. That must have been the stumbling-block! This black neckband is the key to everything, it and the deep-red eyes, viewing one steadily – nothing else. In short, nothing can be more innocent.' Yet here is a contemporary notice about the picture: 'That the *Olympia* was not slashed and torn to pieces was only due to the safety precautions of the administration of the Salon of 1865 (where the picture was on show). The indignation of the public mounted steadily, and finally people concluded that Manet must be making fun of them . . .'

Any comments made here refer to what strikes the eye, and so are not aimed at anything like an iconography of this *Olympia* picture. The reader can find that, for example, in the book by François Mathey (Paris, 1948), which deals with the studies for this picture, the etchings of it, the prototypes by Goya and Jalabert, Manet's copy after Titian, and finally, the copies by Fantin-Latour and Gauguin after Manet. It is a long story, up to the time when Cézanne painted his ecstatic and probably ironic paraphrase of the theme, *La Nouvelle Olympia*.

However, this is one place at least where, in addition to more personal comments on the art of French Impressionism, a few facts on the historical background ought to be mentioned concerning what has happened over the past hundred years to this masterpiece of French painting. Perilous hours were endured in silent nobility. In 1865, *Olympia* was exhibited at the Salon, then two years later during the World Exhibition in a booth erected by Manet. In 1889, six years after Manet's death, the picture was offered to the French state on the initiative of Claude Monet, after a public subscription in aid of Manet's widow, and in 1890 it was accepted for the Luxembourg Palace, where *Olympia* hung opposite the *Resting Odalisque* of Ingres. Since 1947 the picture has been on show at the Jeu de Paume.

On seeing the picture, Courbet is alleged to have said: '*C'est plat, ce n'est pas modelé: on dirait une dame de pique d'un jeu de cartes, sortant du bain . . .*' (It is flat, not modelled: one might call her a queen of spades from a pack of cards, after a bath . . .).

Now let us consider just a few of the many pictures reproduced here, though the rest are all worthy of remark, especially such details as the splendid still-life in the Munich picture, *Luncheon in the studio* (pl. 58), the fish in plate 57, the quite spiritual beauty of the flowers (pl. 56), or the dark cool atmosphere of those night scenes beneath the open sky as in *Boulogne harbour by moonlight* (pl. 60). Finally, there is the exploration of physiognomy, as

46

in the small portrait of the poet Stéphane Mallarmé (pl. 68), a man who always spoke out resolutely in favour of Manet's art. The reproduction is almost as large as the original, and the poet is shown resting at his ease. Here is just a short excerpt from Antonin Proust's description of Mallarmé's appearance in Manet's studio:

'... he had large eyes, his straight nose projected sharply above the thick moustache, with the half-stroke of the lips beneath. The high forehead stood out powerfully below the bushy hair. The ends of his forked moustache touched the dark cravat tied round his neck ... His carefully-chosen words followed one another in regular cadence, and were accompanied by expansive gestures of the hands.' All this Manet 'hits off' perfectly.

It is difficult to make up one's mind about the *Gare Saint-Lazare* picture of 1873 (pl. 61–2), in the National Gallery in Washington (of which not only notices but also copies, or attempts in that direction, were made, and years later still there was the sketch of that pup resting in the lady's lap, rather resembling a guinea-pig). On seeing the original again, one is inclined to feel that something is lacking in the presentation of the people, so that this picture does not reach such a high level of portraiture as the *Luncheon in the studio* (pl. 58), with the young man in the hat in the foreground, a picture which parallels Degas' *Portrait of the Bellelli Family* in the Louvre (Jeu de Paume).

Manet painted the *Gare Saint-Lazare* a year before meeting Monet and Renoir in Argenteuil, hence just before his own period of Impressionism. And it is not really a picture of a railway station, but only of a white cloud of locomotive steam behind a high safety-barrier. The technical subject is poetically disguised here; it is only to be imagined, but therein lies its fascination. Mainly painted in the open, the picture shows Manet's famous model, the attentive-looking Victorine Meurend, seated in front of the barrier. Her young charge in summer dress stands next to her, looking towards the tracks. Hence only the child has a bearing on the atmosphere of the station, and Manet has nothing more to tell about this new wonder of technical science. With him the theme remains, as always, 'human', or at any rate is expressed through people.

Here are observations made in 1964 and 1969 whilst standing in front of the original: 'Blue is the dominant colour. One couldn't really call it a charming picture. The abstract magic of a Degas is missing here, as also in others of Manet's pictures, apart from masterpieces – and by those his art is assessed. If one recalls the portrait of a young man by Velazquez in the same National Gallery in Washington, or the portraits by Frans Hals – also there – one can see a kind of "return" in some of Manet's work, without their full vitality, even though his composition and inventiveness are astounding.'

And then, years later, a quite different kind of notice:

'... this picture remains one of the most beautiful here; the somewhat fleshy child to the right of Victorine is only a "clothes-hanger", really quite without beauty, particularly because of her doll-like appearance and her hair-do. The sleeping pup in Victorine's arms actually turns her into an immobile figure from a still-life; the portrayal of the little girl becomes a mere costume-study; the whole expressive power is contained in one thing

only: the picture of the young lady (of whom the copy-drawings seek to catch her grace rather than her austerity)'.

Now we come to *The bar at the Folies-Bergère* (pl. 73). This magnificent picture, which engages both mind and eyes from the very first sight (and which Günter Busch has studied and described in detail, with especial regard to its reflections) was created in 1881–2, after preliminary studies including one in colour, and is surely the crowning glory of all those works of art exhibited in the gallery of the Courtauld Institute in London. The notes made in 1966 might assist a closer consideration of the work:

'. . . a masterpiece, through and through. Somewhat more subdued, quieter than expected. The unusually straight, wide bridge of her nose! White skin. The costume-jacket, of a deep dark blue, hugs a severely-corseted figure. The bouquet in her bosom pale grey and red. The marble table brightly-coloured, the bottles in their own lovely colours. Everything behind the figure seems to be floating, a reflected image. But the gold-coloured framework and the red partition are real enough! The reflected figures in the gallery seem to be floating gently, above left the dangling legs of a trapeze artist are just visible. Manet is a painter of still-life: the bowl of oranges, to the right of it a red bottle, in front of that a green one! The glass with two roses before the deep blue of her garment is most beautiful – just a simple wine-glass! Important also to remember that everything is life-sized: the lovely barmaid, the bottles, the glasses.'

And an additional comment:

'The whiteness of her arm shades into the reddish, almost coarse skin-colour of a person washing up glasses. The reflected back view (of the beautiful barmaid) makes her look quite matronly: the ear is red, the hair of no particular style or colour, ashy blond, thus she is of no further interest to the painter.'

The 'abbreviations' of his brushstroke kept alive all that freshness which was also to be of benefit in his later *plein-air* pictures. Manet was now embarking on a principle of style in which less importance would be given to the person represented in a picture, *i.e.* the portrait in the traditional sense, than in his earlier works. Now, instead of being the dominant element, the human figures were brought into relationship with the rest of the picture; indeed, to a certain extent, made 'part of the landscape', as in the *Argenteuil* picture. Here the people are suitably dressed and ready for a boat-trip, carefree and relaxed; but it is their summer excursion on the water, not themselves as persons, which seems to have given the painter his impetus to paint. The expression is less definite than in the *Luncheon in the studio*, and the picture is less formal and lofty in concept. A person in sports attire came close to being a subject for caricature in those days, anyhow; one has only to think of Renoir's *The Boatmen's lunch* (pl. 123).

BERTHE MORISOT. Berthe Morisot together with the American Mary Cassatt, brings a decidedly feminine element into the circle of painter friends, happily furnishing further proof

that like-minded people with similar or kindred talent – and wealth of talent is the hallmark of the whole epoch – can enter into this style and its means of expression, be carried away and transformed by it, and in fact live through each phase of Impressionism.

This always leads back to the correspondence of mind within the group, to the creative disputes, to the stimulating atmosphere of the Parisian studios and particularly of the cafés of the period. Here the awareness of their opposition to the officially recognized art, which the public admired and also bought, nurtured a lively exchange of ideas, as did the high accomplishments of each individual – little as they themselves were able to see or define just what their 'Impressionism' of the 'seventies and 'eighties really meant. The painters did not know how to explain it as a practical formula; a study by Fritz Schmalenbach, *Impressionism – an Experiment of Systemization*, has made that strikingly clear. And this analysis is introduced by the author himself, before he later on inverts his principle of investigation, with the following words:

'What is peculiar to Impressionism is perhaps the blending of apparent cheerfulness, vigour, and richness with a high degree of lightness, flimsiness, even poorness behind this appearance, under the surface; it is true to say that this surface means a great deal in the art of painting, and a great difficulty in understanding Impressionism and defining its character in words lies in being able to see this rich and this poor side of it, and to bring the two together.'

Schmalenbach then continues with descriptions such as 'beautiful handling', 'nicely done', and 'hollowing out of the subject', and other such indispensable if hackneyed phrases. But another sentence of wider implications is interesting and important as far as our remarks are concerned, endorsing as it does the statement by Manet which we have already quoted: '. . . but they no longer see the shadows as shadows, but as colour.'

But to return to Berthe Morisot. She was about twenty when she came to Paris, where she met Manet while copying in the Louvre. During the late-sixties she worked in his studio, which explains how Manet came to portray her in a series of pictures which pay homage to her serious charm. These include the *Balcony* picture of the Louvre (Jeu de Paume), and at least four single portraits, among them one of enchanting grace (Cleveland Museum), showing her nervous-looking in hat, fur and muff, turning slightly to the left, and more sketchy than the one from which he made his famous woodcut (ill. p. 45). But she looks loveliest in Manet's picture *Repose (a Portrait of Berthe Morisot)* (pl. 63), which was exhibited at the Salon in 1874. A slight touch of melancholy completes the elegiac atmosphere of the picture, which made an immediate impression upon the public and inspired quite a few good 'imitations'. Very few full-figure paintings of the epoch are as charming as this one.

During the previous year, 1873, Berthe Morisot painted a picture of her sister in front of a veiled cradle (pl. 77), one of the most intimate pictures of that time, which today can be seen in the Louvre (Jeu de Paume). Here she comes into her own by the naturalness of her portrayal, free from that sentimentality of the Salon painters: her subject closely occupies the

immediate foreground of the picture. Berthe Morisot took part in several of the Impressionist exhibitions and belonged to a circle of artists at the centre of which was Manet, whose sister-in-law she later became. The circle was nicknamed the 'gang of Batignolles', after the district of Paris where Manet lived, and where the Café Guerbois was situated. This was the regular meeting-place of the artistic circle, together with writers like Emile Zola and Duranty, novelists and critics, musicians and friends of the arts. Here on Friday evenings discussions on matters of artistic value raged with such intensity that one of them ended in a sword duel between Manet and Duranty.

Berthe Morisot died in her early fifties. Her inborn talent, aided by the beautiful freedom and astonishing assurance which she gained from Manet's teaching, enabled her to attain true mastery of her art. Her mostly small pictures radiate a bright serenity, in which, again following Manet's example, she depicts the homelife of Parisian citizens and of people in the countryside, with the light, magical colour-intensity of the impressionistic way of painting (pl. 75–6), and that bright clarity which reflects the beauty they saw in everyday things.

Those of her paintings reproduced in this book date from the beginning and from the end of that period when the Impressionists exhibited together, *i.e.* the years 1874 and 1886, and they also illustrate the evolution of style experienced by these artists as a group and individually. This involved more and more the dissolving of form, the contours being lost or even denied in the iridescence of colour, a process which neither the Jury of the Salon nor the Parisian public could understand. In view of this revolutionary and, at the time, almost inexplicable impressionistic way of looking at things, this was hardly surprising, for never before had there been such a break with pictorial tradition. And never again has the public reacted with such bewilderment and fury to a new movement in the arts, as if after this shock no greater one could follow. And indeed the whole situation was changed. New movements never again captured the attention of the whole, great, ever-curious art-world in quite the same way.

Even Zola, who in 1866 had still sided with Manet in his articles for the magazine *Evénement* and had consequently been dismissed by the publisher, wrote about the Impressionists ten years later:

'... now we get nothing but flecks of colour. Just look at those portraits! Flecks of colour! Look at those figures! Flecks of colour! Flecks! Flecks! Nothing but flecks everywhere! Trees, houses, whole continents, even oceans – all of them, only flecks!'

This indeed points clearly in the direction of Monet's later works: to his flower pictures, the many paintings of water-lilies (pl. 97 and 100), and to those 'dab-people' of his in the bird's-eye-view of Parisian boulevards and sidestreets, made almost unrecognizable by a huge display of flags flapping so wildly that everything seems topsy-turvy (pl. 90). The dabs, after all, are nothing but signs, as enlargements of Monet's pictures have proved, which is certainly a vindication of style-forms two generations later.

50

CLAUDE MONET. And so we come to Monet, the central figure of Impressionism, that brief and significant epoch of perception and expression which he shared with other like-minded artists. During his eightysix years, Monet went through all the richly-varied phases of its evolution, perfected his personal style, outlived all the others, and finally became a true patriarch, whose heart was kept young by the ever-eager curiosity of his mind. Yet at the beginning of the movement his work showed strict pictorial construction, as in *Girls in a garden* (pl. 83), where these true *plein-air* heroines appear rather like large coloured paper cut-outs stuck on to the canvas.

Later on, in 1872, Monet painted that picture called *Impression, Sunrise* (pl. 89), which unintentionally gave its name to the movement. Measuring only 50 × 65 cm, it can be seen today by artificial light in the Musée Marmottan in Paris, a place of veneration for Monet's art. A blue haziness makes up the whole picture and surrounds the red ball of the sun above ships and harbour buildings. The idea was born at a particular hour out of a natural atmospheric effect, dashed off by his scurrying brush in a personal, almost private pictorial note: a sunrise. And so it appeared on the cover design of the catalogue at the Centenary Exhibition of Impressionism staged in Paris in 1974, while the text about this nebulous picture was mainly concerned with which authors since that time believed they had seen a sunrise in it and which had seen a sunset.

Monet was later to achieve the consummation of his art in colour fantasies in which he constantly explored the transformation of colour through light, on subjects such as ponds covered with water-lilies (pl. 96), haystacks, rows of poplars, and also views of the sublime gothic façade of Rouen Cathedral (pl. 94–4). He meditated upon the theme of colour and light right up to his old age, putting years of concentrated work into his experiments.

It is rewarding to study his progress in the Musée Marmottan, to see how the visions of a painter condense into an always different optical event, whose effect goes far beyond Monet's time, almost indeed as if painted for succeeding generations.

Even Seurat and the Neo-Impressionists attracted him with their thesis of 'colour-division', and those painters of an art independent of reality, the abstract painters of our century, have long since claimed him as one of their forefathers. There is no great museum of art in the world which does not try to point out this 'parentage' of Monet for Informal Art, Tachism, *i.e.* the art of the mid-twentieth century, by showing at least one great water-lily or blossom fantasy of his (pl. 100–101). Or, to reverse the process, the pictures of Sam Francis would also be suitable for the Musée Marmottan.

Thus in Cleveland many years ago one noted:
'Wherever one goes Monet is celebrated – even in the Museum of Modern Art in New York – as one of the chief witnesses for Informal Art, for Abstract Expressionism, for Sam Francis and Pollock, on account of his great, richly coloured, water-lily pictures. No guided tour fails to point out these pictures down to every square inch of their elaboration, as if they were an exercise in diligence.'

Thus Monet's work has this everlasting modernity about it, which however was quite

unintentional. It was certainly outside his thoughts and indeed outside his artistic activity, despite the prophetic role which is wrongly attributed to him. Or are such colour exercises on blossoms above dark still waters, and on tangled thickets or irises, and even more on those scurrying islets of colour upon sand-coloured boulevards – when one looks at them closely, set down on the canvas, are they really and truly the *taches*, the 'patches' of the Tachists, which Hans Hartung still talks about even today?

Going back to the early days of Monet's paintings, one discovers in Hartford (Conn.) an undated picture of his, *The beach at Trouville*, showing ladies with parasols, with green steps and houses on the right; a fresh and attractive picture, solidly structured. Just next to it is Boudin's *Beach at Deauville*. This recalls our earlier remarks on Boudin. Le Havre was the home of Monet's youth, and his first teacher was Eugène Boudin, painter of seascapes and landscapes, and only sixteen years older than Monet.

One must envisage the young Monet as a man who actively sought connections and who found them quickly, with a single-mindedness that explains his initiative in the exhibition of 1874. When he arrived in Paris, Monet, nineteen years old and eager for knowledge, lost no time in approaching Troyon, one of the Barbizon painters, and then the Dutchman, Jongkind. At the Paris atelier of Charles Gleyre, he made the acquaintance of Renoir, Sisley, and Bazille. His manner showed no hesitation but an attitude of mind which was to make him outstanding among the group of painters later on.

As for Gleyre, he was a painter of Swiss origin, totally forgotten for many years, even though Renoir called himself 'pupil of Gleyre' all his life. Recently he has been called to notice by an exhibition arranged by the Art Museum of Winterthur which showed the greatness and the limitations of his work, and emphasized his role as an untiring and also generous teacher. It served also as a revision of that persistently held doctrine in which all that matters in art history is the idea of development, faith in progress, the forward look (Julius Meier-Graefe). A hundred years on, the exhibition took a new look at this widely misunderstood teacher of the Impressionists, who did not even belong to the group 'officially', so never became famous. The catalogue described him as 'this painter of lost illusions', who was 'hushed up or pushed aside by the story of the men of genius.'

Any intercalation of this kind makes it more obvious to what an extent these worn-out ideas of adulation and devaluation are still in use, especially in relation to the art of the latter part of the nineteenth century in France and Germany, opinion swinging from one extreme to the other without finding a proper balance. Nowadays it seems to suffice to have at least saved Manet and the leading figures of French Impressionism from that earlier lack of appreciation, and to define the picture of an artistic era by them alone, only because they were the ones who came most decidedly into the light of publicity.

But now back to Monet. The deep impression Manet's pictures had made upon him, even more so than those of Corot and Courbet, and especially the ones confined to a few figures, induced Monet himself to paint large, panel-like compositions including figures. *Girls in a garden* (pl. 83) is an example; here the ladies, wearing huge, light-coloured crinolines, are

52

decoratively inserted in the light green of an orchard. Here he was trying to outdo all the other painters. Thus Monet's *plein-air* painting began with a certain theatrical exaggeration, which has long since been wiped out by the fame of his other pictures of the same period of single, rather darker figures, such as the studio portrait of *Camille* in the Bremen Academy of Arts; these also indicate the initially higher quality of his studio painting.

Monet's work was already taking on imposing dimensions in the 'sixties. He had an enormous appetite for work. No sooner had he painted the Seine countryside of Argenteuil or Vétheuil than he set off on ever longer journeys, to London, Norway, and Venice. Apart from making the acquaintance of other painters, he also obtained from his travels a knowledge of the world in its different moods and atmospheres, of the air, the clouds and winds in north and south, of the light above the sea (pl. 82), of all those things which the masters of the *paysage intime* in their seclusion on the outskirts of the great Forest of Fontainebleau never experienced, and therefore remained 'minor' masters. The seasons too presented their charms to Monet as they had to Pissarro and Sisley, giving him the opportunity to paint summer scenes (pl. 86) and winter scenes (pl. 78), in the countryside around Paris and on the Seine (pl. 80, 84), and in the white light of the Île-de-France.

Pictures by the individual Impressionists from this period of common purpose during the late 'seventies and early 'eighties are often so alike in their effect that they have been confused with one another. This likeness of style was intentional. The common aim was the representation of the truth of tone and colour and the play of light, just as the painter saw it. And the impulsive speed of the brushstroke (pl. 87) immediately raises the question in the mind of a curious spectator, before Monet's pictures in particular wherever he may come across them, as to how this poetic power of colour comes about, this art of visual fidelity not intellectual concepts; *i.e.* what Cézanne implied when he said admiringly of him: 'Monet is only an eye, but my God what an eye!'

How did Monet go about it? Something like this: the framework of the picture is built up out of beams of colour, only roughly put together; dark, shadowing tones are dispensed with entirely or are determinedly covered over again. Let us develop this in terms of the picture of the *Regatta at Argenteuil* (pl. 87). The picture appears in the thin brightness of a 'Swedish' light; the pale yellow of the sails is not diversified. In general, the picture is made up of blue, green and orange-red of balanced lightness of tone. If one looks closely at, for example, the reflection of mast and highest tree in the clear water, then a characteristic trait of impressionistic art can be plainly seen: *i.e.* how the brush hops in zig-zag fashion down to the lower margin of the picture, leaving behind broken, rose-orange-coloured strands on the canvas, accompanied by right and left brushstrokes. These are 'without form', or do not imitate or reflect any form; they admit only separation and a few tilting horizontals, even slide into each other, covering or enclosing darker tones with lighter ones. Everything is carried out in a bold, quick, free and easy manner, but without any pollution of colour. The principle of the style is this: that the unity of the subject and the colour belonging to it no longer exists, but is sacrificed to the vision of the moment.

Here we have attempted a single description. Only from a detailed study can one learn something of the courage and extraordinary creative capacity of these painters; both these characteristics are expressed by the brush, that simple instrument of flattened bristles, broad or narrow, set in a metal sheath. The sublimity of their brief 'appearance', the unconstrained but neat sequence of brushstrokes, occurs at the moment of inspiration, of *invention*, as soon as the ground colour is hard and dry. That seems to be all there is to it.

How could the public, accustomed to seeing every year in the Paris Salon only the smoothest of painted surfaces, the sleekest accomplishments of the acknowledged artists, the delicate, mother-of pearl transition of values – not to speak of the sweetness of naked beauty as rendered by Carolus Duran and countless others – be expected to follow here? To such a public it must have seemed like a fall into the abyss of deepest ignorance. It is worthwhile to study the comments of the art critics of the day, who did not use insults sparingly. It was quite permissible to write of Manet's *Olympia* as 'a new variety of female gorilla', which would be read as eagerly as the general condemnation of a whole work, such as that of Ballu in the *Chronique des Arts et de la Curiosité*:

'... Although the works of Claude Monet and Cézanne raise laughter, really they should move one to tears; they show a deep ignorance of drawing, composition, and coloration. Children can make a better job of it, playing with colour and paper.'

And thus with every picture Monet painted he widened the gap between himself and this public, which could and should have been his patron. Only a short time before the *Regatta* picture (pl. 87), he turned to his friend Bazille in desperation:

'... I must write to you about a matter of extreme urgency and ask your immediate help. I was certainly born under an unlucky star. I have been turned out of the inn I was staying at, and have lost everything ... My family have turned their back on me. I don't know where I shall find somewhere to sleep tomorrow ...' And, as a postscript: 'Yesterday I was so confused that I was stupid enough to try and drown myself. Fortunately nothing terrible came of it.'

But his pictures in the sunshine (such as plate 88) show not the slightest sign of such an extreme desperation. They are celebrations of the beautiful appearance of things, untroubled and unshadowed by want. The accusation that they were bypassing the problem of human society counted for nothing with these painters. Nor did they concern themselves with the double standards implied by such lofty claims by members of the public. Monet saw the world and also everyday life only in the magic power of colours shining over the contours. Much as he might admire technical achievement, his view of the *Pont de L'Europe, Gare Saint-Lazare* (pl. 91) is pure poetry. Van Gogh's *Railway Bridge at Arles*, with its deeply-incised perspective, is the flame-red answer to Monet's cheerful calm, the work of a painter who wrestled with his problems a different way.

Working on sequences of paintings of the same subject became a characteristic feature of the mature Monet. He, whom Manet had called the 'Raphael of the waters' shortly before he died (Monet outlived him by more than forty years), turned to studies where the subject is 54

merely a pretext and colour is everything. But what saved him from sliding into the confines of theoretic, scientific colour systems was the poetic quality of his nature, his pure, imaginative vision. He and his Impressionist friends added a bit of beauty to this world, which had never been 'mirrored' in this way before.

It is known (from sources which include the letters and other testimonies to be found in abundance in the Musée Marmottan in Paris, thanks to the bequest of the only son who survived Monet, Michel Monet, who died in 1966) that Monet put all the energy he could muster in his old age into these picture sequences. Not all these studies, mostly large-sized, have the same full harmony; at times the colours in their interplay are charged with a power too great for them to carry. Nevertheless, seen as a whole they form the prodigious domain of a painter's dream of everlasting beauty, a dream realized in pictures of his water-lily garden, garlands of water-plants, their bright and luminous flowers nestling in violet-green darkness. The motif is really always the same, but has a thousand variations. There are furthermore the colourful sequences of *Haystacks*, the views of *Rouen Cathedral* in the Louvre (Jeu de Paume), and the widely dispersed sketches of *Poplars* and *Water-lilies*. Finally, there is that immense mural ensemble on the ground floor of the Musée de l'Orangerie (opposite the Jeu de Paume in Paris) where, in the two *Salles des Nymphéas*, the nineteen huge canvasses inspired by *Water-lilies* (1914–1918) disclose their serious enchantment. These colour experiments of Monet, which were perfected at a time when the togetherness of the group was only a memory, were based on studies made by the painter when he was still young. He had come to the conclusion that different effects could be obtained from the same motif by painting it at various times of day and by different lights. Thus it came about that later on he tackled the twin-tower façade of Rouen Cathedral (pl. 93–4) and other subjects to a time-table; *i.e.* he continued painting a particular picture only at a prearranged hour.

This is in fact the most consequential contribution of Impressionism as a whole: the study of the perpetually changing appearance of things as the source of an ever-different pictorial interpretation. In such a series of views, the solid, three-dimensional aspect of the content is lost in the play of surface colour. The amount of concentration Monet needed here is unimaginable. In admiring this artist's great life-work, these 'soliloquies' in paint must never be forgotten (pl. 95–104), if only because they teach the wonders of vision. The portrait is totally absent from his painting, differing here from Renoir in his later period.

AUGUSTE RENOIR. Let us begin our considerations of Renoir and his work with two portraits of Monet. The first, also to be found in the Musée Marmottan in Paris, shows him sitting at a table poring over a book and smoking a pipe (pl. 105). The other, painted in 1872, shows Monet seated in profile, wearing a round hat, a pipe in his mouth and his arm draped comfortably over the arm-rest of a chair as he reads a paper, against a background of greenish-blue darkness (pl. 112). Renoir was the youngest of that group of 1874, a painter blessed

from the beginning, a resurrected Watteau as one might say, and therefore a true 'idol' of the arts.

We first encountered him in this book at Argenteuil, accompanied by Monet, and coming to the notice of Manet. We have mentioned him as an acknowledged pupil of Gleyre, who found himself at ease amongst the painters of Barbizon, where in 1866 he began painting in the open. It is well-known that, when very young, Renoir made a modest living out of painting on porcelain. Only in his spare time could he manage to go to the Louvre to make studies, that is, to copy, as was the common practice then. It is sad to think that no such copies after the old masters by the Impressionists have been preserved, such as those we have by Delacroix.

Again, it was the overwhelming effect of Manet's art which brought Renoir to painting single figures. His early portrait of his girl-friend *Lise* (in the Essen Folkwang Museum) brought him success even in the Salon, which indicates his assurance from the beginning, as does the picture of the *Riders in the Bois de Boulogne* (pl. 108), now in the Art Gallery at Hamburg. Painted in the deeply toned, pre-impressionistic style of which it is a superlative example, the picture shows a lady and her son on horseback; the two figures are nearly life-size and represent an extremely daring enterprise, such as until then only Velazquez and van Dyck had undertaken. Renoir was still wrestling with the problem of presentation and truth to nature here. He never tried to tackle such a difficult theme again.

Towards the end of the 'sixties Renoir too said goodbye to the restrained, exalted tone of the atelier, and went out into the open with Monet, where together they painted shoulder to shoulder such pictures as the delightfully colourful *La Grenouillère* (The Frogpond) (pl. 106). La Grenouillère was a popular amusement place between Chatou and Bougival, on the Seine, where one could dance in the open, hire pleasure-boats, or even go for a swim. The summer holiday atmosphere is well suggested by Renoir's painting, with its many light and well-placed dabs of colour. The theme of the picture allowed Renoir to paint just what caught his eye, for the complete anonymity of the scene of Parisians enjoying the countryside permitted a work of art independent of the specific locality or the identity of the persons in it, where the magical flicker of the brush could just put in enough to suggest the whole scene. Here we see the artist's sheer joy in painting. And for no-one in this epoch is this so true as for Renoir, that one paints 'for pleasure'.

Moreover, this picture is a bold venture in every respect, for with few horizontals and verticals, which are not formed by the small group on the islet, it must manage to maintain balance. But there is no danger of losing the delicacy of the scene or of spoiling the silvery brilliance. In front of this picture we can understand the remark, 'a resurrected Watteau'; it really seems like a picture from long ago and another world, and is like Watteau's *Embarkation for Cythera* transposed into an 'understandable' scene.

Looking at such a picture, we can only guess at the inspirational power which possessed the young Renoir to paint like this and give no intimation of the crippling poverty he was

undergoing at the same time. An artist's fate does not cling to his work. A year earlier, Renoir, who was then just twentyeight, had painted Sisley and his wife (pl. 117) together in a garden lane. This picture is less than half life-size (*i.e.* on a dangerously small scale) yet it recalls Manet's style in its smooth firmness, and is painted still in the tones of the studio, without coloured shadows. As in Manet's *Le Déjeuner sur l'herbe*, it is set before a wooded background of indeterminate foliage, rather like stage scenery, bearing no relation to the closely described figures of the loving couple, who are thus made the centre of attraction. This picture has long been counted as one of the *chefs-d'oeuvre* of French painting, and since 1912 has been one of the most important works of art in the Wallraf-Richartz Museum in Cologne. When one discovers that it possibly conceals a mood of desperation on the part of Renoir the painter, who had to ask his friends to model for him because he could not afford professional models, then surely there can be no further doubt as to whether or not these artists were really needy. Their existence was full of tension, as Bazille has symbolized in his painting of the very young Renoir balancing on a chair, to be seen in the Jeu de Paume.

Here, as in the *Lise* portrait, something becomes apparent that already fascinated his contemporaries: the complete naturalness of his portrayal of a person, which is a basic characteristic of Renoir. As Théodore Duret affirms: 'Renoir excels in the portrait.' This has already been seen in the first portrait of Monet (pl. 105); less so in the second one (pl. 112), which has a certain comfortable, middle-class air about it which does not seem in keeping with Monet's outlook on life. Partly it was admiration which made him paint like that. The glowing clay pipe is excellent.

Renoir achieved that enchantment of unspeakable tenderness and elegance so characteristic of him in *La Loge* (pl. 107), in the Courtauld Institute Galleries in London. In this picture, painted in 1874, everything seems like finest porcelain – a 'fragility' in human form. With regard to the coloration of this picture, one noted:

'. . . a greenish white, actually only white and black and a quite pale yellow, plus the pink rose in her hair. The white is cooled down by a trace of blue. Rouge on her lips. Hair greenish, parted in the middle with a very fine brushstroke. The garment is a gem.'

This charming lady in the theatre box (her partner, looking unperturbedly around him through his opera glasses, is very much a background figure) is an object of value in herself as well as in terms of painting. She opened up a round of portraits (pl. 111, 116, 121), just as *La Grenouillère* was the start of a number of pleasant summer scenes, luncheon pictures and jollifications under the trees. Time and again this rare, cautious magic in which Renoir envelops his models discloses itself around their almost childlike youthful forms, even where commissioned works were concerned. And those always came to his rescue.

The large picture of the ball at the *Moulin de la Galette* (pl. 115) shows a merry, crowded dance-floor in the open, under the shadow of chestnut trees, with the lights flickering unsteadily above. In a scene like this, not only does the cobalt blue of the patches of shade stand out strongly, but the throng of human figures turns into one big filigree of interplaying colours. This is quite different from the *Boatmen's lunch* (pl. 123), which gains its charm

from the sunny midday brightness resting on the reeds behind the figures in a shallower spatial recession; a somewhat narrower world-on-Sunday. Both pictures seem to have a certain similarity in the grouping and the interrelation of the persons portrayed, but whereas in the *Moulin de la Galette* the hustle and bustle of the crowd reaches far into the depth of the garden, above which the round white gaslights are outlined with deliberate precision, in the *Boatmen's Lunch* it is the singling out of delicious items which makes the picture so attractive. The group of figures and the masterly still-life on the table give this painting its sumptuous quality. A short excerpt from notes to this magnificent picture, which was painted in 1881:

> '. . . full of life, fresh; the still-life on the table is a precious piece on its own. The girls are little round sweeties, without exception. The reeds are a background feature. The bare arms of the men are a bold venture here for Renoir. Everything is kept behind a veil of unreality, close as it seems to be to the spectator. A certain grumpy earnestness about the resting oarsmen, surrounded by their men and women friends, either secretly admired or just added as an intended contrast of "strength" and "tenderness", adds something of a burlesque note to the scene, just slightly touched on and almost lost amongst the richness of the overall visual effect. This picture also tells us a great deal about the life and soul of an epoch.'

In the Frankfurt picture, *After luncheon* (pl. 120), with the gentleman on the right lighting a cigar and partly cut off by the picture margin, Renoir's usual narrative verges on the anecdotal. The painter seems to make use of a pause in the conversation; as narrator he falls silent in order to muse with delight over the sight of a lady whose face is not exactly radiant with intellect. Here a certain type of woman clearly gives us a sign of things to come; we see something of that indulgent tenderness and loss of individualization to be found in the *Bathers*, together with an exaltation of feminine beauty (as already in *La Loge*) which conjures up the art of Boucher and the eighteenth century. The worship of woman was something the painter never gave up, even when he was very old and the brush had to be tied to his arthritic hand.

After the year 1881, during which a visit to Algeria changed his palette (pl. 126) and when he had also travelled to Italy, the south of France became Renoir's paradise, his Arcady, a perfect setting for his beautiful bathers. His earlier work had already prepared the way for this last period.

He started to paint this world of the bathers in the early 'eighties, first of all with *Les Grandes Baigneuses* (pl. 129), in Philadelphia. Severely constructed, this picture is full of the overwhelming charm of radiant youthfulness, and the preliminary drawing for it (pl. 128) in the Louvre (measuring 100 × 160 cm and really more of a cartoon) is without doubt one of the most masterly drawings of the nineteenth century. In its melodic lines, flow of movement, openness of expression, and its comprehension of the 'fecund moment' – according to Lessing – it even surpasses the picture. This is perhaps why the deliberate and precise painting results in a certain rigidity about the faces and limbs of these young girls

58

playing their ingeniously-invented water game; also the picture tends to monumentalize the figures as it transfers their free-and-easy play into a carefully thought-out picture plan. Seeing drawing and picture together, however, it is clear that both are perfectly balanced compositions, and demonstrate that Renoir's study of Raphael's frescoes in the Vatican three years earlier had been of benefit to him, as had his visit to Pompeii, and had renewed his faith in the classical heritage. From here on, feminine beauty was to be his untiring and consummate theme. Time and again he painted youthful beings in various poses, drying themselves, combing their hair (pl. 134), mostly nude, and in a soft light which refracts on their skin in light, mother-of-pearl tones, sparkling most deliciously (pl. 119, 130, 131).

In these pictures the landscape is steeped in a cloudy haze, but regains its importance in his latest ones. The scene was then the Mediterranean (pl. 125), where he had gone to seek a cure for his arthritis, and where by painting he overcame his pain.

Cagnes near Nice became his permanent home. This actually came about unintentionally, for he had originally gone there only to save an old olive grove from being destroyed. But as it turned out, a house was built there according to the practical ideas of Mme Renoir, and the art-dealer Vollard, that great discoverer of genius, reported: 'One was greatly amazed at finding Renoir in a well-ordered household, he who was so indifferent to the material side of life, with his sons well brought up and the meals punctually on the table.'

Here the old Renoir painted olive groves, the soft undulations of the mountains, spurs of the Alps, with the sea shimmering through pale green foliage, in pictures which now showed bathers of more voluptuous forms, often colossal in physique (pl. 132–3), relaxing in this sunny paradise of the south. These pictures already point towards the sculptural work of the old Renoir, a separate creative province which we cannot go into here. The work was executed under his guidance by a young sculptor, for physical disability allowed the artist to do no more than convey his instructions with the help of a 'baton'. The mention of his sculptural work is enough to indicate Renoir's exceptional position, and links him with Degas, another artist important in this field. In such dual activity they both had a long career: Renoir lived until 1919, Degas to 1917. A presentation of their numerous pieces of sculpture would require a book of its own.

In this brief review, we can mention only a few characteristic features and stages of Renoir's gigantic *oeuvre*, which spanned more than half a century and which has been constantly admired all over the world by four generations of spectators. Our remarks can merely serve as pointers to the illustrations. This applies to all the other artists referred to in this book, and the author is aware of being so brief with Bazille and Caillebotte.

Renoir's picture in the National Gallery, *First evening out* (pl. 114), with the very young lady in the opera box, would certainly be worth lingering over in words. There is such flowerlike freshness in the appearance, in the timorousness of look and gesture, a sweetness of indefinable magic expressed in the sensitive brushstrokes. This can be explained by Renoir's wonderful ability, exceptional even within the group, to capture in a picture an overwhelming moment of life. One is reminded of Marcel Proust's sensitive depiction of such scenes in the

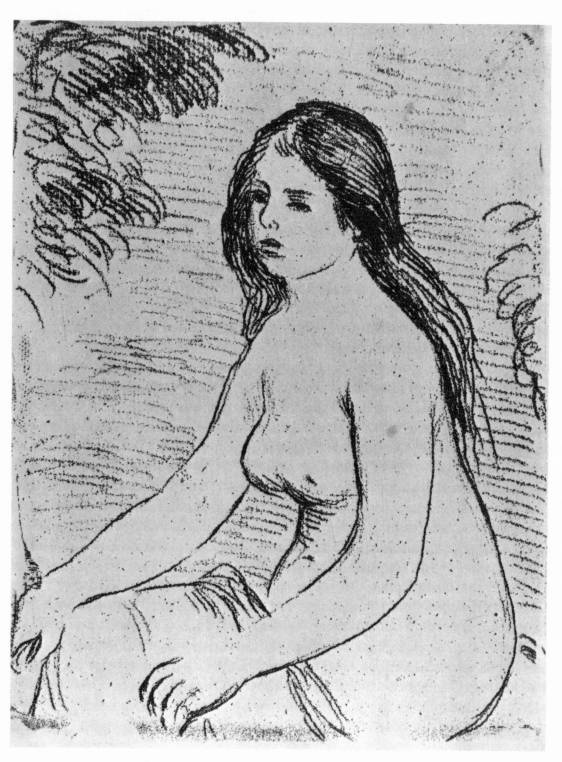

AUGUSTE RENOIR:
Bather. Etching. 60

volumes of *À la Recherche du Temps Perdu*, but only in the sense of a similar 'atmosphere', not of literary connections. Renoir was not an illustrator.

The circus girls (pl. 122) in their fanciful but tawdry finery, looking restlessly around the arena and far less beautiful than the serenely resting bathers, anticipate a sphere of interest typical of the later Degas (who, like Renoir, finally translated his painter's experience of form into sculpture): the dancers and racehorses.

Degas' *Dancer* – in real net tutu – with an almost ascetic expression on her face as she stretches out her head, is a feat of modelling almost equal to his painting, so much does it reveal the artist's ruthless vision. But perhaps he has come to the most accurate conclusion, after hundreds of hours of observant studies, in this waxen 'doll' with a faded yellow ribbon in her hair, stretched to the limit by her ballet-exercise. She is a fitting monument to the rigorous ballet-school of the nineteenth century.

Degas created many statues of similar consequence, widening his scope and mastery over the decades. He was more obstinate and difficult, more of a lonely genius than Renoir, who maintained his inborn sense of beauty throughout his life, even intensified and then generalized it with such constancy that this love of beauty triumphed first over his poverty and then over his infirmity.

Such sense of beauty was an especial stroke of luck in this rich epoch, interwoven with quite different artistic trends. Renoir remained ingenuous and blessed, as defenceless against calumny as against rigid methodology. He passed safely through his predestined zones of artistic development like a great innocent who knows where he wants to go but is unable to describe the way to it. At all events, he called himself a 'lucky fellow'. His crisis during the mid-eighties, which is so often talked about, revealed itself in a kind of stiffness or harshness in his way of painting, but was merely a transitory stage in his creativity such as all painters go through, during which they try out and put into effect more than one *maniera*.

Renoir has shown that constancy to an original principle of vision is sufficient to gain wide recognition and general esteem beyond the narrowness of the atelier, for which his *Sleeping woman with raised arms* in the Oscar Reinhart Collection in Winterthur will always be valid proof for the author.

MARY CASSATT. Mary Cassatt, a young painter from Pennsylvania who settled in Paris, had already exhibited successfully – and that in the momentous year of 1874 – in the Salon, where her work caught the attention of Degas. Degas, about whose attitude of mind some observations have still to be made in order to explain the greatness of his still not readily understood art, invited her to exhibit with the Impressionists in future. This she did, on four occasions, even though her real fascination was with the works of Courbet, Manet, and of course Degas himself. Thus the young American from Pittsburgh, who had already spent six years travelling in western Europe, was liberal enough to exhibit her latest pictures together

with the Impressionists, who in those days were the subject of laughter and ridicule, and to

EDGAR DEGAS: *Statue of a Dancer.*
Musée du Louvre, Paris.

take sides with them. This, in its turn, secured for her the development of a personal style, free from the patronizing ways of the Salon Jury.

The human figure was exclusively her theme, painted mostly outdoors and in the soft light of a sheltered garden or veranda, out of the sun. Plate 174 is a picture from 1886, the time of the group's last joint exhibition. It shows the light-coloured figure of a woman, her half-length portrait taking up nearly all the picture area, and surrounded in this case by vegetation; in other pictures it might be by a light interior. This is an arrangement generally common to her pictures.

We have only this one example here by which to illustrate her style. It has nevertheless all the qualities of this artist, who painted mainly women, especially mothers with their children, in their familiar, private and domestic environment. Thus this *Young woman sewing* sits close

62

to the artist, facing her, silently engrossed in her work. She is not envisaged as if simply passing the time, or as showing any curiosity towards the painter, or in terms of the play of broken colour in light and shade, but is painted with a solid, formal precision, erect, and endowed with a modest charm and simple beauty.

John Rewald has this to say about her art in general and about this picture of the young needlewoman in the soft, blueish half-light of the garden:

'... although she was not actually a pupil of Degas, she was nevertheless influenced by him. In both, intellect predominated, and they shared a special liking for drawing. In addition, Mary Cassatt had her own characteristic mixture of feeling and cool directness.'

To which we add a quotation from the often renewed notes made before the original in the Louvre:

'... a very cool, also intellectually cool, picture; the head is bowed and the pale blue light reflecting upon her face is only allowed to "blossom out" somewhat on her lips. The form is elegant, oblique, forward-leaning. Hands and arms tell their own story. A lucid picture.'

It is known that Mary Cassatt, who died in 1926, was instrumental in introducing the art of French Impressionism into the great private collections on the American east coast, which in turn have since become the great nucleus of the public museums. A very recent publication of the New York Graphic Society, Boston (Mass.), entitled *American Impressionism*, puts her in her proper place as a great artist and also as intermediary on behalf of modern French painting across the Atlantic. Her contribution was not only important as far as the European background of this movement is concerned, for French Impressionism has found a sequel in North America of which we are little aware.

EDGAR DEGAS. The great diversity of talent which characterized this epoch of French painting only becomes fully apparent when one considers the work of Edgar Degas, who is still admired by his compatriots today as one of the most strong-minded personalities of the century, a man of great independence of intellect, upright and correct, as severely critical of his own art as of that of others. He had little interest in nature, and the human presence was far more important in his work. His portraits show a questioning seriousness (pl. 135), and a charm which is never obtrusive (pl. 141). His subjects seem as if unobserved, as if accidentally in the picture, even purposely set off centre, near the edge of the picture (pl. 136). Fullness and emptiness occupied him in a new way.

The people in his pictures and drawings appear quite as brooding and self-occupied, though they abruptly confront the spectator more in noble pride than in challenge as in some of Manet's portraits, and they fully disguise the feelings of their creator.

Despite his highly-accomplished painting, Degas said of himself: 'I was born to draw, first and foremost.' In order to get to know the real character of this artist a little better, whilst

viewing his light and airy paintings and pastels of riders, dancers, and scenes from the ballet, it is enough to cite just one sentence from the book of essays by the poet Paul Valéry, *Dance, Drawing and Degas*. Indeed one would have liked to have added many more of his extremely pertinent remarks, based as they are on immediate, almost clashing, and often not very polite encounters between Degas and Valéry. Valéry says:

'... he was however himself a real fighting-cock and a terribly unreasonable one at times, who would fly into a rage particularly about problems of politics or drawing. He would never give an inch, and would soon start ranting and raging, using bad language, and then would abruptly break off ... but considering the Neapolitan blood in his veins, which made him flare up so violently, one could sometimes wonder whether he didn't enjoy playing the role of a difficult fellow and getting a general reputation for that sort of thing ...'

Paul Valéry met the sixty-year-old Degas at the house of a Paris art-dealer in 1894, when he himself was only twentythree and hardly noticed by Degas. If one adds to his very apposite observation about a 'professional outsider' a remark made a whole generation later by Georges Rivière in his monograph, *Monsieur Degas, Bourgeois de Paris*, then it will be not so difficult to understand why the great literary minds were always fascinated by this strict teacher of a new style of painting. Rivière says:

'... no artist has proved a better observer of his contemporaries than he has, in faithfully rendering the characteristic attitudes of his models; nor has anyone made so clearly apparent the diverse manners and movements of an epoch.'

Remarks of this kind apply to his whole work. One encounters examples in nearly all the great art galleries of the world, in cabinets of engravings, and in private collections, where a picture by Degas also bears witness to the spirit of the house. What it shows is a mixture of charm together with an uncanny accuracy in the drawing, in the *disegno*. That is an inner notion of appropriate form which reaches to the margins of the pictures (pl. 143); this leaves him free to choose unexpected angles of vision, perspectives, views from above and below, undreamed-of by any of his contemporaries. Scenes such as *The cotton market in New Orleans* (pl. 137), in which the figures are 'strewn' all over the office; or the *Orchestra musicians* (pl. 143), where one tries to catch a glimpse of the stage past their heads; or that grand-burlesque double-portrait of the singer Ellen André and the engraver Desboutin having an apéritif (pl. 150), given the somewhat emotive title *Absinthe*, all point to the audacious individuality of his vision. Degas built up his compositions, first as a painter and then increasingly in pastel drawing, in unexpected and original ways, approaching the viewpoints offered later in photography. The many *valeurs* (outward signs of the refinement of this vision) moderate the dominance or monopoly of the drawing by an infinitely sublime gradation from brown to grey, with white emerging from the grey (pl. 150), and in the pictures and studies of his dancers (pl. 144–7, 149, 152–4) cover the relentless severity of the drawing by veritable clouds of tulle and gauze. Degas found the delicate

64

65 EDGAR DEGAS: *Three Dancers*. Pastel – Kunsthalle, Bremen.

medium of pastel the one best-suited to his ingeniously contrived portrayals of these graceful figures.

And here we should like to quote some admiring, and rather amusing, comments from an essay, still worth reading today, by the painter Max Liebermann on this subject:

'At first sight Degas' pictures give the impression of a snapshot. He has a knack of composing which makes it look uncontrived . . . one can pick out a Degas from a distance by its original segment of nature . . . suddenly a double-bass interrupts one's view of the stage, and it's done with so sure a touch, just in the proper place, we feel it is just right and couldn't be otherwise. How he sometimes places the horizon right at the top edge of the picture, without regard for the sacred rule of the golden section, so as to give us a better view of his ballet-dancers' feet; how he shows us his models in the most impossible attitudes and in the most unbelievable situations; as they step into the bathtub, dress and undress, dry themselves. All done with a naïveté with which young innocent girls would talk about the most intimate things . . .'

We too could report many such observations noted in our own modest vocabulary, but who wouldn't rather hear the words of a great Berliner about a great Frenchman?

All his paintings and pastels, even such a brilliant, instantaneous study as that of the cabaret singer, the *Chanteuse au Gant* (The singer in gloves) (pl. 151) in the Fogg Art Museum in Cambridge (Mass.), an apparent sanctuary in America for French art of the nineteenth century, transpose the often novelettish content entirely into colour and form without digression. And while in his later years Degas concentrated more and more on pastel and mixed techniques, thus continuing a French tradition of the eighteenth century (Maurice de Latour, Perronneau, Chardin) he also kept track of a wealth of human activity which seems to be inexhaustible in its complexity. He made numerous paintings of race-horses, race-meetings, jockeys, and gentlemen riders (pl. 138–140), motivated by an intense interest in thoroughbreds in motion and the art of movement in general, and later, when his sight began to fail, created many excellent statuettes of horses and dancers in wax, to be cast in bronze. He also made a series of studies of female nudes in and around the bathtub (nothing Arcadian about them) in which colour and drawing are in perfect accord. This is what Degas himself had to say about it, one supposes with intentional sarcasm: '. . . the human animal, self-occupied; a cat, licking itself.' (pl. 155, 157).

At about the time when the Impressionists (Degas never counted himself as one of them, preferring to call himself 'the classical painter of modern life') were grouping themselves around Monet and getting their joint exhibition under way, Degas, returned from a visit to relatives in New Orleans, became involved in the world of the Paris theatre. He was a regular visitor at the rehearsals (pl. 142) and the dancing classes. Here it was not only the solo performer, dancing or training hard (pl. 144–5), in motion (pl. 146) or standing still (pl. 154), who occupied him, but also the chorus, their formations, and the space around them. Their swift movements fill the emptiness yet at the same time emphasize it, transform it (pl. 142, 147, 152), and at times they melt together in a symphony of colour in which the dancers

EDGAR DEGAS:
Self-portrait, 1886.
Lehmann collection,
New York.

67

appear like precious ornaments and themselves become a stage-picture, a living screen of many shapes (pl. 149, 153). Thus the principle is always carried through to its reversal.

Degas saw and painted all this without ever abandoning firmly defined form, unlike the later Monet and his *Nymphéas* where the subject of water-lily buds and calyxes, mostly seen in perspective, upon deep, richly coloured ponds, was only the starting-point of his studies. The smooth character of the picture is however common to both, and this also allows for making careful comparisons with the art of the later Renoir; plates 149 and 132 will be helpful here.

With that rare ability to hold the visually satisfying moment within the flow of movement (an ability which runs parallel with that of photography, which was invented about the same time), whether in the strictly rehearsed steps and leaps of the young dancers or on the turf, Degas was the first to paint things as they are observed, not as imagined to be. In order to see the difference between the hitherto mistakenly imagined subject and Degas' correctly observed version (pl. 139), one has only to look at Géricault's engraving of an English race-course, in which he represents the galloping horses as flinging all four legs out backwards and forwards in the manner he believed to be the true and best expression of swift movement. And who knows how many portrayals of racehorses in this state of 'full sprawl' would have been accepted by us even today, had not Degas and then Toulouse-Lautrec since taught us differently . . .

After his portraits, Degas turned to the exploration of the contemporary scene in and around Paris, and came to the conclusion that something like a pictorial representation of professions and activities must be possible and that his previous experience would enable him to do it. So pictures were made of milliners, seamstresses, laundresses, and ironing-women at their work. All his subjects are observed with his characteristic cool and accurate appraisal, and it is not surprising to find such contrasts as the perfect control of a stage pose (pl. 151) and the ease of complete naturalness (pl. 156), *i.e.* a kind of double-portrait of female existence. We have the applauded high note of the famous soubrette and then the hearty yawn of a tired ironing-woman, both with nearly the same oblique high oval of a mouth which is worth looking at. Mention should also be made of the different kinds of artistic medium used here: in the one case a smoothly finished work in delicately stippled pastel, illumined by transparencies of whitish light; in the other case, mildewy flecks of half-dry oil-paint laid on meagrely covered canvas, giving the picture an open and sketchy quality. This versatility of techniques, which the reproductions make abundantly clear, gave Degas an advantage over the Naturalists who were tied to the motif.

In all the gestures and associations, in all the nearness to the model in training or at work, in his alert eye and also in his detachment, there remains a grain of irony which is part of the artist's make-up, a distance which includes the ingredient of caricature. This not only becomes apparent in the famous and now missing picture of Vicomte Lapic with his two daughters in the Place de la Concorde, where the cigar-stub hanging from the father's mouth aspires to become a centre of attraction in the composition, but also in the picture so-called

68

Absinthe (pl. 150), already mentioned. Here the two well-known 'models' patiently submit to the will of the then fortytwo-year-old painter and assume the expression of a somewhat inhuman oddness and depravity. Not being allowed to talk to each other they therefore sit there silently, not even having a meal, but in their attitude and dress brilliantly playing their assigned role of human separation: that famous 'side by side in apathy' which Degas invented. If one examines the original closely, there cannot be the slightest doubt of the painter's intention to indicate a tragedy here. And that only eight years after Renoir's painting of the intimate 'togetherness' of the Sisley couple. Unwittingly, the absinthe-drinkers evoke memories of the Parisian *vie bohème*, of the artist's 'fate', of the then newly emerging type of big-city inhabitant. They become the material of a novel, figures out of a novel, the pictorial symbol of conflicts; and all this according to the inspiration and also the mocking spirit of a painter with Daumier's work in his mind. He was succeeded by someone who makes the motif-world of *Absinthe*, the cafés and dance-halls of Montmartre, the theatre, and the brothel, into an easily impressed pretext for transforming this now long-departed world into high art, and in this way, the only way, to hand it down to us: Henri de Toulouse-Lautrec.

HENRI DE TOULOUSE-LAUTREC. His cast of characters ranged from the anonymous and obscure to names once famous in the Parisian scene. At the outset of his career his work showed some influence of the Impressionists (*The artist's mother at breakfast*, pl. 159) but the course his life was destined to follow meant that his talent must seek quite different goals from theirs. His subject-matter centred on the narrow world of entertainment around him, the haunts of vice and pleasure of a great metropolis, viewed dispassionately through the eyes of a crippled aristocrat whose brush was his only weapon. He was more a draughtsman than a painter, more concerned with dashing off an inspired 'hit' than with the meticulous execution of a painting. And when, in his brief, hectic, and soon-ended life and work, he began more and more to achieve his results by means of restricted colour in isolated areas, rather than by means of the finely-distributed dabs and strands of colour of his early works (for example, *Poudre de riz*, pl. 158, a picture whose theme seems to have associations with Degas' *Absinthe*), then this signalled a new phase, a new surface technique, which has had a decisive influence on colour-lithography ever since. This new surface design is really his creation; originally meant as 'pavement art', he brought this form to such unsurpassable perfection that it cannot be improved on. One has only to look carefully at posters such as *La Revue Blanche* (with Misia Sert as an ice-skater, pl. 167) or *L'Estampe originale* (with the great, melancholy singer Yvette Guilbert reading the print, pl. 168).

Henri de Toulouse-Lautrec belonged to the second generation, lived only thirtyseven years, was thirty years younger than Degas, and his life spanned only the middle third of Monet's long existence. Furthermore, he was twenty years younger than Gauguin, more than ten years younger than van Gogh. As an artist he was more deeply rooted and more closely involved in Paris than any of the others; to him the landscape was a horror and a healthy life

denied. In his work, shadows are always coloured and indeed multi-coloured, because his subjects were only occasionally brightened by daylight. Theatre, dance-hall, the circus, the brothel, the drawing-room of the *maisons closes* – there, almost exclusively, was his artistic arena and there he felt at home, drawing incessantly night after night in a world of footlights (pl. 170), in a frenzy of creativity which seems to have made up the whole tenor of his life. Nightly, beneath the glitter of smoking gaslamps, the famous folk-dancer La Goulue (the gluttonous one), an artist of immense natural verve, danced with outrageous impudence together with much admired charm in the company of the scrawny Valentin, in the midst of the lounging crowd of Parisian merrymakers (pl. 160). One needs to remember that the 'amusements' before the turn of the century were thoroughly unsophisticated, and suited to the tastes of the ordinary people of Paris.

Such an impetuous, striking kind of art, which was entirely aimed at catching the exciting moment of the stage appearance, the person 'in performance', the mood of the hour, had no time for the cautious painting technique of Impressionists such as Sisley and Pissarro and their scenes bathed in colourful light. Here, in the work of Toulouse-Lautrec, there is no trace of the tender fragrance of that sunlit Arcady, the Île-de-France. Out of destiny and vocation, the gifted Toulouse-Lautrec, condemned to live out a pygmy existence, cultivated a field of creativity for himself, the subject-matter of which was drawn mostly from the seamy side of life. Yet he observed and recorded these themes with such insight and brilliance that he was often able to turn them into admired and enduring works of art. This can best be seen today in the Musée Toulouse-Lautrec in Albi, his birthplace, in the south of France, which houses many of his world-famous paintings, lithographs and studies (pl. 163–6). Toulouse-Lautrec's handling was that of a painter who wrote in colour, conveying the essential details with a few rapid strokes, letting the coarse, buff-coloured base of his paintboard come into play as part of the design, and finding his favourite medium in bright-drying gouache, by which means he could express himself with perfect clarity (pl. 163). He left the delicate nuances of a pastel by Degas behind him, but heightened the illumination of his subjects to the limit which artificial light allowed, in accordance with the requirements of the artistic design. Notable examples include the portraits of his relative, the *bon-viveur* Gabriel Tapié de Celeyran (pl. 166), cautiously picking his way across a fiery red carpet, or that of the female clown Cha-U-Kao (pl. 171), in the Oskar Reinhart Collection in Winterthur, in her huge, mustard-coloured, low-necked, plush-silk collar, her green plus-fours, with her heavily-rouged mouth in a white-powdered face beneath her white wig. The clowness is a walking statue of imposing presence, clad in the burlesque trappings of the circus and yet, as always with Toulouse-Lautrec, not lost in cheap laughter, but dignified and in earnest. To the eloquent look of astonishment found in Manet's portrayal of a person (pl. 61), and the searching appraisal in a portrait by Degas (pl. 135), Toulouse-Lautrec adds a psychological insight into the character of the people he portrays. This introduces a new dimension of outstanding physiognomic interest (pl. 162), a self-assurance born out of routine (pl. 165 and 171) linked with a uniquely persuasive art which vibrates through the entire body, as in the

70

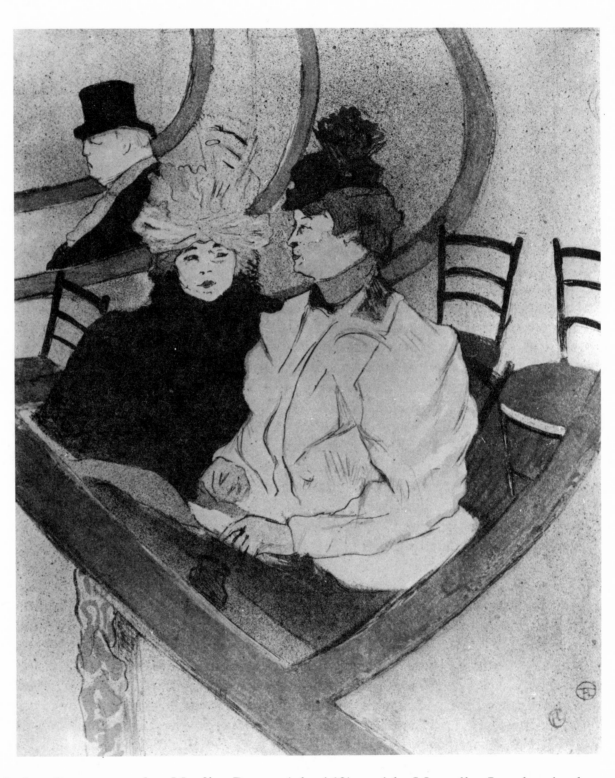

HENRI DE TOULOUSE-LAUTREC:
La Loge,
colour lithograph, 1897.
Wallraf-Richartz Museum,
Cologne.

painting of the *Dance at the Moulin Rouge* (pl. 169), with Marcelle Lender in her dance-costume, which unfolds like an orchid, making her a flower in human form.

There is no shortage of frivolous sketches in his work or of exaggerated portrayals (pl. 161 and 160), hence of brilliantly apt caricature. This pertains to that long-departed world of Montmartre which Toulouse-Lautrec recorded, along with its dark and gloomy aspects, but

still more does it belong to the vision of this uniquely gifted artist, whom Julius Meier-Graefe has called the *ésprit de Paris*.

Toulouse-Lautrec's masterly compositions of simplified line and eye-catching design are seen with striking effect in his lithographed posters. This process of surface printing in coloured inks on huge sheets of paper opened up a new era of art for everyman, far from the ideas of Impressionism.

This art of Toulouse-Lautrec, this 'art on paper', far removed from the traditional and customary field of easel-painting, whether done in the studio or finished out of doors, might perhaps be compared with the woodcuts and wood-engravings of Gauguin. But the subject-matter of the two artists comes from different worlds. Toulouse-Lautrec found all the 'exotic' elements he needed in Paris. With Gauguin, the inspiration was literally 'exotic', the world of the people of the South Seas, totally unknown at that time and imagined as Arcadian; with Toulouse-Lautrec, for quite different reasons, it was the obscure, shady nightlife of Paris, seen from a new angle of vision. One might well say that this was enhanced into art by Toulouse-Lautrec and by him alone. *Fin de siècle* and also decadence.

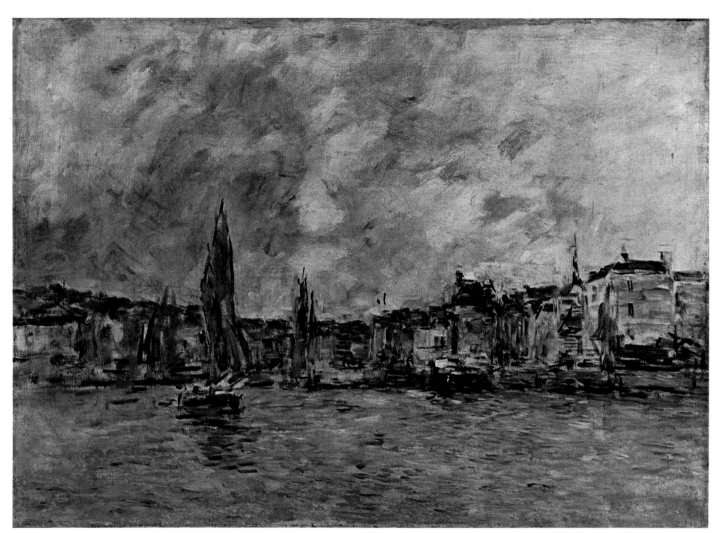

4 EUGÈNE BOUDIN
Honfleur harbour,
1896.
Musée des
Beaux-Arts,
Le Havre.

5 EUGÈNE BOUDIN
Trouville, 1874.
Private collection.

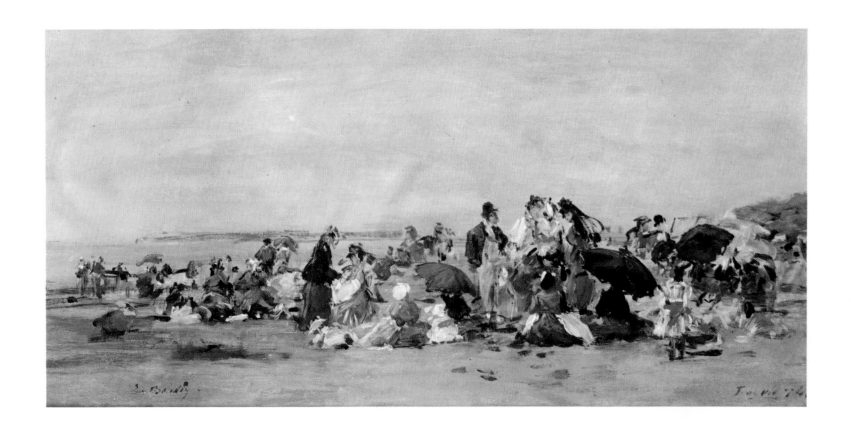

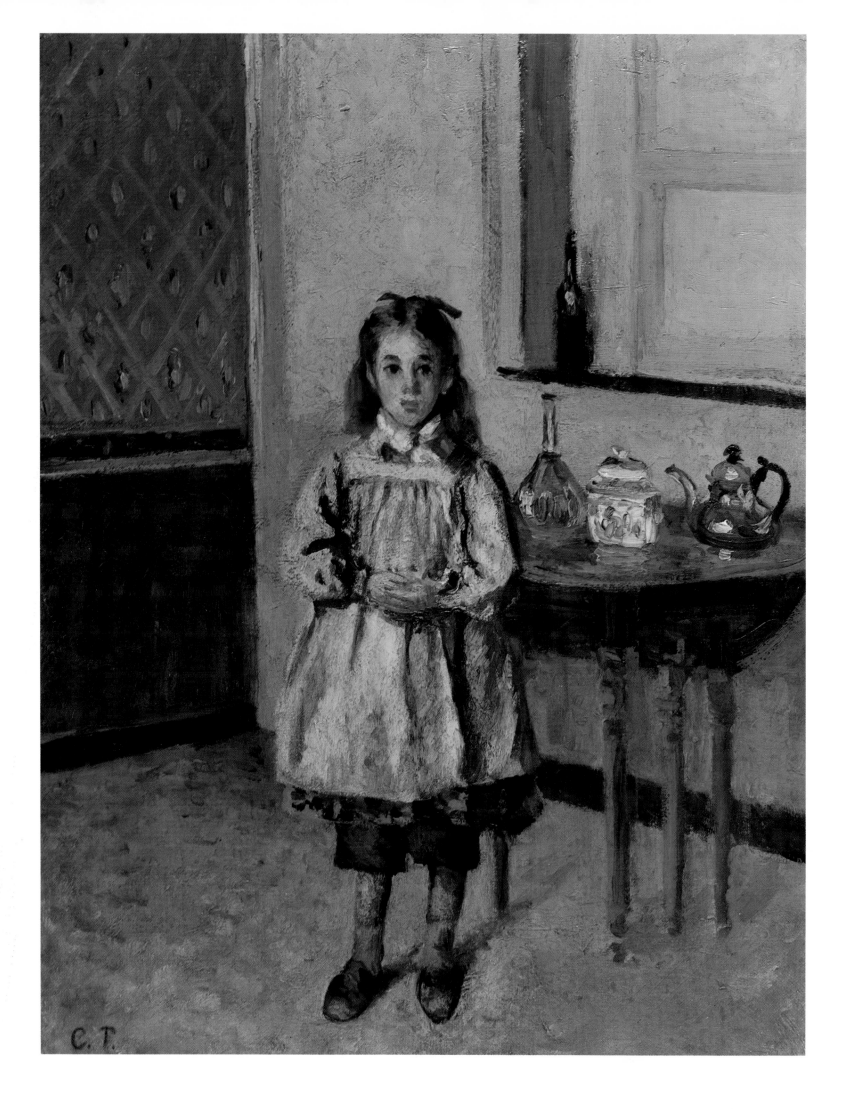

Opposite

26 CAMILLE PISSARRO
Portrait of Minette, 1872.
Wadsworth Atheneum, Hartford, Connecticut.

27 CAMILLE PISSARRO
Approach to the village, 1872.
Musée du Louvre, Paris.

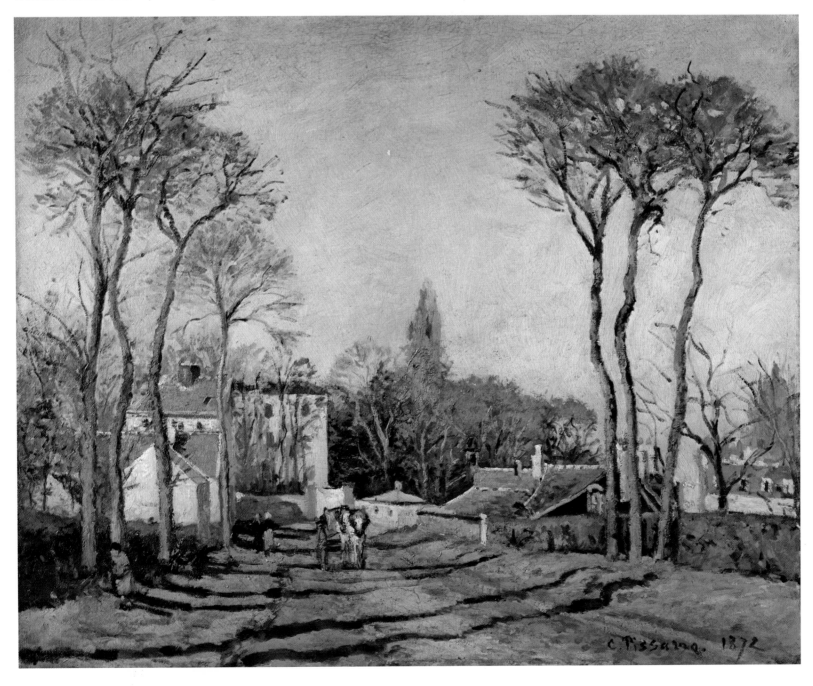

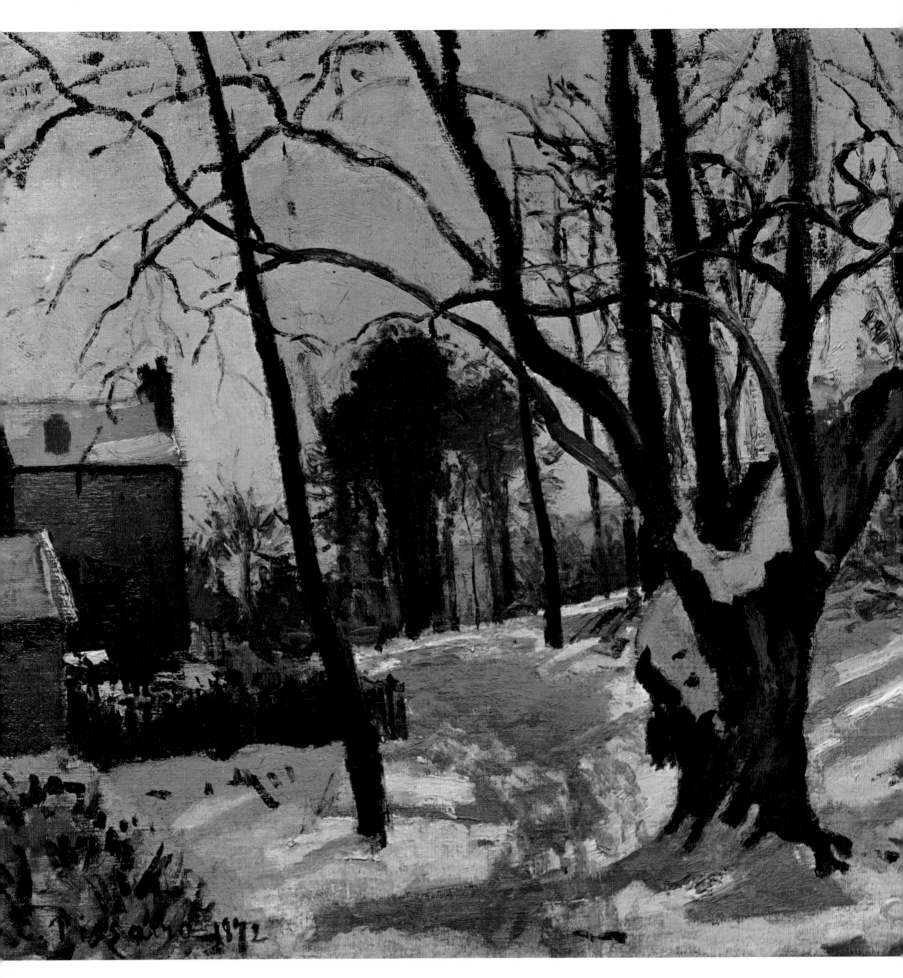

28 CAMILLE PISSARRO
Snow in Louveciennes, 1872.
Paul Rosenberg collection, New York.

29 CAMILLE PISSARRO
Vegetable garden and trees in full bloom, 1877.
Musée du Louvre, Paris.

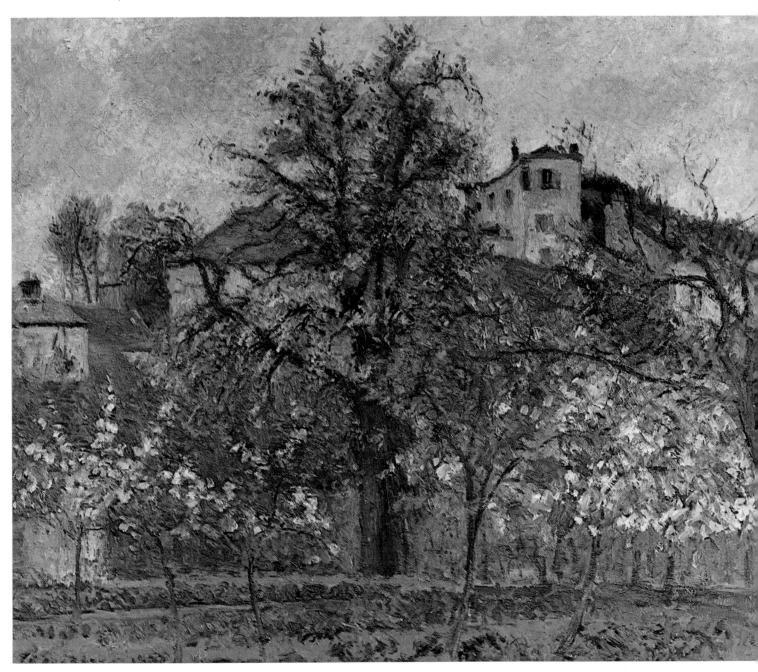

Opposite

30 CAMILLE PISSARRO
Little bridge at Pontoise, 1875.
Städtische Kunsthalle, Mannheim.

31 CAMILLE PISSARRO
Landscape near Pontoise, 1874.
National Museum, Stockholm.

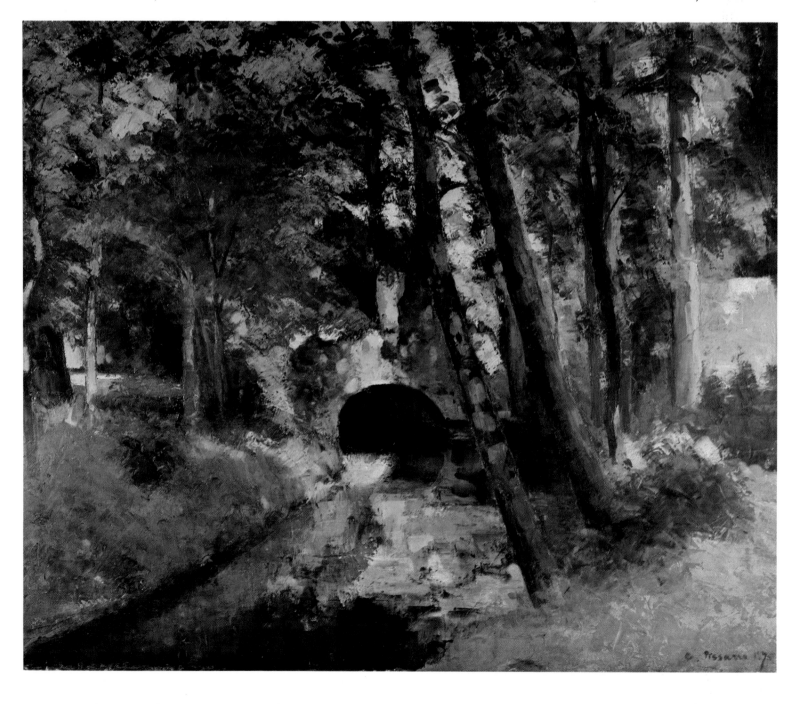

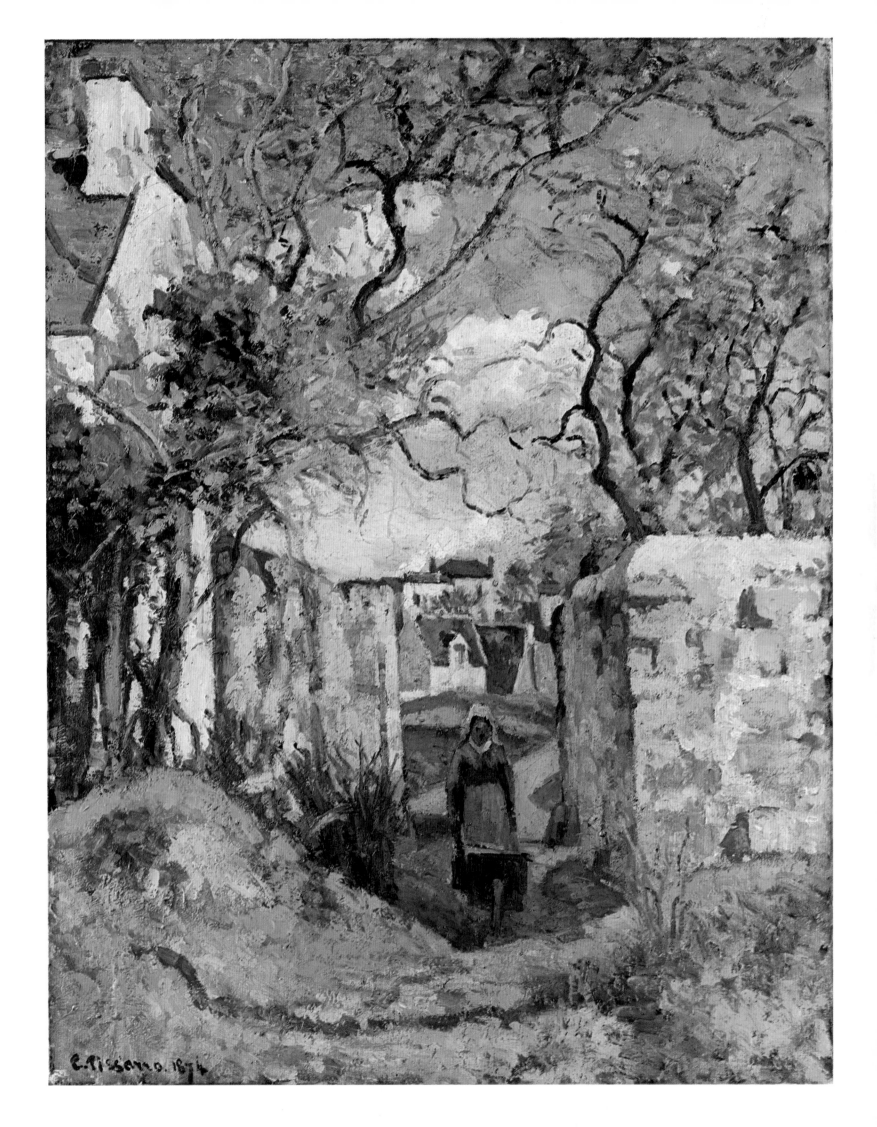

Opposite

32 CAMILLE PISSARRO
Street scene in Pontoise, 1879.
Private collection.

33 CAMILLE PISSARRO
Landscape in February, 1875.
Ny Carlsberg-Glyptotek, Copenhagen.

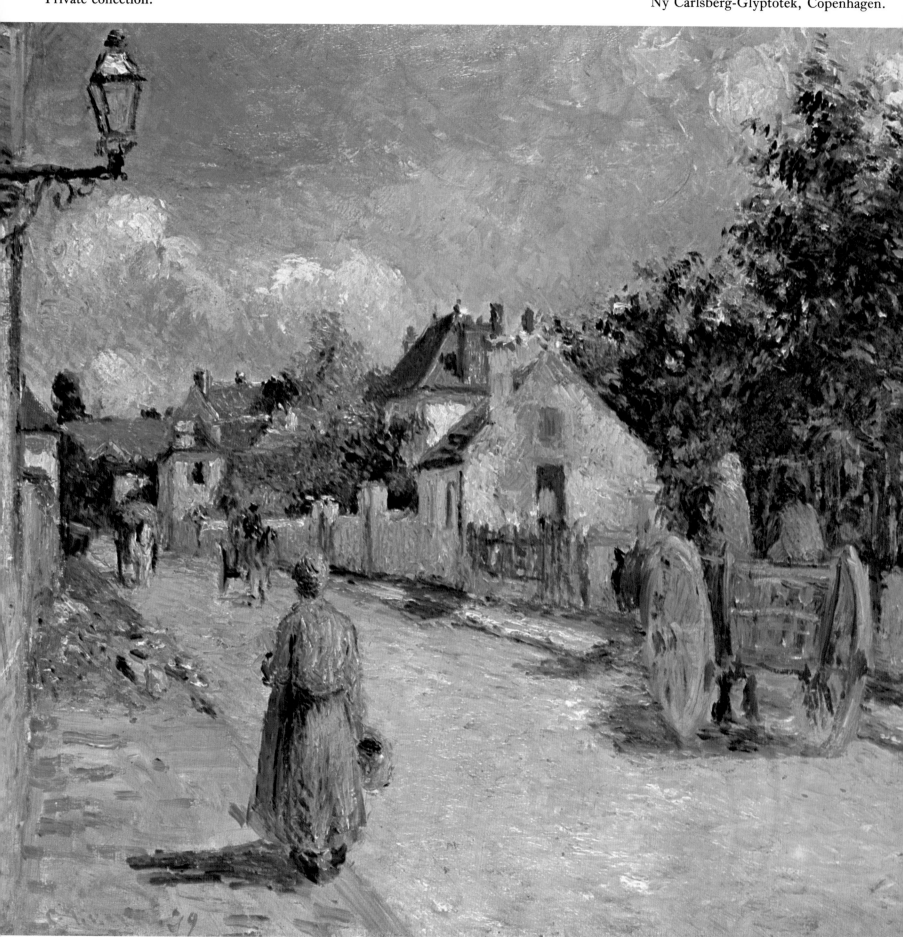

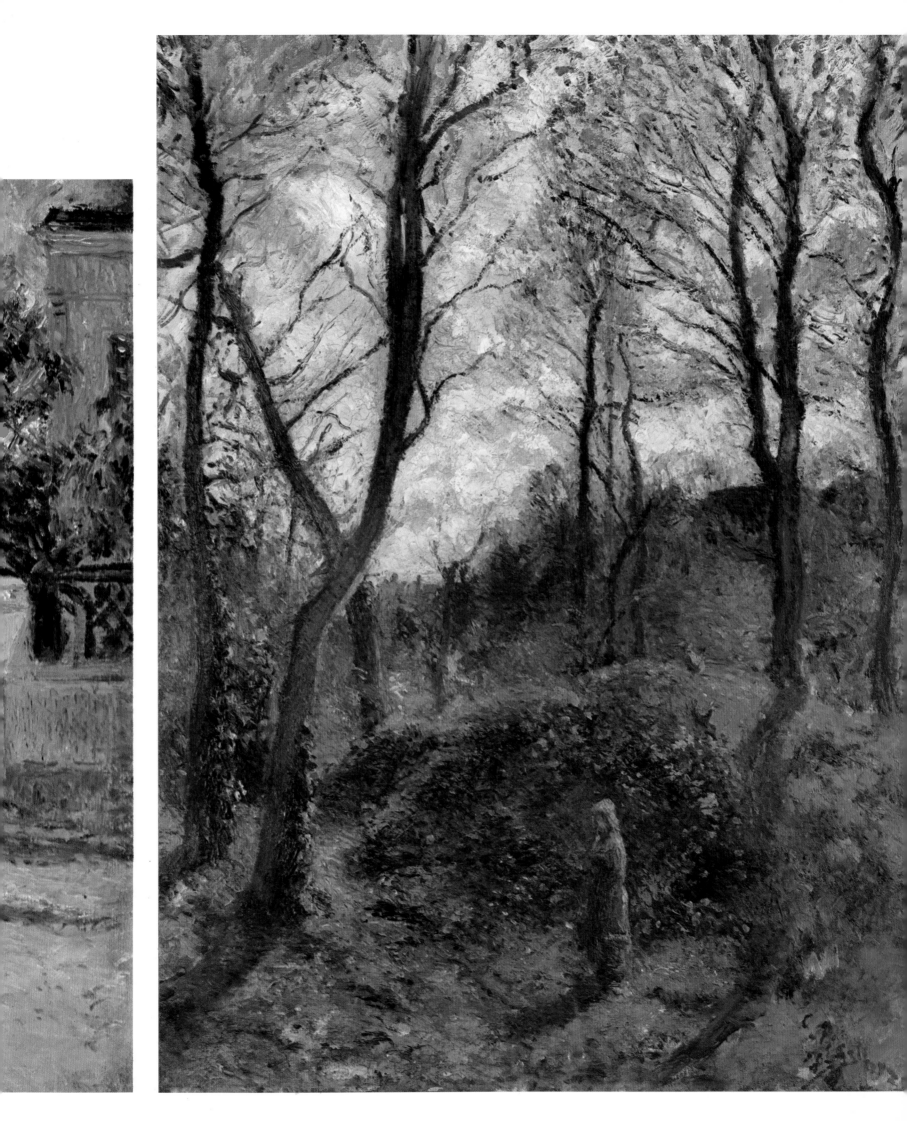

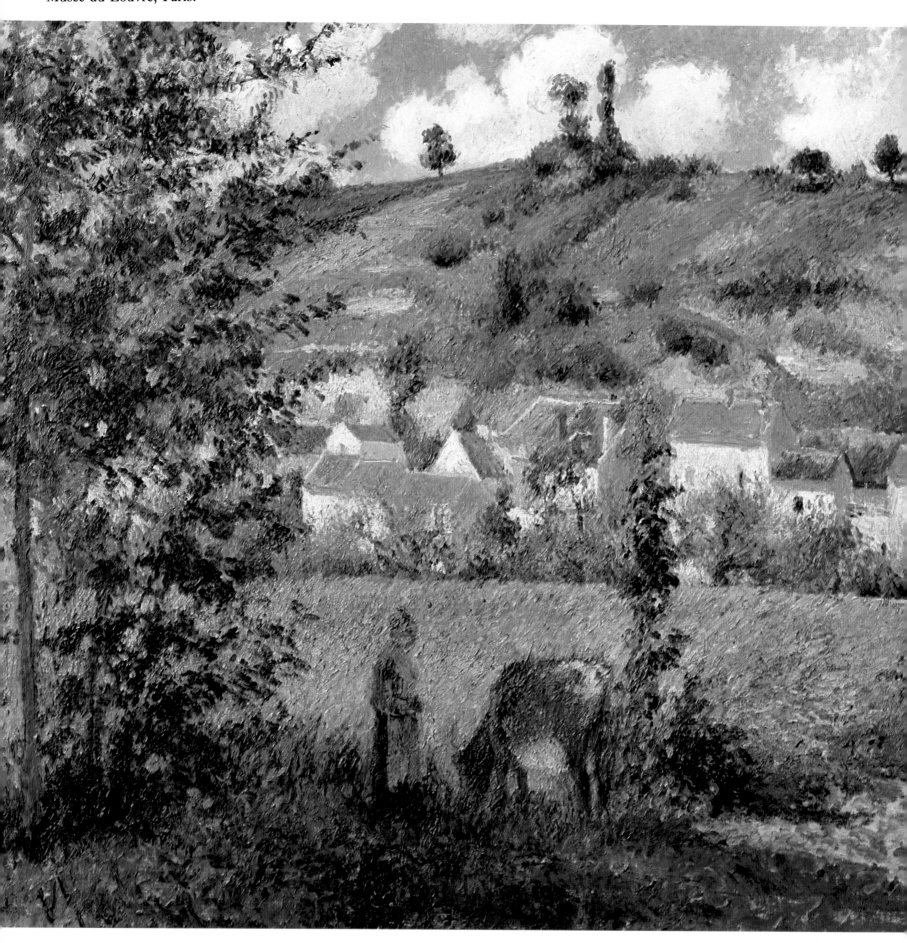

34 CAMILLE PISSARRO
Landscape near Chaponval, 1880.
Musée du Louvre, Paris.

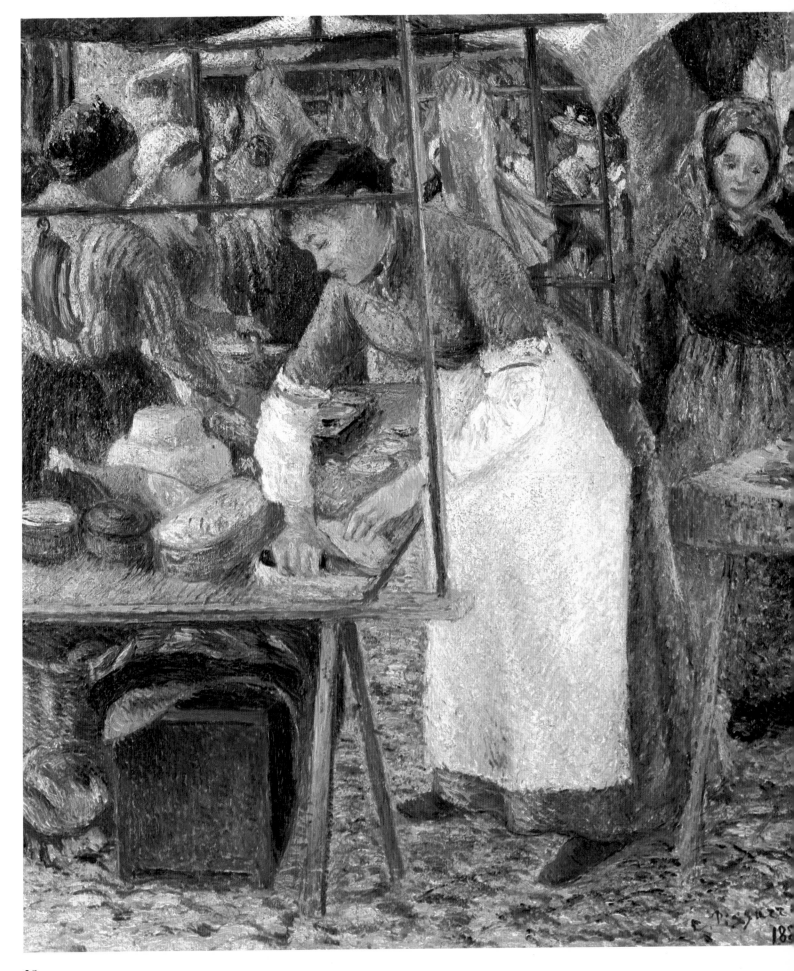

35 CAMILLE PISSARRO
The pork-butcher, market scene, 1883.
Tate Gallery, London.

36 CAMILLE PISSARRO
Boulevard Montmartre, Paris, 1897.
Hermitage, Leningrad.

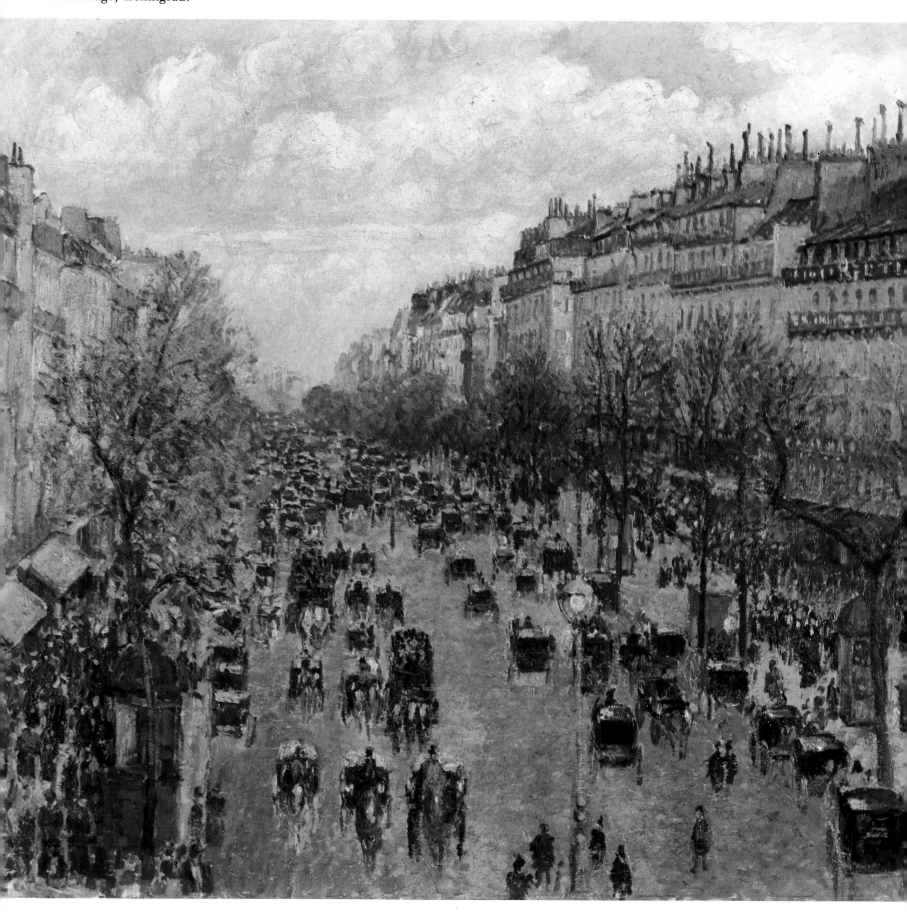

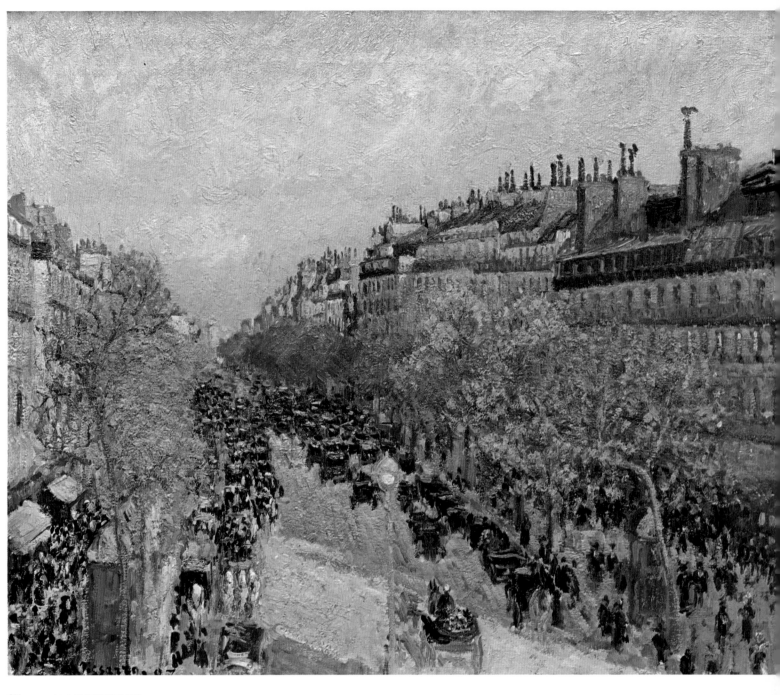

37 CAMILLE PISSARRO
Boulevard Montmartre at sunset, 1897.
Nathan collection, Zurich.

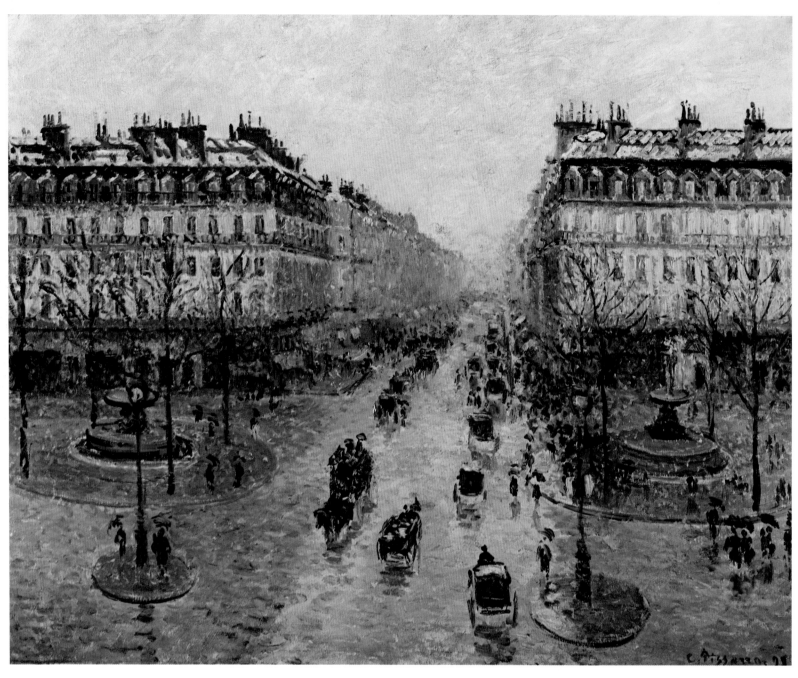

38 CAMILLE PISSARRO
Avenue de l'Opéra, Paris, 1898.
Pushkin Museum, Moscow.

39 CAMILLE PISSARRO
In the garden.
Národní Galerie, Prague.

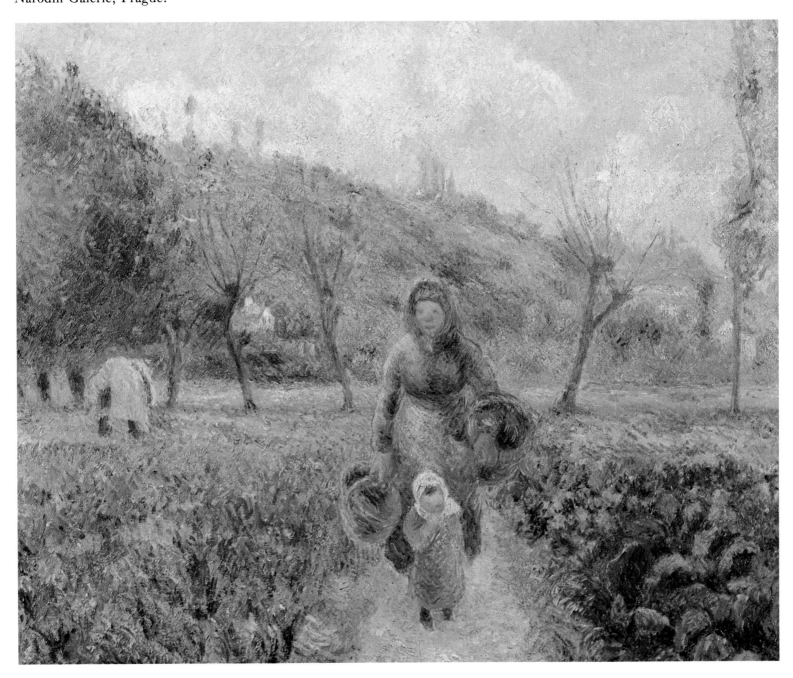

40 CAMILLE PISSARRO
The Seine, with the Pont des Arts, 1901.
Kunstmuseum, Basle.

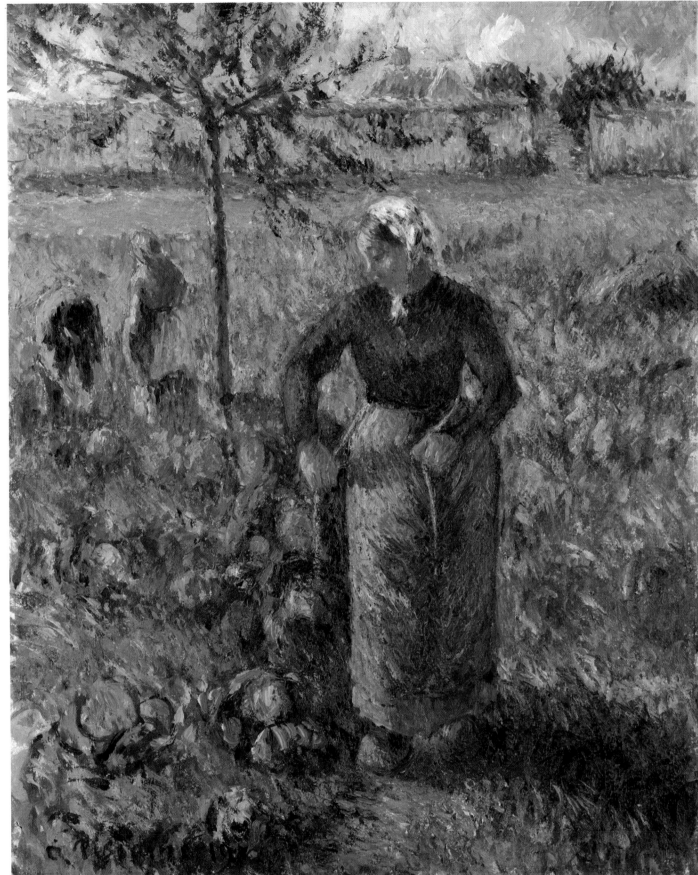

41 CAMILLE PISSARRO
Peasant woman in a cabbage field, 1902.
Private collection.

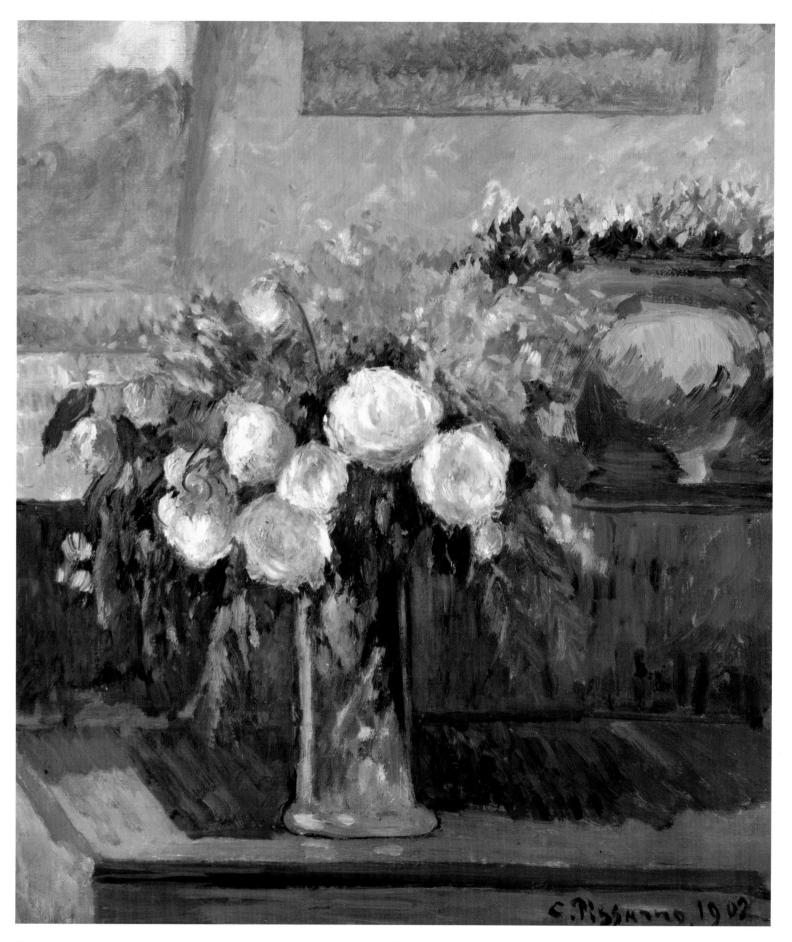

42 CAMILLE PISSARRO
Roses, 1902.
Private collection, New York.

Opposite

43 ALFRED SISLEY
The regatta at Molesey, 1874. Musée du Louvre, Paris.

44 ALFRED SISLEY
The banks of the Seine near Bougival, 1876. Private collection.

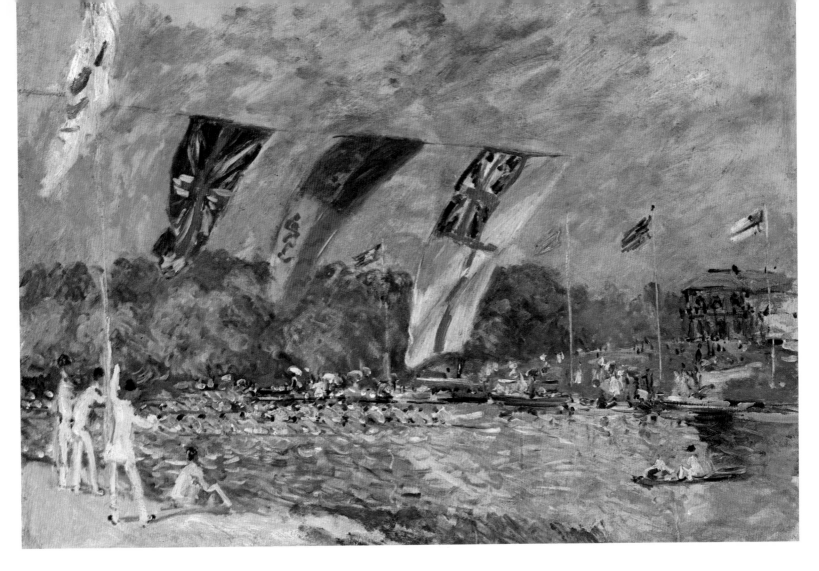

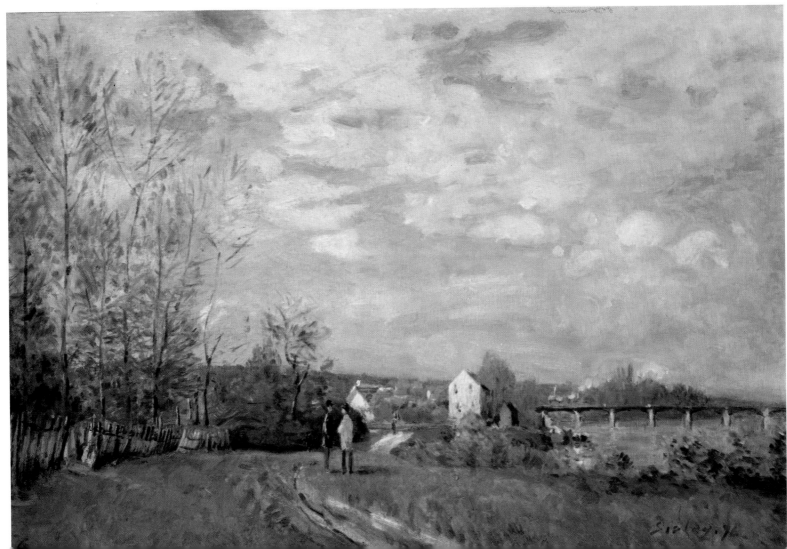

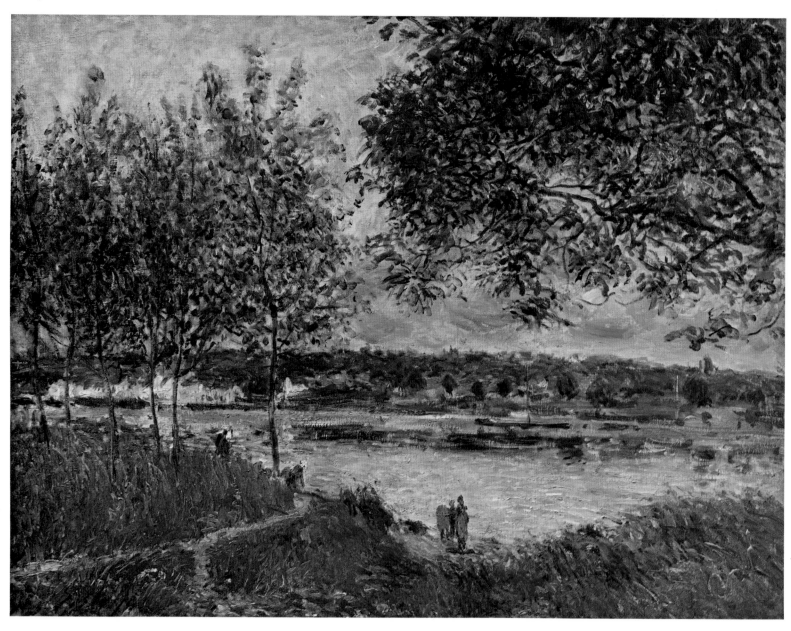

45 ALFRED SISLEY
The path to the old ferry in By, *c.* 1880.
Tate Gallery, London.

46 ALFRED SISLEY
The Seine at Marly, 1876.
Musée des Beaux-Arts, Lyons.

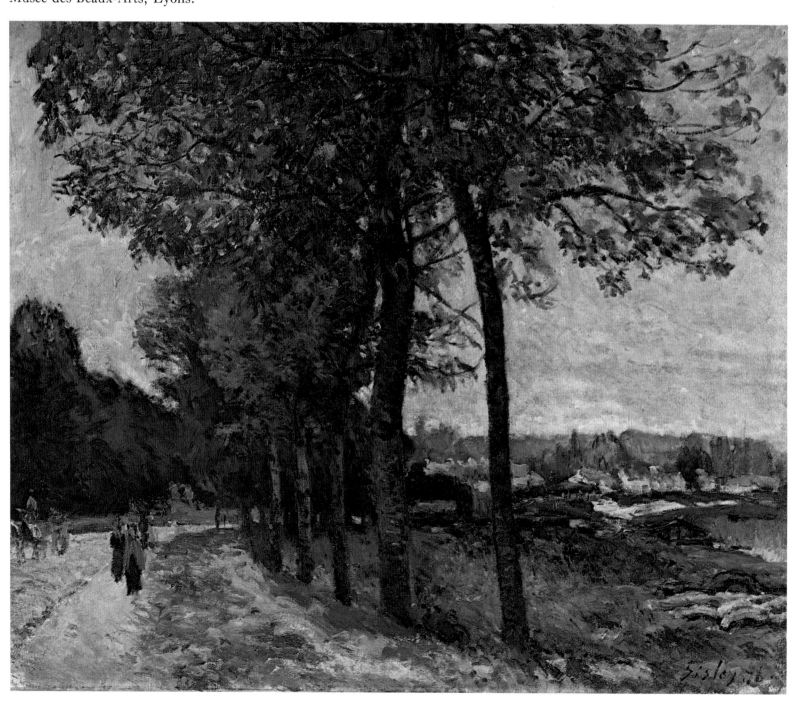

47 ALFRED SISLEY
Riverbank near Saint-Mammès, 1884.
Hermitage, Leningrad.

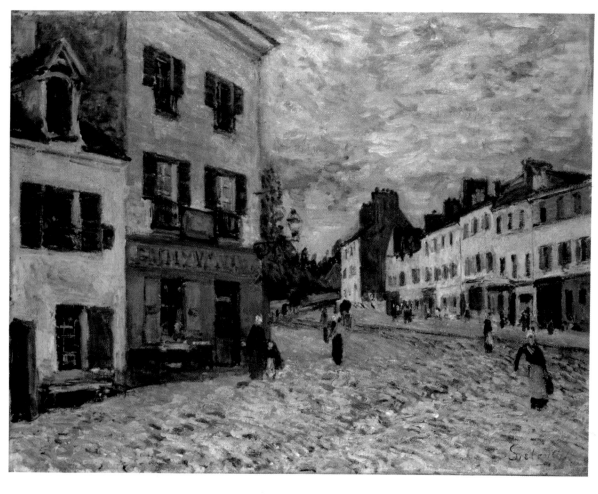

48 ALFRED SISLEY
The market-square in Marly, 1871.
Städtische Kunsthalle,
Mannheim.

49 ALFRED SISLEY
Landscape.
Private collection.

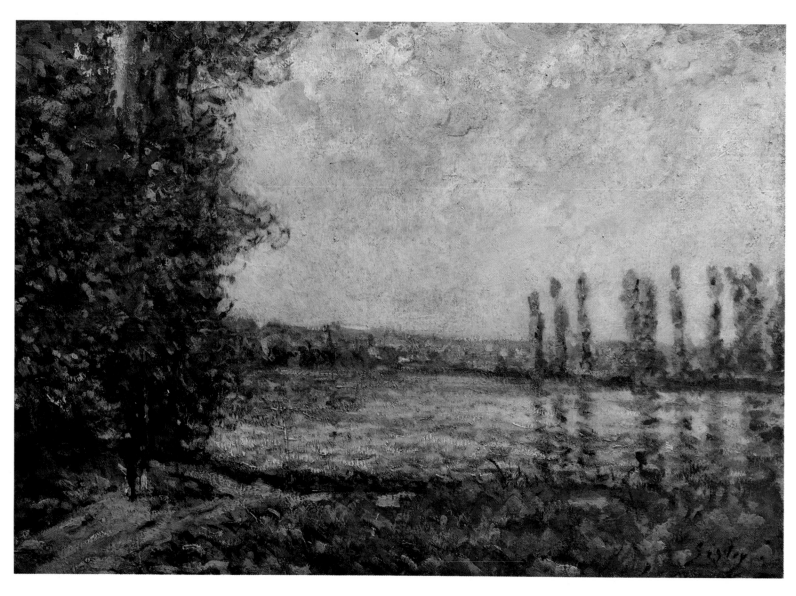

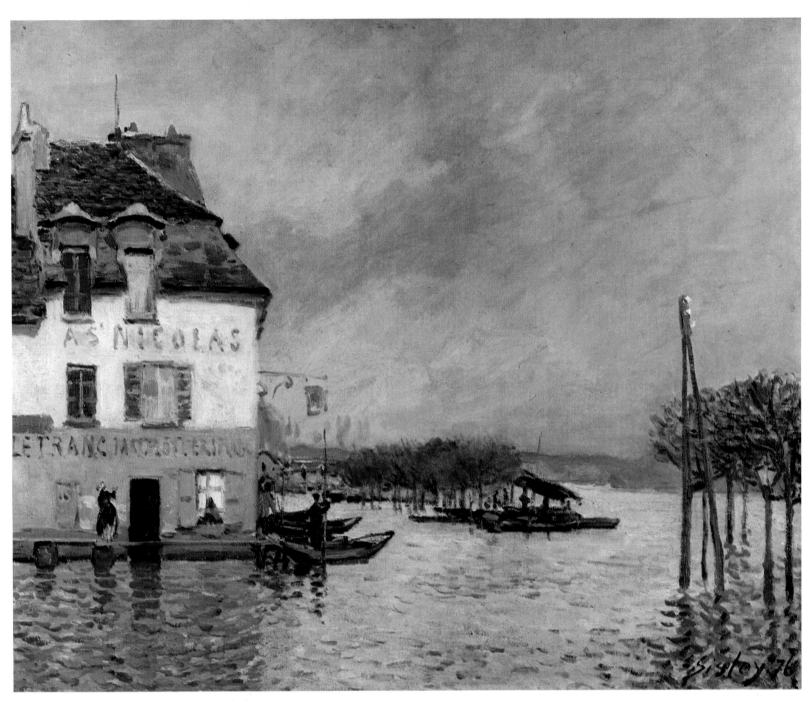

50 ALFRED SISLEY
Flood at Port-Marly, 1876.
Musée des Beaux-Arts, Rouen.

Opposite

51 ALFRED SISLEY
Field-guard in the forest of Fontainebleau, 1870.
Private collection, Switzerland.

52 EDOUARD MANET
Concert in the Tuileries, 1862.
National Gallery, London.

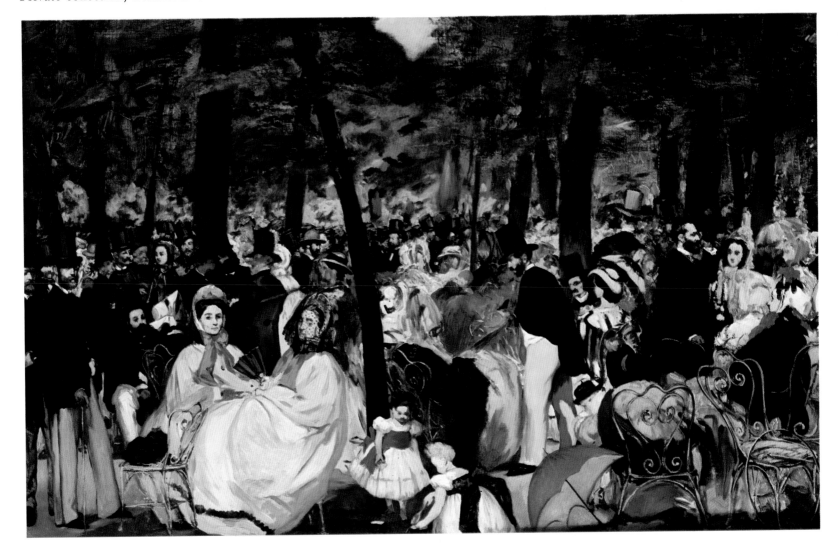

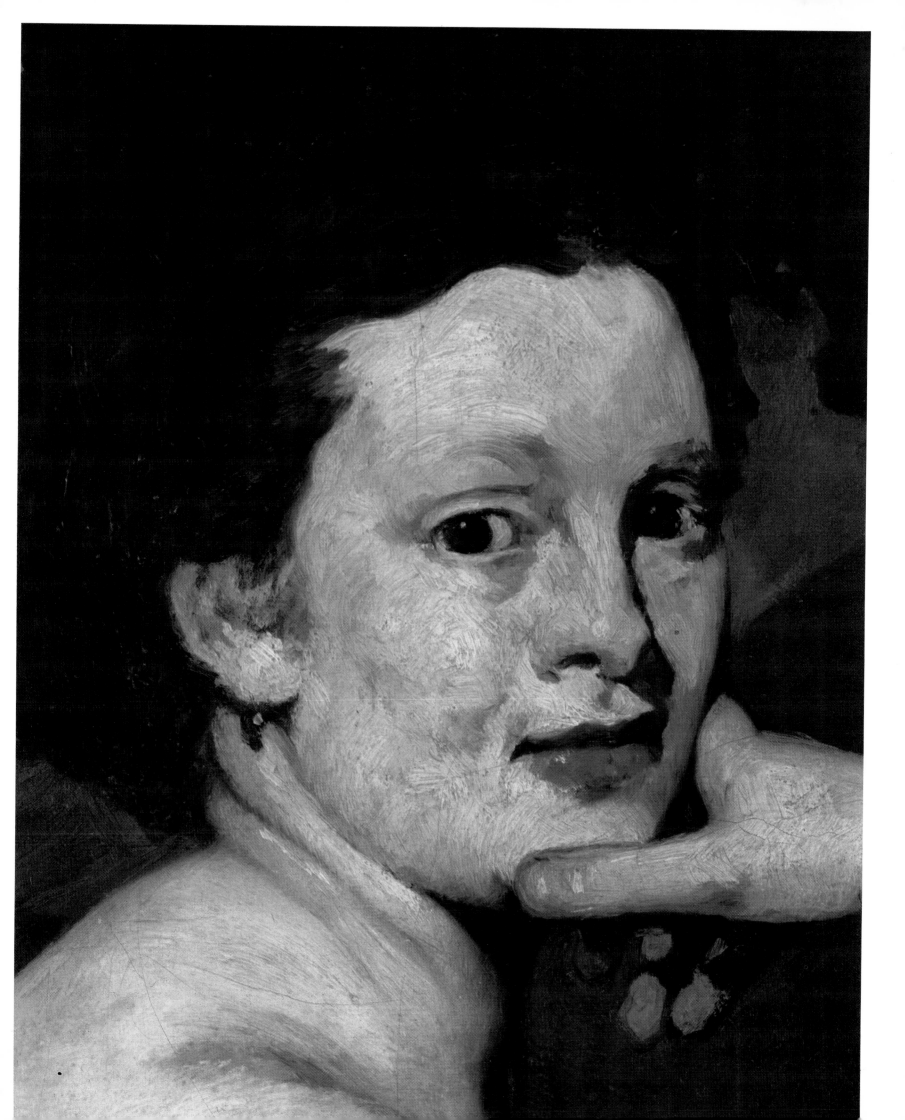

Opposite

53 EDOUARD MANET
Detail from *Le Déjeuner sur l'herbe* (plate 54).

54 EDOUARD MANET
Le Déjeuner sur l'herbe, 1863.
Musée du Louvre, Paris.

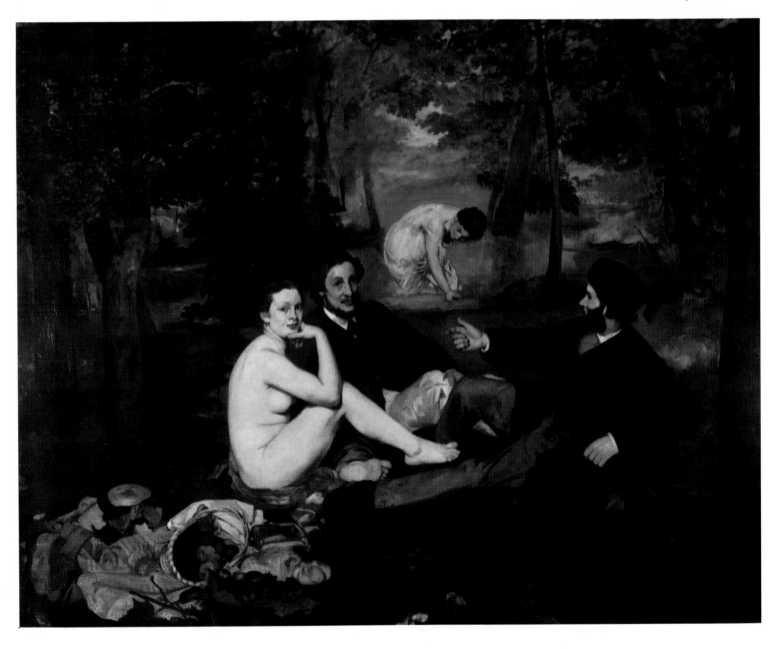

Opposite

55 EDOUARD MANET
Olympia, 1863.
Musée du Louvre, Paris.

56 EDOUARD MANET
Peonies, 1864/5.
Musée du Louvre, Paris.

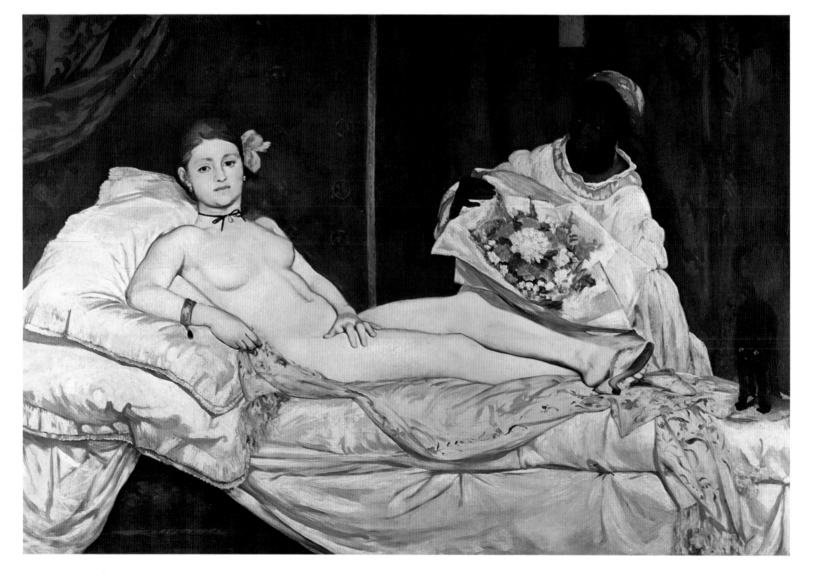

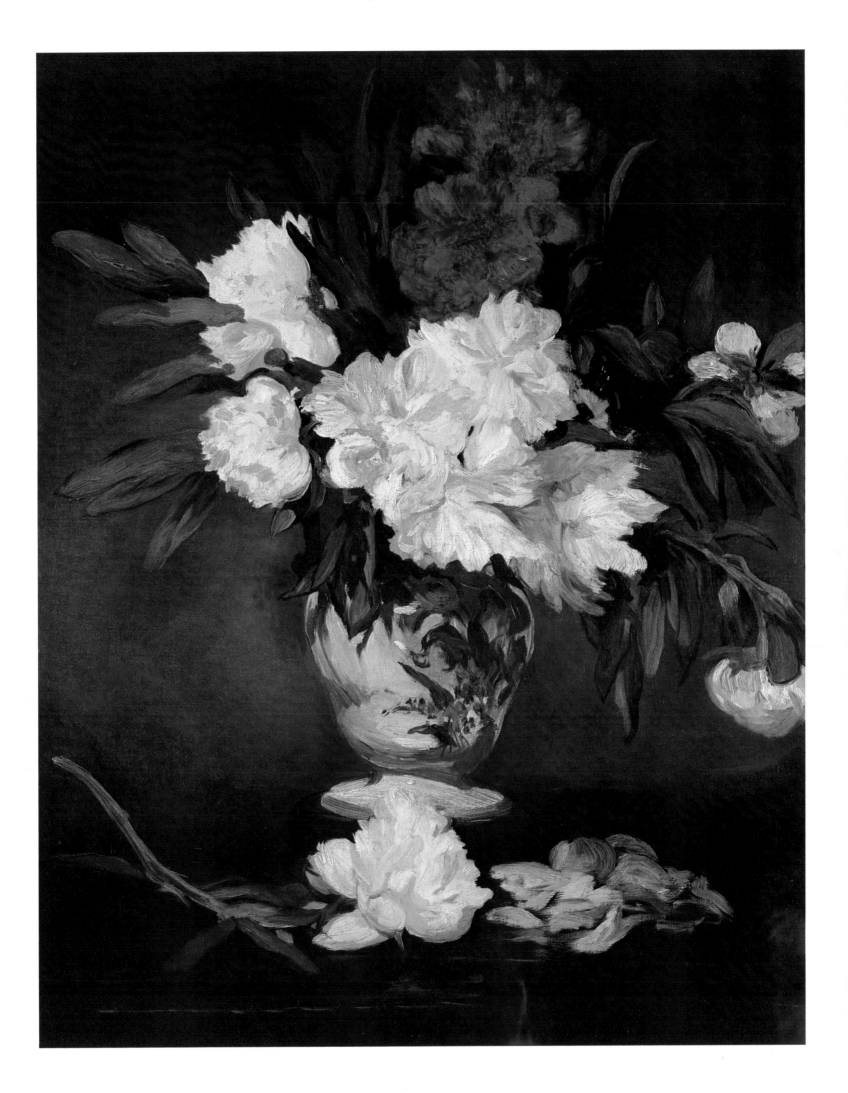

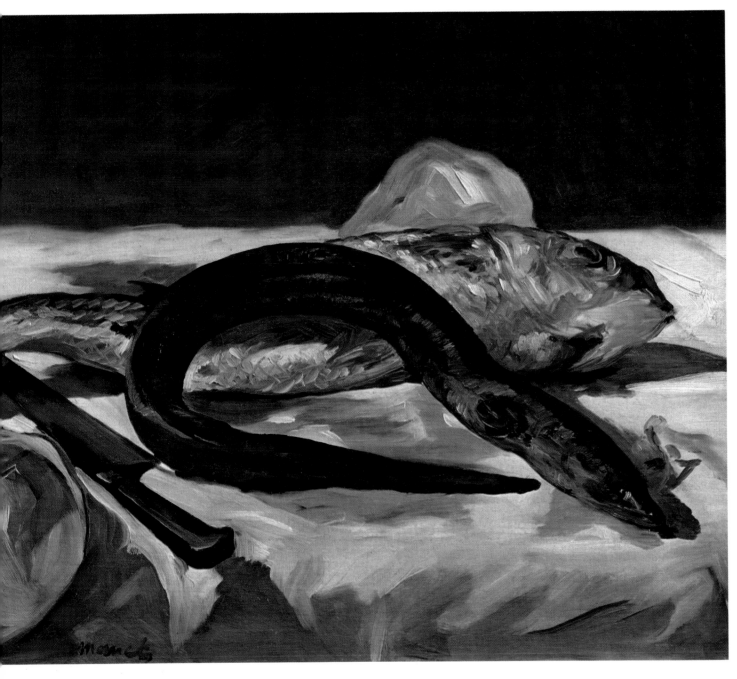

57 EDOUARD MANET
Still-life with eel, *c.* 1864.
Musée du Louvre, Paris.

58 EDOUARD MANET
Luncheon in the studio, 1868.
Bayerische Staatsgemäldesammlungen, Neue Staatsgalerie, Munich.

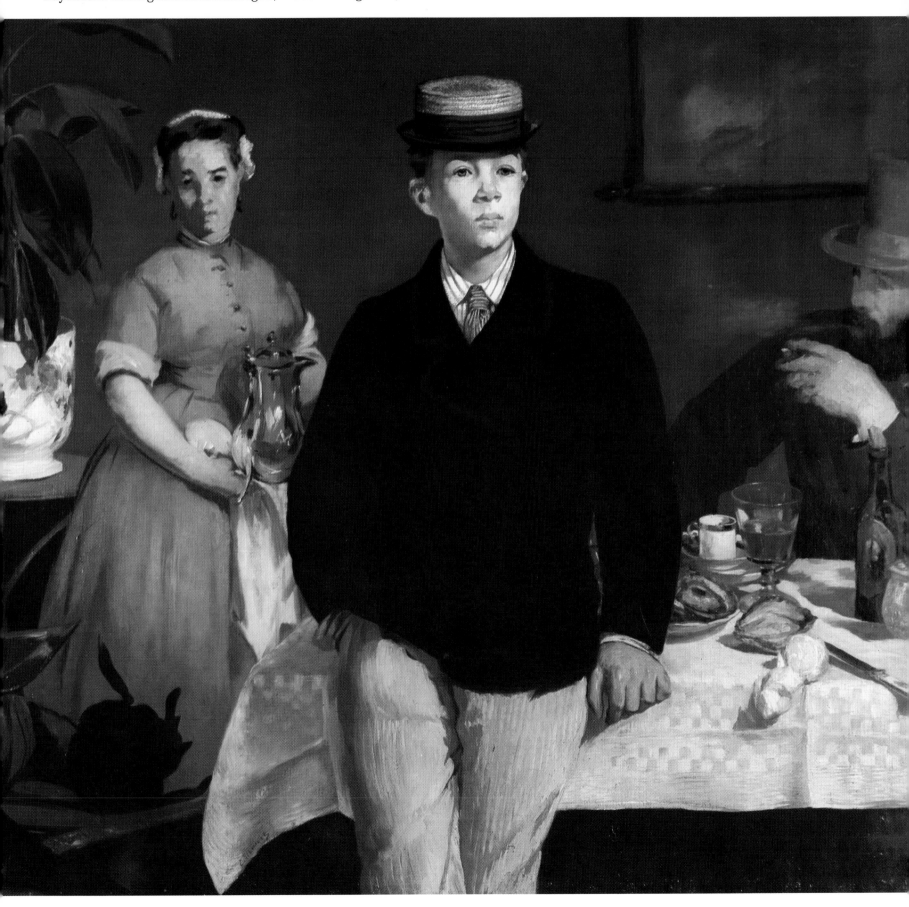

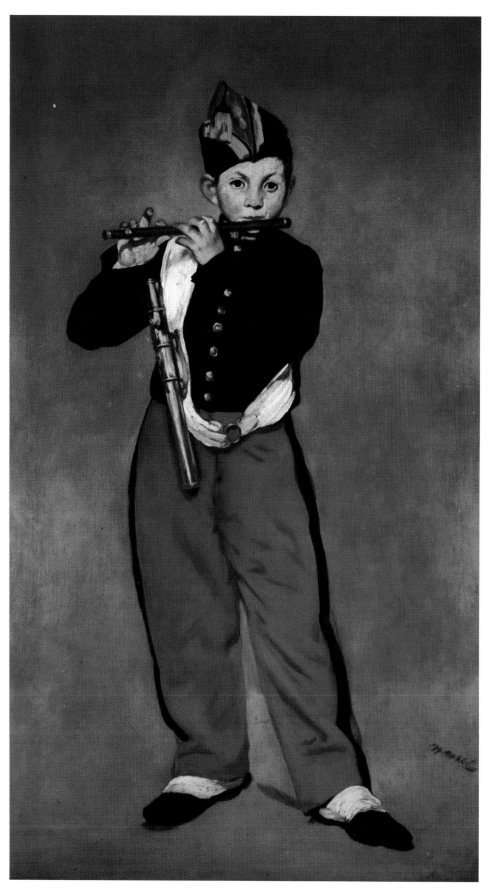

59 EDOUARD MANET
The fifer, 1866.
Musée du Louvre, Paris.

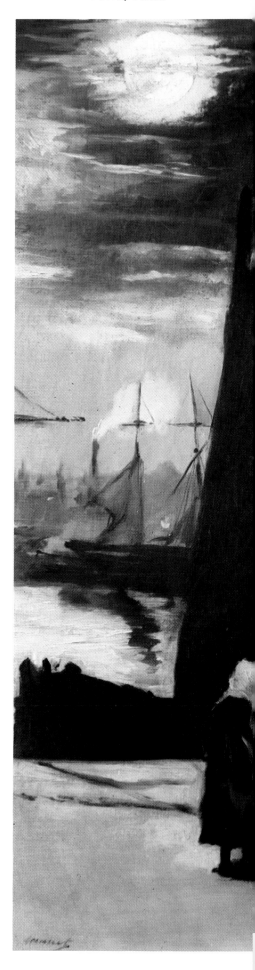

60 EDOUARD MANET
Boulogne harbour by moonlight, 1869.
Musée du Louvre, Paris.

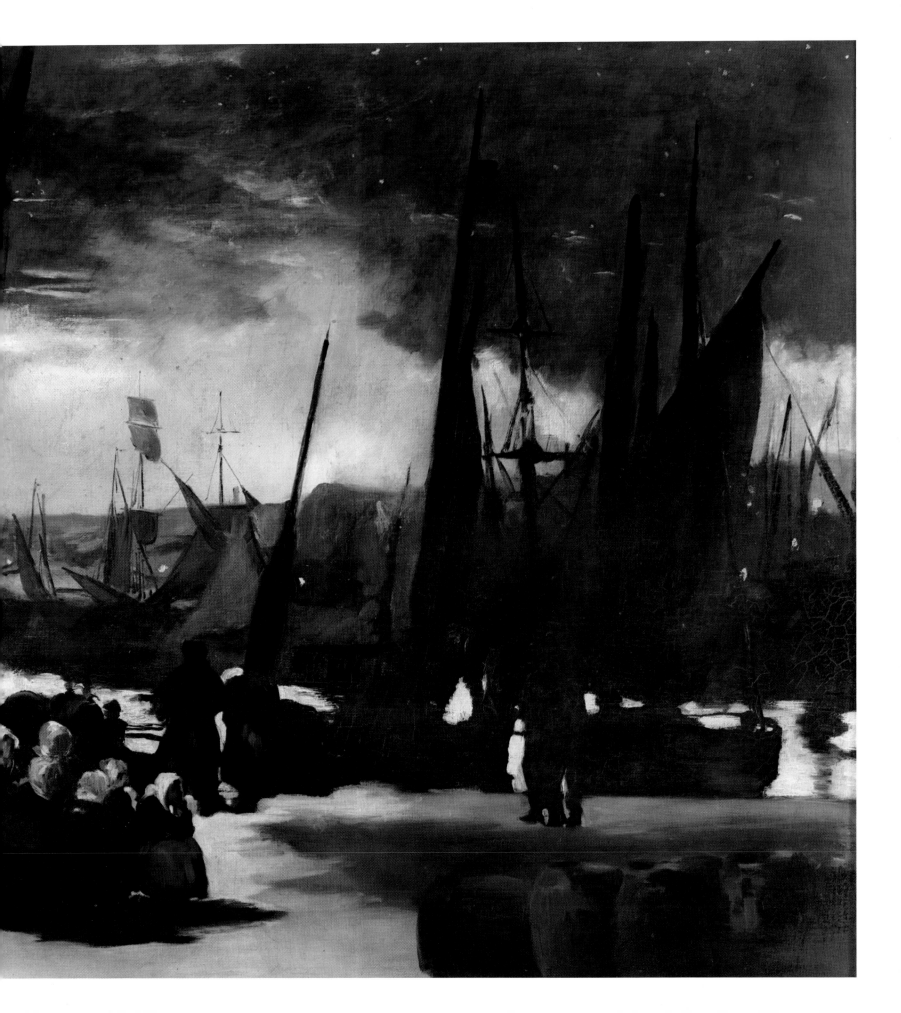

61 EDOUARD MANET
Gare Saint-Lazare, 1873.
National Gallery of Art,
Gift of Horace Havemeyer,
Washington D.C.

Opposite

62 EDOUARD MANET
Detail from *Gare Saint-Lazare* (plate 61).

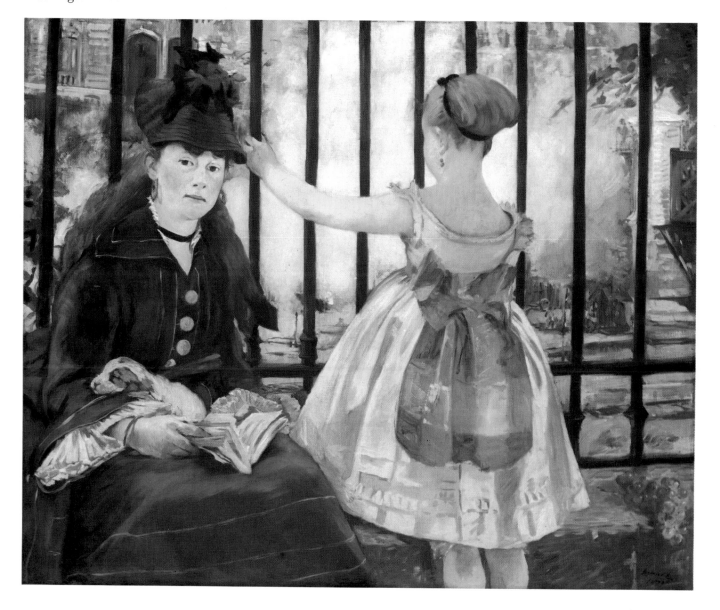

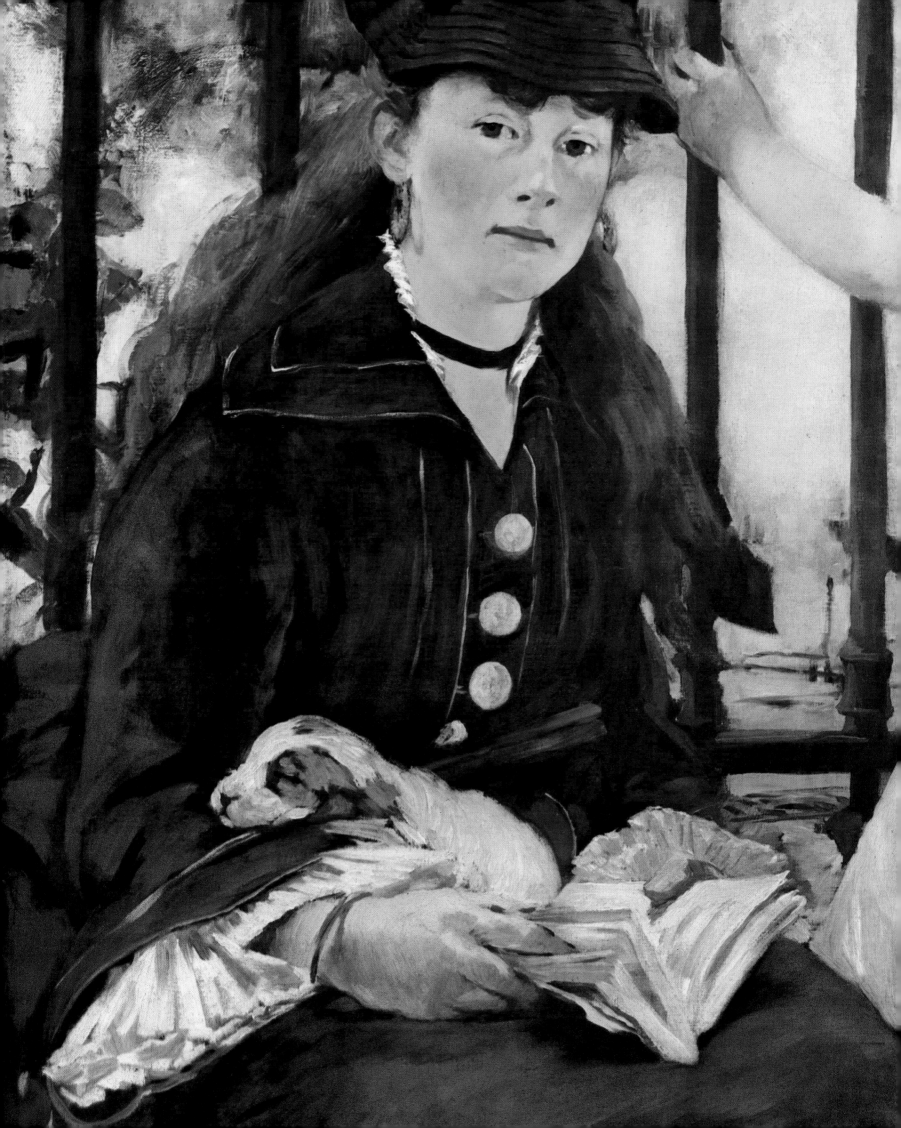

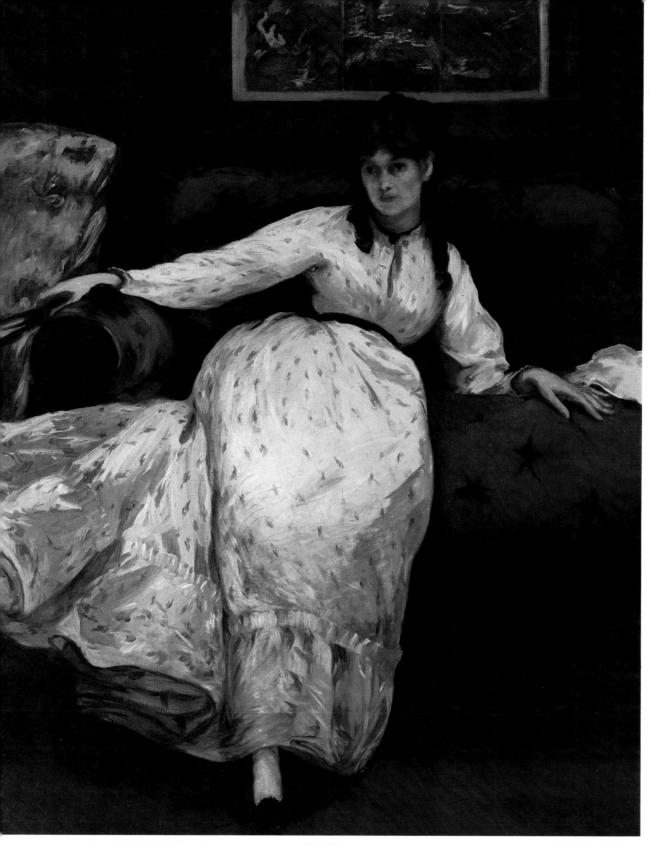

63 EDOUARD MANET
Repose (a portrait of Berthe Morisot), 1869.
Rhode Island School of Design, Providence.

64 EDOUARD MANET
The croquet game, 1873.
Städelsches Kunstinstitut,
Frankfurt.

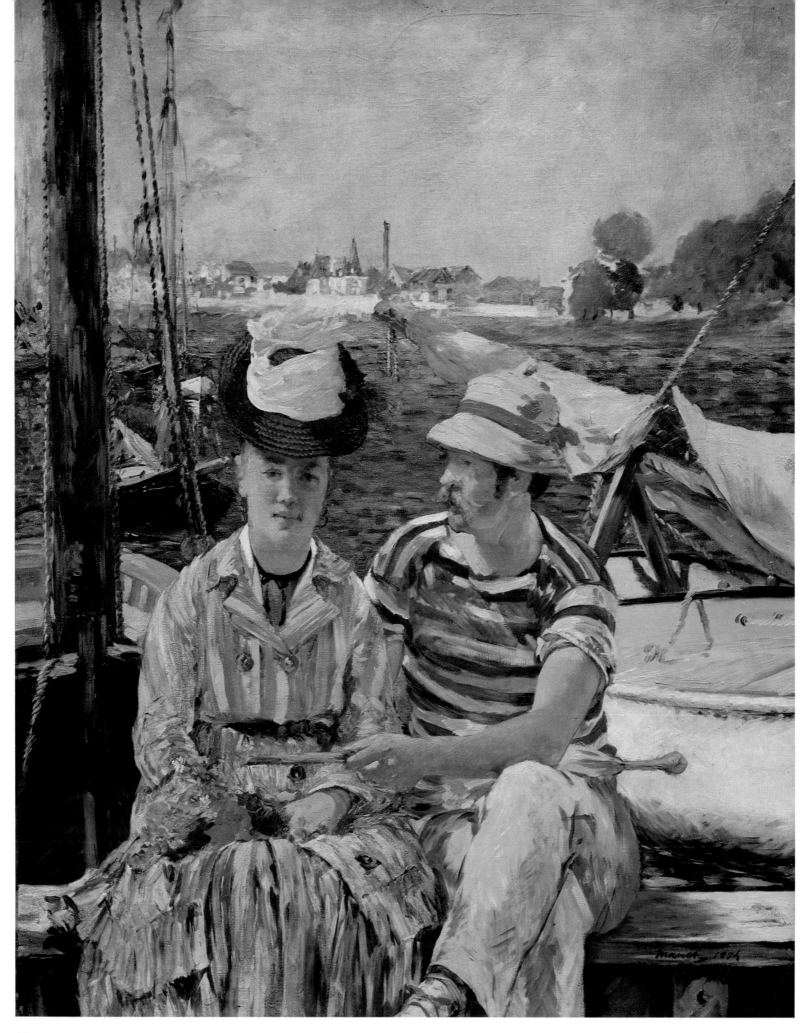

65 EDOUARD MANET
Argenteuil, 1874. Musée des Beaux-Arts, Tournai.

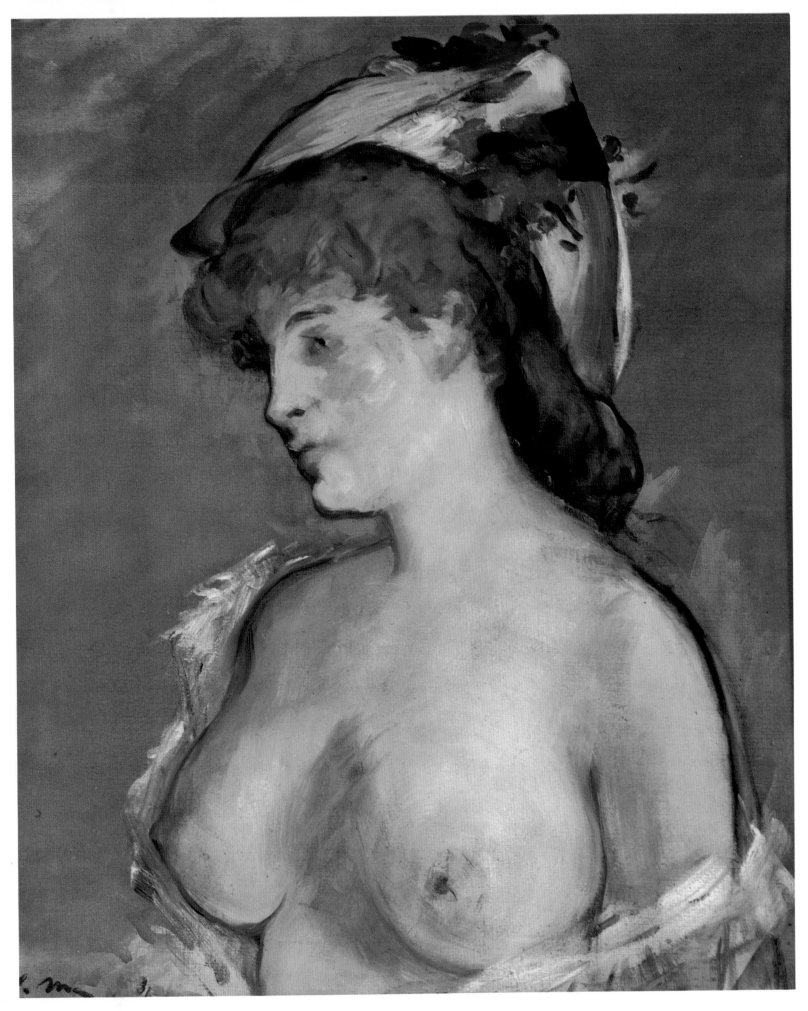

66 EDOUARD MANET
Blonde woman with bare breasts, 1875/78. Musée du Louvre, Paris.

67 EDOUARD MANET
View of the Place Clichy, 1877.
Private collection.

68 EDOUARD MANET
*Portrait of the poet
Stéphane Mallarmé*, 1876.
Musée du Louvre, Paris.

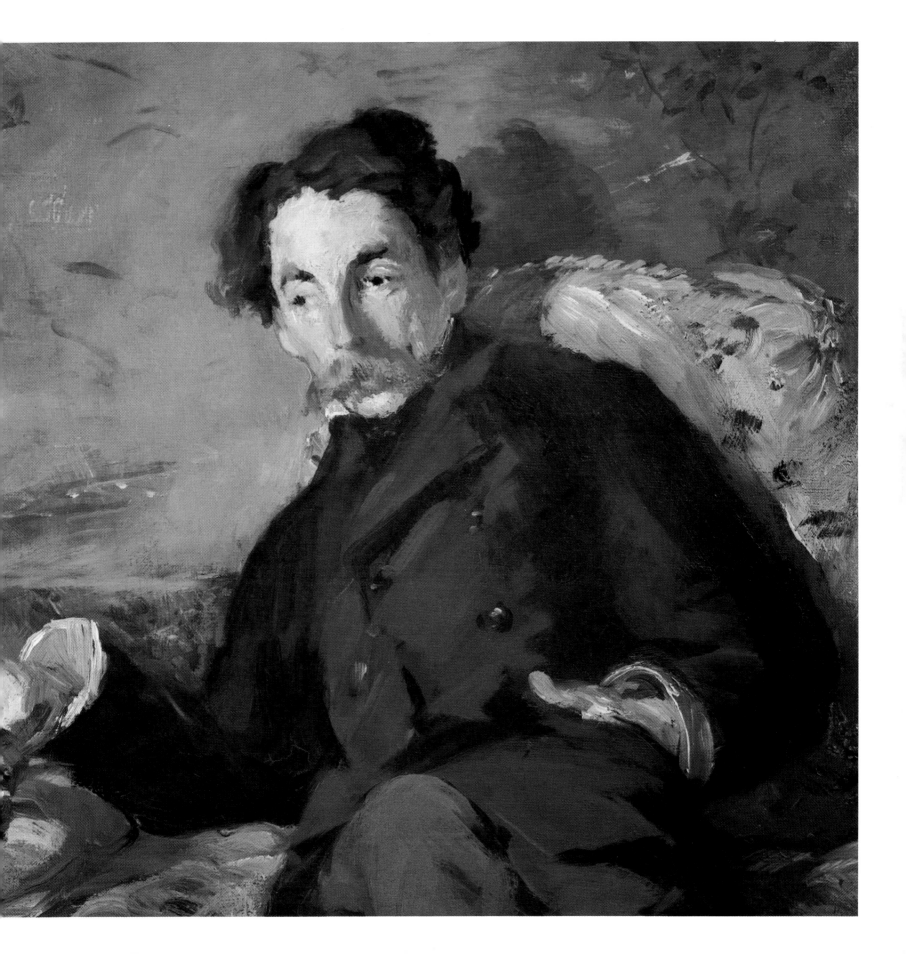

69 EDOUARD MANET
In the winter-garden, 1879.
Staatliche Museen, Gemäldegalerie, Berlin.

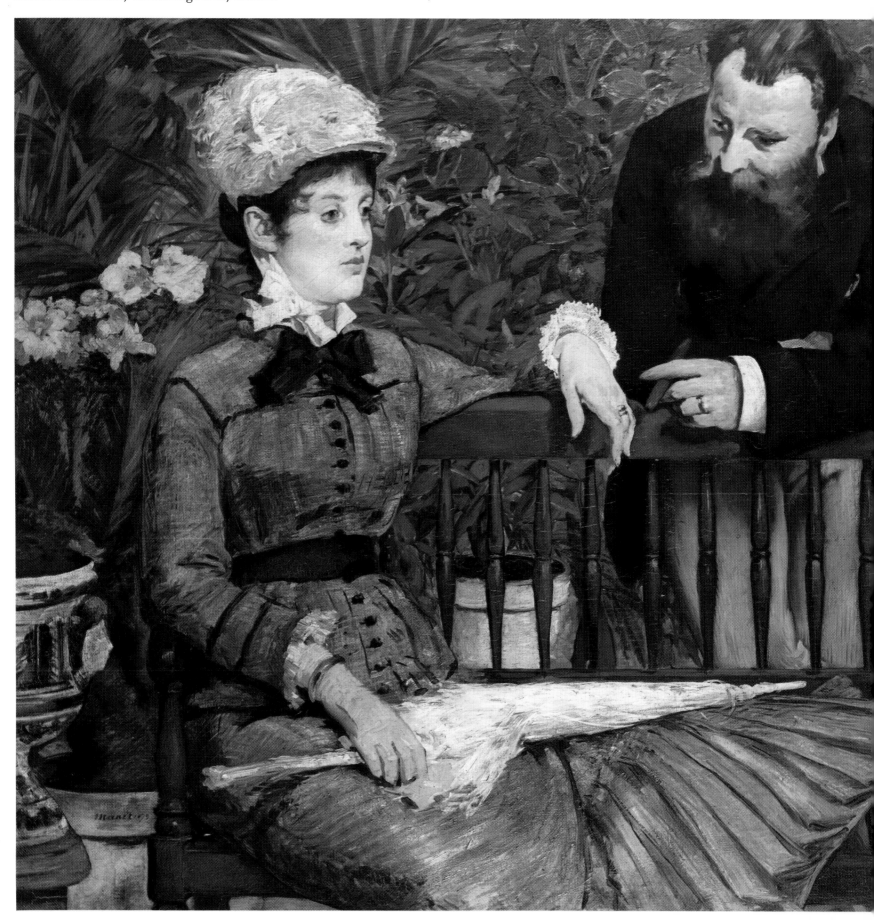

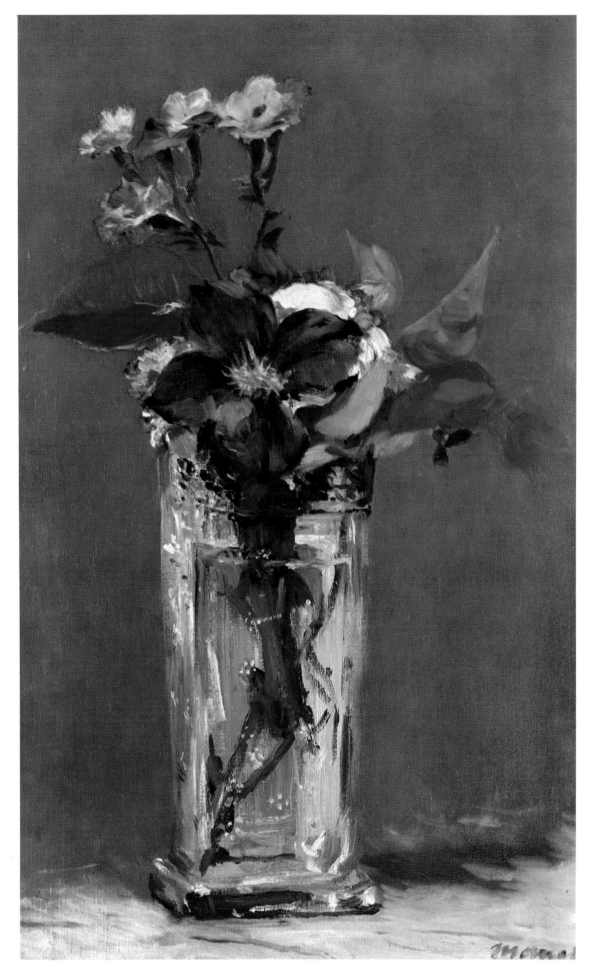

70 EDOUARD MANET
Crystal vase with flowers, 1880/83.
Musée du Louvre, Paris.

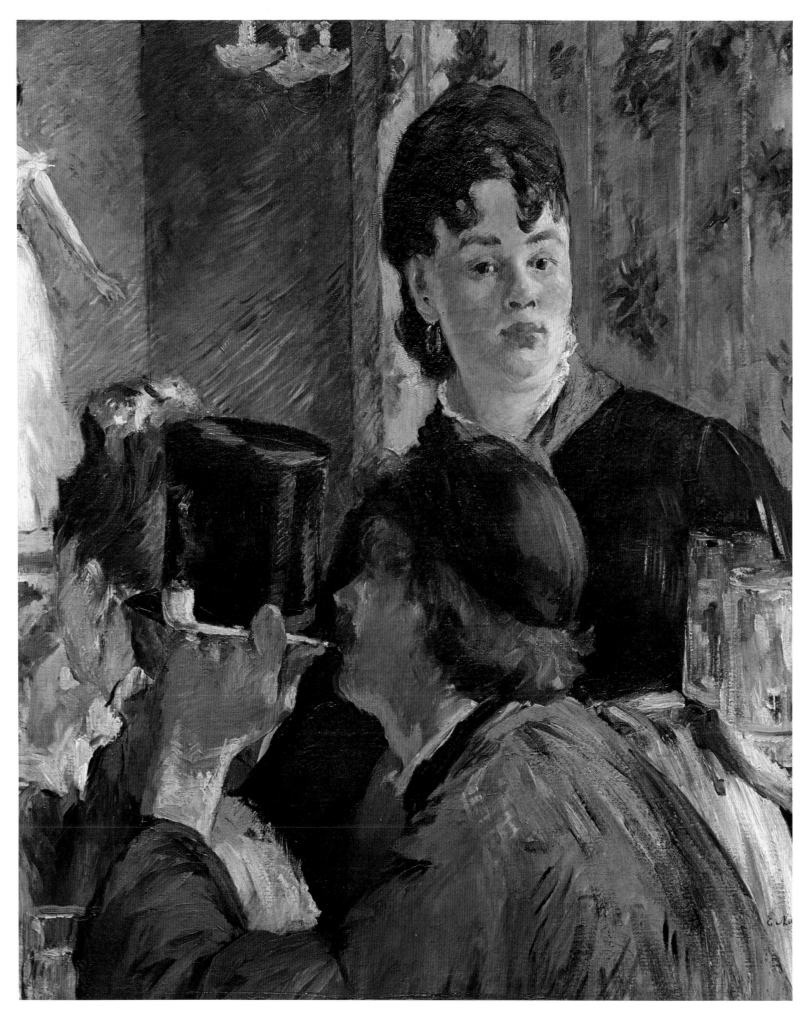

71 EDOUARD MANET
The beer-waitress in the restaurant of the Reichshofen Brewery in Paris, 1878/79.
Musée du Louvre, Paris.

72 EDOUARD MANET
The music-hall singer, c. 1880.
Private collection.

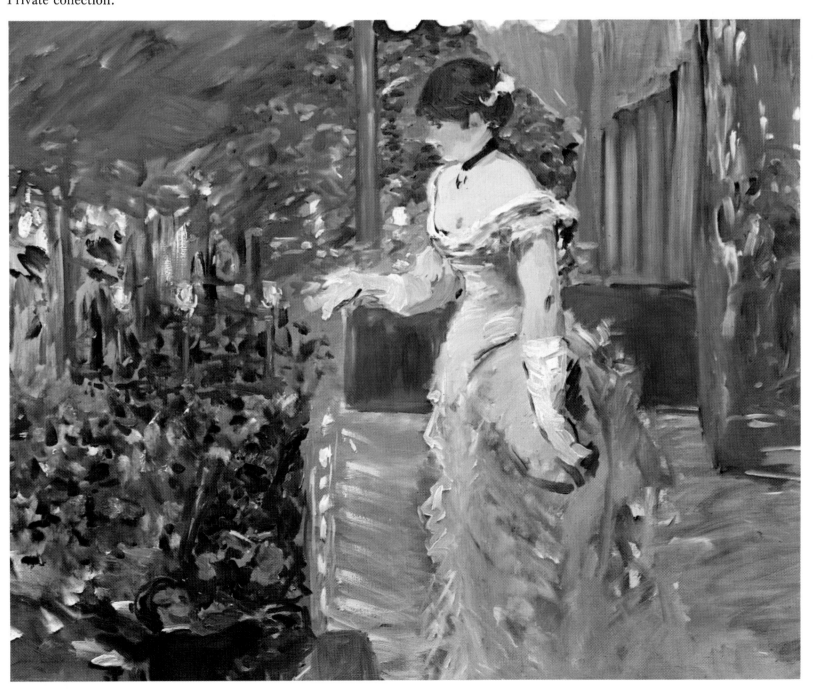

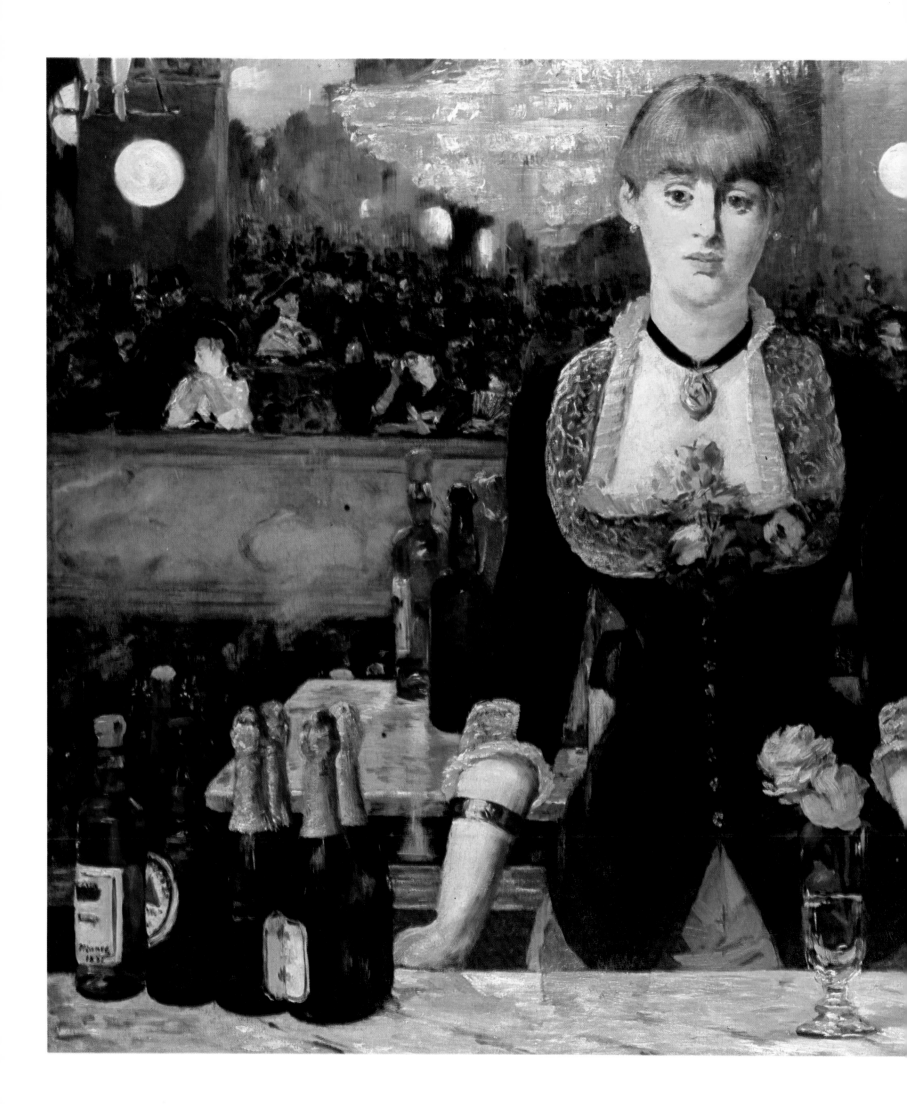

73 EDOUARD MANET
The bar at the Folies-Bergère, 1881.
Courtauld Institute Galleries, London.

74 EDOUARD MANET
The escape of Rochefort, 1881.
Private collection.

75 BERTHE MORISOT
Chasing butterflies, 1874.
Musée du Louvre, Paris.

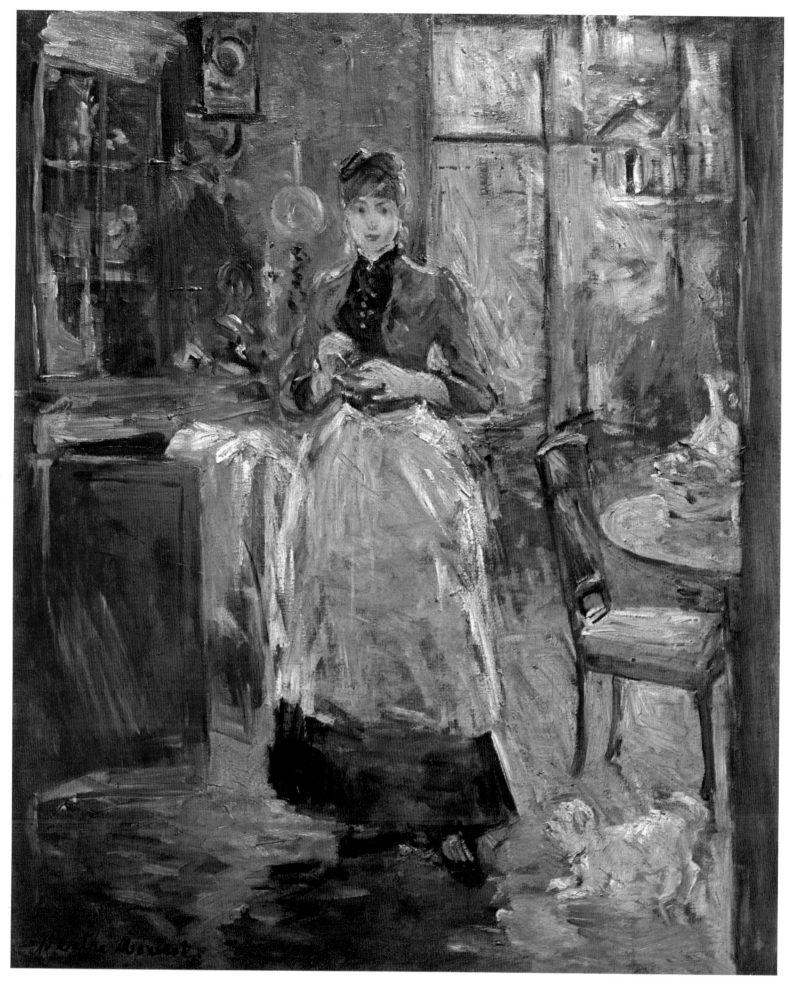

76 BERTHE MORISOT
In the dining-room, 1886.
National Gallery of Art, Chester Dale collection, Washington D.C.

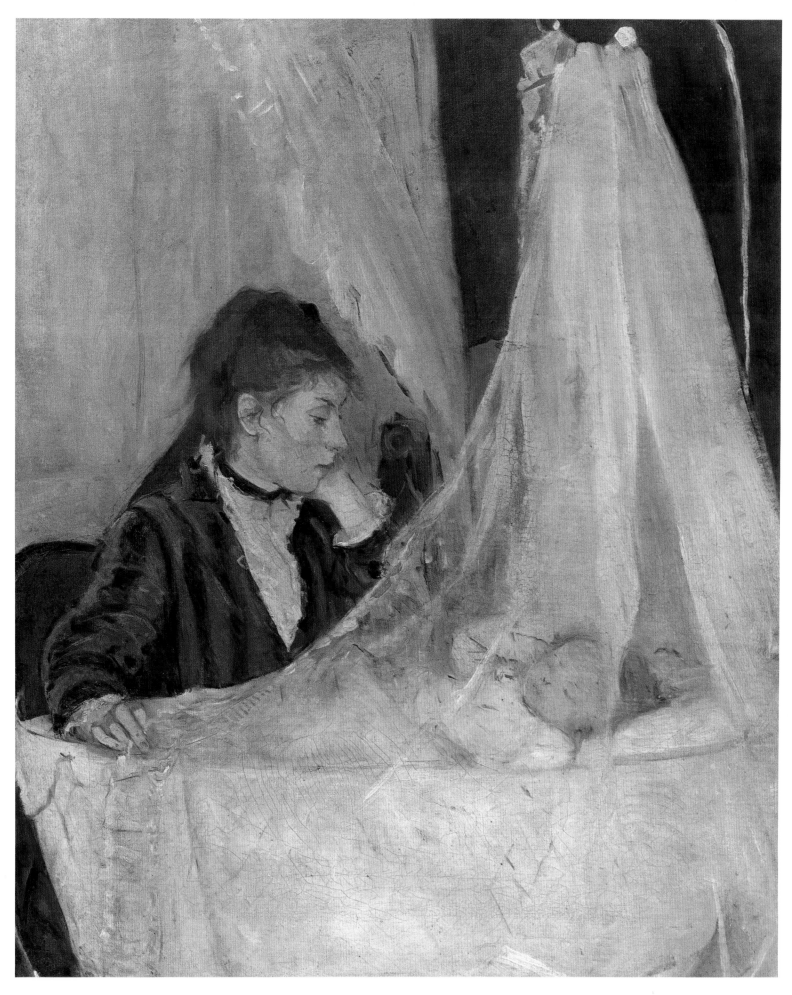

77 BERTHE MORISOT
The cradle, 1873.
Musée du Louvre, Paris.

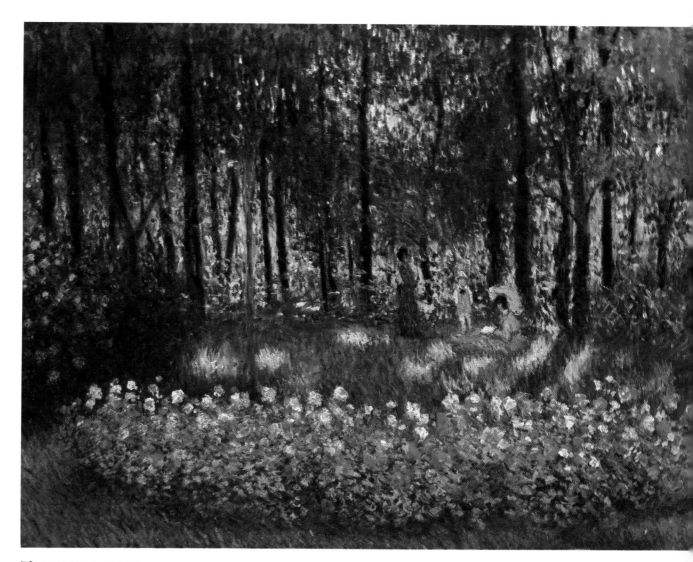

79 CLAUDE MONET
In Monet's garden at Argenteuil, 1875.
Private collection.

Opposite

80 CLAUDE MONET
The beach at Sainte-Adresse, 1867.
The Art Institute of Chicago.
Mr and Mrs Lewis L. Coburn collection, Chicago.

81 CLAUDE MONET
Terrace at Sainte-Adresse, 1867.
Metropolitan Museum of Art,
Rev. T. Pitcairn collection, New York.

82 CLAUDE MONET
The rocks of Belle-Île, 1886.
Pushkin Museum, Moscow.

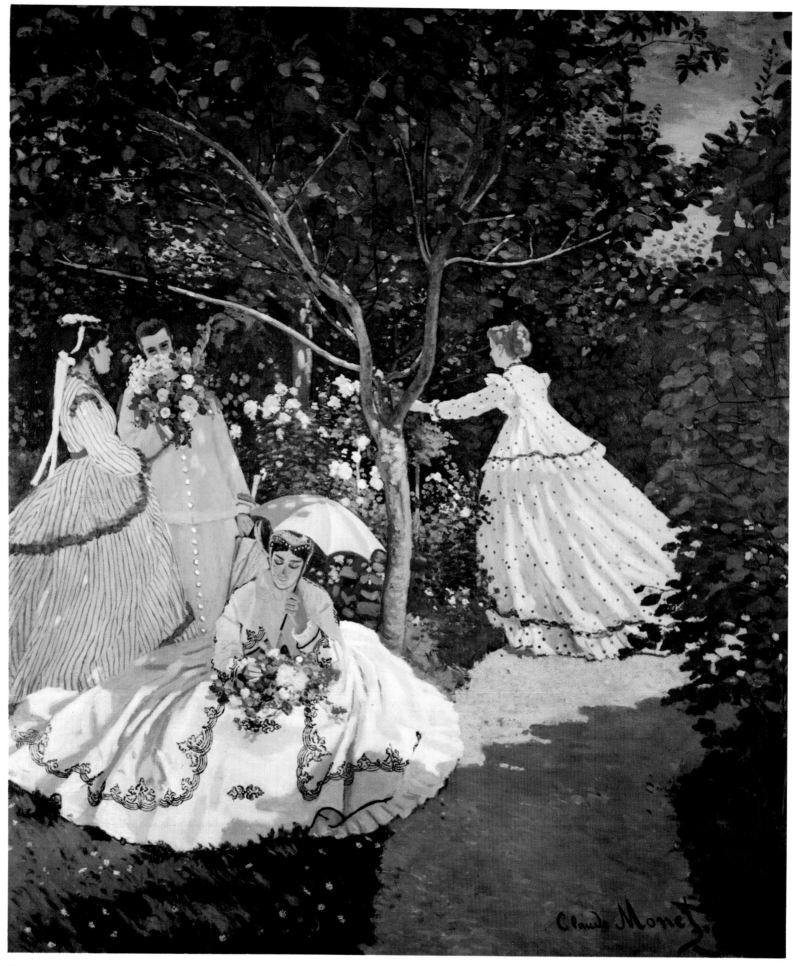

83 CLAUDE MONET
Girls in a garden, 1867.
Musée du Louvre, Paris.

84 CLAUDE MONET
Argenteuil, 1875.
Jean Walter-Paul Guillaume collection,
Musée de L'Orangerie, Paris.

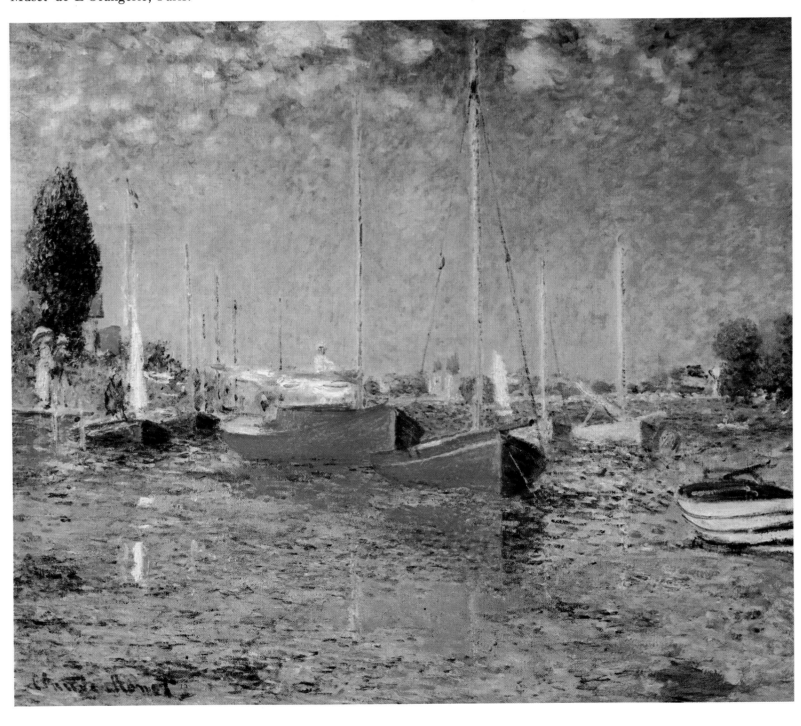

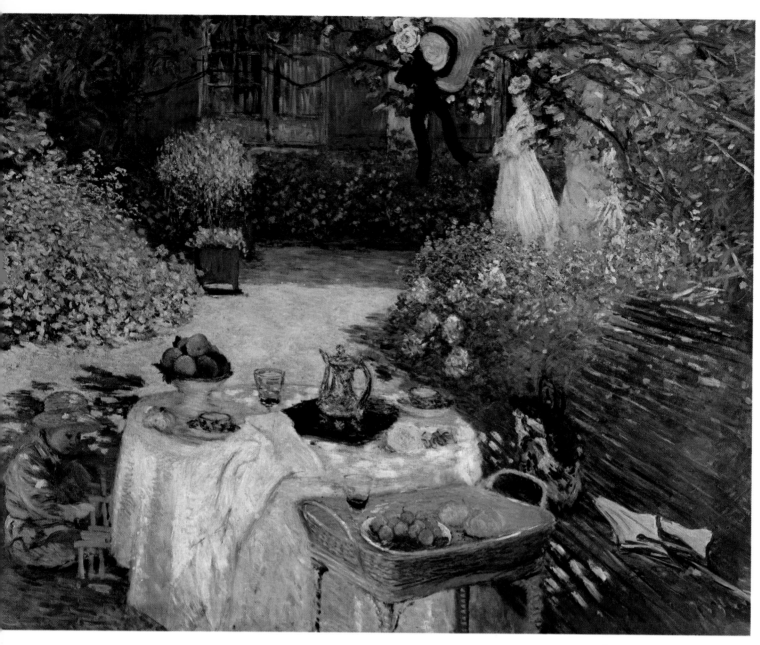

85 CLAUDE MONET
The luncheon, 1872/74.
Musée du Louvre, Paris.

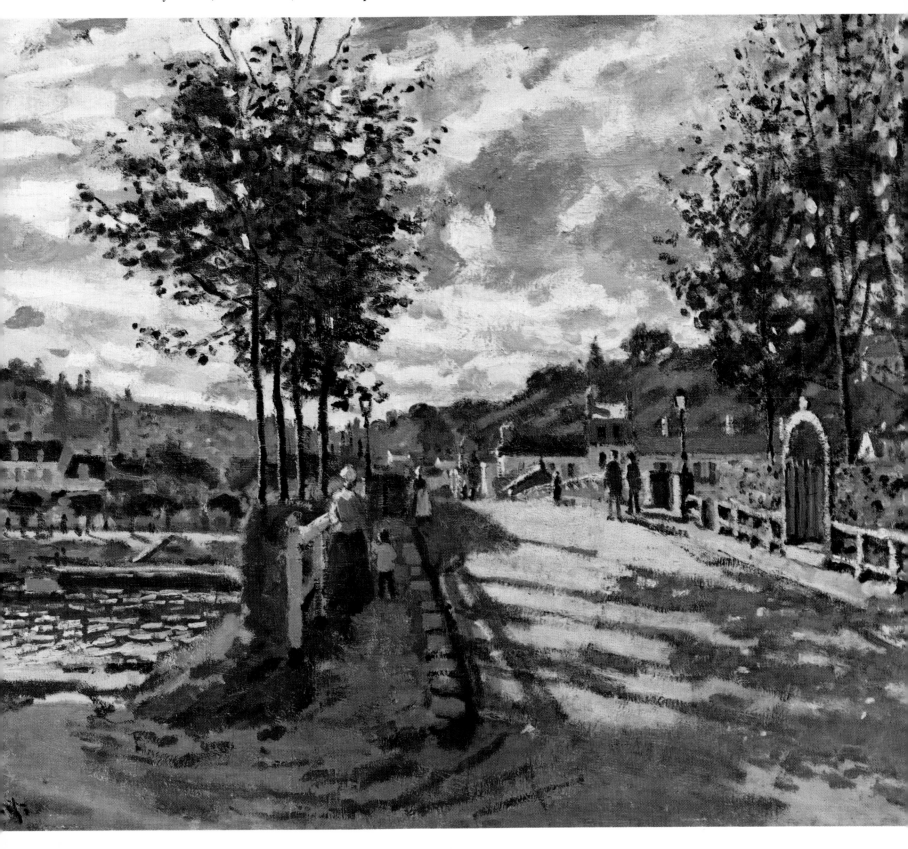

Opposite

88 CLAUDE MONET
Lady with sunshade, 1886.
Musée du Louvre, Paris.

87 CLAUDE MONET
Regatta at Argenteuil, c. 1872.
Musée du Louvre, Paris.

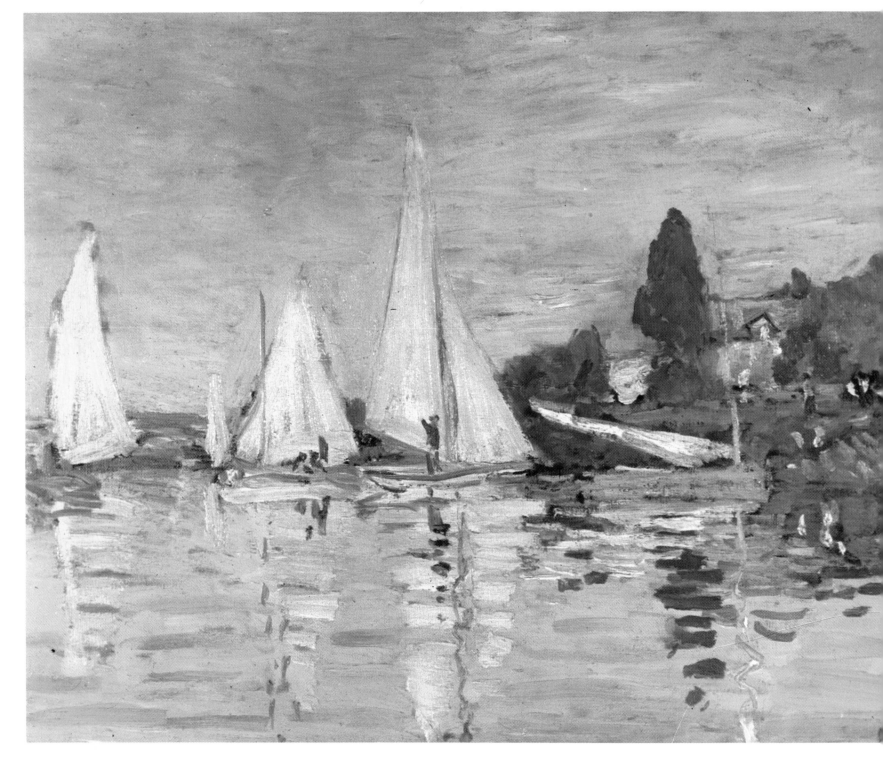

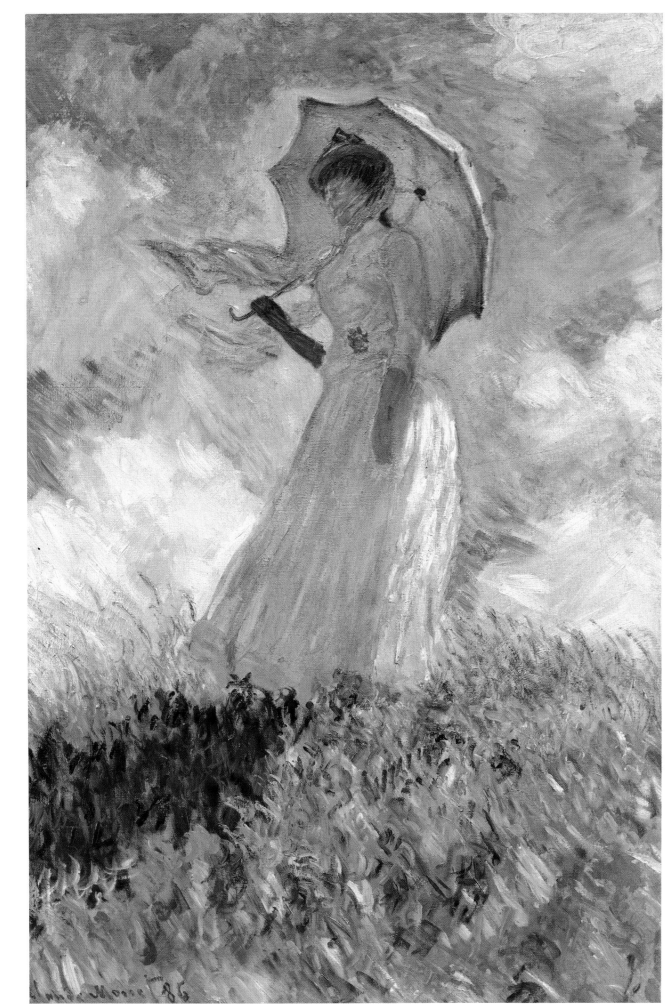

Opposite

89 CLAUDE MONET
Impression, sunrise, 1872.
Musée Marmottan, Paris.

90 CLAUDE MONET
The Rue Montorgueil adorned with flags, 1878.
Musée des Beaux-Arts, Rouen.

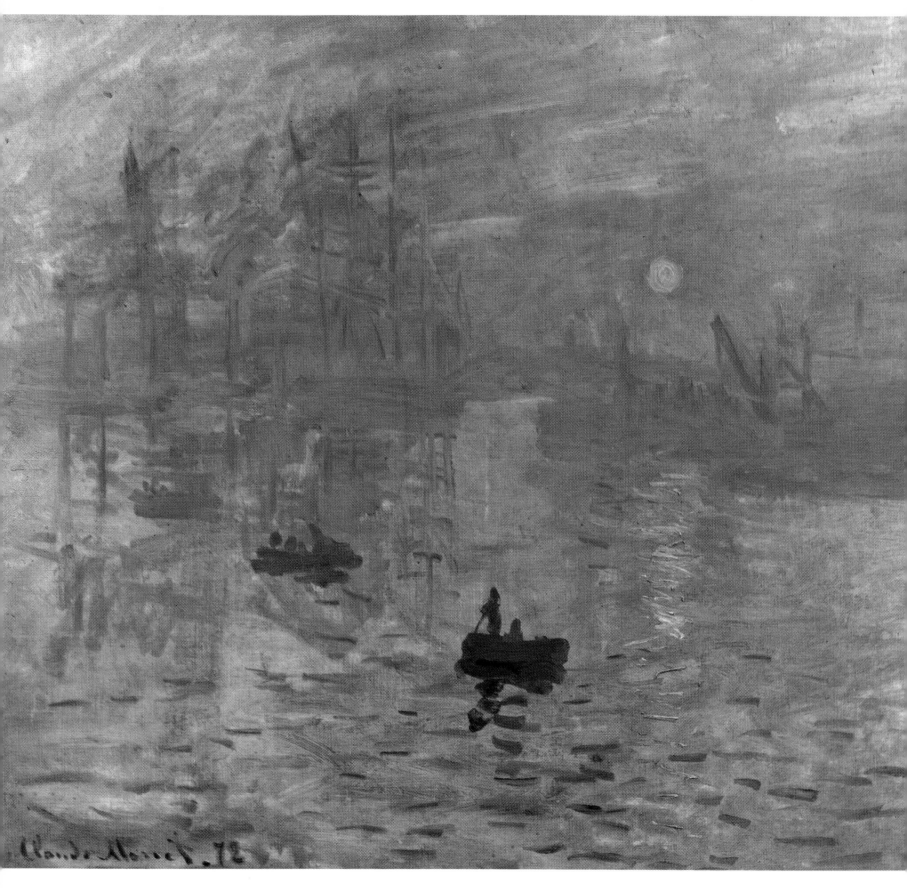

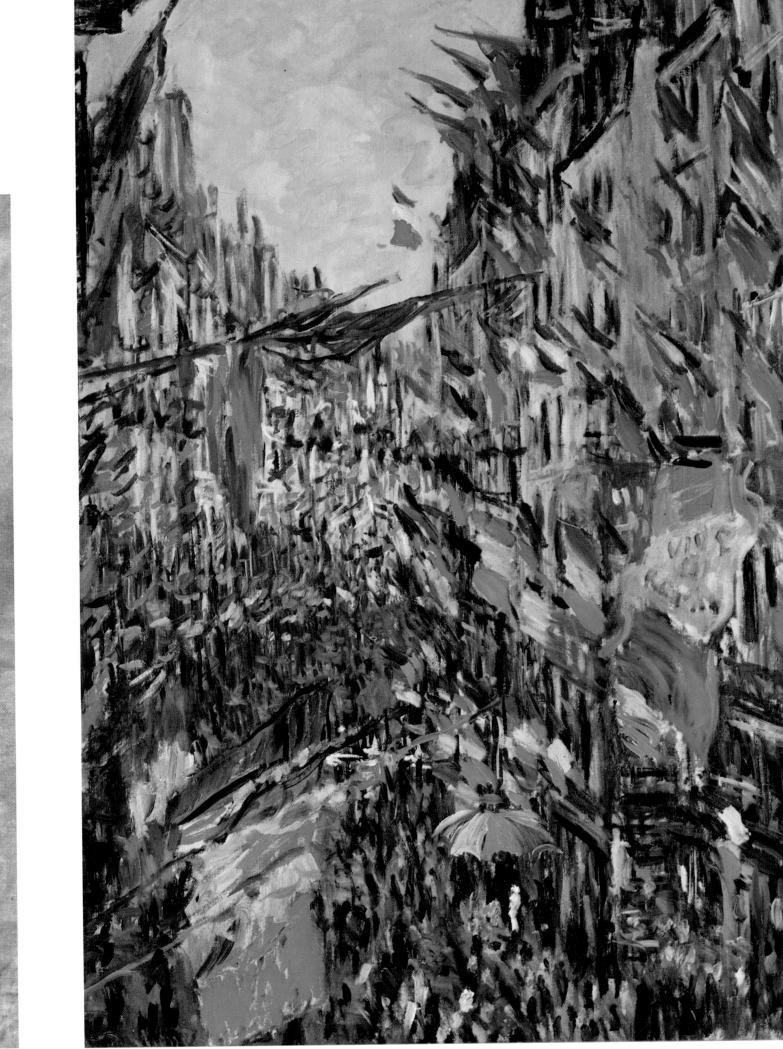

Opposite

91 CLAUDE MONET
Pont de l'Europe, Gare Saint-Lazare, 1877.
Musée Marmottan, Paris.

92 CLAUDE MONET
The castle of Dolce-Acqua, 1884.
Musée Marmottan, Paris.

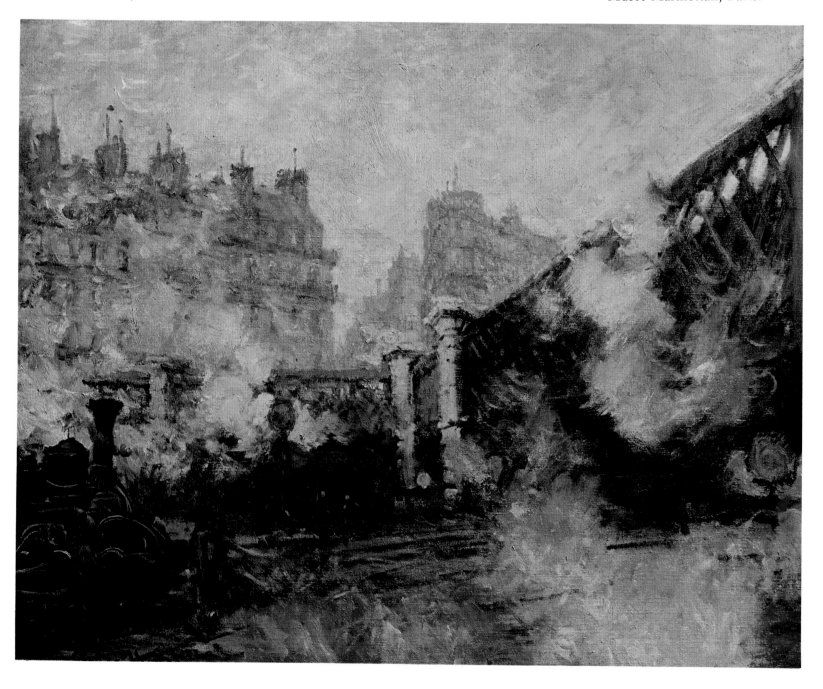

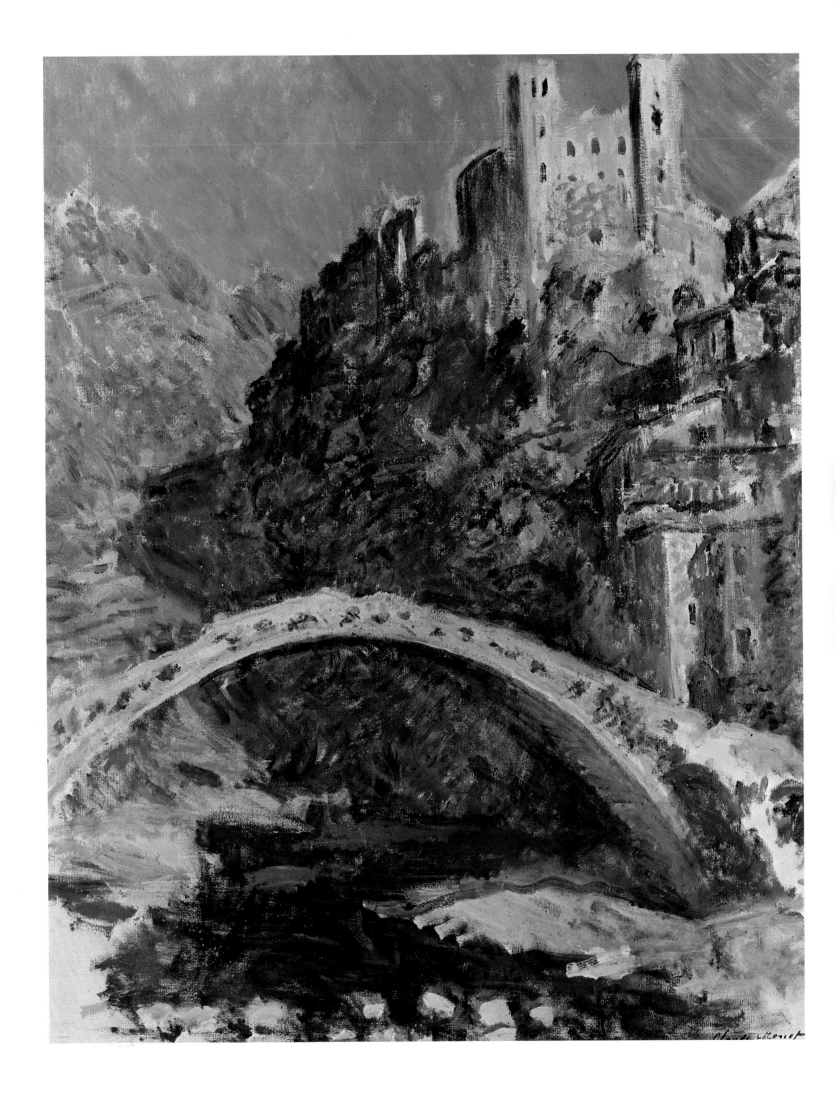

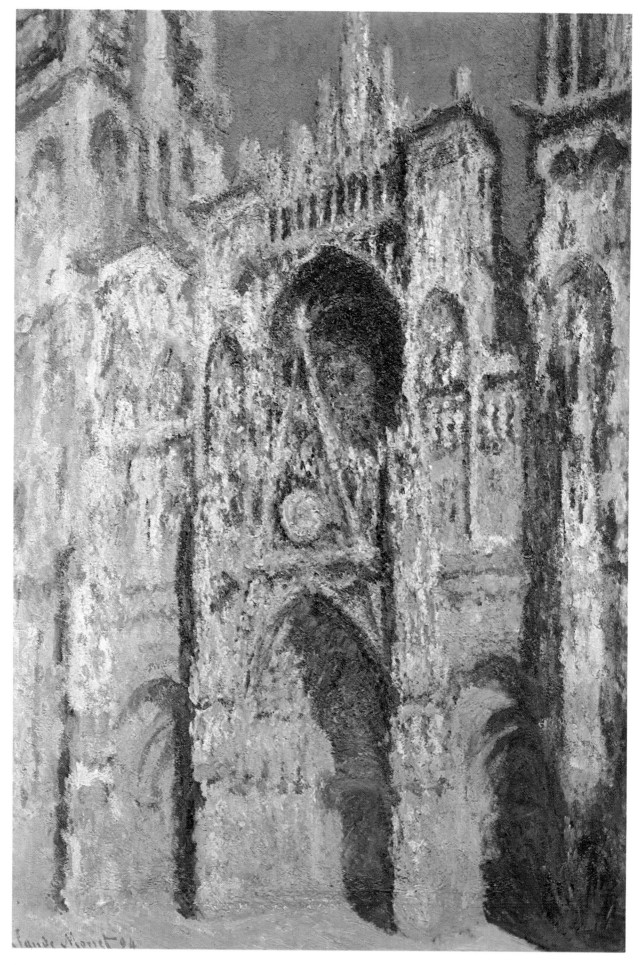

93 CLAUDE MONET
Rouen Cathedral, the façade in sunlight, 1894.
Musée du Louvre, Paris.

Rouen Cathedral, Cour d'Albane, at dawn, 1894.
Musée du Louvre, Paris.

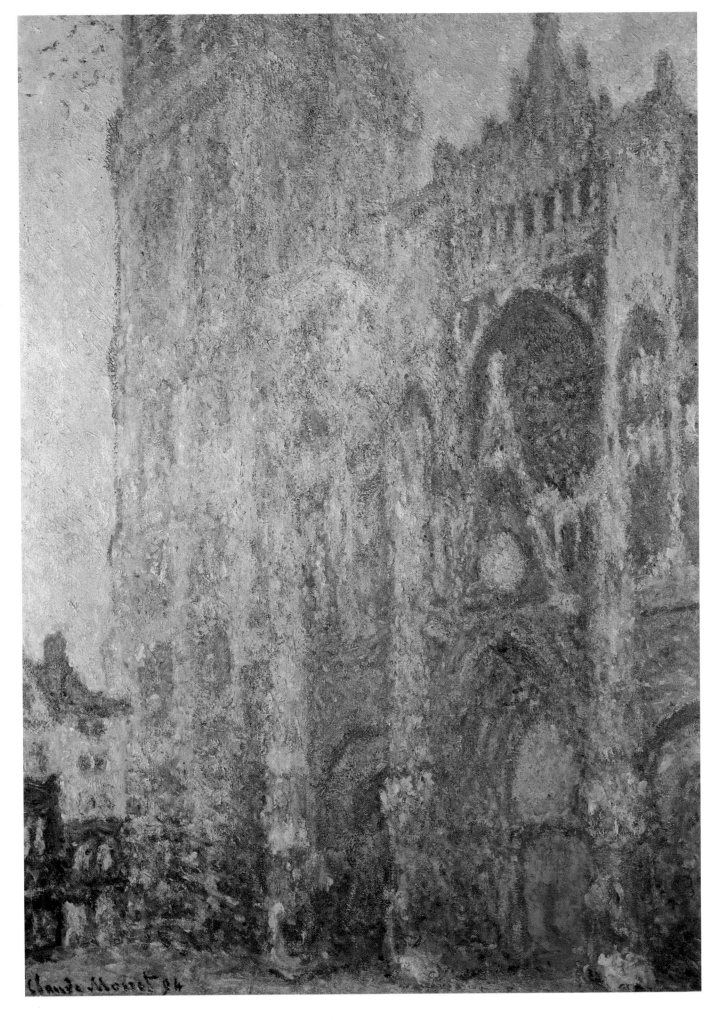

95 CLAUDE MONET
The Houses of Parliament, London, 1903.
National Gallery of Art, Chester Dale collection, Washington D.C.

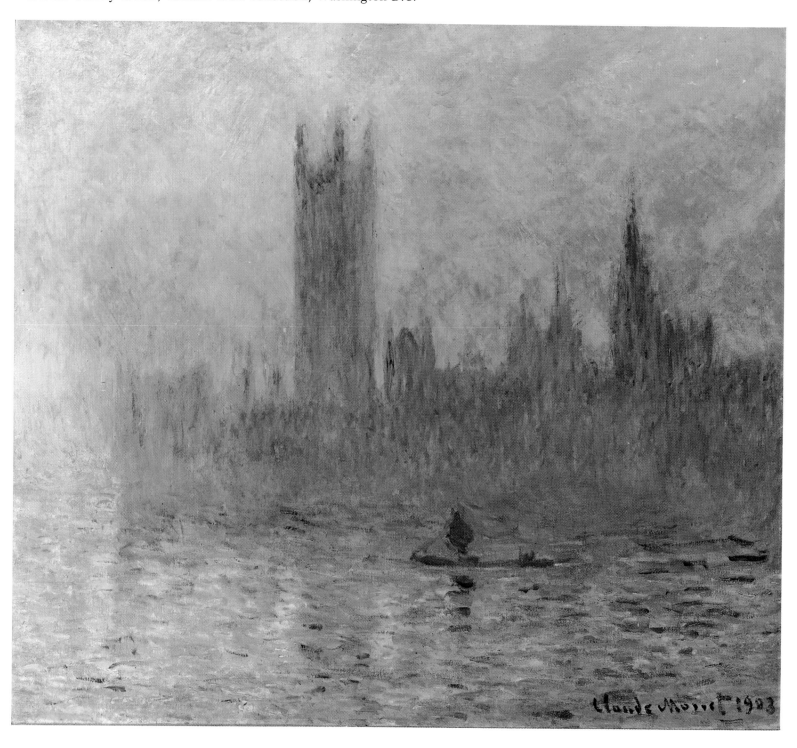

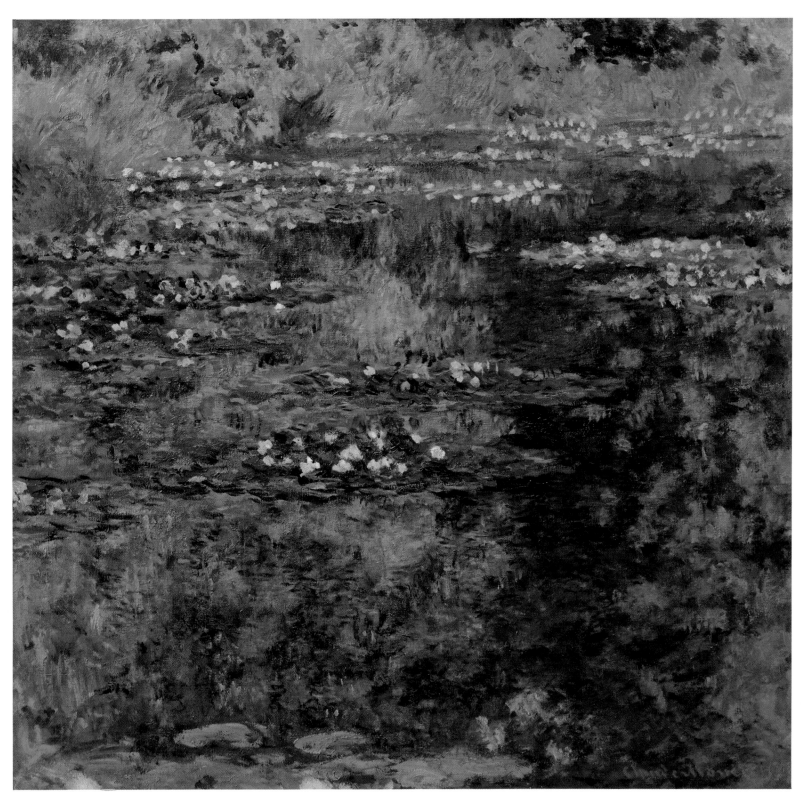

96 CLAUDE MONET
Water-lilies, 1904.
Musée du Louvre, Paris.

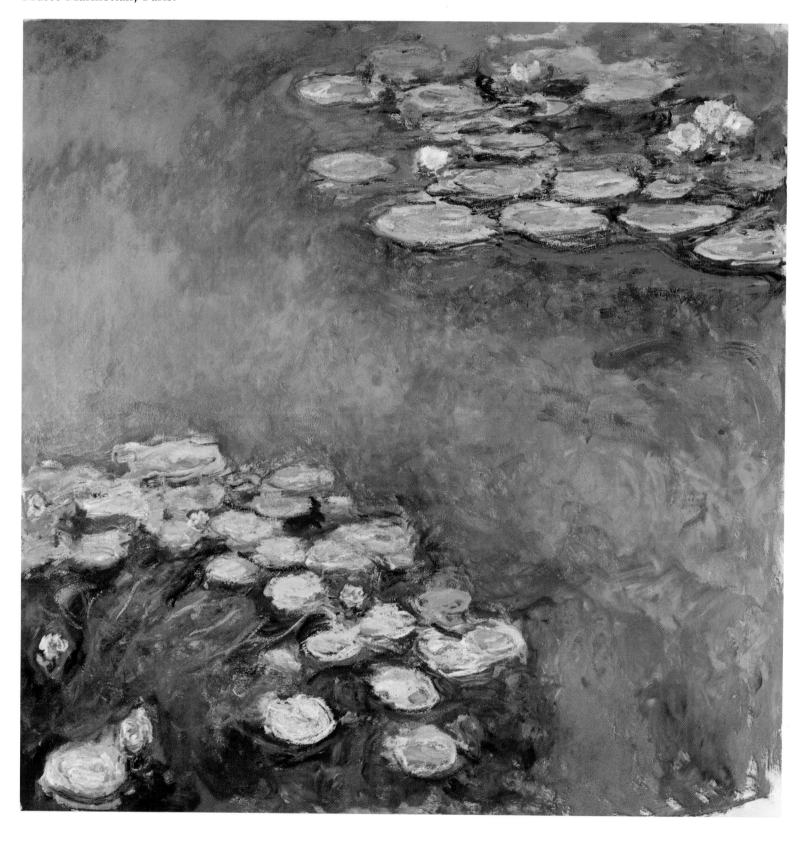

98 CLAUDE MONET
Yellow irises at Giverny. Musée Marmottan, Paris.

99 CLAUDE MONET
Water-lilies, 1916/18. E. G. Bührle collection, Zurich.

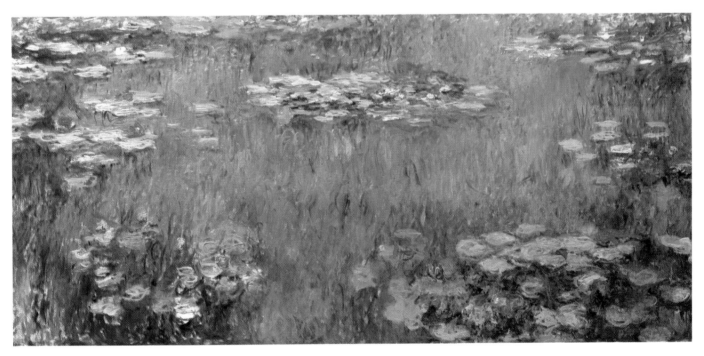

Opposite

100 CLAUDE MONET
The flower garden, 1922/25.
H. E. Smeets collection, Weert.

101 CLAUDE MONET
Detail of *The flower garden* (Plate 100).

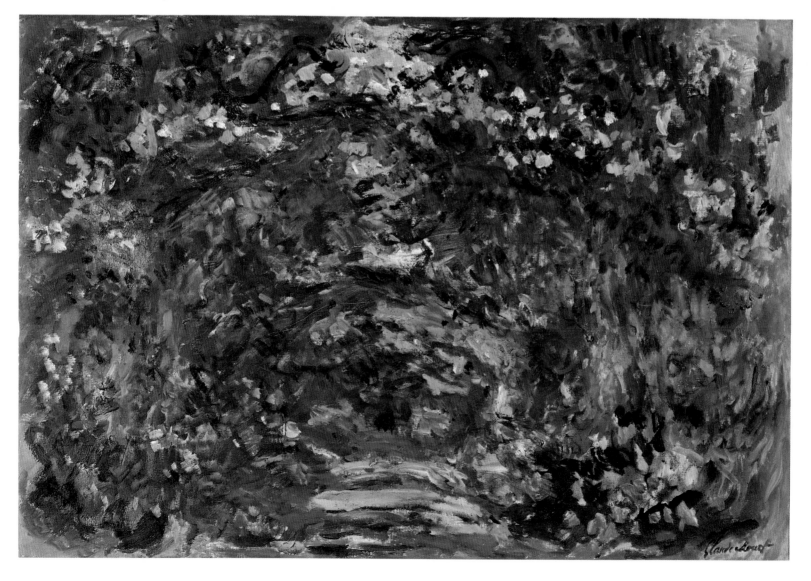

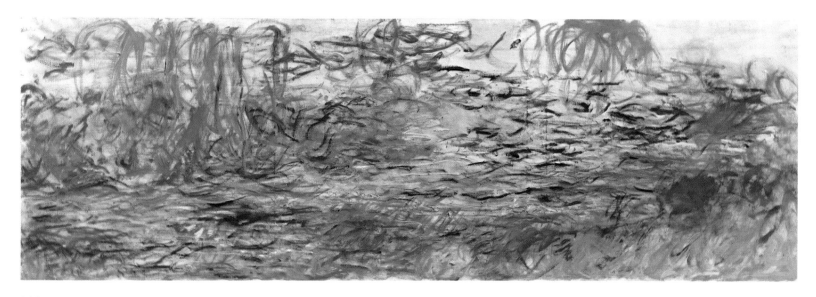

102 CLAUDE MONET
The pond, 1919/25.
Musée Marmottan, Paris.

103 CLAUDE MONET
Wistaria.
Beyeler collection, Basle.

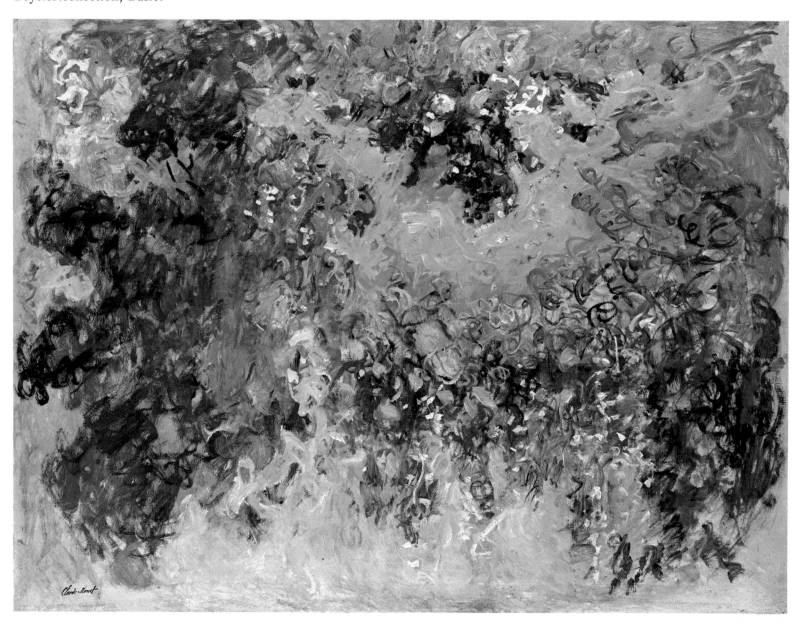

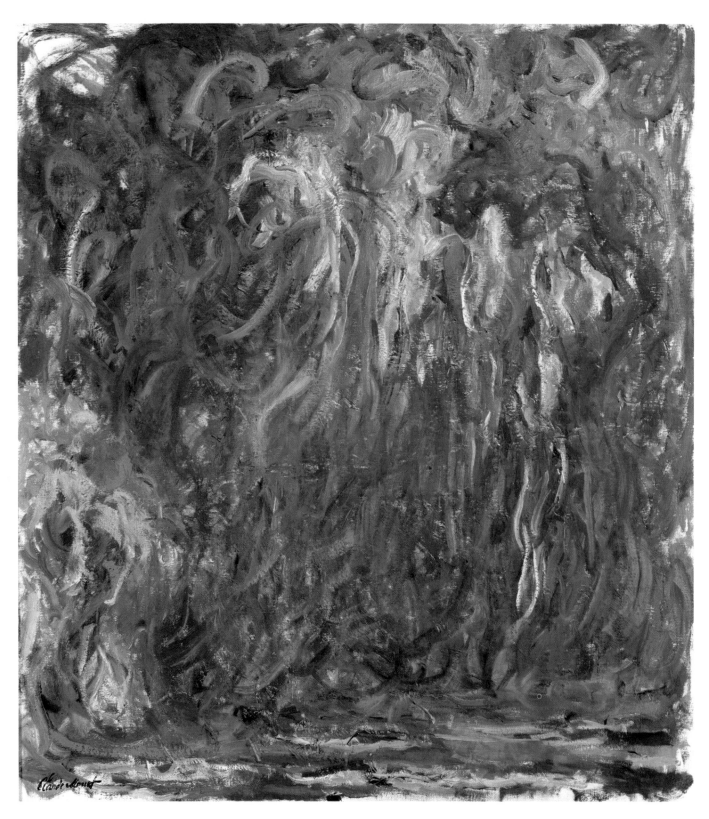

104 CLAUDE MONET
The weeping willow, *c*. 1923.
Beyeler collection, Basle.

105 AUGUSTE RENOIR
Portrait of Claude Monet, 1872.
Arthur Sachs collection, Paris.

106 AUGUSTE RENOIR
La Grenouillère, 1868/69.
Nationalmuseum, Stockholm.

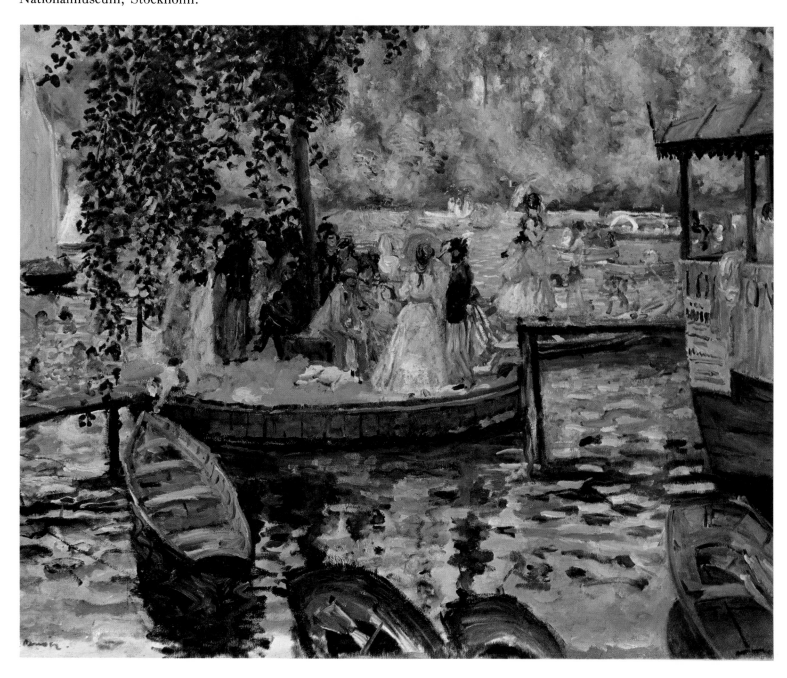

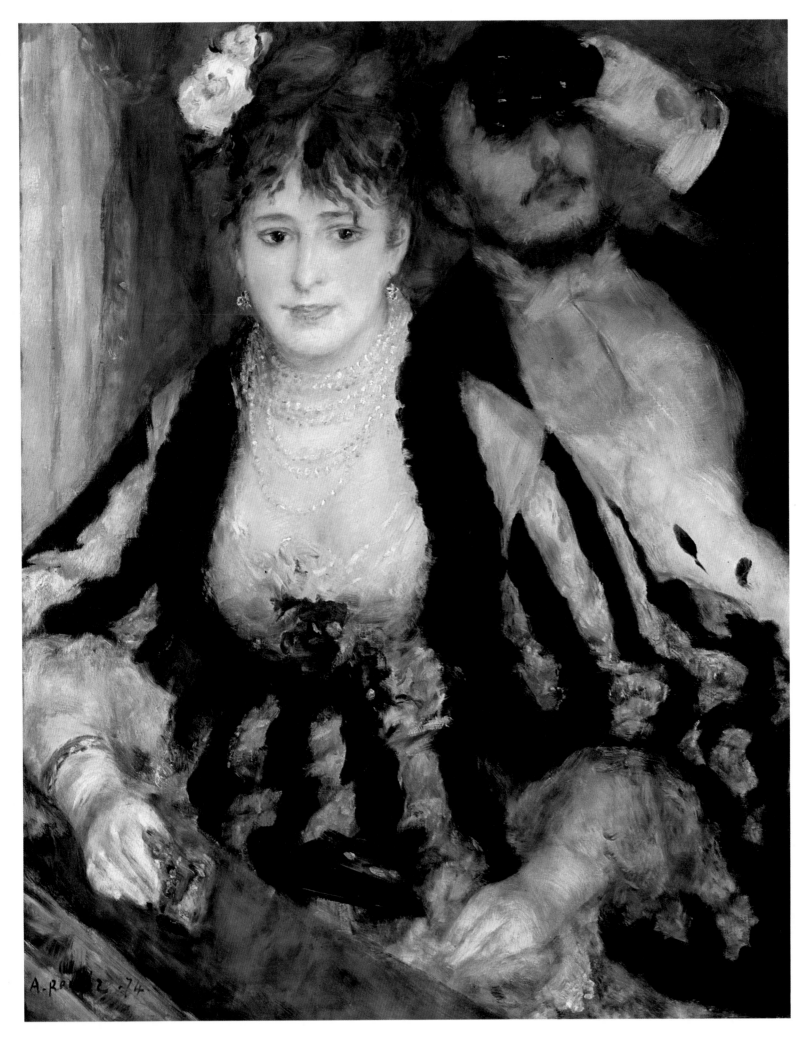

107 AUGUSTE RENOIR
La Loge, 1874. Courtauld Institute Galleries, London.

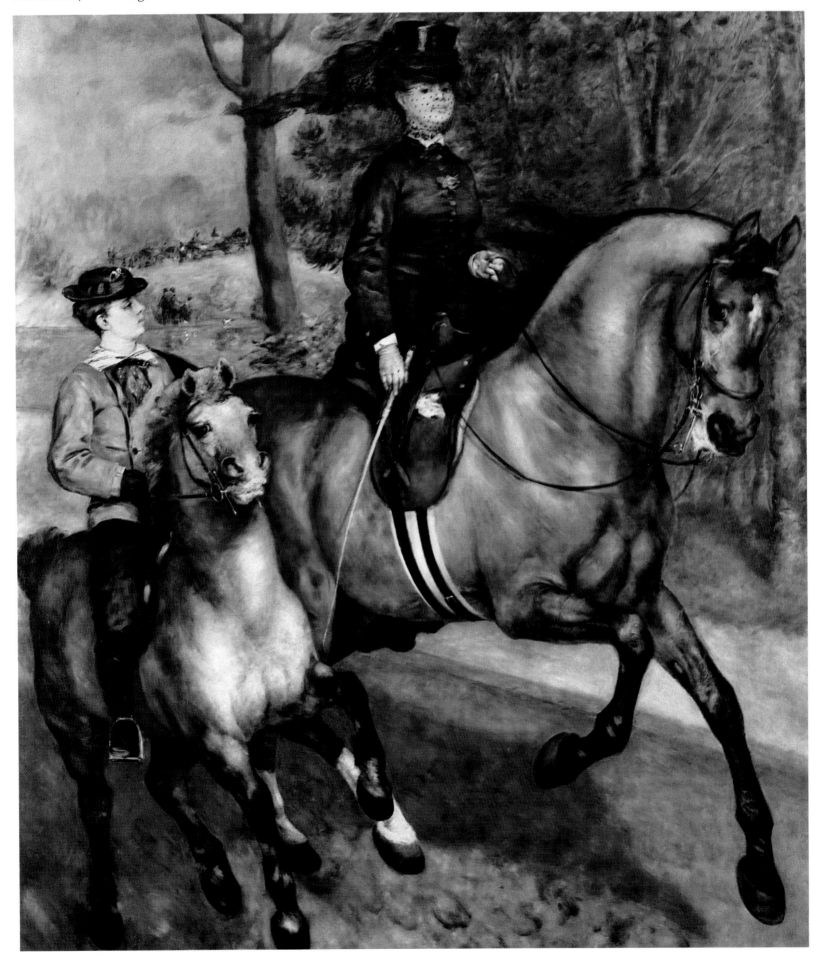

109 AUGUSTE RENOIR
The Seine near Champrosay, 1876.
Musée du Louvre, Paris.

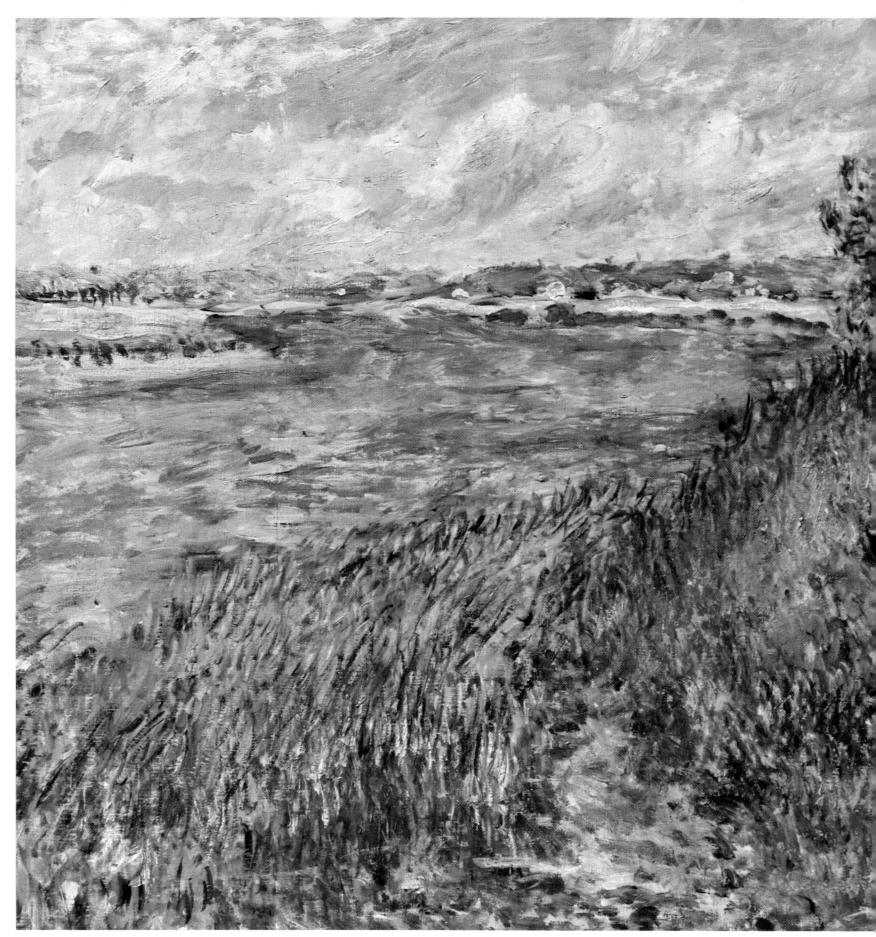

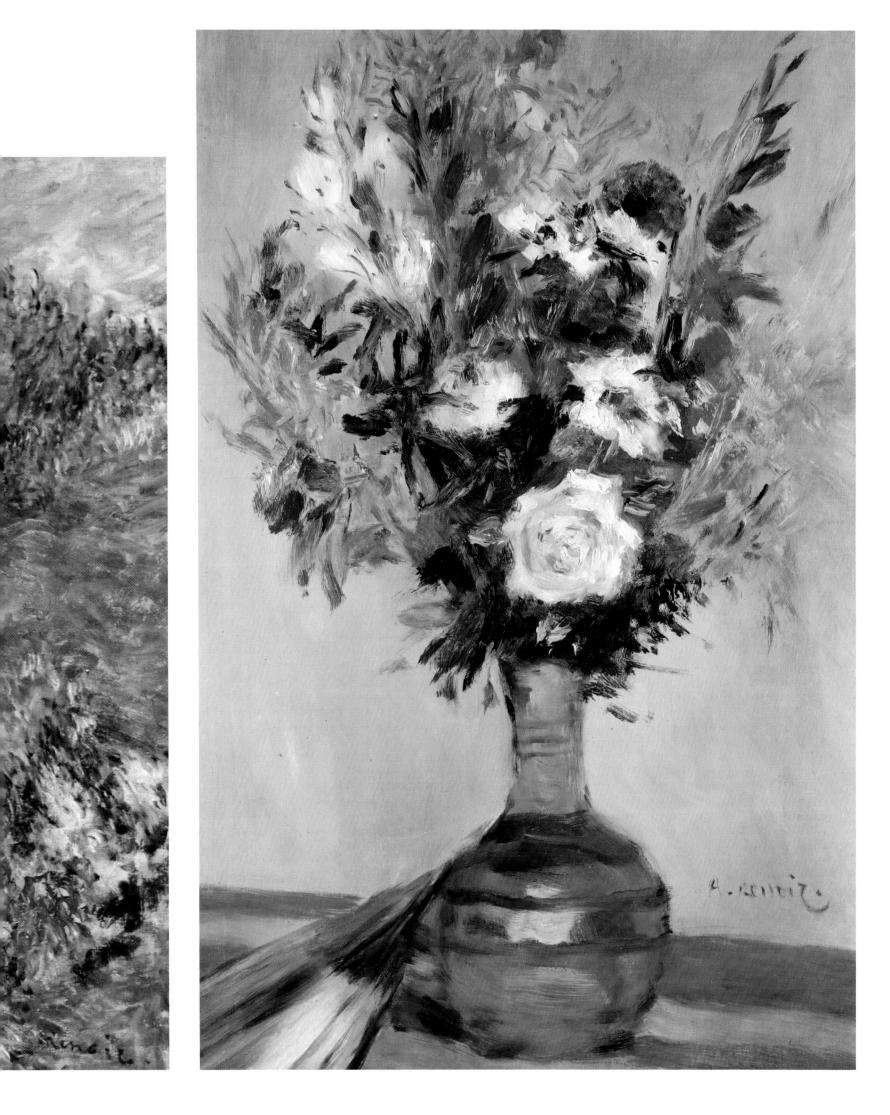

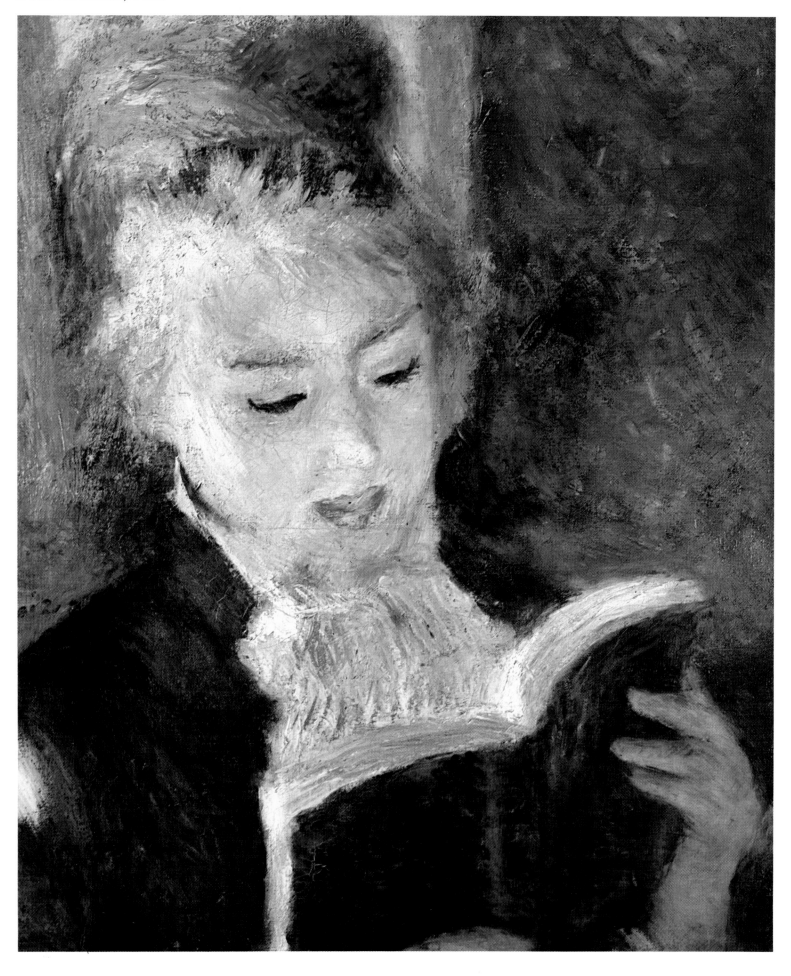

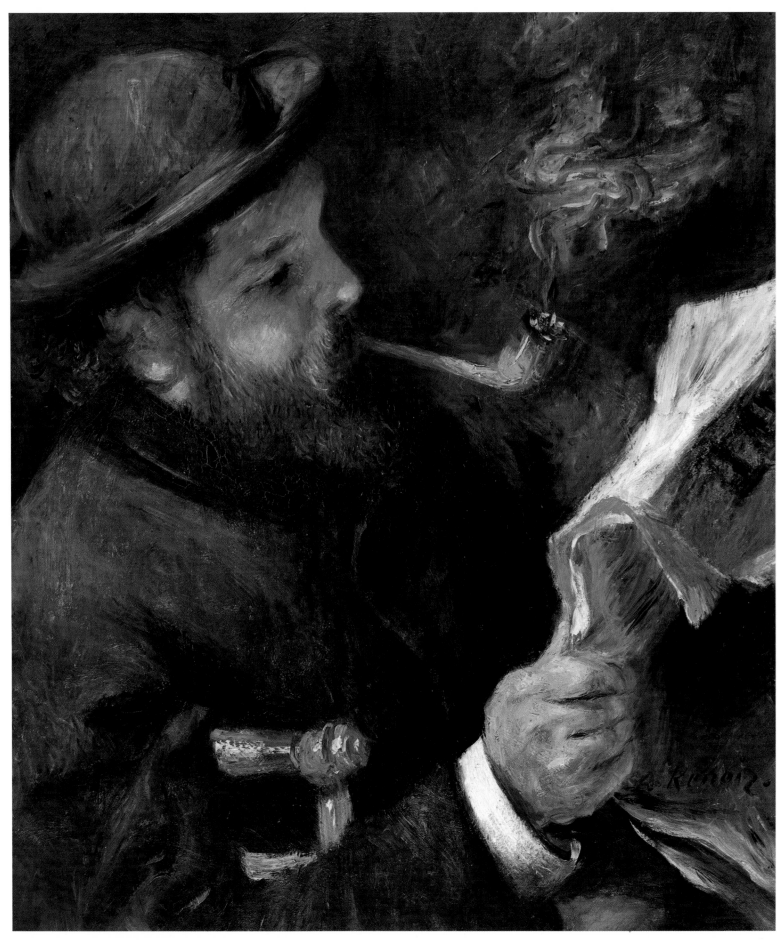

112 AUGUSTE RENOIR
Portrait of Claude Monet, 1872.
Musée Marmottan, Paris.

113 AUGUSTE RENOIR
Wild poppies, c. 1876.
Musée du Louvre, Paris.

Opposite

114 AUGUSTE RENOIR
First evening out, 1875/80.
National Gallery, London.

115 AUGUSTE RENOIR
Le Moulin de la Galette, 1876.
Musée du Louvre, Paris.

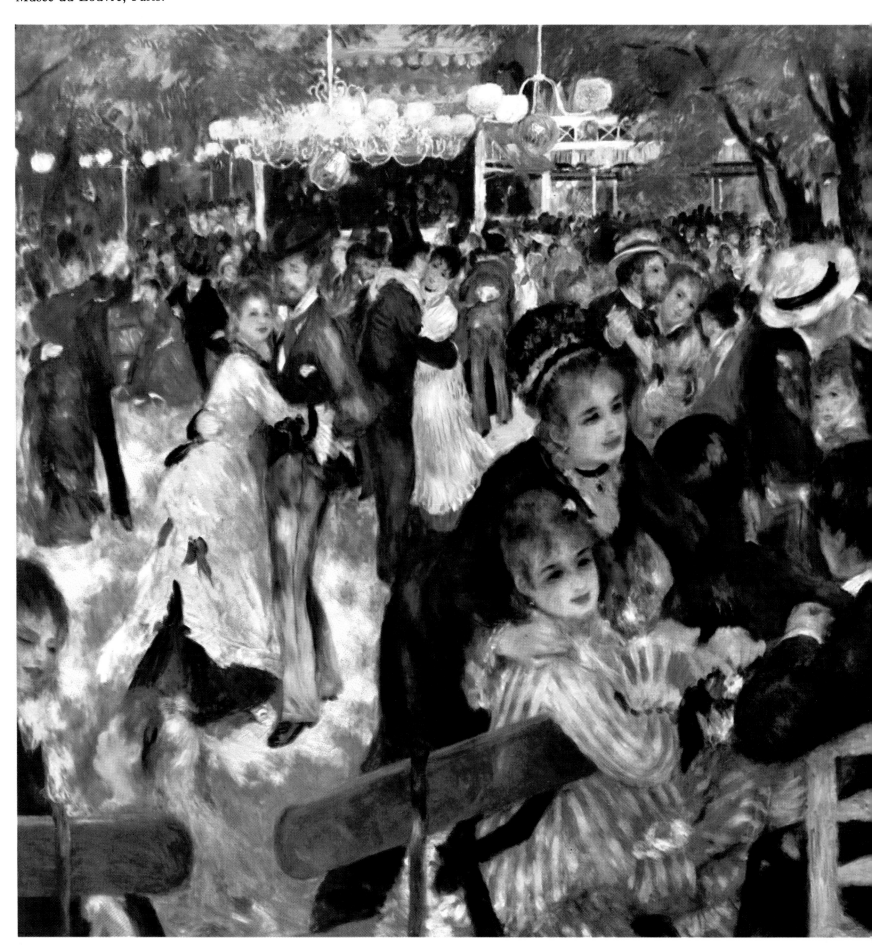

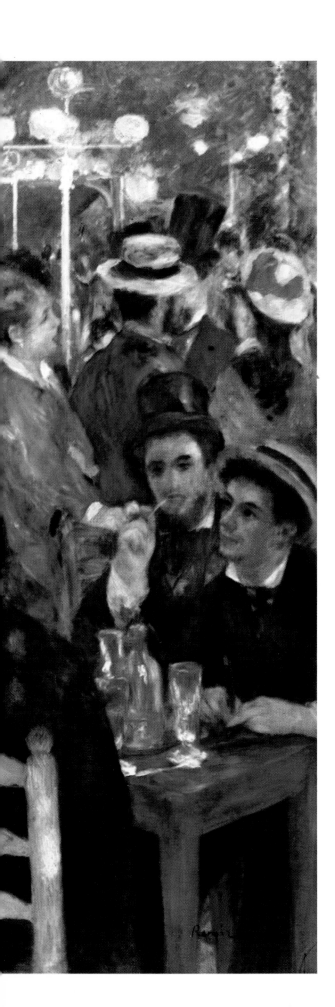

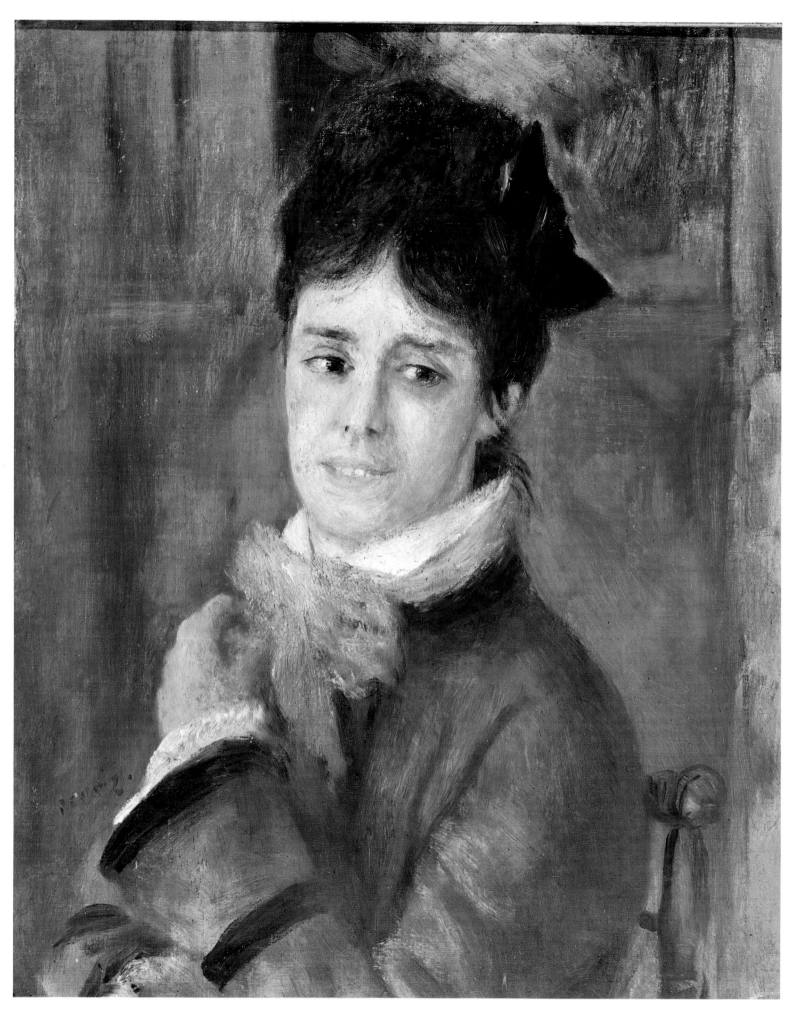

116 AUGUSTE RENOIR
Portrait of Mme. Monet, 1872, Musée Marmottan, Paris.

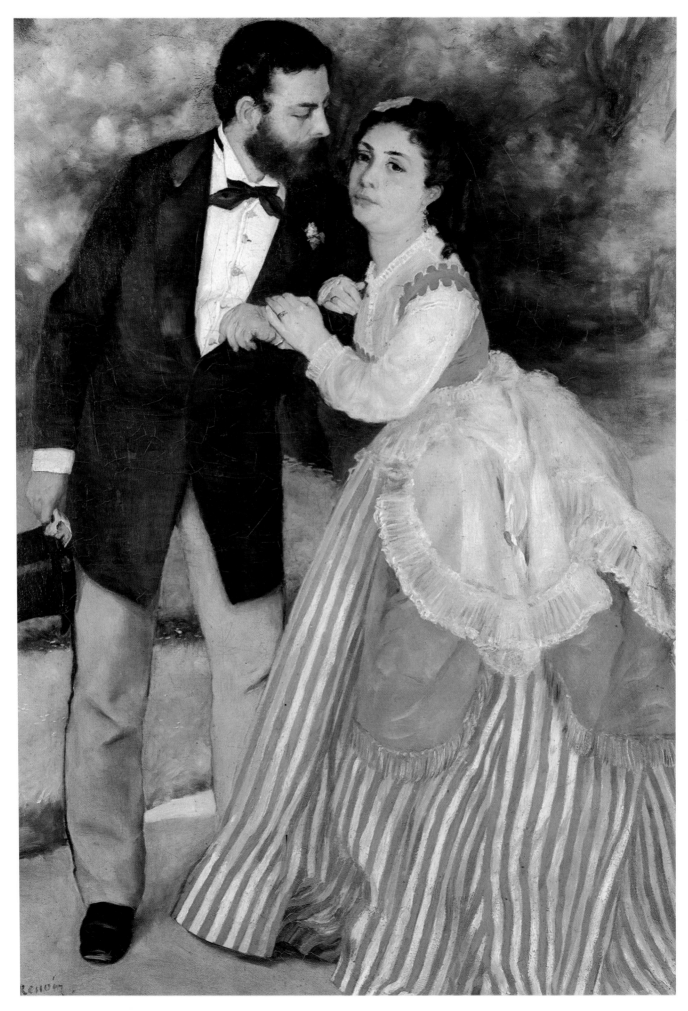

117 AUGUSTE RENOIR
The Sisleys, 1868. Wallraf-Richartz Museum, Cologne.

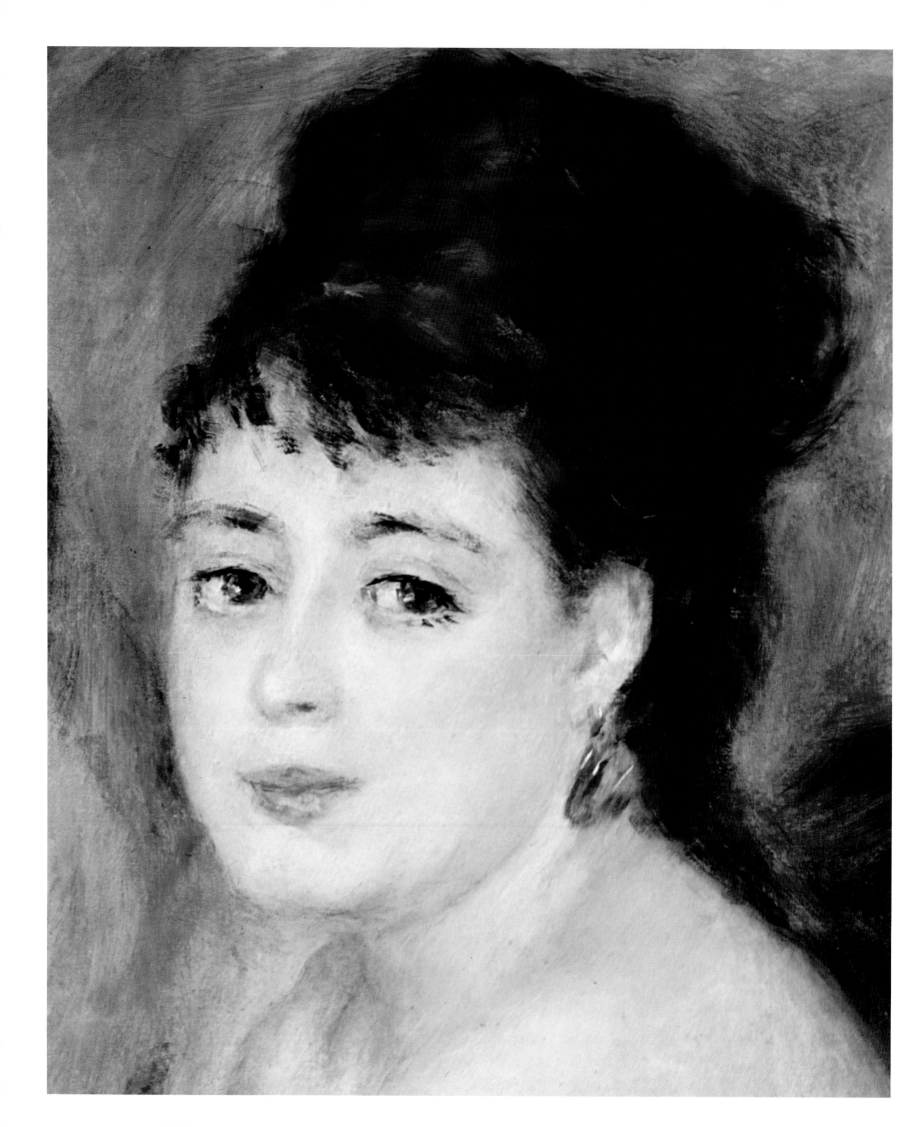

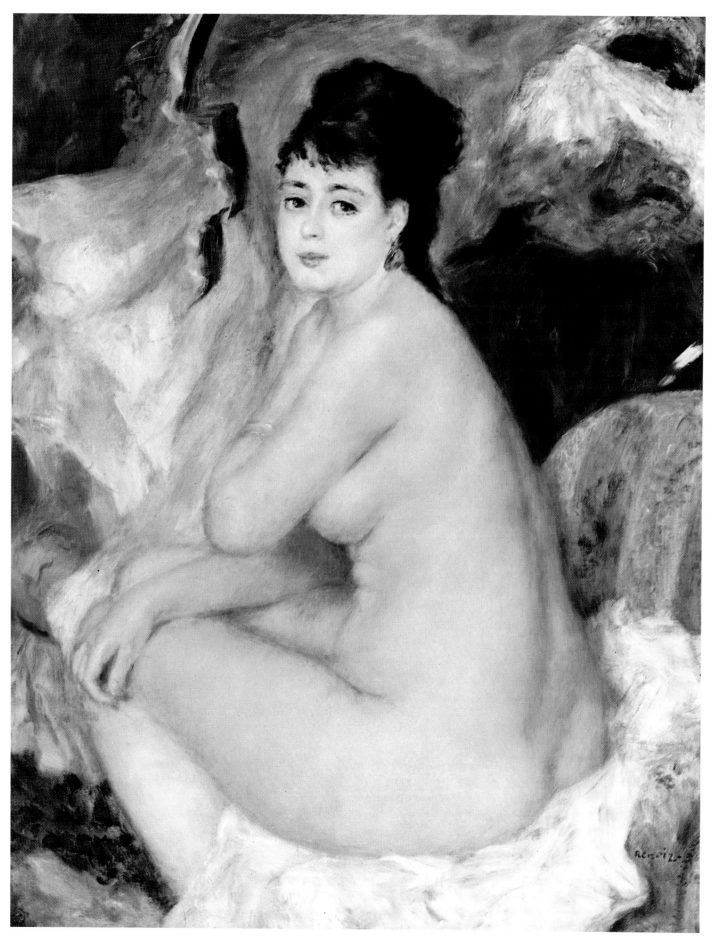

Opposite

118 AUGUSTE RENOIR
Detail from *Nude on a Sofa* (Plate 119).

119 AUGUSTE RENOIR
Nude on a Sofa, 1876. Pushkin Museum, Moscow.

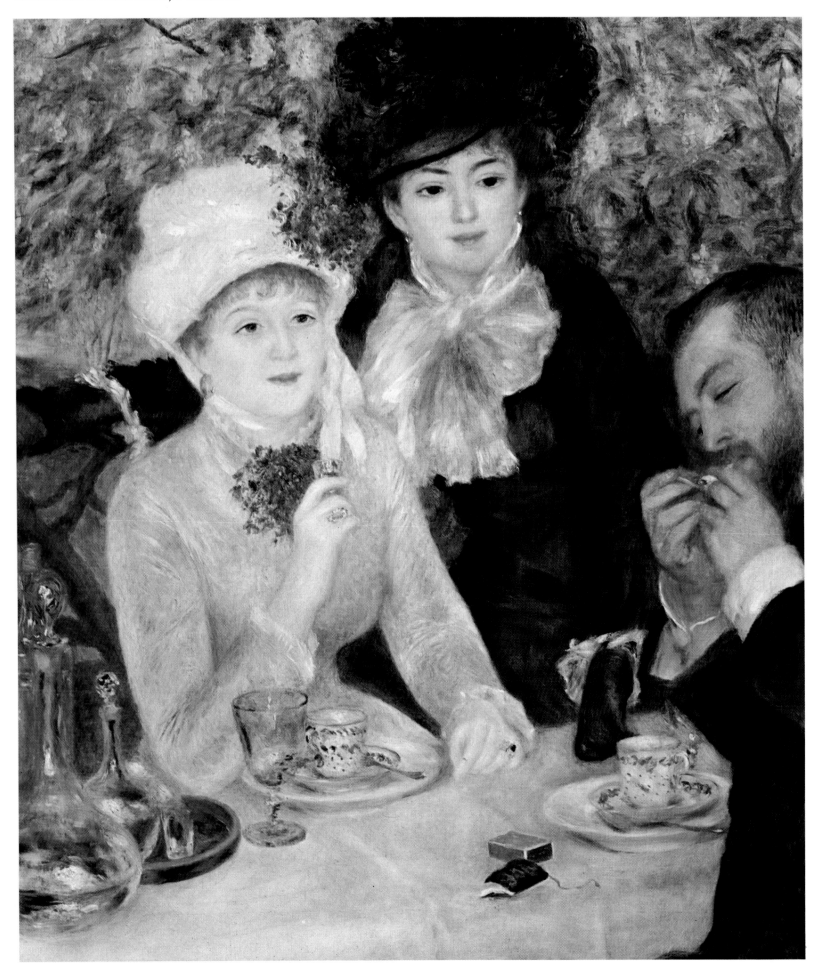

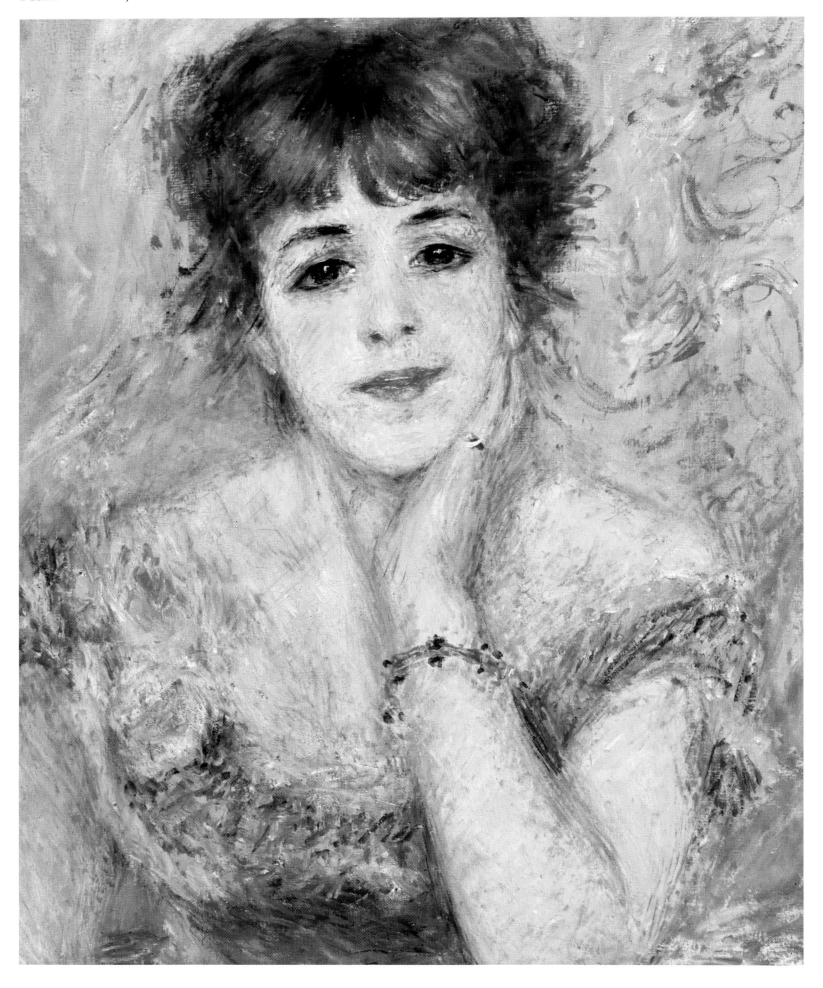

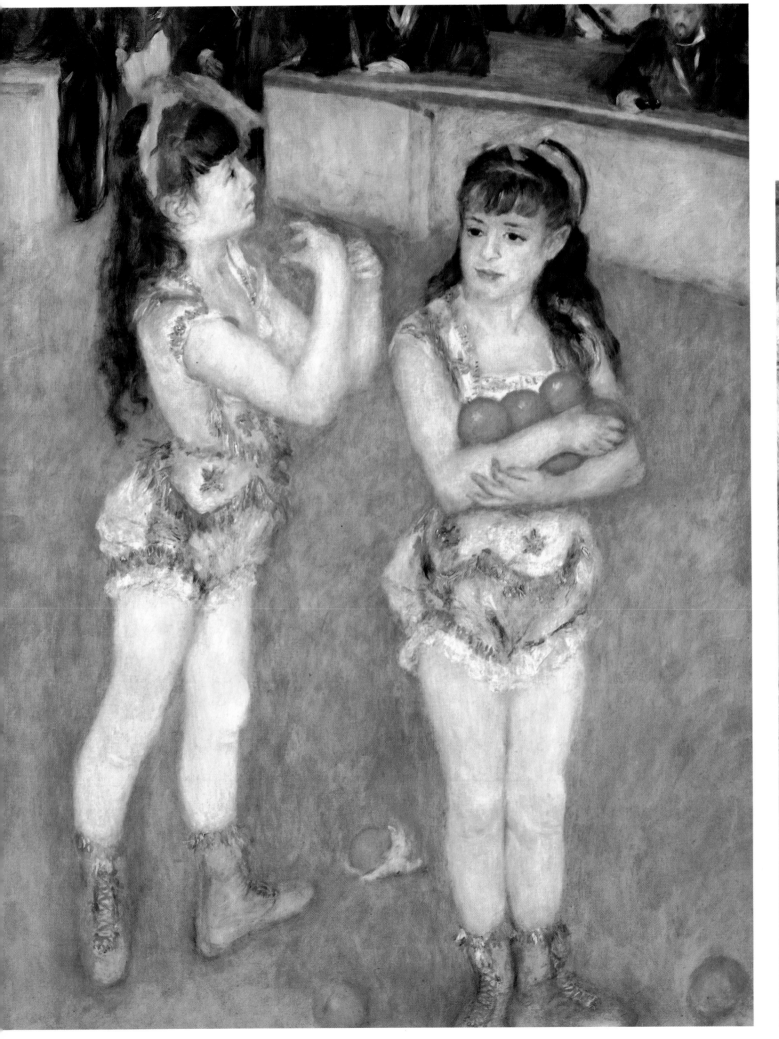

122 AUGUSTE RENOIR
Two young circus girls, 1879.
The Art Institute, Chicago.

123 AUGUSTE RENOIR
The Boatmen's lunch, 1881.
The Phillips collection, Washington D.C.

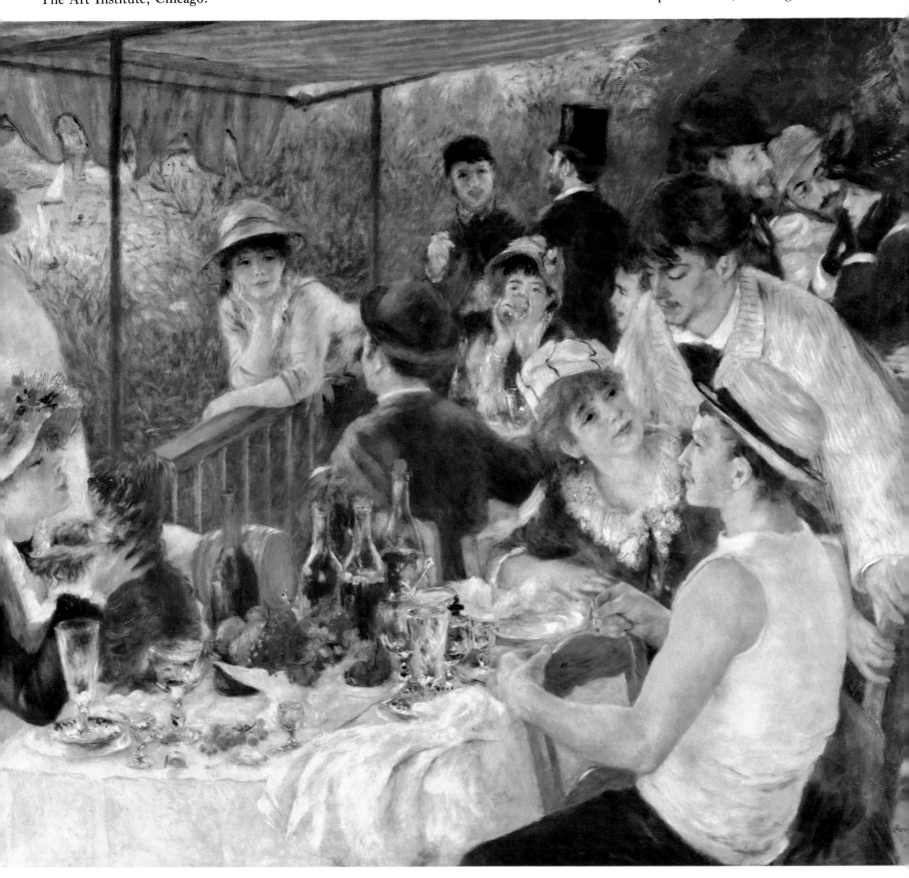

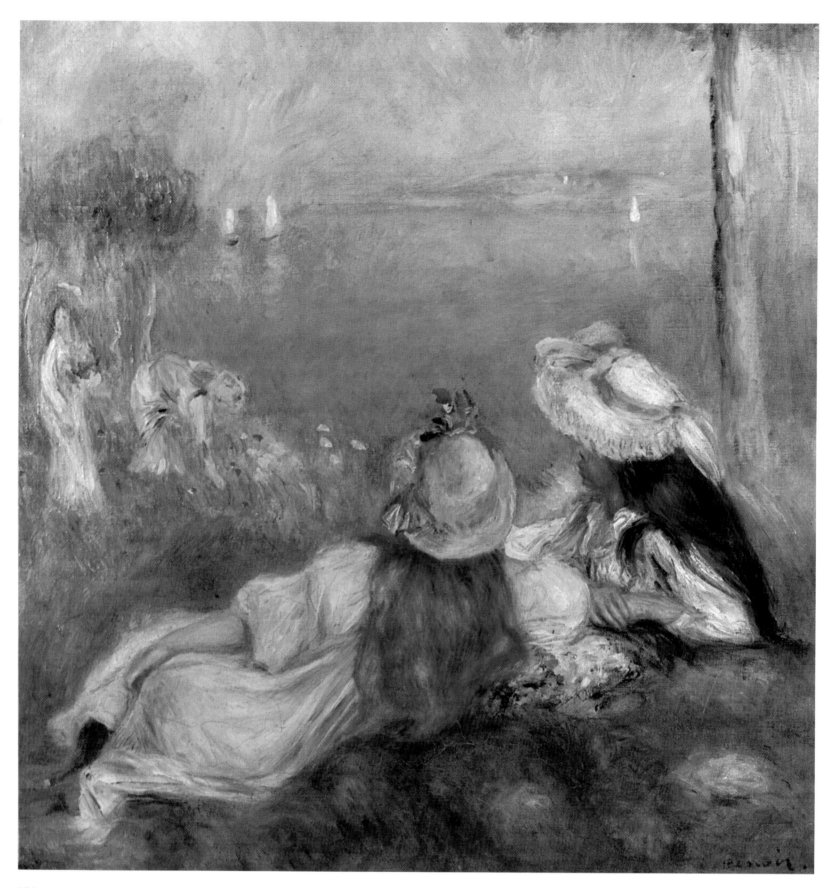

124 AUGUSTE RENOIR
Girls on the sea-shore, 1894.
Durand-Ruel collection, Paris.

125 AUGUSTE RENOIR
L'Estaque, 1882.
Museum of Fine Arts, Boston.

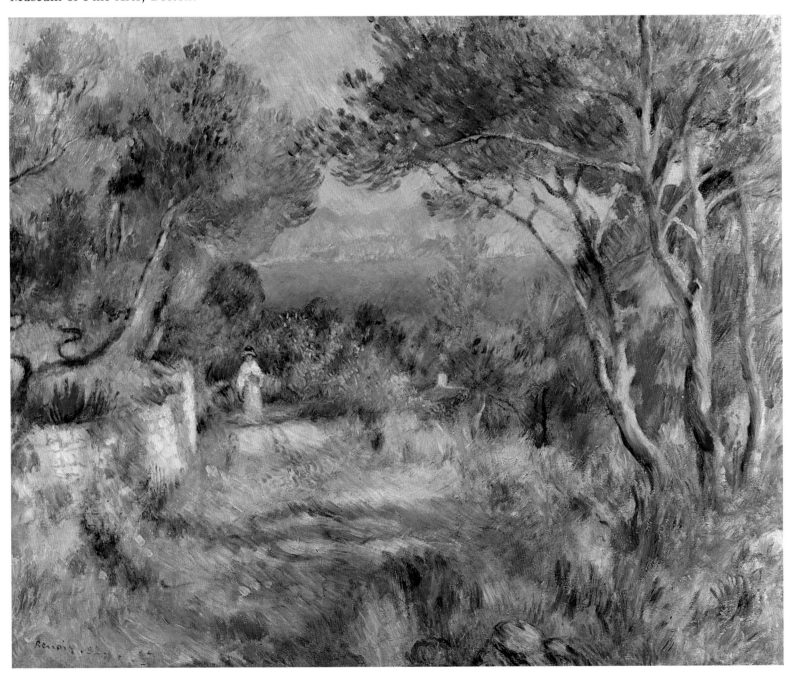

126 AUGUSTE RENOIR
Arab festival in Algiers, 1881.
Musée du Louvre, Paris.

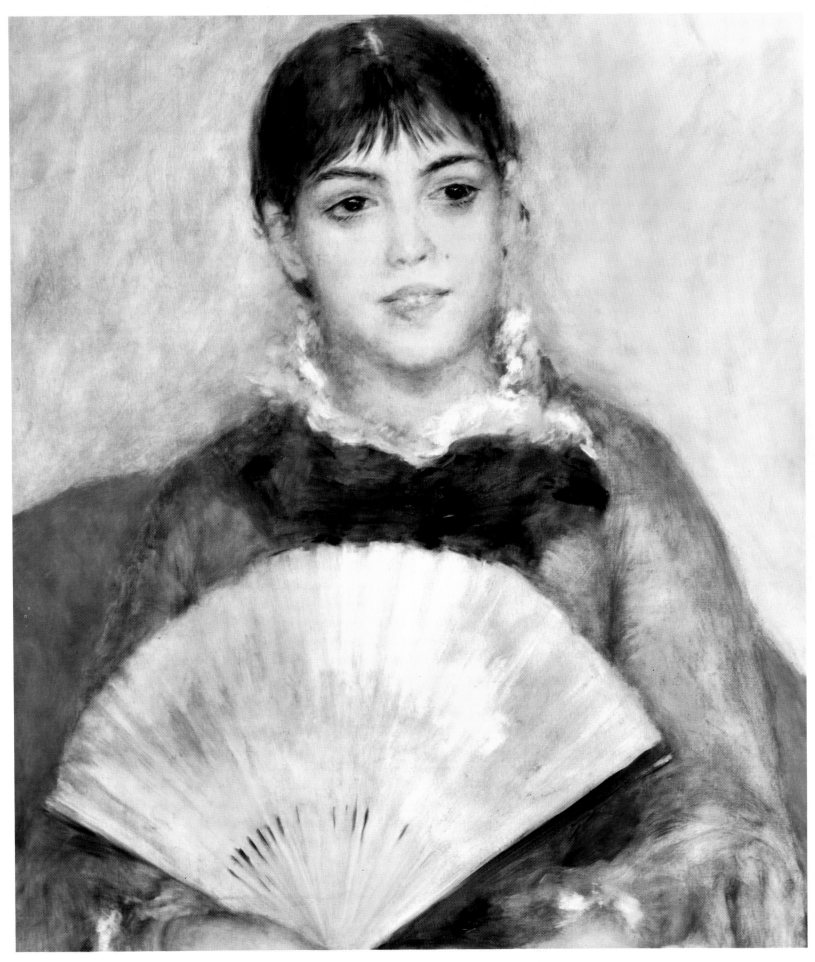

127 AUGUSTE RENOIR
Girl with a fan, 1891. Hermitage, Leningrad.

128 AUGUSTE RENOIR
Study for
Les Grandes
Baigneuses, 1883/85.
Musée du Louvre,
Cabinet des dessins,
Paris.

129 AUGUSTE RENOIR
Les Grandes
Baigneuses, 1884/87.
Philadelphia Museum
of Art,
Carroll S. Tyson
collection,
Philadelphia.

Opposite

130 AUGUSTE RENOIR
Bather, 1882.
Private collection.

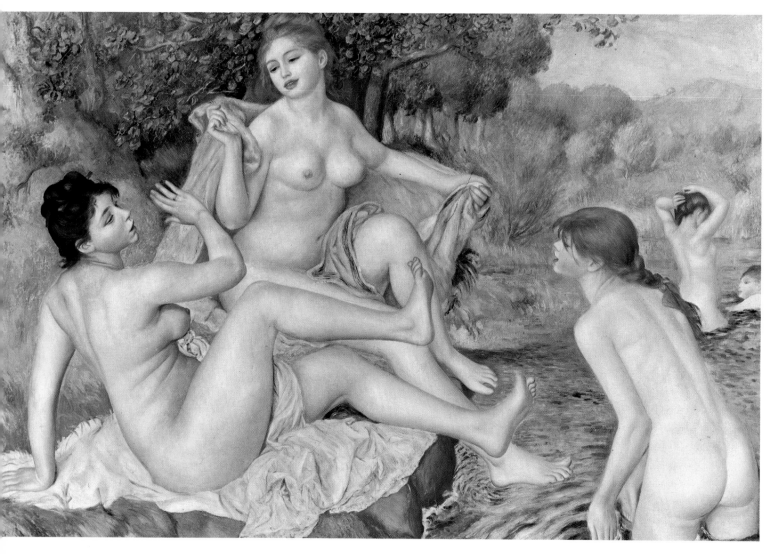

Opposite

131 AUGUSTE RENOIR
Seated bather, 1910.
Museo de São Paulo,
São Paulo.

132 AUGUSTE RENOIR
Two bathers, c. 1915.
Nationalmuseum,
Stockholm.

133 AUGUSTE RENOIR
The bathers, 1918/19.
Musée du
Louvre, Paris.

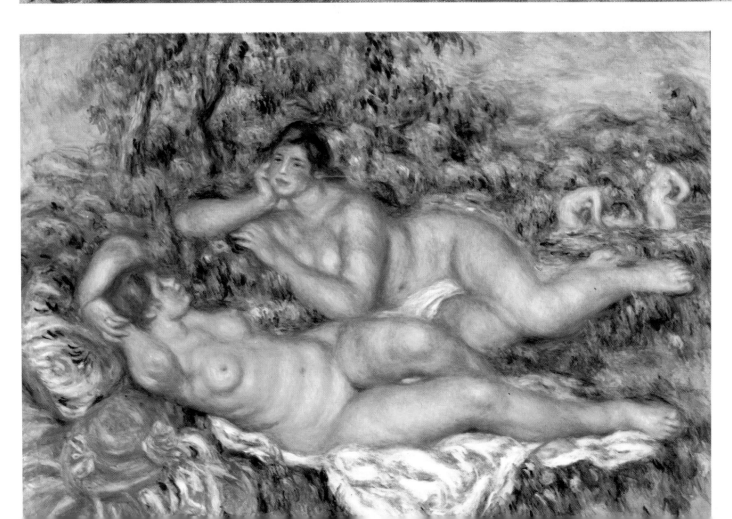

Opposite

134 AUGUSTE RENOIR
Woman combing her hair, 1907/08.
Musée du Louvre, Paris.

135 EDGAR DEGAS
René Degas as a child, 1855.
Private collection.

136 EDGAR DEGAS
Diego Martelli, the engraver, 1879.
National Gallery of Scotland, Edinburgh.

137 EDGAR DEGAS
The cotton market in New Orleans, 1873.
Musée des Beaux-Arts, Pau.

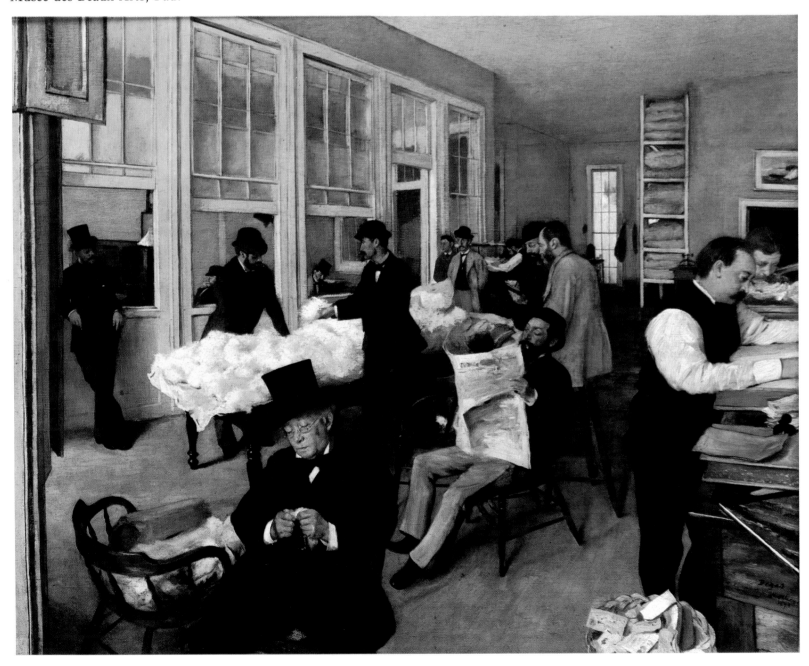

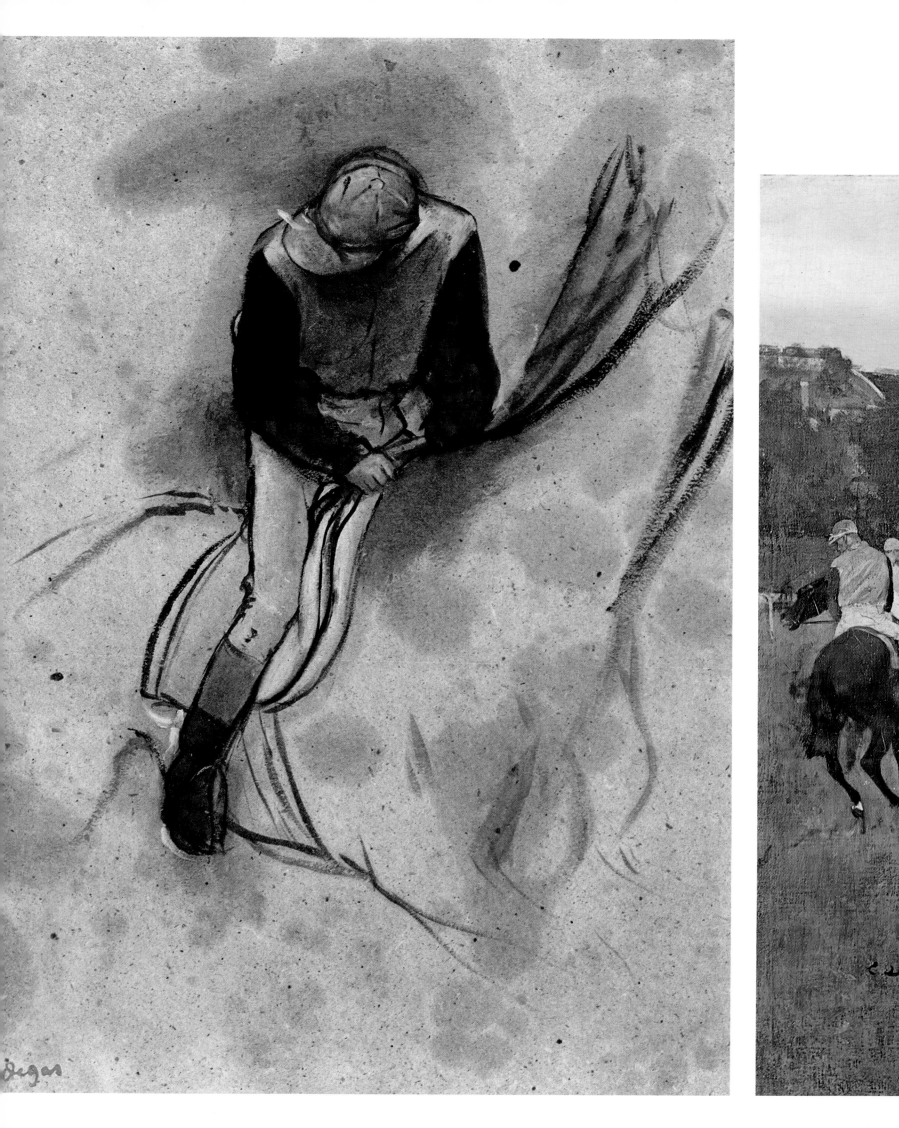

Degas

138 EDGAR DEGAS
Jockey, 1868.
Private collection.

139 EDGAR DEGAS
Race-horses at Longchamp, 1873/75.
Museum of Fine Arts, Boston.

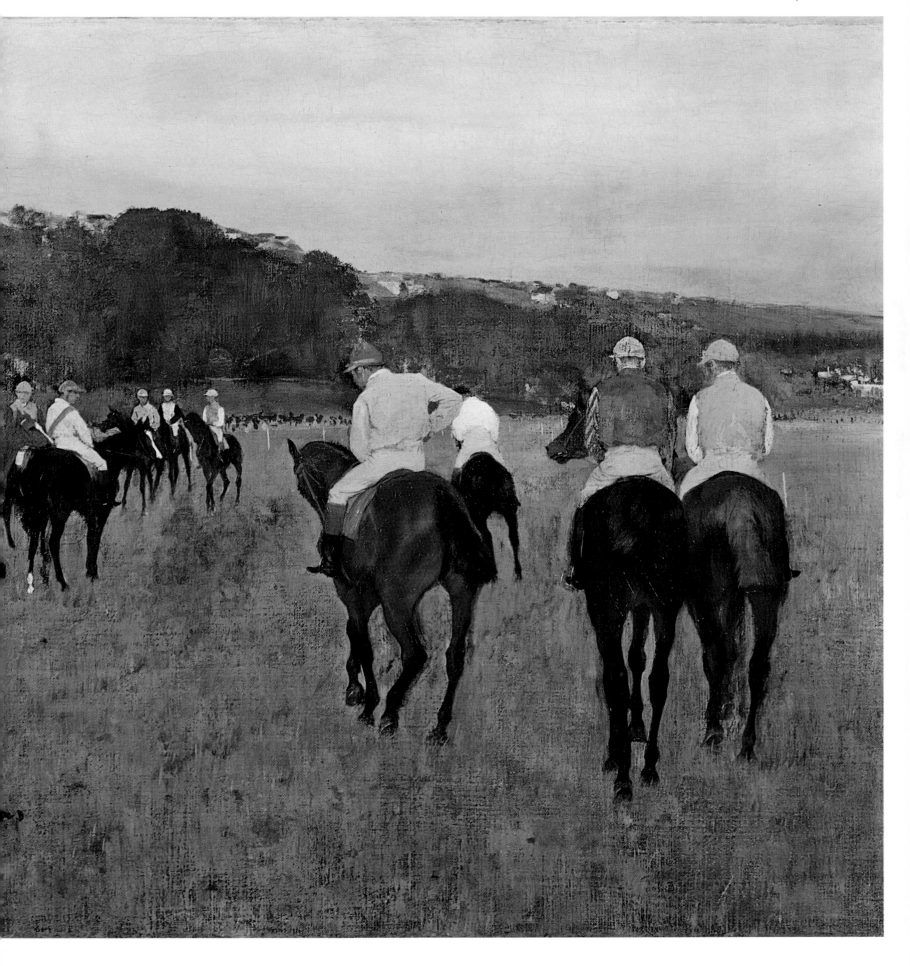

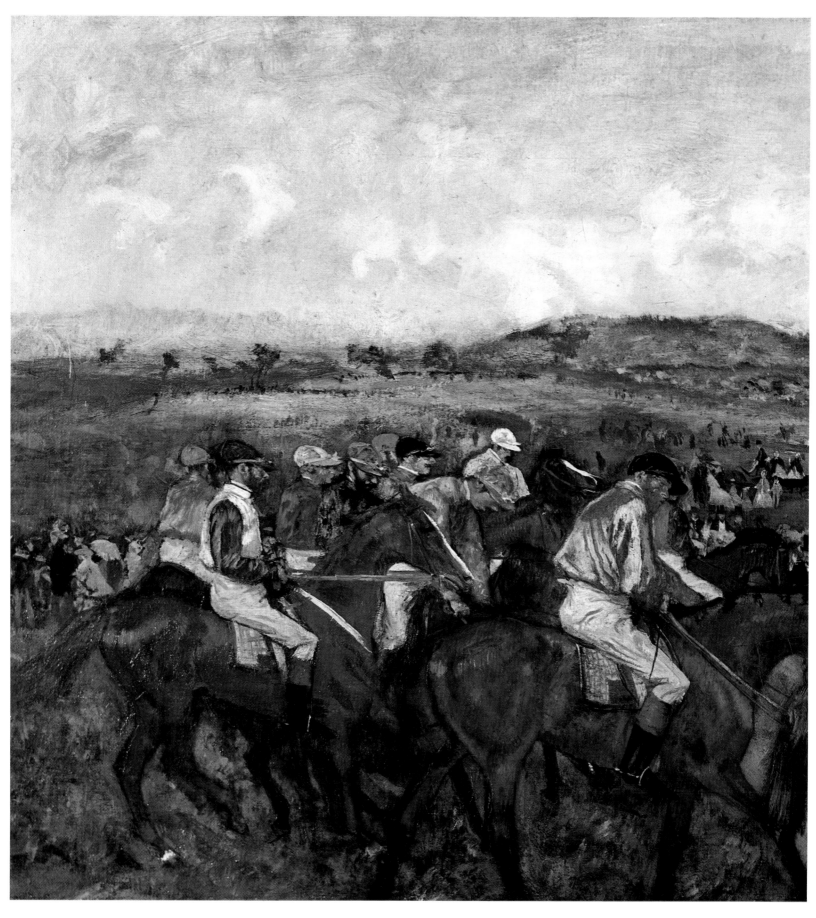

140 EDGAR DEGAS
Before the start (detail), 1862.
Musée de Louvre, Paris.

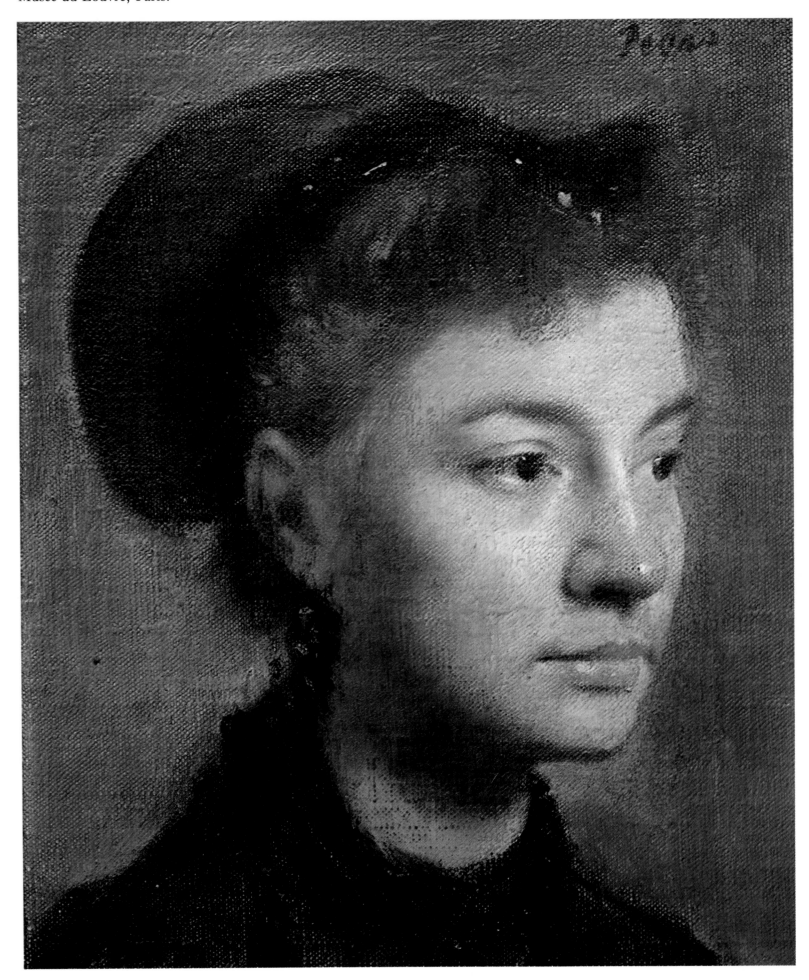

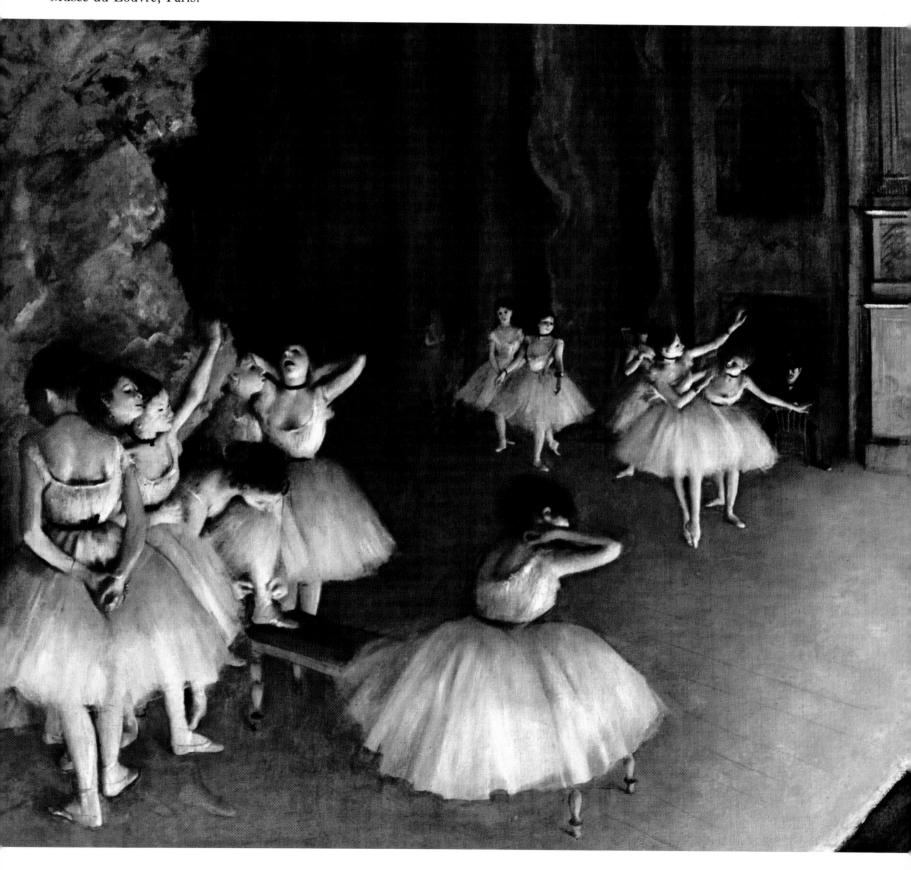

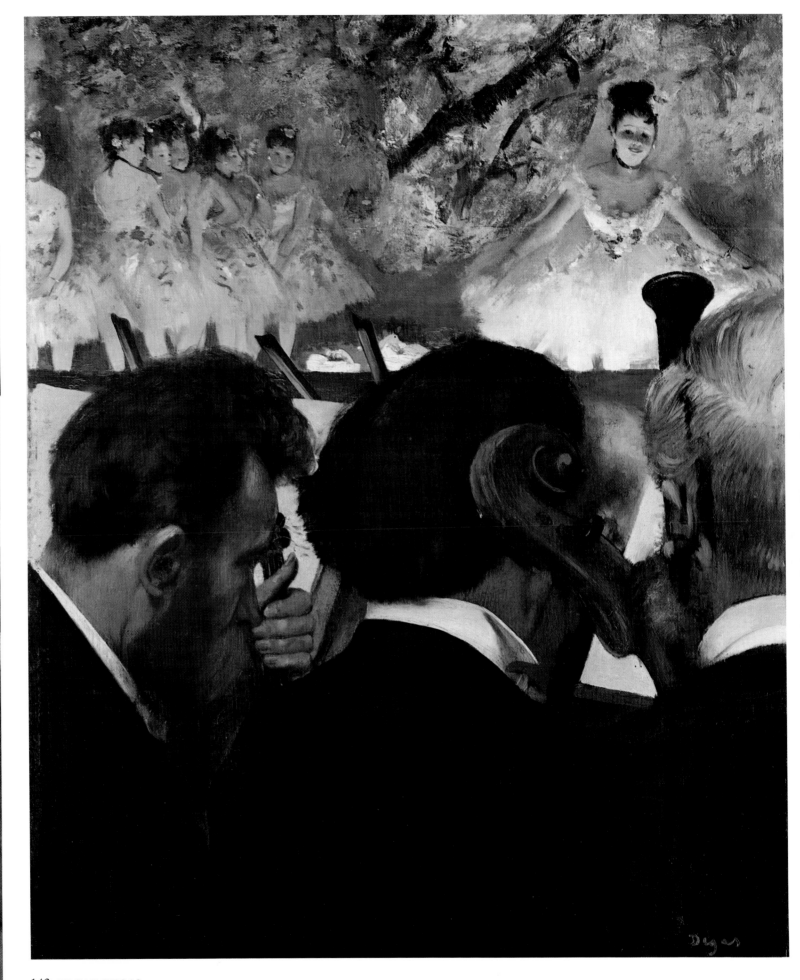

143 EDGAR DEGAS
Orchestra musicians, 1872.
Städelsches Kunstinstitut, Frankfurt.

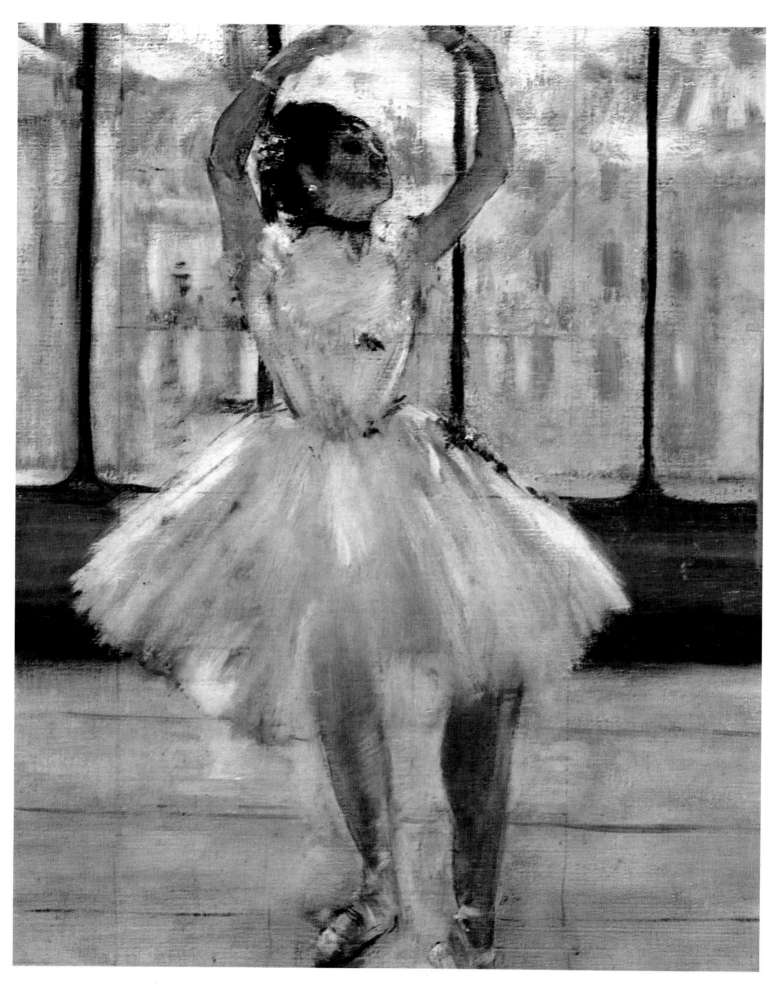

144 EDGAR DEGAS
Dancer posing for a photograph (detail), 1877/78.
Pushkin Museum, Moscow.

145 EDGAR DEGAS
Dancer tying her shoe ribbons, 1886.
Durand-Ruel collection, Paris.

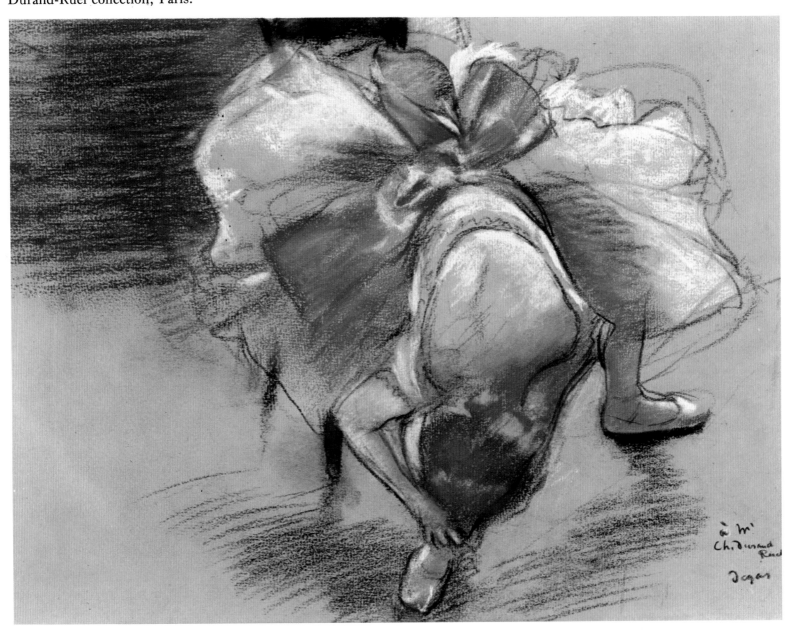

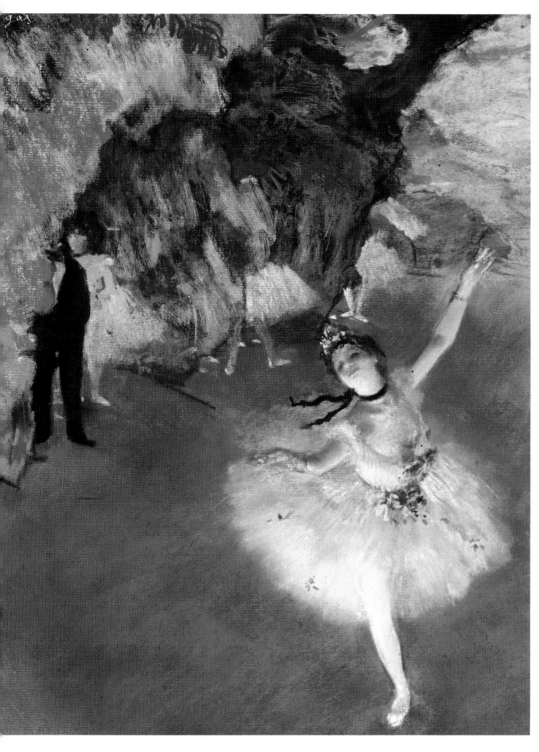

147 EDGAR DEGAS
Dancers, 1884.
Durand-Ruel collection, Paris.

146 EDGAR DEGAS
Dancer on the stage, 1878.
Musée du Louvre, Paris.

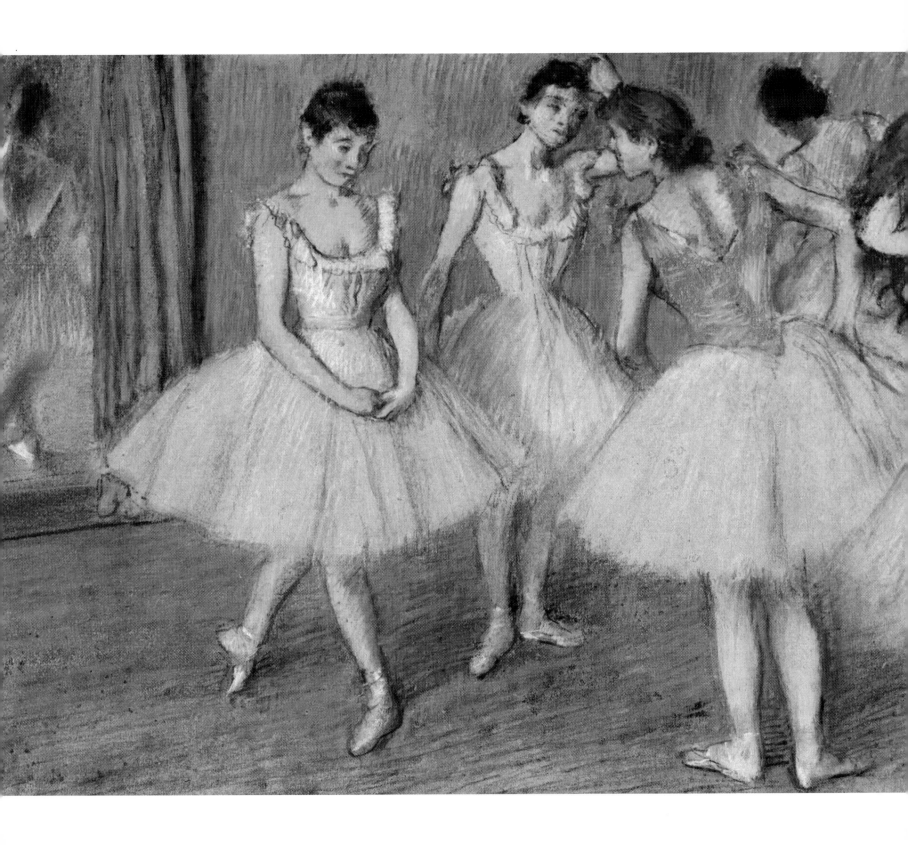

148 EDGAR DEGAS
Detail from *The Blue Dancers* (plate 149).

149 EDGAR DEGAS
The Blue Dancers, 1890. Musée du Louvre, Paris.

150 EDGAR DEGAS
Absinthe, 1876.
Musée du Louvre, Paris.

151 EDGAR DEGAS
The singer in gloves, 1878.
Fogg Art Museum, Cambridge, Mass.

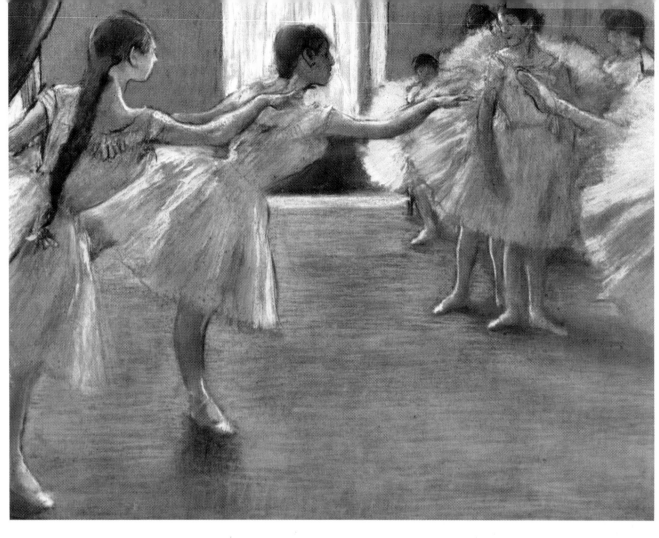

152 EDGAR DEGAS
Dancers in rehearsal, 1879.
Pushkin Museum, Moscow.

153 EDGAR DEGAS
In the wings, 1882.
National Gallery of
Scotland, Edinburgh.

Opposite

154 EDGAR DEGAS
Dancer with fan, 1879.
Private collection.

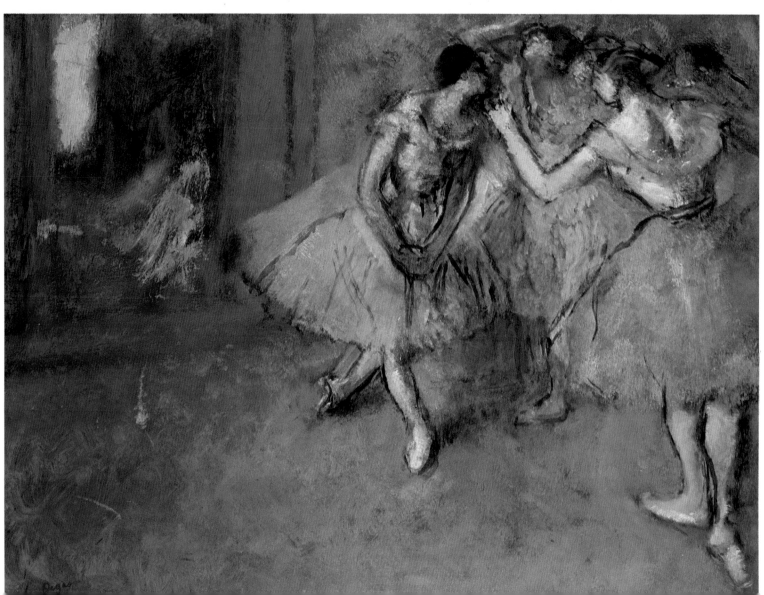

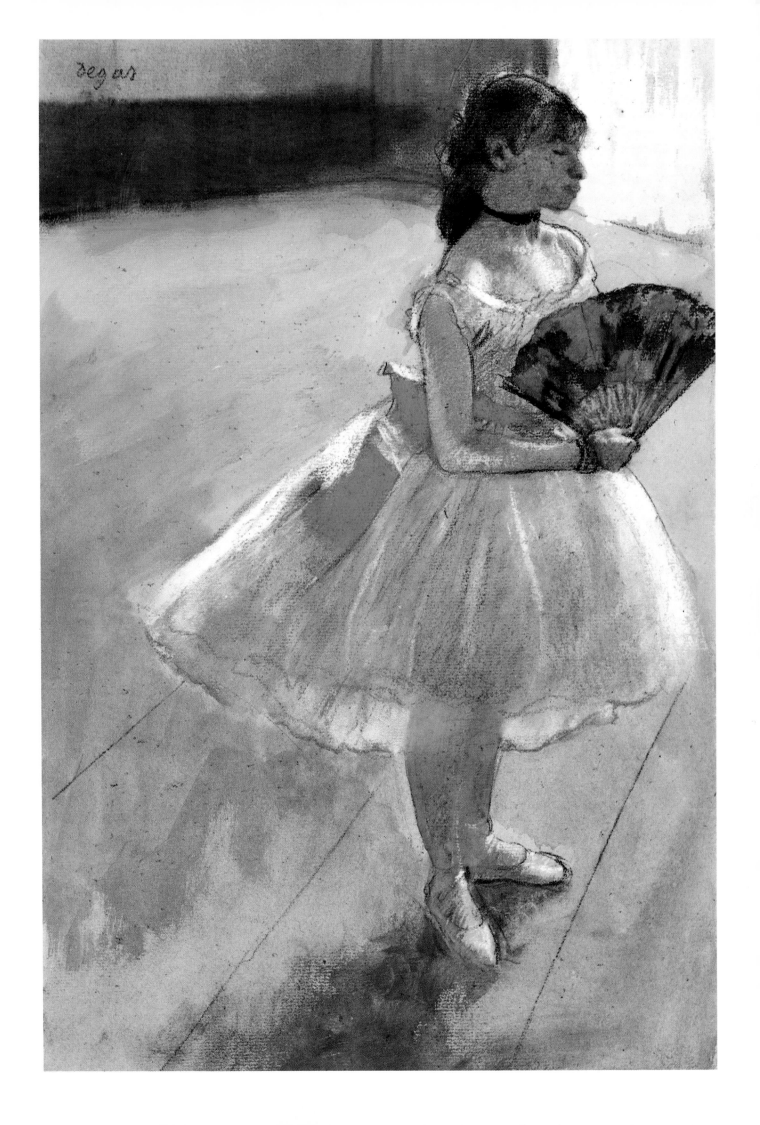

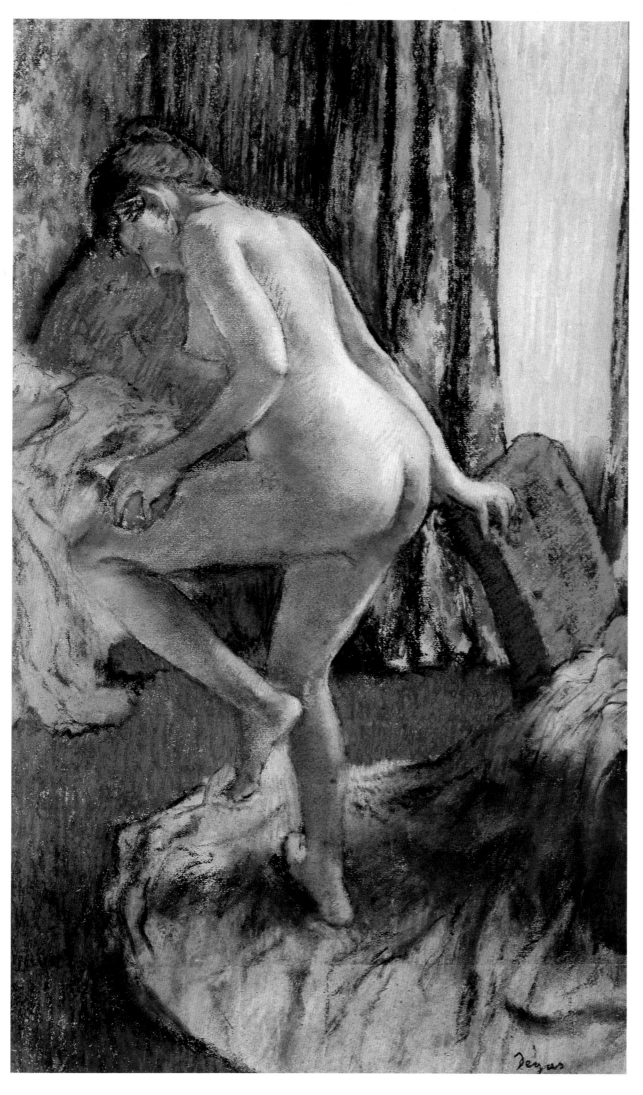

155 EDGAR DEGAS
After the bath, 1883.
Durand-Ruel collection, Paris.

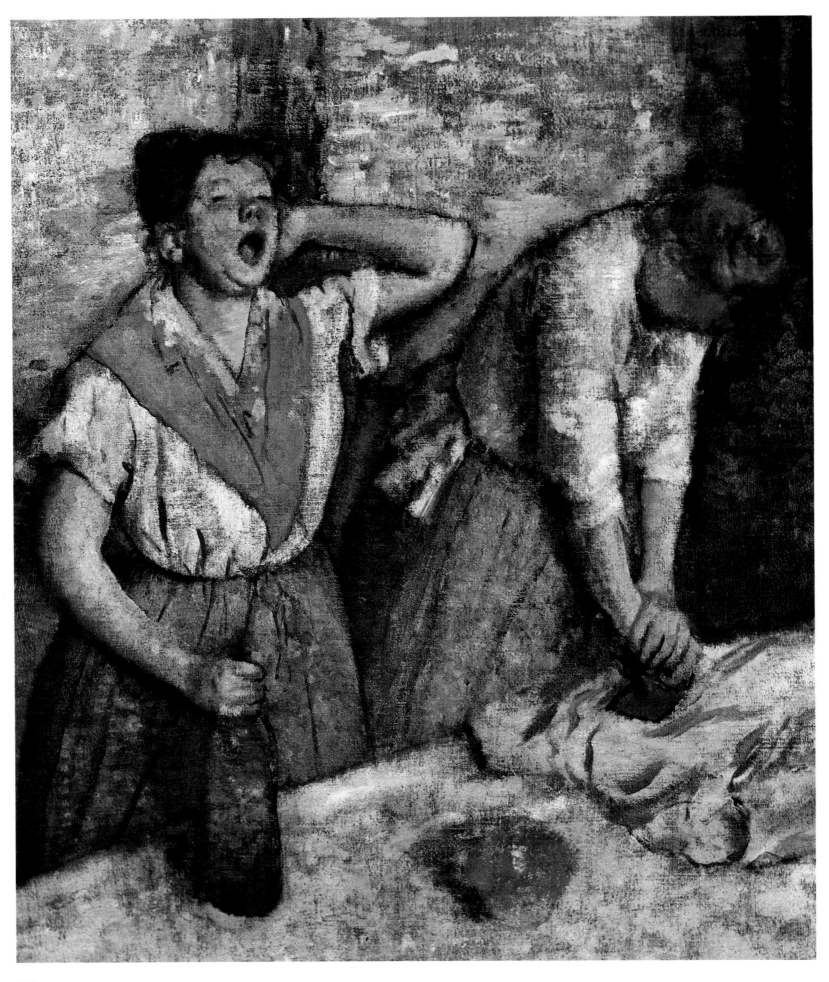

156 EDGAR DEGAS
The laundresses, 1884.
Musée du Louvre, Paris.

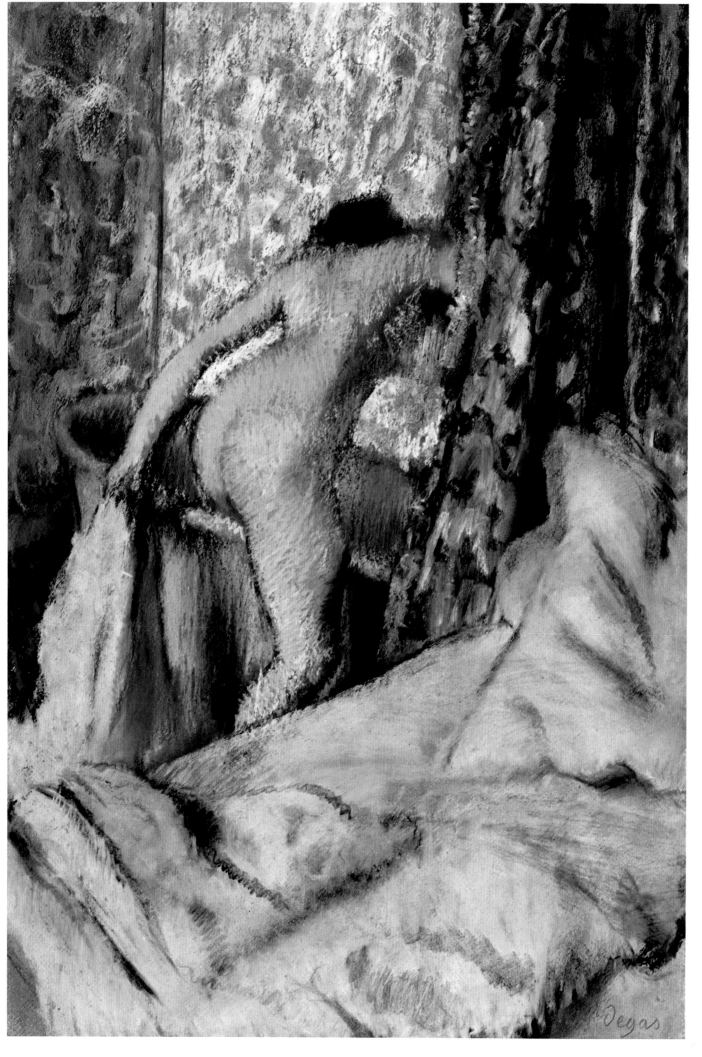

157 EDGAR DEGAS
The morning bath, *c.* 1890
The Art Institute,
Potter Palmer collection,
Chicago.

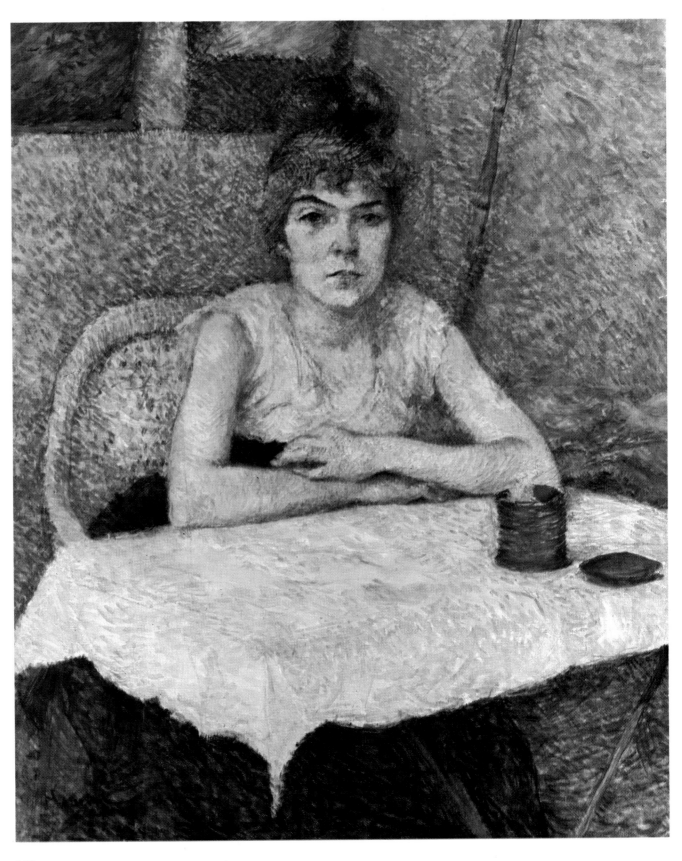

158 HENRI DE TOULOUSE-LAUTREC
Poudre de riz, 1889.
Stedelijk Museum, Amsterdam.

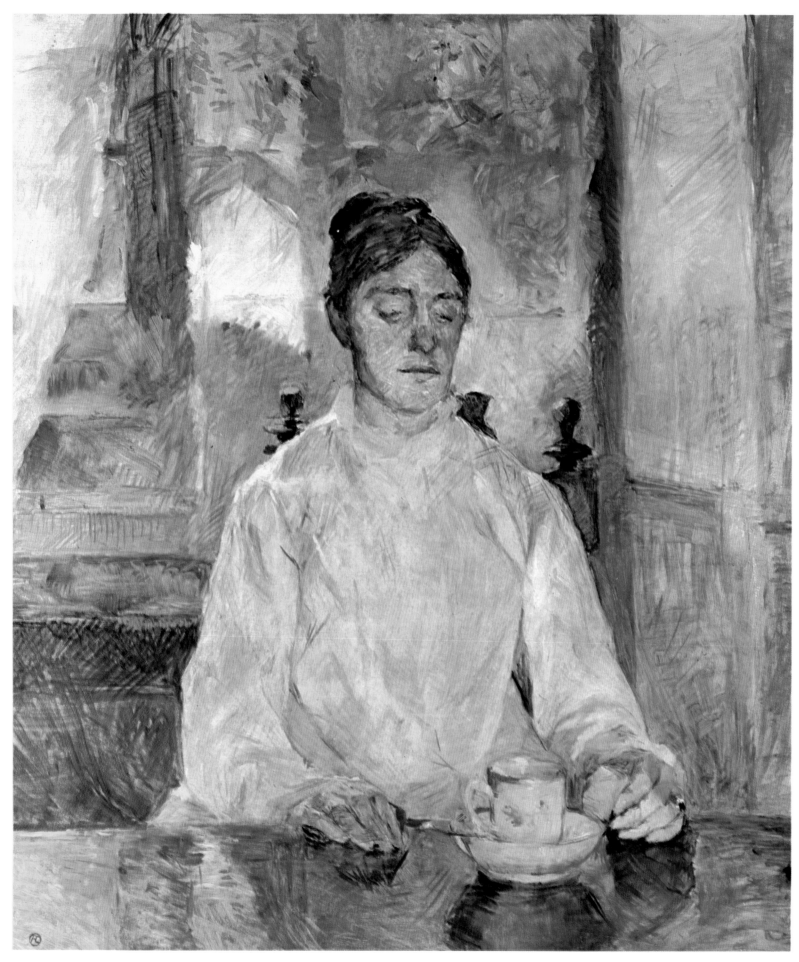

159 HENRI DE TOULOUSE-LAUTREC
The artist's mother at breakfast, 1883.
Musée Toulouse-Lautrec, Albi.

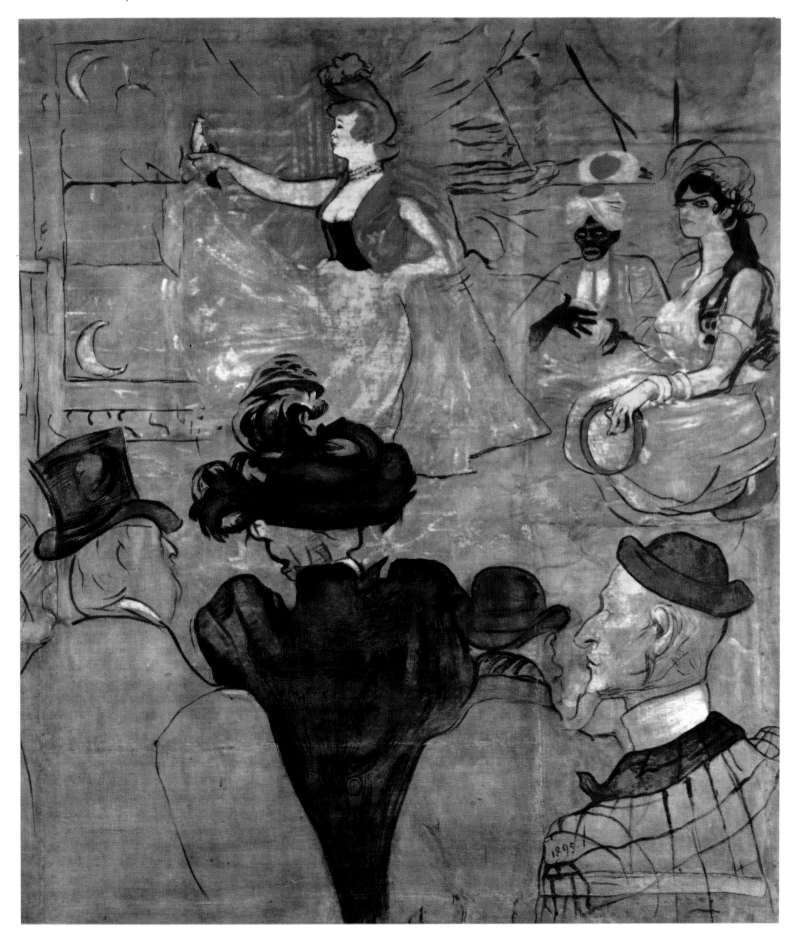

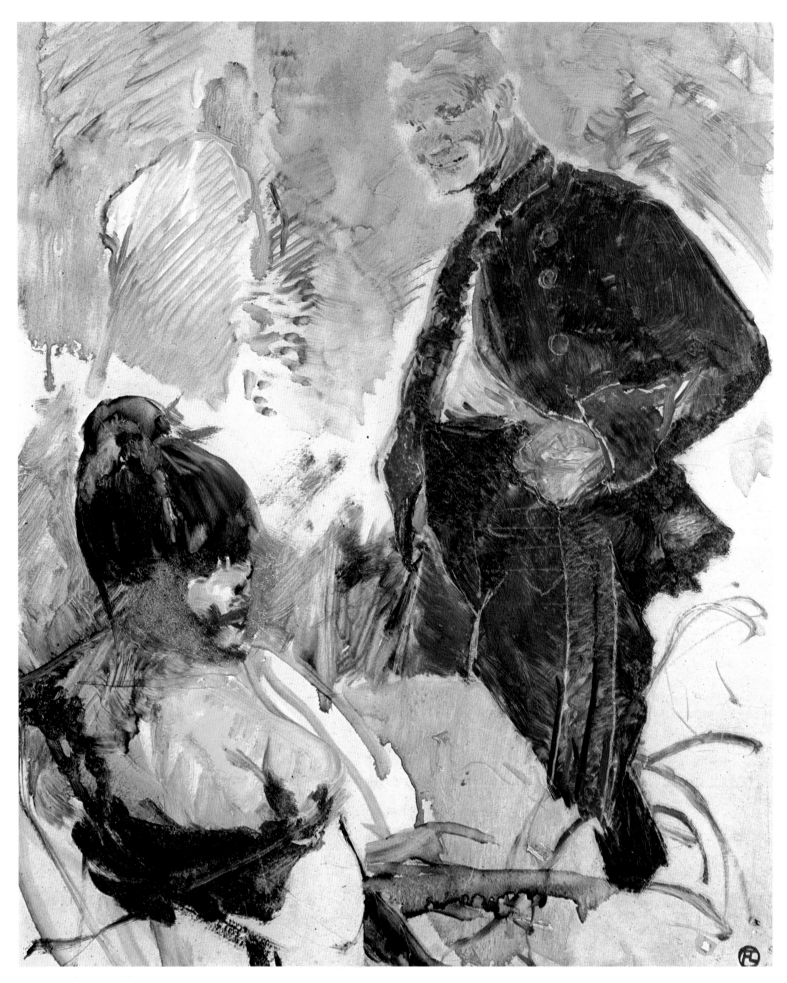

161 HENRI DE TOULOUSE-LAUTREC
Artilleryman and woman, 1886.
Musée Toulouse-Lautrec, Albi.

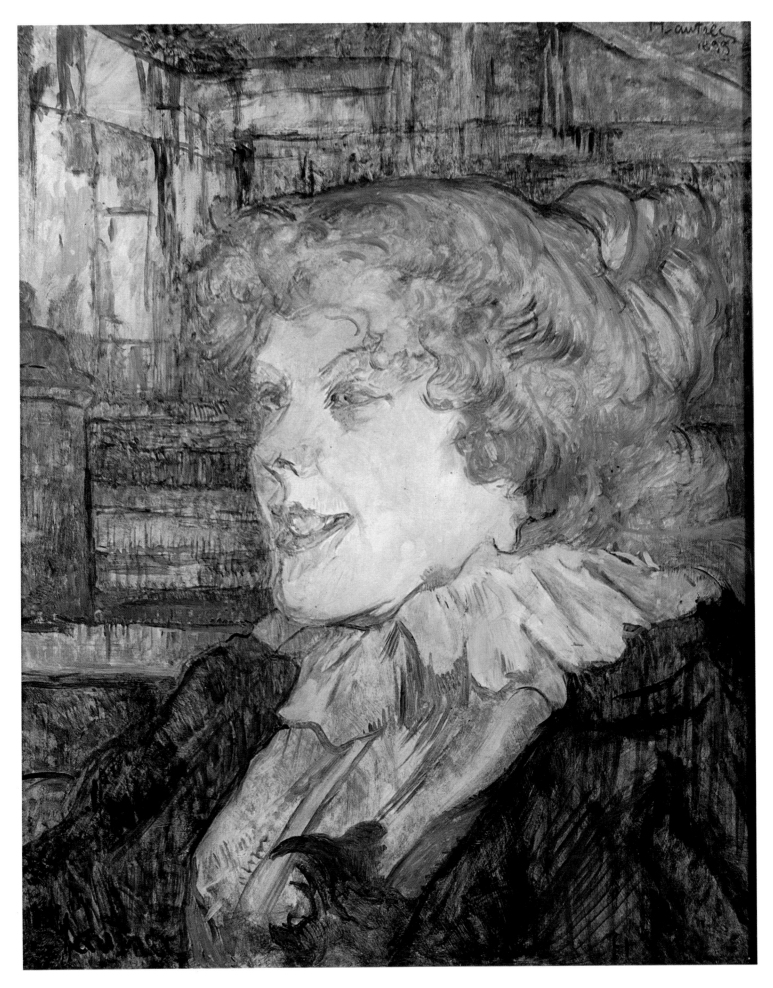

162 HENRI DE TOULOUSE-LAUTREC
The Englishwoman at the 'Star', Le Havre, 1899.
Musée Toulouse-Lautrec, Albi.

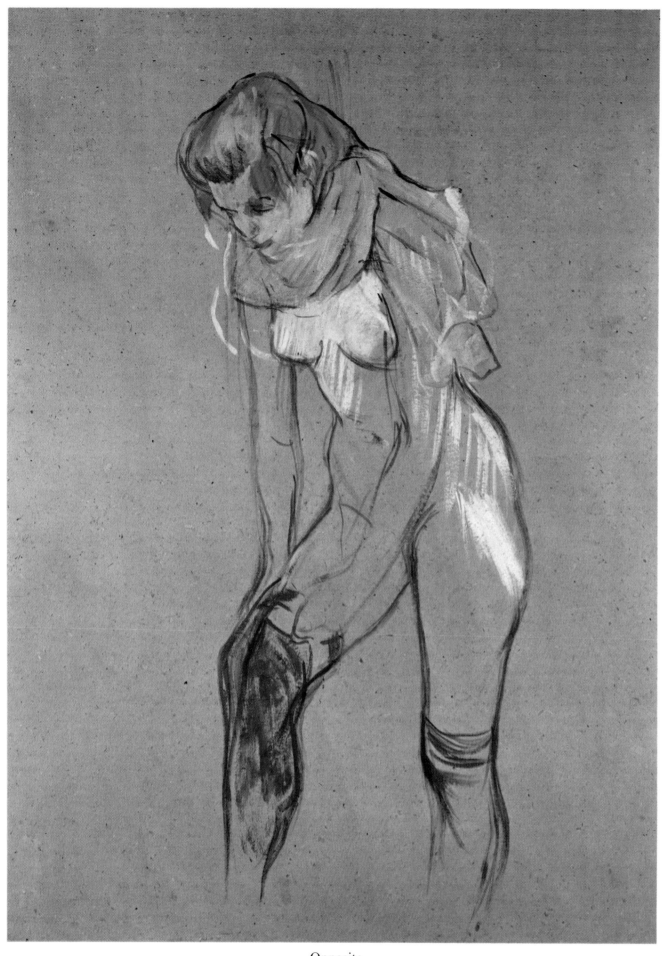

Opposite

163 HENRI DE TOULOUSE-LAUTREC
Woman drawing on her stockings, 1894.
Musée Toulouse-Lautrec, Albi.

164 HENRI DE TOULOUSE-LAUTREC
Detail from *Woman drawing on her stockings* (Plate 163).

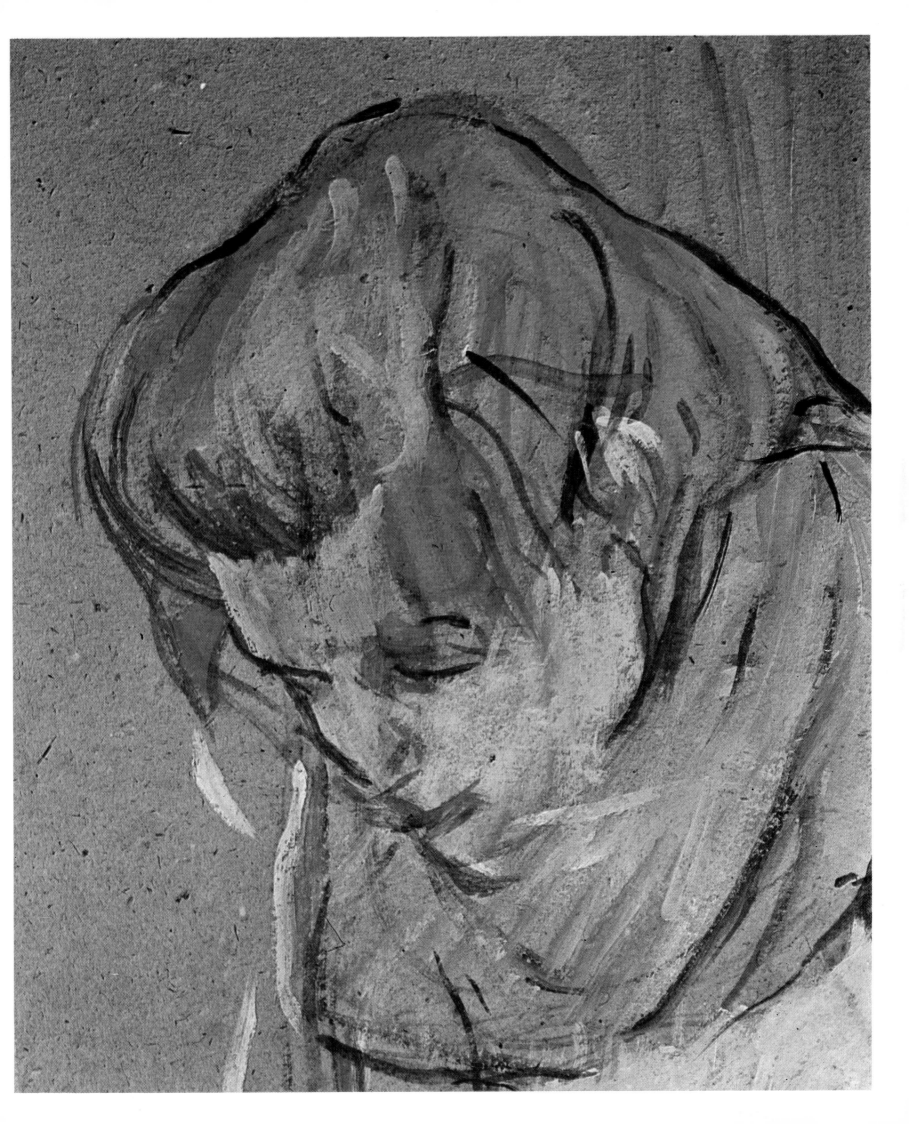

165 HENRI DE TOULOUSE-LAUTREC
The salon in the Rue des Moulins, 1894.
Musée Toulouse-Lautrec, Albi.

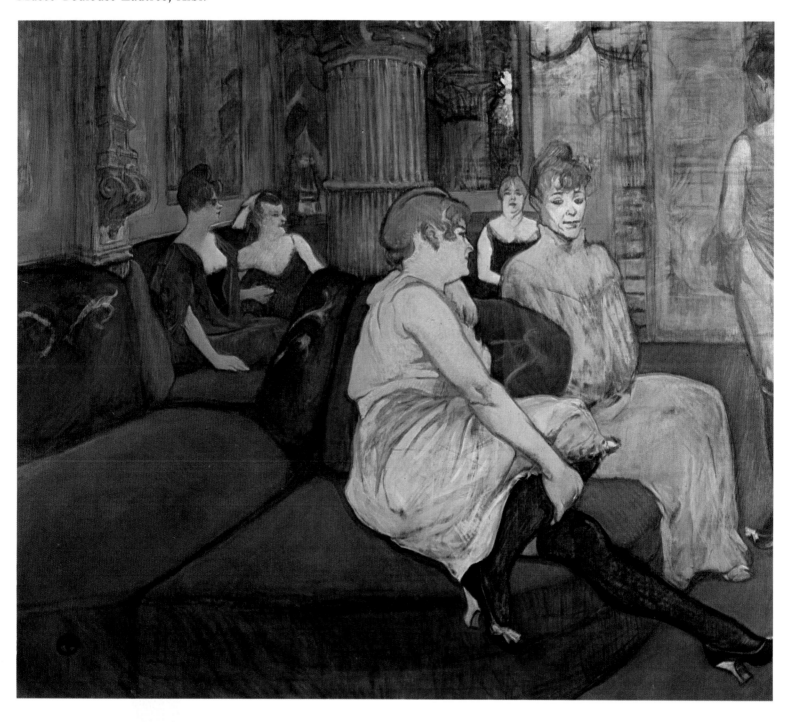

166 HENRI DE TOULOUSE-LAUTREC
Portrait of Gabriel Tapié de Celeyran, 1894.
Musée Toulouse-Lautrec, Albi.

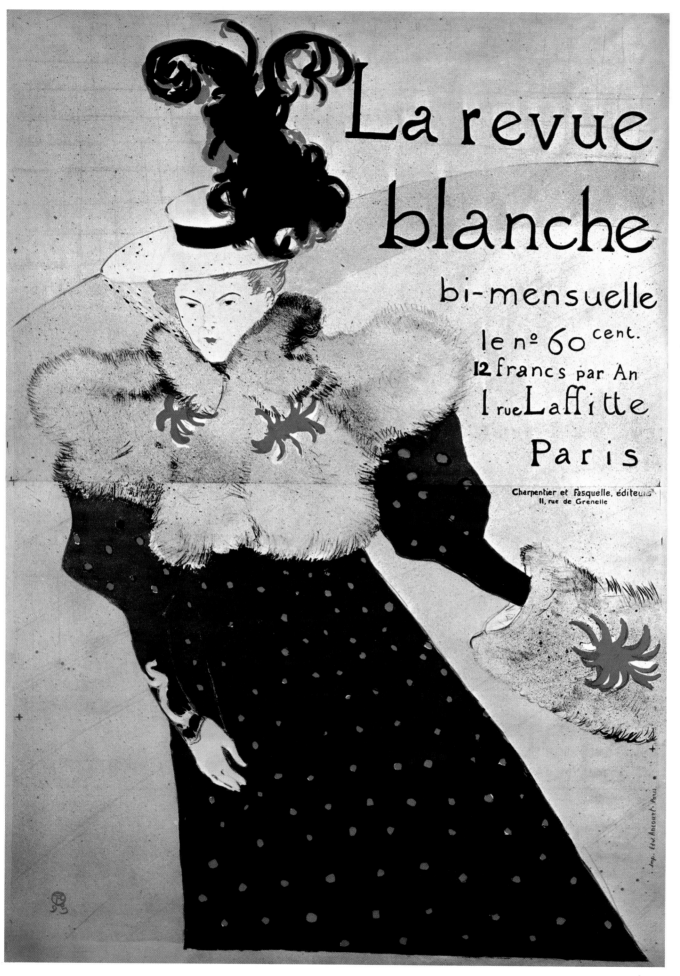

La revue blanche

bi-mensuelle

le n° 60 cent.

12 francs par An

1 rue Laffitte

Paris

Charpentier et Fasquelle, éditeurs
11, rue de Grenelle

167 HENRI DE
TOULOUSE-LAUTREC
'La Revue Blanche',
1895, lithograph.

Opposite

168 HENRI DE
TOULOUSE-LAUTREC
'L'estampe originale'
(published by Le
Journal des Artistes).
Lithograph. 1893.

169 HENRI DE
TOULOUSE-LAUTREC
The dance at the
Moulin Rouge, 1890.
Henri P. McIlhenny collection
Philadelphia.

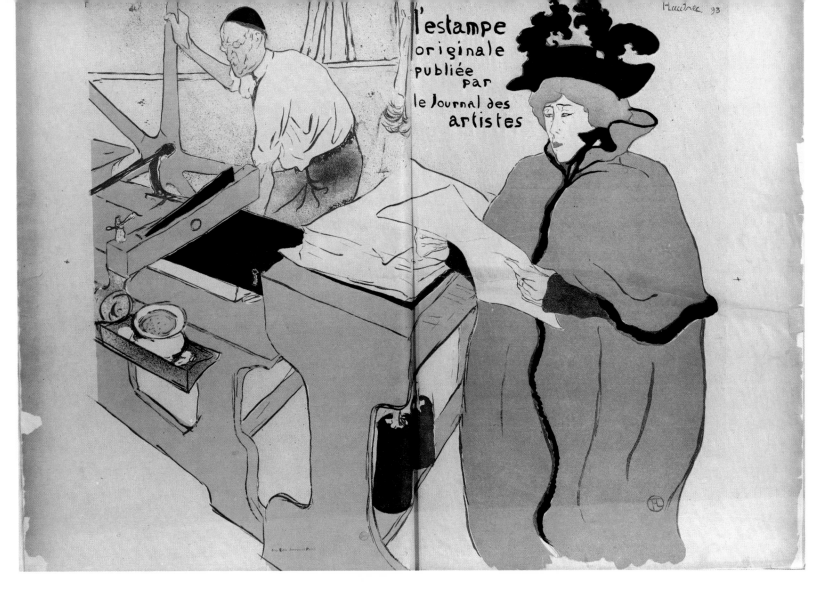

l'estampe
originale
publiée
par
le Journal des
artistes

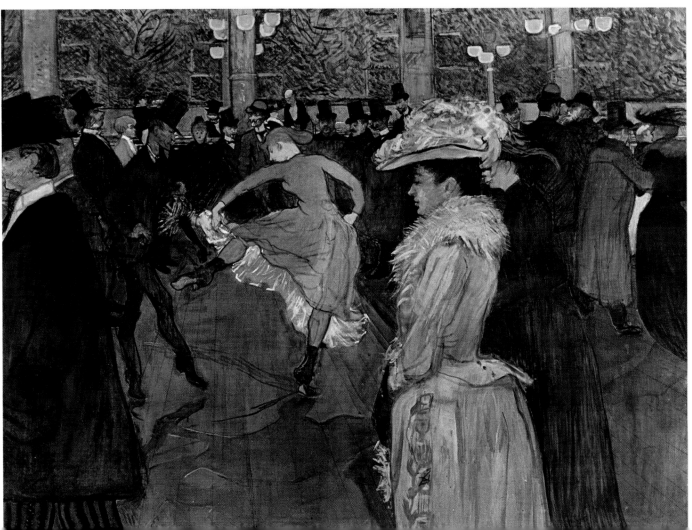

170 HENRI DE TOULOUSE-LAUTREC
Marcelle Lender dancing the bolero in 'Chilpéric', 1895.
Private collection.

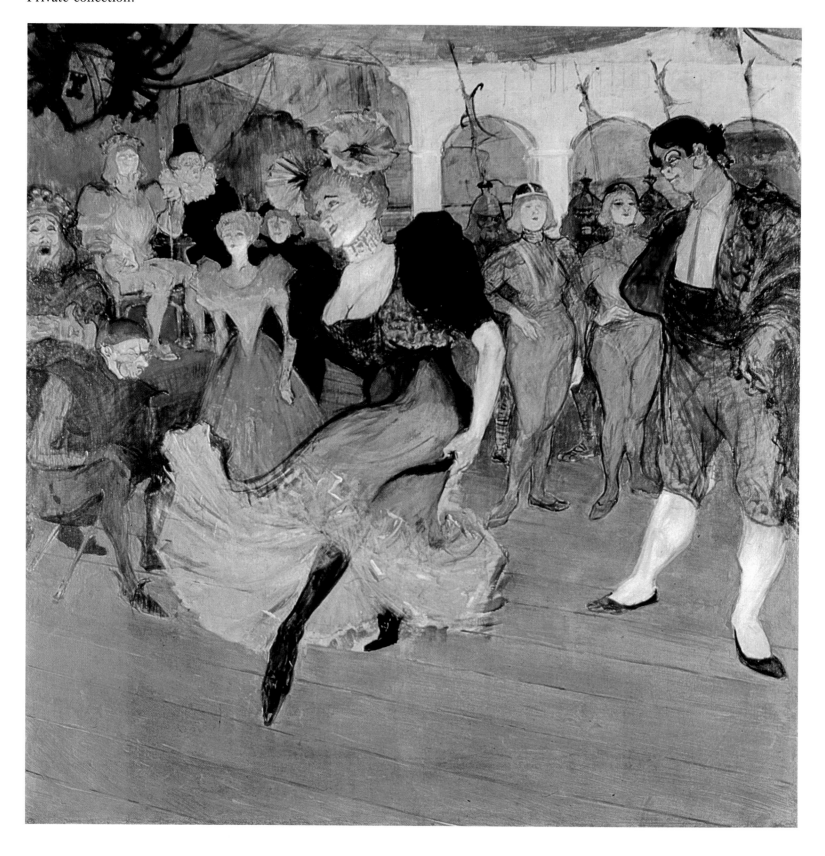

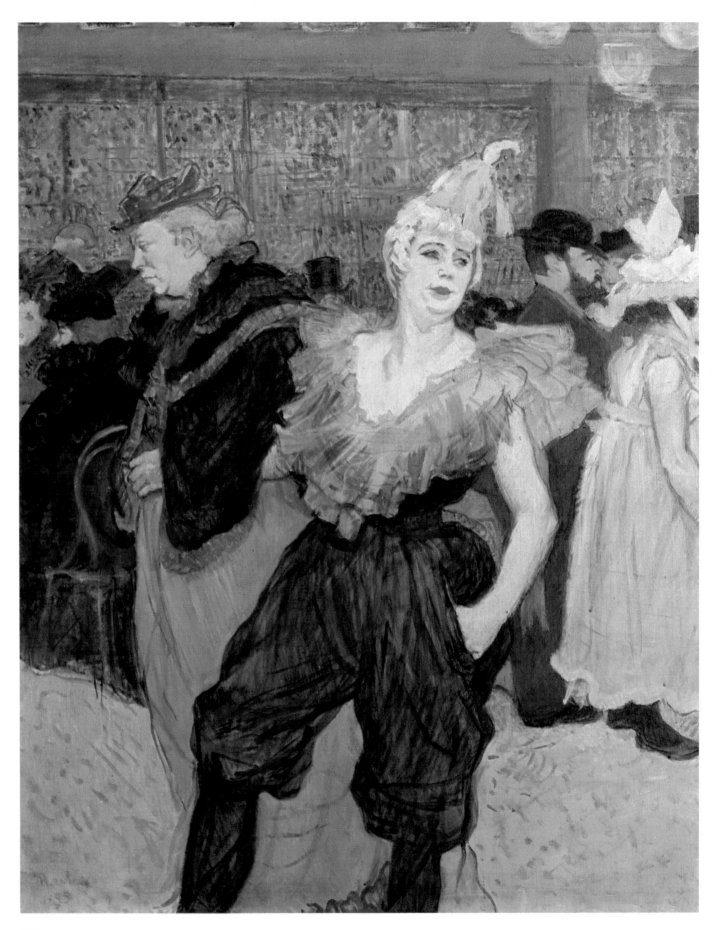

171 HENRI DE TOULOUSE-LAUTREC
The clowness Cha-U-Kao, 1895.
Oskar Reinhart collection, Winterthur.

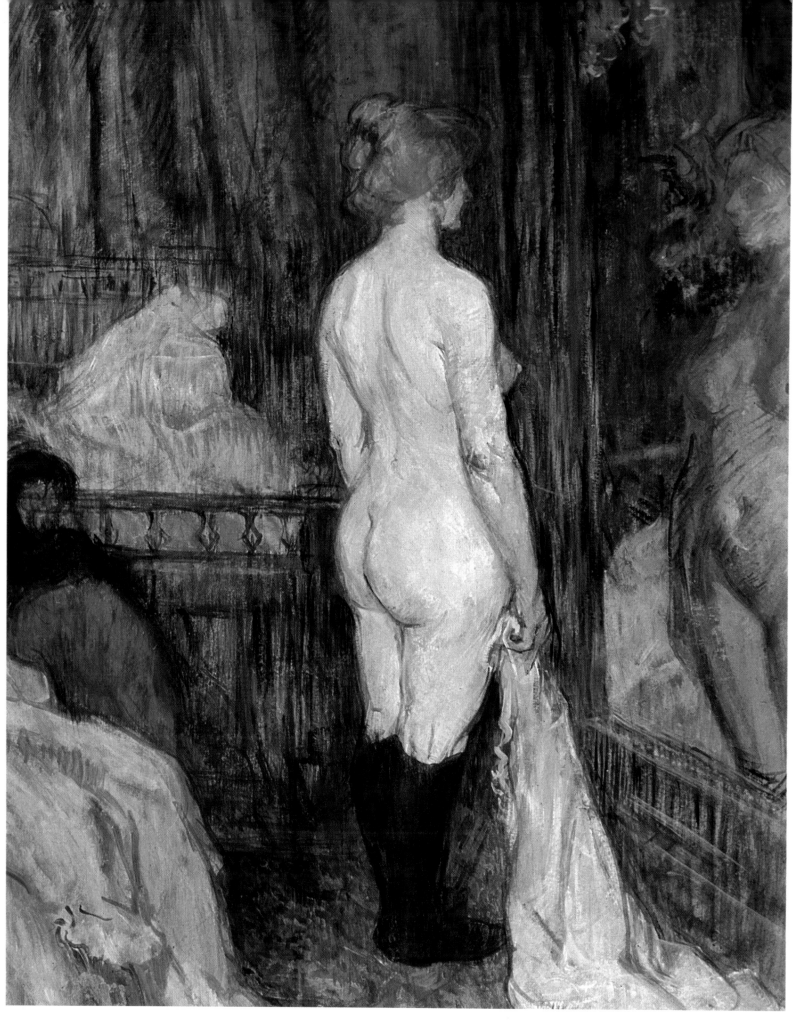

172 HENRI DE TOULOUSE-LAUTREC
Nude before a looking-glass, 1897.
Mr. and Mrs. Ira Haupt collection, New York.

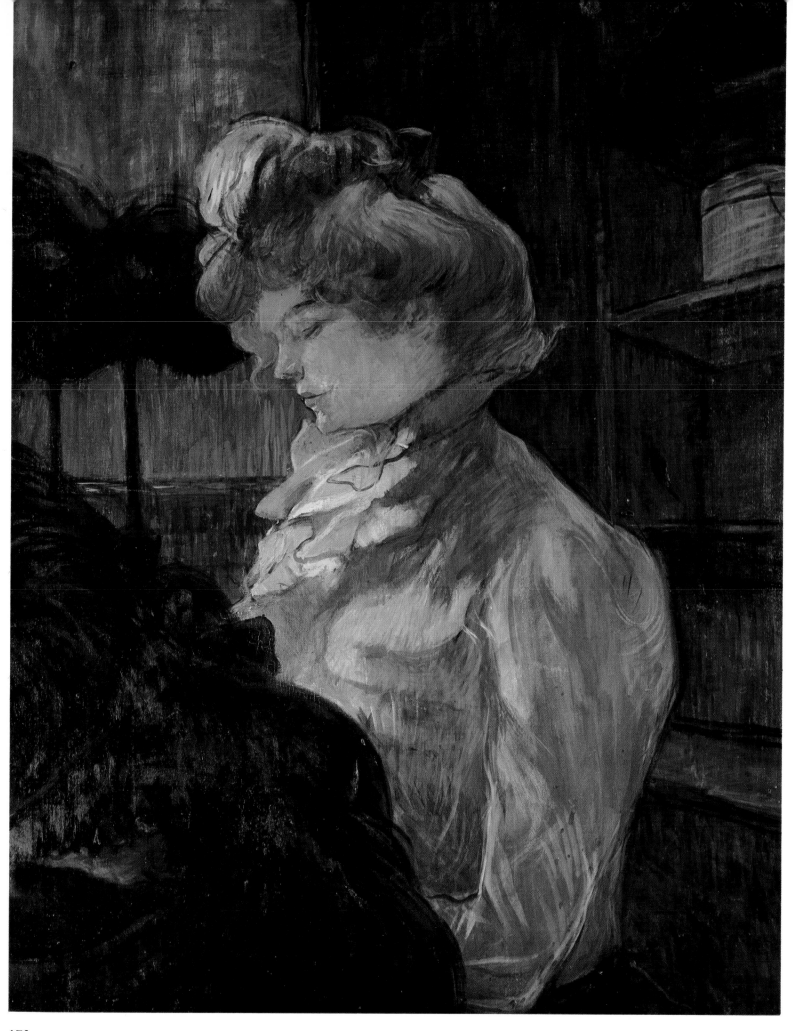

173 HENRI DE TOULOUSE-LAUTREC
The milliner, 1900.
Musée Toulouse-Lautrec, Albi.

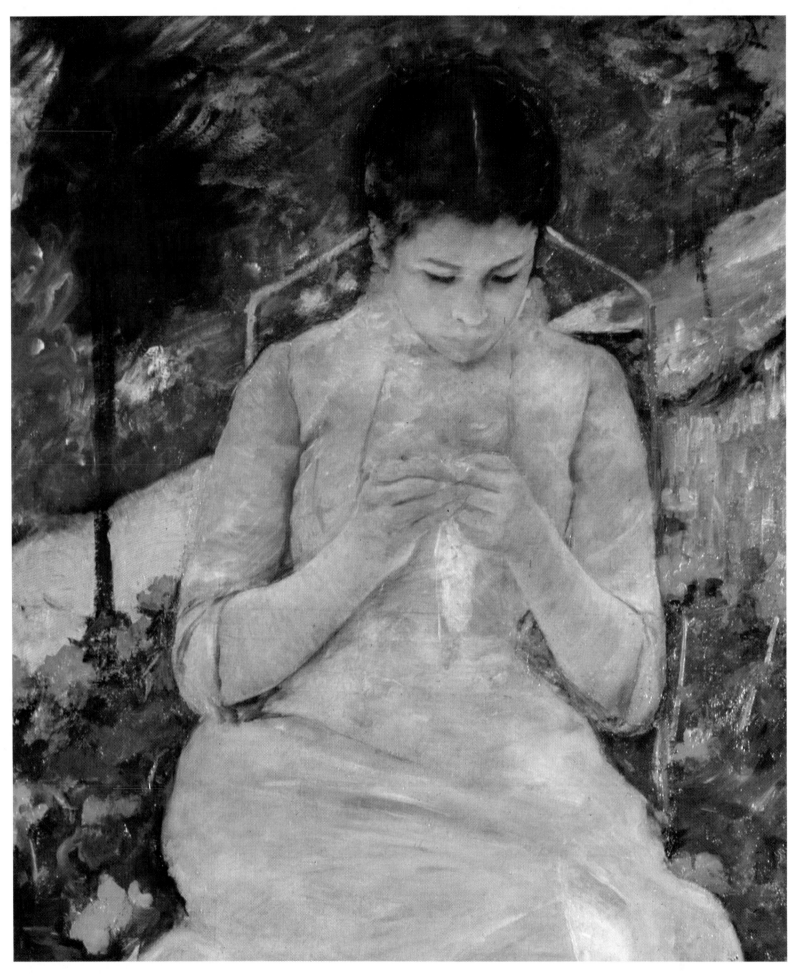

174 MARY CASSATT
Young woman sewing, 1886.
Musée du Louvre, Paris.

SEURAT AND NEO-IMPRESSIONISM

One of the most unforgettable experiences of a leisurely journey through the great American museums is to come face to face with Seurat's *Sunday afternoon on the Île de la Grande Jatte* (pl. 178) in the hall of French painting at the Art Institute of Chicago. Measuring 2 × 3 metres, this immense, highly-systematized canvas, made between 1884 and 1886, consists of millions of minute, glittering dots of colour.

What does this signify?

Georges Seurat, who was twenty years younger than Monet, after having made many careful preliminary studies (*e.g.* pl. 175) on the banks of the Seine and in the studio, began this painting, prompted rather more by scientific zeal than artistic impetus, when he was twentyfive; he had only a few more years to live. This masterwork, discovered and created by a new kind of vision, was by a man who gathered a circle of artists around him as a matter of course, and who even filled the old Pissarro with enthusiasm for his 'invention'. He found confirmation for the theories he was himself elaborating in the writings of contemporary scientists on optics and colour. David Sutter, for example, had recently published an article on *Phenomena of Vision*, in which he said that nature must be seen through the eyes of the mind and not only through those of the body in the manner of creatures without reason – natural talent must be infused with knowledge. In spite of their absolute character the rules should not however hamper the spontaneity of inspiration or of execution.

When, during the long period he was at work on this painting, the young Seurat showed it to fellow-painters such as Dubois-Pillet and Signac in order to explain his theories in front of the picture, and they, like all the other occasional visitors, were full of enthusiasm for the festive masterpiece, Seurat protested: 'You all seem to see something poetic in what I have done. But I only put my method into practice, that's all.'

Now the effect of this picture would have worn off long ago and we should not continue to admire this sunny Sunday afternoon at the popular leisure island in the Seine near Asnières (nowadays in the shadow of the high-rise blocks of the Parisian satellite-town of La Défense) both as a painting and as an accomplishment of Divisionism, if in it Seurat had not actually arrived at a creative synthesis of art and science. Hence a step forward from Impressionism.

What had happened? To put it very briefly (because the details can be found in every essay on Pointillism since that time), Seurat proceeded from the theory, which was soon to be examined and expanded by Signac, that he could 'improve' on Impressionism, give it a scientific basis, by taking into account the mutual interaction of complementary colours, arranging them in a colour circle, dividing and defining them individually. He found that according to the law of contrast a colour reaches its maximum intensity when placed next to its complementary colour (the three complementary colours are orange, green, and violet). In juxtaposition, two complementary colours enhance each other; when mixed, they destroy each other.

These few words must suffice to indicate something of the theory made use of by Seurat in a technique which enabled him to achieve effects of brightest luminosity by placing innumerable touches of pure colour in a carefully balanced arrangement of dots.

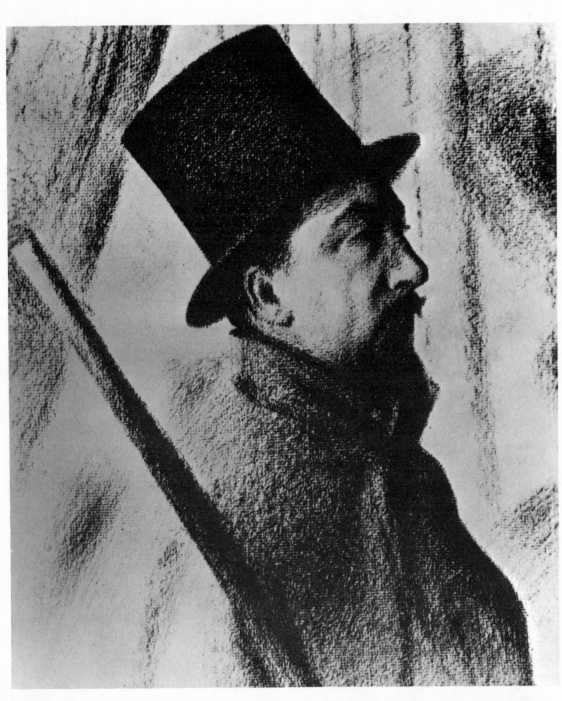

GEORGES SEURAT: *Portrait of Paul Signac*. Charcoal drawing, 1890 – G. Signac Collection, Paris.

The writer and critic Félix Fénéon, who had first come to Paris in 1881 when he was only twenty (Signac later immortalized him in a symbolic portrait, pl. 187), warmly supported Seurat's art and his artistic theory, to which public and press had immediately reacted in the same abusive manner as they had done ten years earlier to that of the Impressionists. Having first carefully studied the scientific theories on which the method was based, he wrote various explanatory articles on the subject, together with a description of the mighty painting *La*

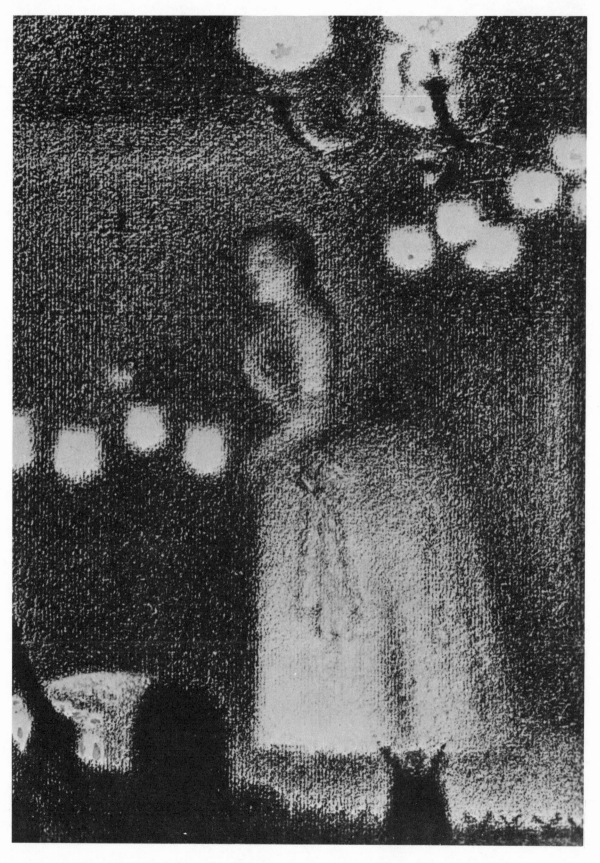

GEORGES SEURAT: *Café singer*. Charcoal drawing

Grande Jatte in the newly founded review *Vogue*, on the strength of many conversations with Seurat, Signac, and their circle, for whom Fénéon coined the name 'Neo-Impressionists'.

Fénéon's thoughtful commentary still carries conviction, after a hundred years, and is well worth bearing in mind while one looks at the magnificent colourplate here or recalls the impression made by the original.

Seurat himself considered this picture so important that he included it as a side-screen, to the left in the background, of his small painting *Les poseuses* (pl. 179).

Let us now quote from Fénéon's description of the picture of 1884–6, with which he substantiated his thesis that the Neo-Impressionists give landscape a definitive and absolute aspect – in contrast to the art-of-the-moment of the Impressionists.

'If one looks at any one patch of uniform tone in Seurat's *Grande Jatte*, one finds in every centimetre of this surface a whirling swarm of little dots which contain all the elements out of which the relevant colour tone is composed. Take that grass-plot in the shade: most of the dots express the barely felt effect of the sun; occasional additions of purple make up the complementary colours to green; a Prussian blue, influenced by an adjacent patch of grass in full sunlight, thickens towards the borderline but fades away gradually across the border ... Set out on the canvas in very close proximity but separately, these colours mix on the retina. ... At whatever part of his great painting one may choose to look, one sees a well-balanced, patiently elaborated tapestry, in which any random brush-effect would be superfluous, little tricks are made impossible, and where there is no room for "bravura" – even if the hand may be awkward, the eye must be quick, sharp and clear.'

So much for a brief extract from the writings of this ardent advocate of neo-impressionistic art, which, like that of the Impressionists, is preserved for us today in the form of individual and enduring works. A certain static solemnity, typical of hot, late-summer days, is well-suited to this form of painting: ships at rest in calm waters (pl. 189), or sea-cliffs enveloped in purple (pl. 188), and finally a seascape coming very near to sheer abstraction by the highly-talented Henri Edmond Cross (pl. 191), which is like an anticipation of the inventions of Paul Klee.

Such motifs lend themselves more readily to this 'divisionist' way of painting than do the more agitated river and harbour scenes of Paul Signac (pl. 185–6), in which the precise pattern of dots often gives way to a rocking, staccato rhythm of lines. And the juxtaposition of tones which only mix in the spectator's eye, as advocated by Seurat, here becomes sacrificed to an artistic temperament more inclined to the spontaneous and the decorative. This points to the limited applicability of Seurat's theory. Some of Signac's finest works are to be found in watercolours and still more in watercoloured drawings, where such a method of painting in separate dots was technically not possible, nor was it attempted. This is borne out by the high value set on them by collectors and in galleries. In order to discover his real ability, one has to go to the graphic collections.

Again one sees in Signac's profile-portrait of Fénéon (pl. 187) in New York, which makes him look like a conjuror or modern magician, and in Seurat's large picture of the *Circus* (pl. 182) in the Louvre (Jeu de Paume), something of the limits of this neo-impressionistic art form: soft paleness as of a tapestry, a plainly-evident stiffness caused by strictly adhering to the canons of form, a readily apparent air of 'unreality'. From all this, however, the attractive ladies, the dogs and resting children, the trees, lights and shadows of *La Grande Jatte* are exempt, however severely statuesque this majestic painting may appear to be. But it is also representative of a whole style, or style reform.

It is well to remember that Seurat's *Circus* is a panel and not an easel-painting; there is a complete absence of those purple tones which suggest spatial depth, and it shows nothing of the true-to-life actuality of someone like Toulouse-Lautrec. Here it is evident that the restraint imposed by the method checked any spontaneous outbursts. If one thinks of Toulouse-Lautrec's decorations for La Goulue's dance-booth in Montmartre (pl. 160), then one can see the difference not only in terms of method but also in relation to life itself. Certainly, Toulouse-Lautrec was an artist who never missed a good opportunity to paint what he saw, a cheeky, swift performance. But besides that, the attitude to life of these two so fundamentally different artists is made abundantly clear: on the one hand, the relentless observance of a principle believed to be correct and pointing the way to all future developments; on the other, an inspired piece of mischief by the noblest 'house-painter' of all time.

These notes were made regarding the *Circus*:
'. . . pale, as if behind a veil, also looking somewhat remote because Seurat has quite intentionally surrounded everything with a broad passe-partout of blue dots, in addition to the wide, painted frame; this passe-partout completely pushes back the scene by its own independent intensity. And the white circus horse, upon which the young rider tries to do her balancing-act, is a pallid Pegasus and nothing else.'

Seurat was a draughtsman and painter who quickly absorbed all that academic teaching could offer him and became one of the great innovators of the nineteenth century. A proud and dedicated man, he was an examplar to his followers, among whom we find new names together with that of Pissarro, as evidence of the latter's unexhausted vitality even into old age. During this same period, van Gogh developed his art in Paris and brought it to perfection in the south of France; Gauguin painted new and prophetic pictures in Brittany and in the South Seas; Cézanne became the architect of a new structural logic of vision and painting; while Degas and Renoir embarked on the great works of their old age. At the same time, in addition to Paul Signac, there were the painters Henri Edmond Cross (pl. 191), Dubois-Pillet (pl. 189), Petit-Jean (pl. 190), and several others in Paris, where in 1886 the last of the eight group exhibitions of the Impressionists took place. With that, their togetherness faded away, new ideas were tried out, and the art scene began to take notice of the dignified Puvis de Chavannes as well as the undignified Henri de Toulouse-Lautrec. 222

PAUL SIGNAC: *Fishing-boats*
at La Rochelle.
Watercolour, 1911 –
Wallraf-Richartz Museum,
Cologne.

223

This was the time when the first commitments of the admirers of these painters, often living in quite modest circumstances themselves, were made, and the Impressionists were able to sell some pictures; the names of well-known art-dealers are mentioned in this connection for the first time. The American Mary Cassatt won over her liberal fellow-countryman Havemeyer for the new art, and Paris finally became the art-centre of the world. Manet had already died, and Frédéric Bazille, who had come very close to Manet's art with the splendid clarity of his *La Toilette* (pl. 22) of 1870, now in the museum at Montpellier, had been killed in action in the Franco-Prussian war in the same year. The constant influx of new talent into Paris allowed for the assimilation of alien impulses, the comparison of the viewpoints of science and of the fine arts and even their correlation. This is not to say that every theoretical experiment and philosophical verification finally became art. But, for the first time, various groups of artists helped each other to give vent to their ideas, founded magazines, discovered supporters and buyers, widened their sphere of influence beyond Paris and found in exhibition-partnership a kind of permanent, independent enterprise which was under their own control and free of prejudice. Nevertheless mistrust, intrigue, biting criticism and arrogance within their own circle sometimes marred their association. And such questions as to when and where Seurat's colour-dots became too small, whether they could possibly be the one-and-only way of achieving a new form of painting, whether they could be applied to drawing, were often discussed most fervently yet fruitlessly at many a round-table conference.

But from this second phase of artistic activity we have inherited a wealth of works of art which have never failed to inspire and delight the spectator up to the present day, even though the theories behind them have long been forgotten; there is no room here to enlarge upon those ideas.

175 GEORGES SEURAT
La Promenade au Singe, 1885.
Smith College Museum of Art,
Northampton, Mass.

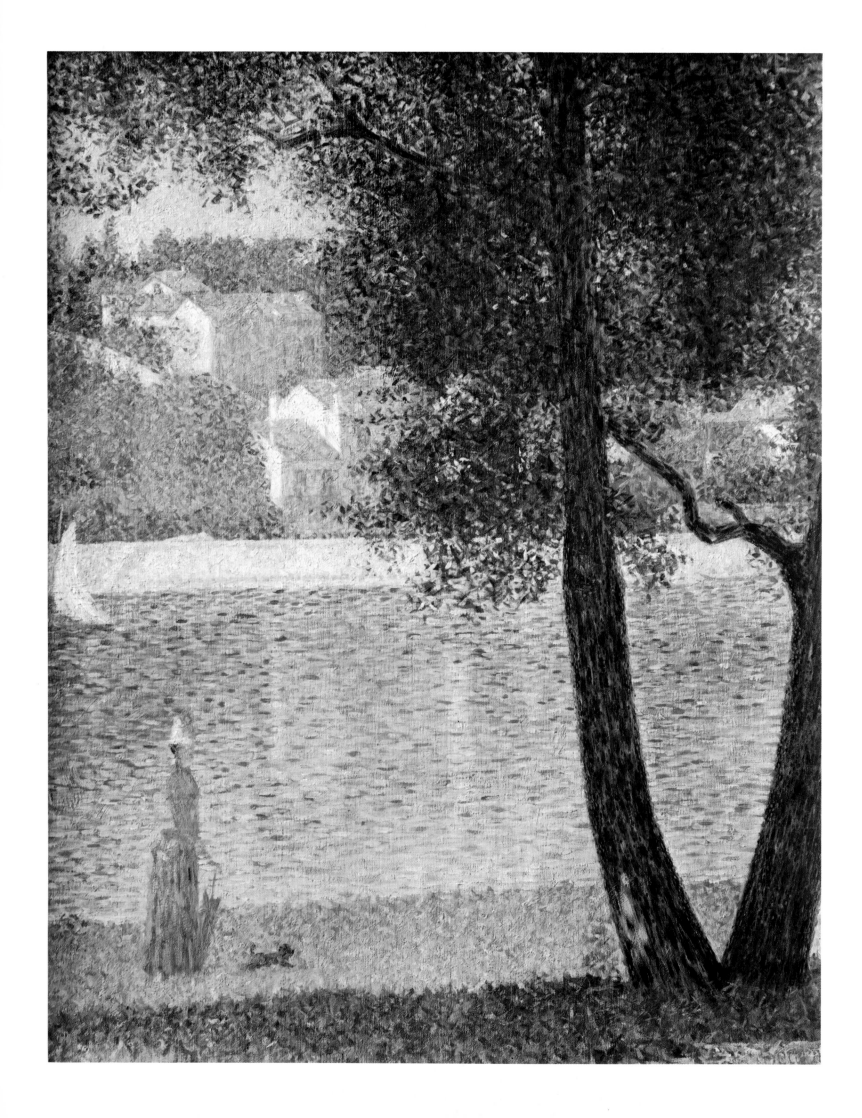

Opposite

176 GEORGES SEURAT
The Seine near Courbevoie, 1885/86.
Private collection, Paris.

177 GEORGES SEURAT
'La Maria', Honfleur, 1886.
Národní Galerie, Prague.

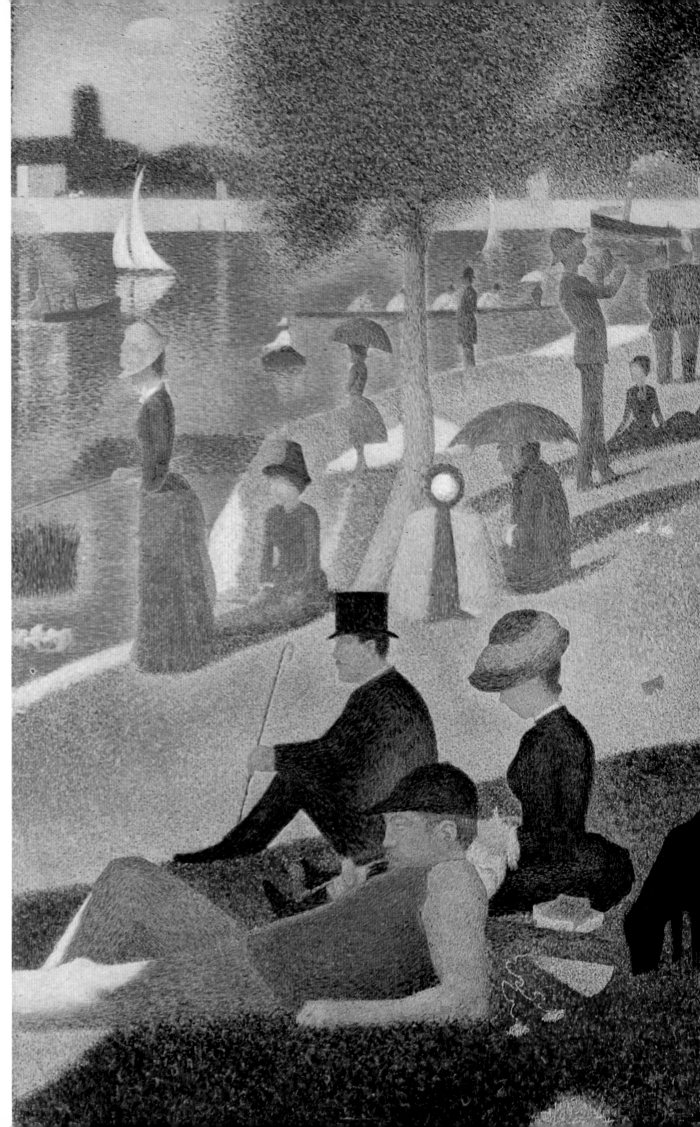

178 GEORGES SEURAT
*Sunday afternoon on the
Île de la Grande Jatte*,
1884/86.
The Art Institute,
Helen Birch Bartlett
Memorial Collection,
Chicago.

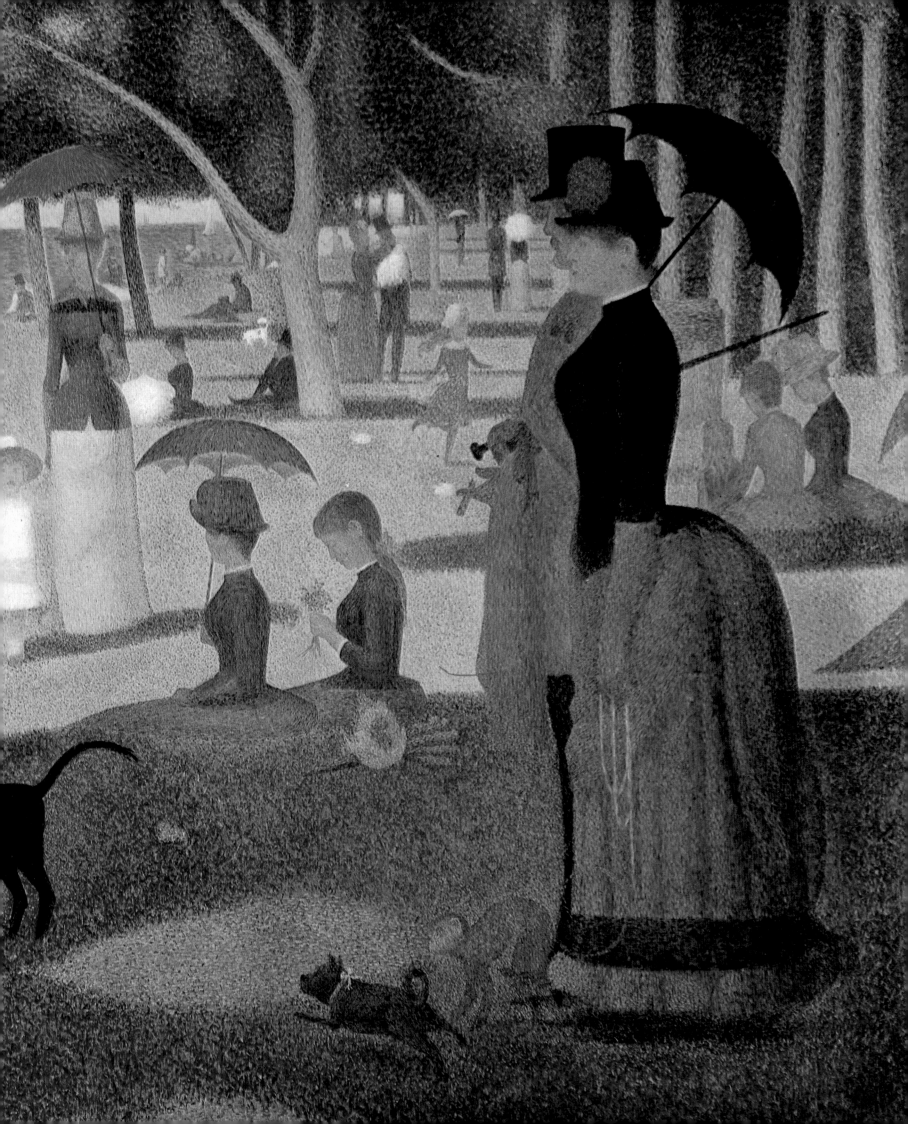

179 GEORGES SEURAT
Les poseuses, 1887/88.
Barnes Foundation, Merion, Penn.

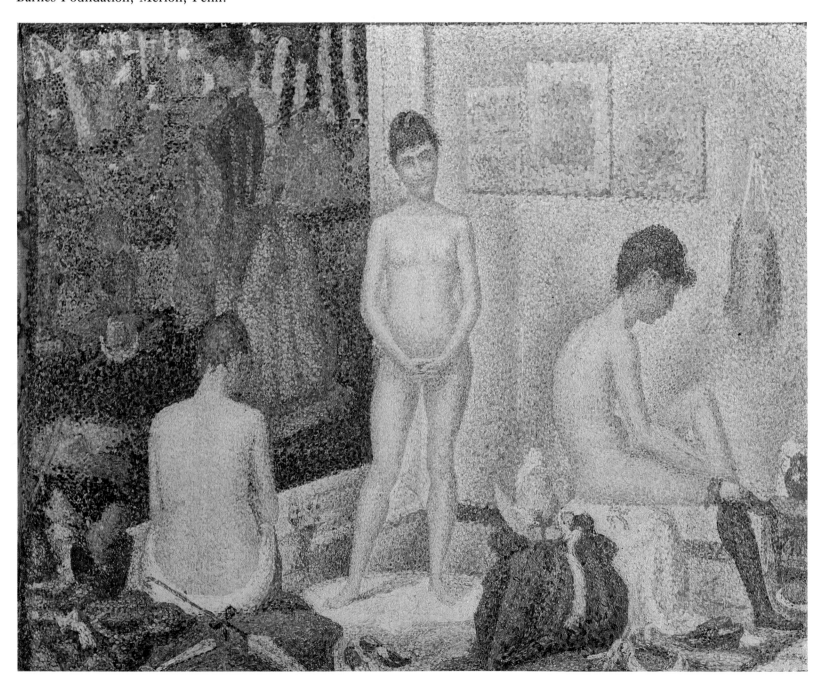

180 GEORGES SEURAT
Nude in profile, 1887.
Musée du Louvre, Paris.

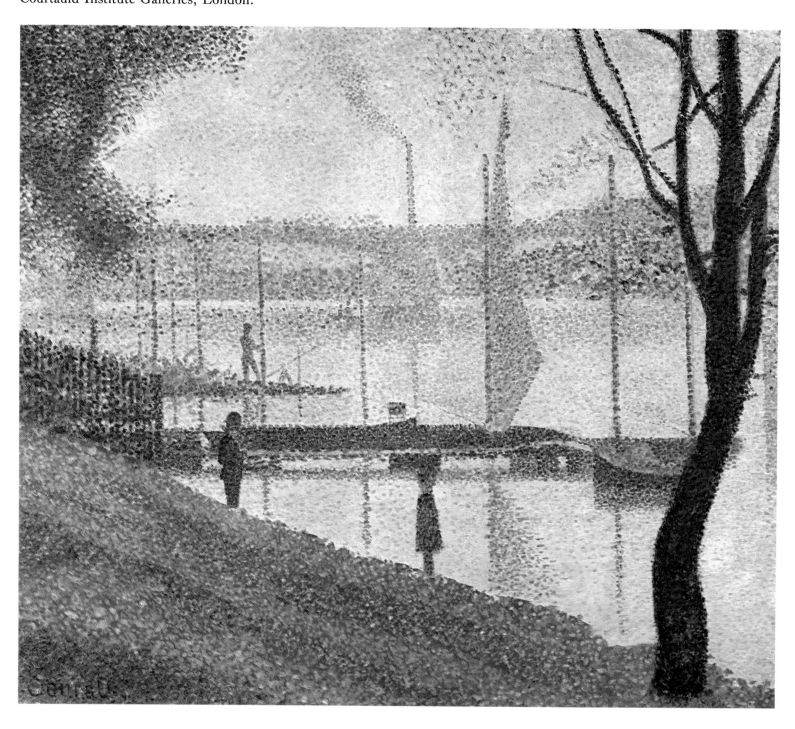

182 GEORGES SEURAT
The Circus, 1890/91. Musée du Louvre, Paris.

183 PAUL SIGNAC
The Harbour, 1907.
Museum Boymans-Van Beuningen, Rotterdam.

184 PAUL SIGNAC
The St-Jean Fort, Marseilles, 1907.
Musée de l'Annonciade, Saint-Tropez.

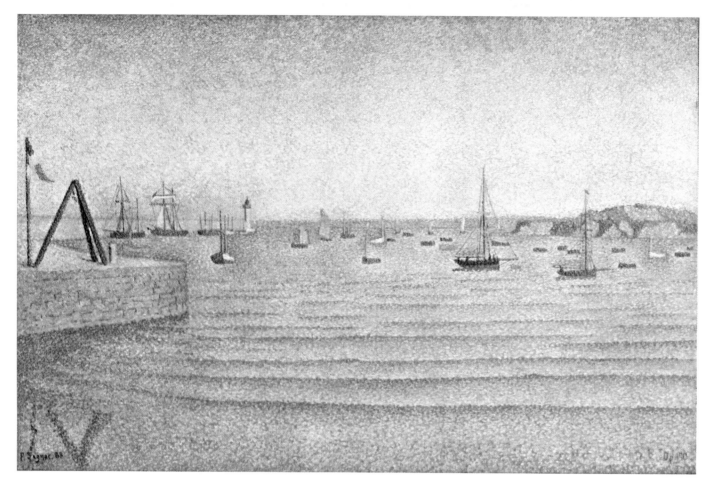

Opposite

185 PAUL SIGNAC
Portrieux Harbour, 1888.
Staatsgalerie, Stuttgart.

186 PAUL SIGNAC
View of Saint-Tropez, 1896.
Musée de l'Annonciade, Saint-Tropez.

187 PAUL SIGNAC
Portrait of Félix Fénéon, 1890.
Joshua Logan collection, New York.

188 THEODOR VAN
RYSSELBERGHE
*La Pointe Perkiridec,
near Roscoff in
Brittany*, 1889.
Rijksmuseum Kröller-
Müller, Otterlo.

189 ALBERT
DUBOIS-PILLET
The Seine at Paris,
1888.
Arthur Altschul col-
lection, New York.

Opposite

190 HIPPOLYTE
PETIT-JEAN
*Portrait of Mme.
Petit-Jean*, 1892.
Musée de
l'Art Moderne, Paris.

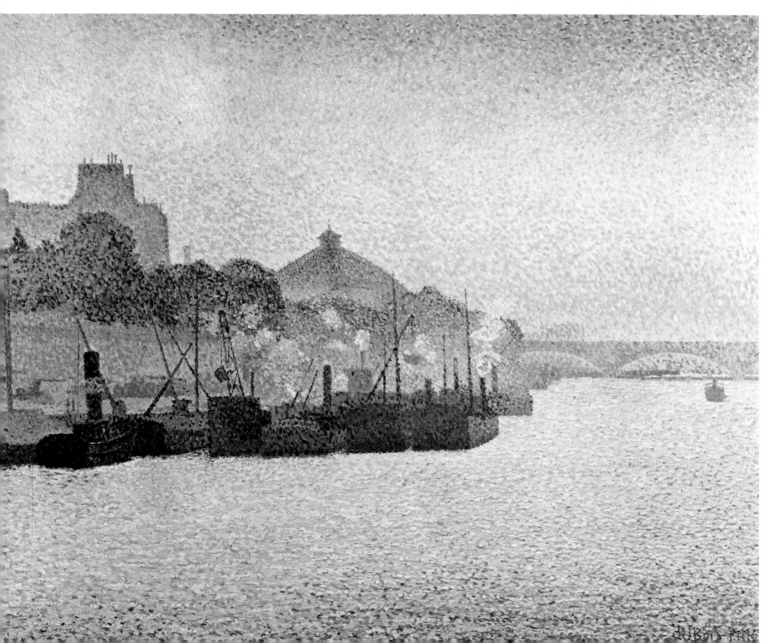

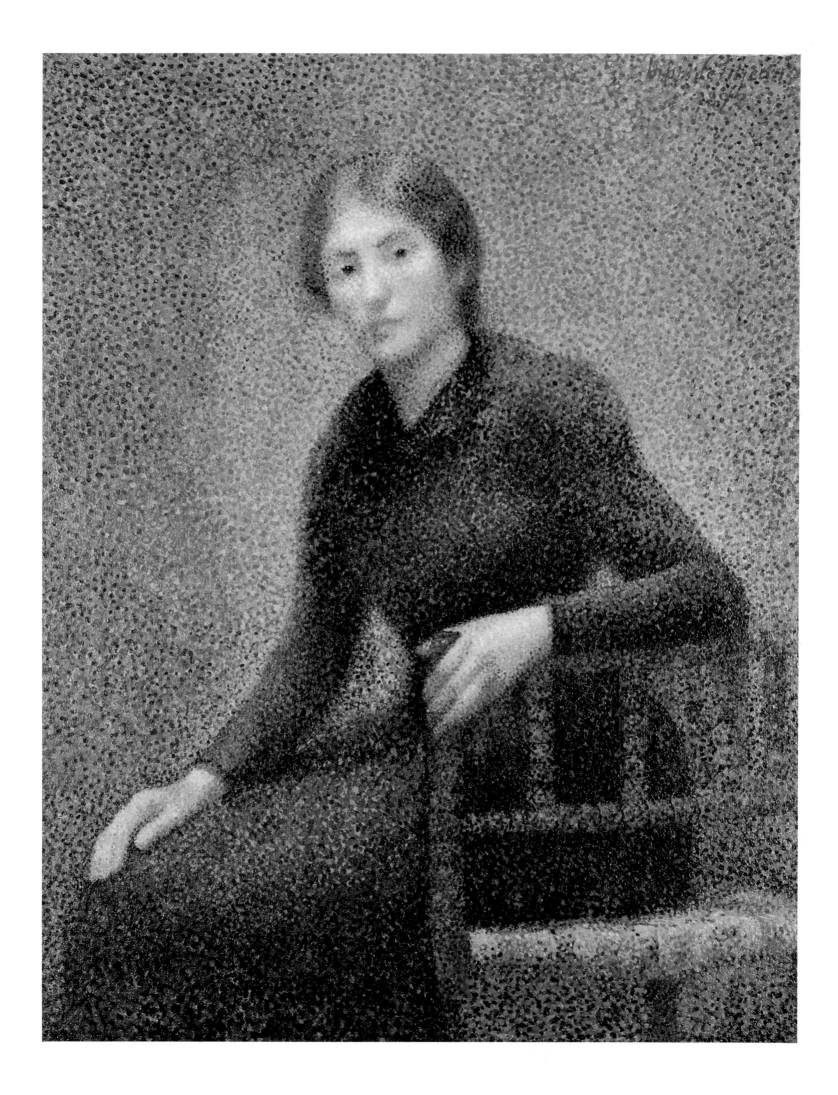

191 HENRI EDMOND CROSS
Les Îles d'Or, 1892.
Musée de l'Art Moderne, Paris.

THE WAY INTO THE FUTURE

As we have mentioned earlier, along with the Impressionists there were quite differently-orientated talents at work in Paris and elsewhere in France at the same time, and our remarks have now led us to the consideration of three great names among them: Cézanne, Gauguin, and van Gogh. Cézanne was the same age as Sisley, Gauguin was ten years older than Seurat, and van Gogh's active painting years spanned only the decade from 1880 to 1890.

Reduced to the simplest terms, it can be said that their artistic efforts were no longer directed at transposing the 'beautiful appearance' of the visible world into a magical pictorial language, that is, actually taking the semblance for the reality, but much more at rediscovering solid form and with it a strengthening of the pictorial element, by which something more and other than the impression was intended and was achieved.

The backgrounds of these three artists and individualists, who have perhaps occupied the minds of succeeding generations the longest, were widely different. Like van Gogh, Gauguin gave up a professional career to become a painter, but in his case with a preconceived idea of what he wanted to achieve. Cézanne, on the other hand, developed and clarified his lapidarian style steadily over many years, whereas van Gogh broke free of The Netherlands in a vehement outburst and went via Paris into Provence, stepping from darkness into the bright full light of the sun.

PAUL GAUGUIN. Gauguin, though here we can only briefly allude to his development, was the one of that trio whose style was the least impressionistic in the rendering of nature. He made radical discoveries about composition and colour, giving solid form and definition to the stylized pictorial structure, and making use of a large flat surface for his designs (pl. 192). In this way he put the rules of procedure firmly back into the hands of the artist from the beginning, thus releasing him from the overwhelming need to be merely representational of his subject. Nevertheless, the influence of his early impressionistic period was decisive in saving his work from ever becoming lost in literary allusions.

At the last great exhibition of his work in Germany several years ago, Germain Bazin quite rightly pointed out that his strange compositions, in mostly arbitrary but always harmoniously arranged colours, were always painted from nature or from a model. He added another observation which might be of help as we regard Gauguin's often awe-inspiring and barely understood pictures.

Bazin says:

'What makes painting seems so "unmodern" today is the fact that we have very little classical education nowadays, so that a great deal of the essential charm of this kind of painting, its intellectual content, is lost. That mythical world in which people used to live quite naturally is for us today absolutely unimaginable. The mysterious idols of the

Maoris appeal to our fantasy far more – but for how much longer?' And here is Bazin's final warning (written in 1960, one must remember): 'Soon the last primitive people will have vanished from this earth, and, once man has started his journey into space, the old Maori cult will be just as incomprehensible to him as the Apollinistic and the Orphistic cults. Then the subjects Gauguin has painted will seem to be just as boring as those of Poussin . . .'

Those words were written some sixty years after Gauguin's death. He would certainly have approved of them, because they are in accord with his own aspirations after pictorial content, after depth of meaning, beyond the symbolic power of colour in landscape painting. And yet all these endeavours were painted under conditions of the most appalling distress, intrigues, misunderstandings, in a sort of martyrdom of which the world took no notice. Unlike van Gogh, Gauguin dreamt of a life in a far-off, almost out-of-reach paradise when in 1890 he applied for permission from the French government to go to Tahiti and settle there. There the life of this painter and ever-restless man was haunted by the problems of existence, upon which he meditated in brilliantly-written and illustrated letters, reaching far above the thinking and feeling of the Impressionists, going into the absolute, and considering the uncertainty and menace which hangs over the whole of human existence.

To his painter-friend Émile Bernard he wrote:

'. . . painting, after all, is like man himself mortal and in perpetual struggle with matter.

If I thought about the absolute, I would give up every effort, even that of living.'

Only in his self-commiseration is contained that degree of naïveté which connected Gauguin with the painters of the village of Pont Aven, a retreat in Brittany, where they were seeking new symbols worthy of representation. From there, in 1891, he set off via Paris for the far South Seas, for Tahiti; earlier, in 1887, he had made a trip to Martinique.

This apparent disorder and confusion of a restless life, which others too have led, has perhaps made him an obscure figure, but not so his art, which had and still has an overwhelming and mysterious power. If one wants to get an idea of the wide range of his work then one has only to look at his seascape in the Göteborg Museum (pl. 193) and his painting of the *Great tree* (Fatata te Moua) (pl. 196) in Leningrad, in order to get the man and the painter into proper perspective. Mirbeau has written with understanding on this subject in an essay:

'. . . the fact that a man should voluntarily flee civilization, seeking to forget and be in peace, to find himself and be able to hear his inner voice, which had been drowned here (in Paris) by the noise of our passions and quarrels, seems to me remarkable and exciting. Paul Gauguin is an extraordinary, disturbing artist.'

He then goes on to talk about Gauguin's Peruvian ancestry, his life as a sailor and then as a clerk for a Paris Exchange broker, his awakening interest in art and his attraction to the work of Puvis de Chavannes, to Degas, Manet, Monet, Cézanne, and his study of Japanese prints. (With the opening up of Japanese ports to the western world after 1858 and the discovery of Japanese art by Europe, Japanese influences were among the most significant on modern art

242

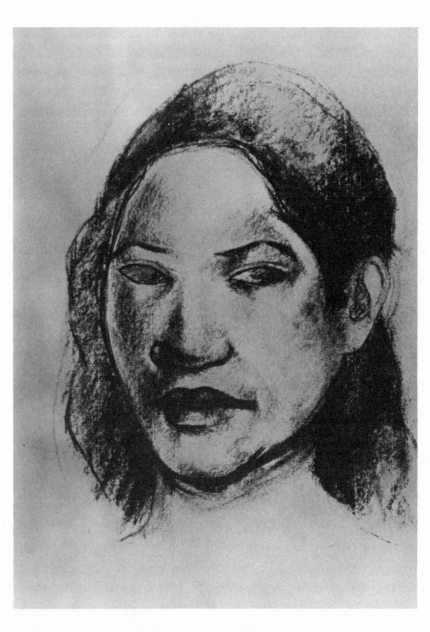

PAUL GAUGUIN: *Head of a Tahitian Woman*. Charcoal drawing, 1892 – Private collection, Paris.

at the end of the nineteenth century – Manet for example had already been influenced by Japanese coloured woodcuts. The subject would make a whole chapter in itself, but cannot be included here.)

Thus we see that Gauguin was a unique person, with his vague yet positive yearnings, his extraordinary vision and unusual way of life, creating truly enigmatic paintings, woodcuts and engravings, as if they were meant to be warning signs set up for us – *i.e.* those 'idols' to which Bazin referred.

PAUL CÉZANNE. As in the case of van Gogh, we have room here for only a few references to Cézanne's work as a whole, and can merely try to follow it to some degree through the examples reproduced in this book as a selection from many hundreds of others. These are pictures which, through their greatness, have such educational power that their effect, undiminished even after two generations, has continued to provide life and sustenance to the vast region of painting, good and bad, up to the present day. This deep and enduring influence, greater even than that of the Impressionists, was made possible through a lifetime of methodical work and endeavour such as we can barely imagine, on the part of a genius more concerned with the realization of an idea than with artistic recognition. Unperturbably he pursued his laborious analysis of colour and tone, from which emerged apparently by chance this art which astonished all around him.

Cézanne's intellectual contribution to French art and to world art in general has been overwhelmingly demonstrated at the Centenary Exhibition of 1974. A man of turbulent, baroque temperament, he became the architectural genius of picture composition, in which a reflected relation to nature was maintained along with the sensual density of its presentation (pl. 201–2), but far removed from the bright and hymnic devotion to nature which characterized the work of strict Impressionists like Pissarro and Sisley.

We can give only a few notes to these pictures, the study of which, especially of the three *chefs-d'oeuvre* in the Barnes Foundation near Philadelphia (three rocky landscapes with an unbelievably sublime 'build-up' of trees, lofty in form and flaky, open and vivid in colour) and of all the others in galleries and private collections on both sides of the Atlantic, could take a lifetime. In addition, there are the solidly constructed, slowly developed portraits and groups of figures (pl. 197–8).

A few words should be added here about Cézanne's painting technique: he used to thin his oil paint so drastically with turpentine, thus deliberately changing the character of the medium, that it was almost like painting with watercolour. This was altogether contrary to the rules of painting. 'With full brush, in broad unhindered strokes,' as Wescher puts it in *La Prima Idea*, he modelled bright groups of figures of a naïvely exaggerated distortion and in an unexpected intensity of movement, against a dark, imaginative landscape. This proclaims his passionate disposition as a man and his disregard of mere aesthetic beauty. His figure paintings in particular show his rejection of bourgeois taste; these always keep a purposely experimental character and sometimes remained unfinished as they were often painted without a model and are more the reflections of the inner conflict, the inhibitions, and the self-torture of this stupendous artist.

Cézanne's creativity advanced slowly. Towards the beginning of his career, about 1863, we find him still influenced by Manet's dark paintings, as were nearly all the other painters mentioned here. This can be taken as a sign of an inner spiritual accord amongst all the painters, and endorses our earlier suggestion to give this commentary the tacit sub-title: Manet and Impressionism.

His meeting with Pissarro in Auvers-sur-Oise (1872–4) brought Cézanne to the landscape.

244

And over many years for hours on end he persevered in painting the landscape in heat and cold, in the north as well as in his native Aix-en-Provence, until in the end he contracted a deadly cold whilst sitting before his model, which in a few days put the sixtyeight-year-old painter to sleep forever.

But the 'motif' meant something quite different to him than it had done to the painters of Barbizon. He expressed his predilection for geometric volumes in 1906, the year in which he died, in terms other than the often-quoted maxim about the cylinder, the sphere and the cone, in these words: 'The main thing about a picture is to get the volume right: therein lies the talent of a painter.' Or put in another way: 'When colour has its richness, form has its plenitude.'

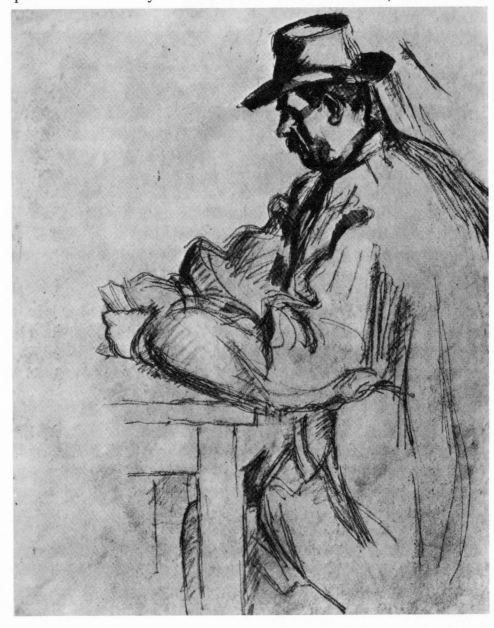

PAUL CÉZANNE: *Card player*. Drawing, painted over with watercolour, 1890-92. Museum of Art, Providence, Rhode Island.

His slowness and perseverance resulted in a legacy to posterity of crystal-clear paintings and watercolours of a spiritual density, which had already inspired whole generations even before he died, notably the Cubists: Picasso, Braque, and Juan Gris. His influence on modern art has been greater and more decisive than that of any other forerunner, and his teaching is summed up in this simple sentence: 'The only means by which progress can be made is nature, for the eye is trained by contact with nature.'

In his work, whether it be the still-lifes with their fruit, bottles and glasses, shaped and coloured according to his idea, or the landscapes, in which the structural elements obey his formative power, or the figures, which in their simple build-up look as if they were hewn out of stone (pl. 198), in all, the paint settles heavily in a rich mosaic of coloured strands upon the canvas, often overlapping or closely cleaving, and shining as in a mighty 'hymn to the sun' (pl. 202).

VINCENT VAN GOGH. And it was also with a hymn to the sun of the French south that Vincent van Gogh closed and crowned his two full years (1888–90), two years of furious and dedicated activity marred by illness, a pattern which characterized his whole life as an artist and a man. Arles (pl. 203) and Saint-Rémy were the places which saw his fullest development; the Mediterranean coast (pl. 204) at the Rhône estuary, the Camargue, the Alpilles (pl. 206), the gently undulating foothills of the Alps – these make up the landscape which his brush transcribes. Bright stabbing brushstrokes are set over dark areas of pure, sparkling, divided colour, after Seurat's method, but moving in mighty streams through the picture-plane or leaping up as cypresses in the shape of flames; those are powerful brush-thrusts which go in waves and curves through clefts and gorges to finish up in concentric orbit round the ball of the sun. He was the only one, quite literally, to have painted the sun like that. And in his very last pictures in Auvers-sur-Oise it had already set.

It was in Paris itself, before going to Arles and eventually returning to the north of Paris to stay in Auvers, that van Gogh absorbed the decisive influences of French Impressionism. His instinct saved him from seeking to prolong a pointillist interlude in which the impressive gloom of his early paintings of peasant carts, potato-eaters, and weavers would only have been redeemed by the luminous sky of Paris, as the pictures produced there truly indicate. As the letters between the brothers Theo and Vincent record in unique and tragic exactness almost every day, Vincent's departure to the south had the character of a real 'mission', as had happened before when he went amongst the miners. And if at first only the two brothers themselves understood it as such, then later it was communicated to the rest of the world. The mighty, sweeping, and inquiring spirit, the earnestness of van Gogh had certainly been understood in Paris, but in the south only a postmaster, a parson, and an asylum superintendent (together, as always, with his brother Theo) got the message. This should be all posterity needs to know about him, because the evidence of his painting, as it appears in the farewell-picture of Auvers, the self-portrait (pl. 207), shows the unimpaired and

indestructible greatness of an emotionally disturbed man beset by demons. But it shows still more: it is the new strengthening of form by the addition of expressive means, by transmutation of colour, by the abstract animation of the background and by those furrows and grooves that the brush makes on face and garment, not actually contours and edges but an inner drawing, so that the individual brush movements are given freedom to perfect the drama of the human figure.

This is no longer dealing with beauty in Monet's sense, painting the play of light on the stonework of a cathedral; it is creating with an animation from within, a probing into secret

247 VINCENT VAN GOGH: *Cornfield with Cypresses near St. Rémy*. Reed-pen and pencil.

structures, even in the case of that impoverished field before Arles (pl. 203); hence it is concerned with a motif hitherto considered unsuitable, a shameful neediness.

Here, the great anguish of life (which certainly had oppressed the young Monet and Renoir at Argenteuil, which had tormented Gauguin and harrowed Pissarro and Sisley) is at last openly declared and painted. Here, in pictures, are his fears about the stability of this earth, expressed most clearly perhaps not in those startling cypresses but in the picture of the café of Arles (pl. 205). This was a modest establishment on the Place du Fore, where the humble citizens used to go for a drink in the evenings, and where the ginger-haired Dutchman standing by the roadside made his famous reed-pen sketch, swiftly, possessed, in a sort of hurried note-taking. Afterwards, in his studio at the 'yellow house', he painted this truly great 'night-piece' from memory, with magically illuminated house-wall and sun-roof and the table-tops like little islands, with the uneven cobblestones and the midnight-blue gateway into the old Roman town of Arles. To the right behind the plane trees is the façade of the Hotel Nord Pinus which contains fragments of Roman architecture and still offers today the expensive comfort of its red dining-room behind the dark window-shutters, as it did then, though always beyond van Gogh's reach. Above it all, the night sky full of glittering stars.

Thus the new element of van Gogh's art is that out of sublime despair he wrested a material for his pictures which revealed and exalted the soul. The unalloyed transmutation into painting remains a rare event in art history and goes beyond the aim of Impressionist artists who manifested their life experience only through their letters, notes, articles, and in their endless discussions in the cafés where they flocked round their respective spokesman. To prepare a 'feast for the eye', according to Delacroix, remained their general theme, a theme which, though old, renews itself at every contemplation. Unaware at the time of the worldwide repercussions of their style, they raised a purely optical province to the level of the most epoch-making painting since Poussin and Rembrandt, since Velazquez and Frans Hals, since Vermeer and Ruisdael.

Nowadays, a hundred years after that initial scene-setting at Argenteuil, the number of names associated with this movement has been extended, their order of precedence has been repeatedly turned upside down, the various correlations, agreements, supposed equality of values, have been put into historical sequence and order of importance, only to be revised even further in the light of various detailed investigations and so displaced once more.

To be sure, what is gained from this constant review and enlargement of the artistic panorama is only a new crutch for today's public to lean on as they pace past the long rows of pictures on the walls of the Grande Galerie at the Louvre, for example. The works themselves remain unaffected by it all, in a peculiarly restricted yet boundless eloquence, in their place – and that place depends on the attention the art-lover is prepared to give them. This can prove such an engrossing and also such a long-lasting occupation that a single lifetime, even with seeing eyes, is not long enough.

192 PAUL GAUGUIN
'Bonjour, Monsieur Gauguin', 1889.
Národní Galerie, Prague.

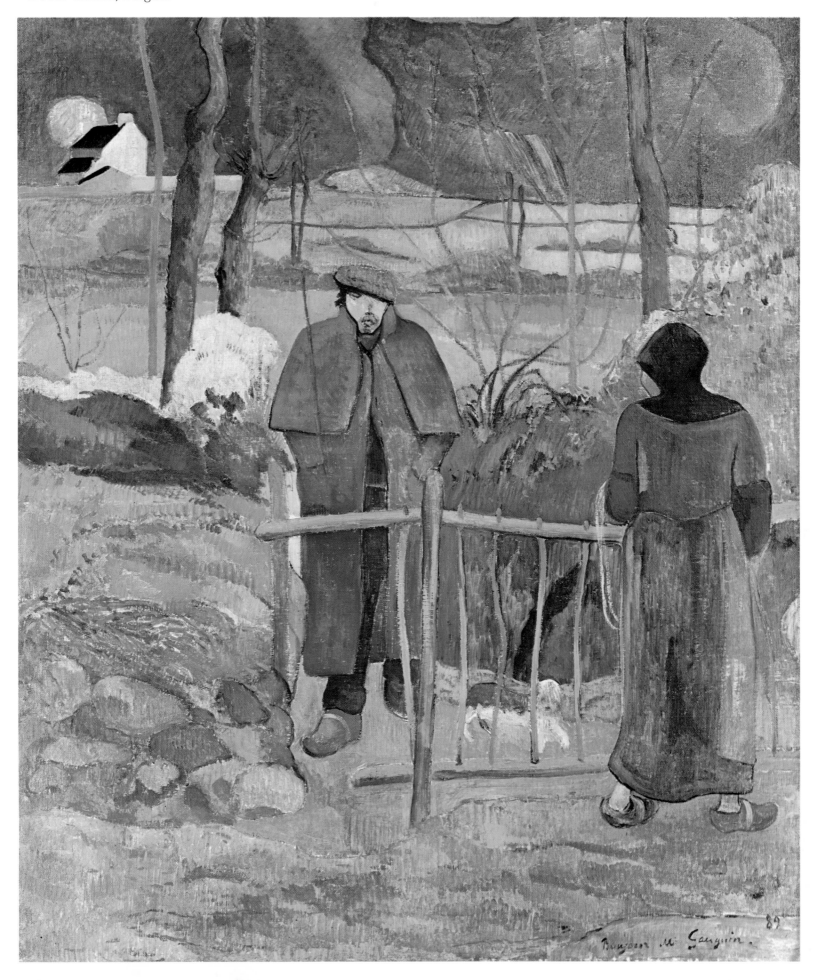

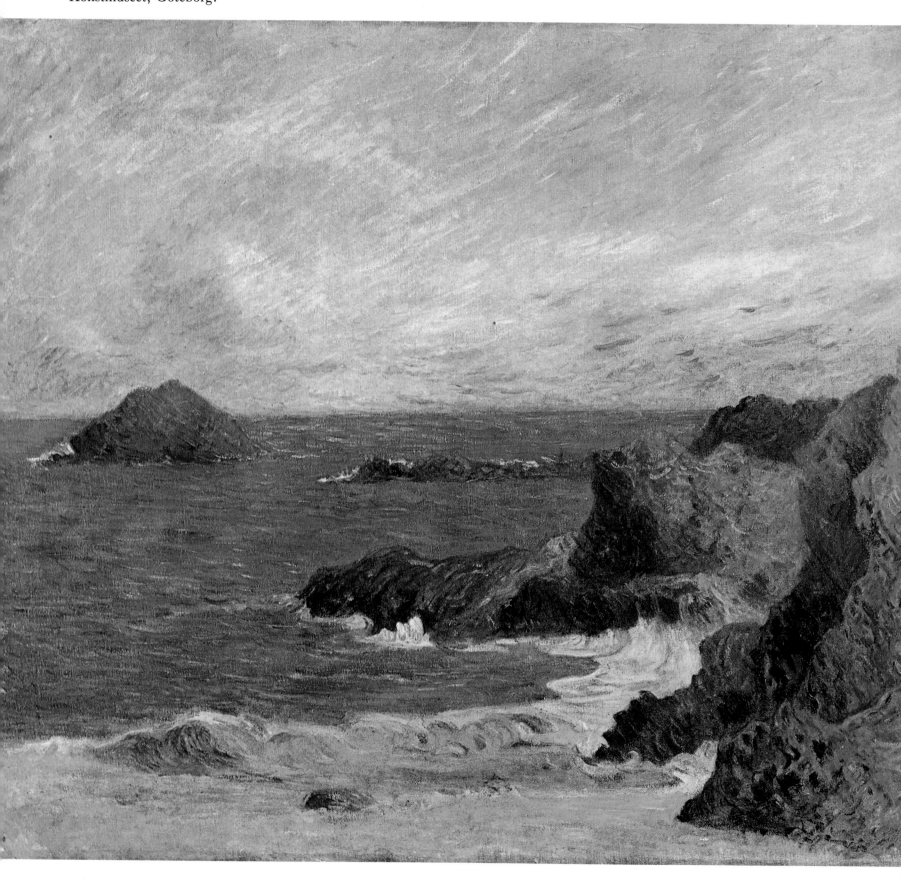

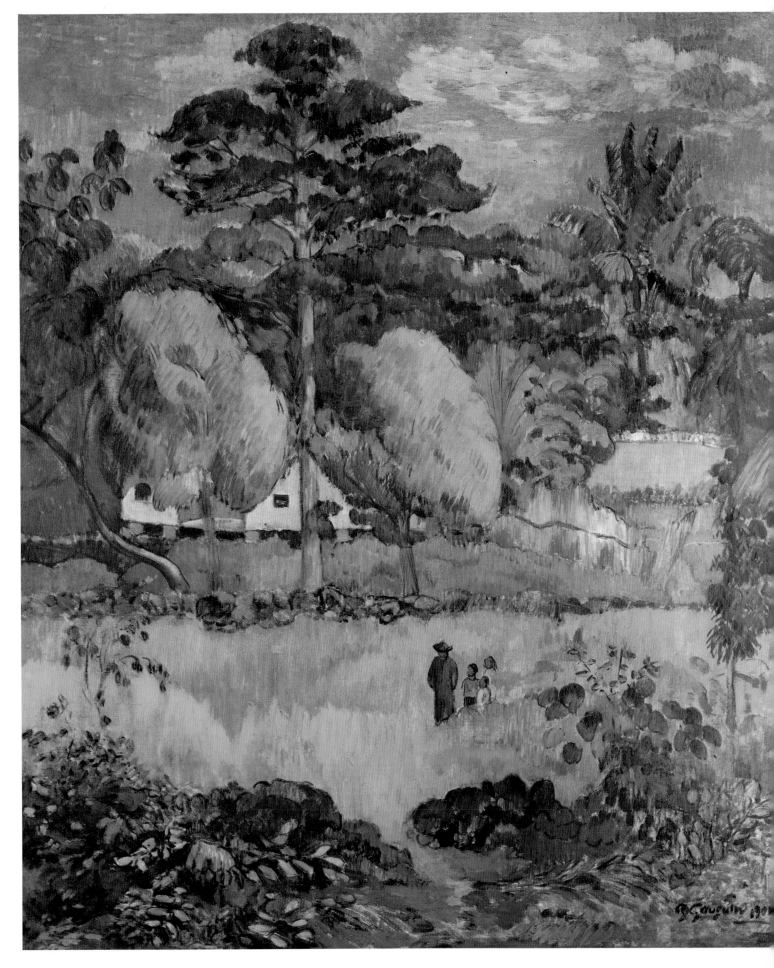

194 PAUL GAUGUIN
Landscape, 1901.
Musée de l'Orangerie, Jean Walter–Paul Guillaume collection, Paris.

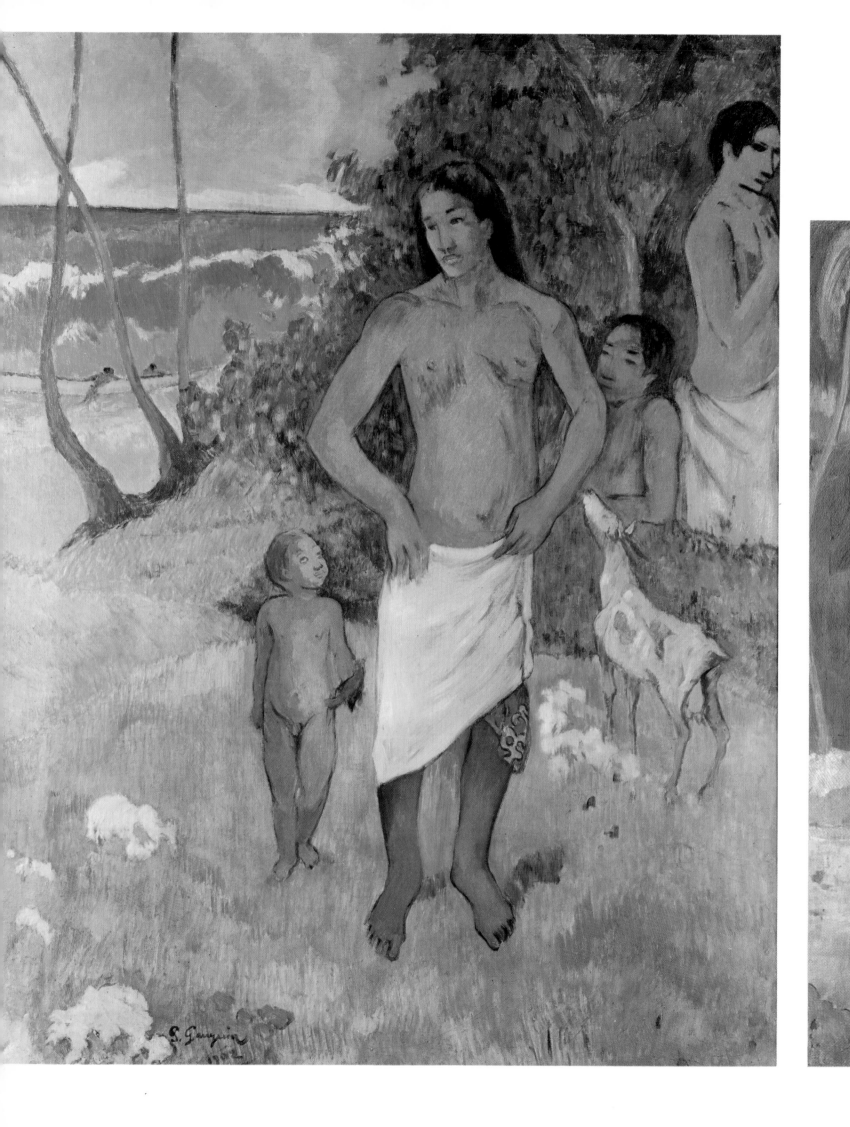

Opposite

195 PAUL GAUGUIN
A walk by the sea-shore, 1902.
Private collection, Lausanne.

196 PAUL GAUGUIN
The great tree, 1892.
Hermitage, Leningrad.

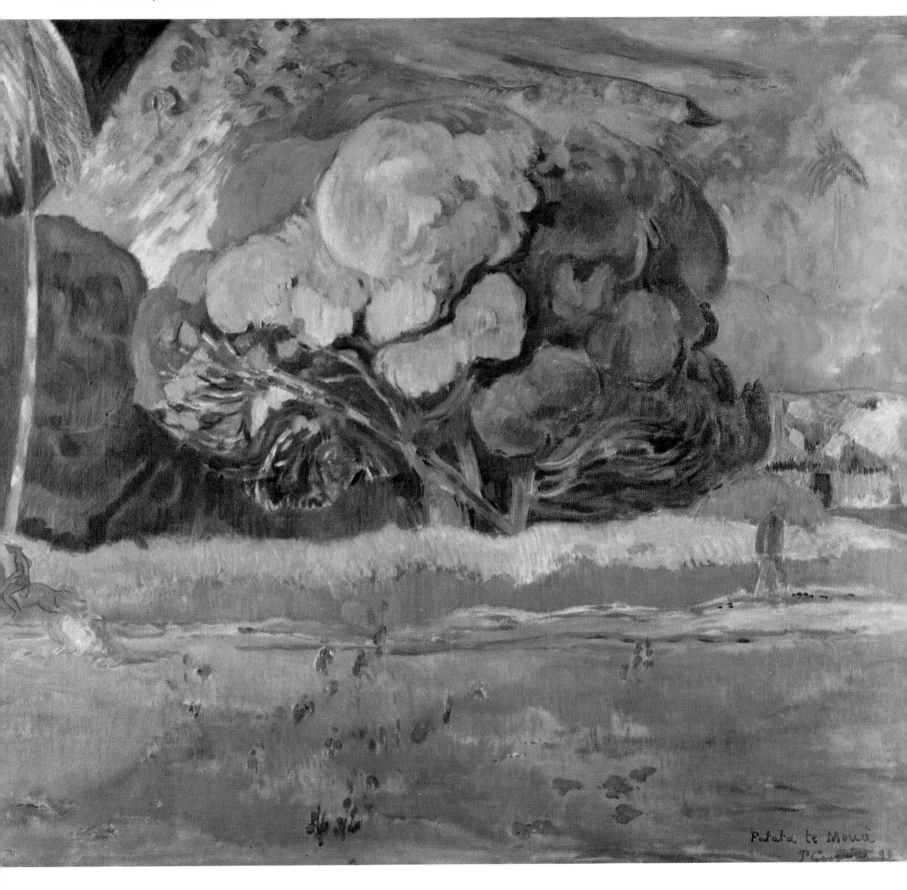

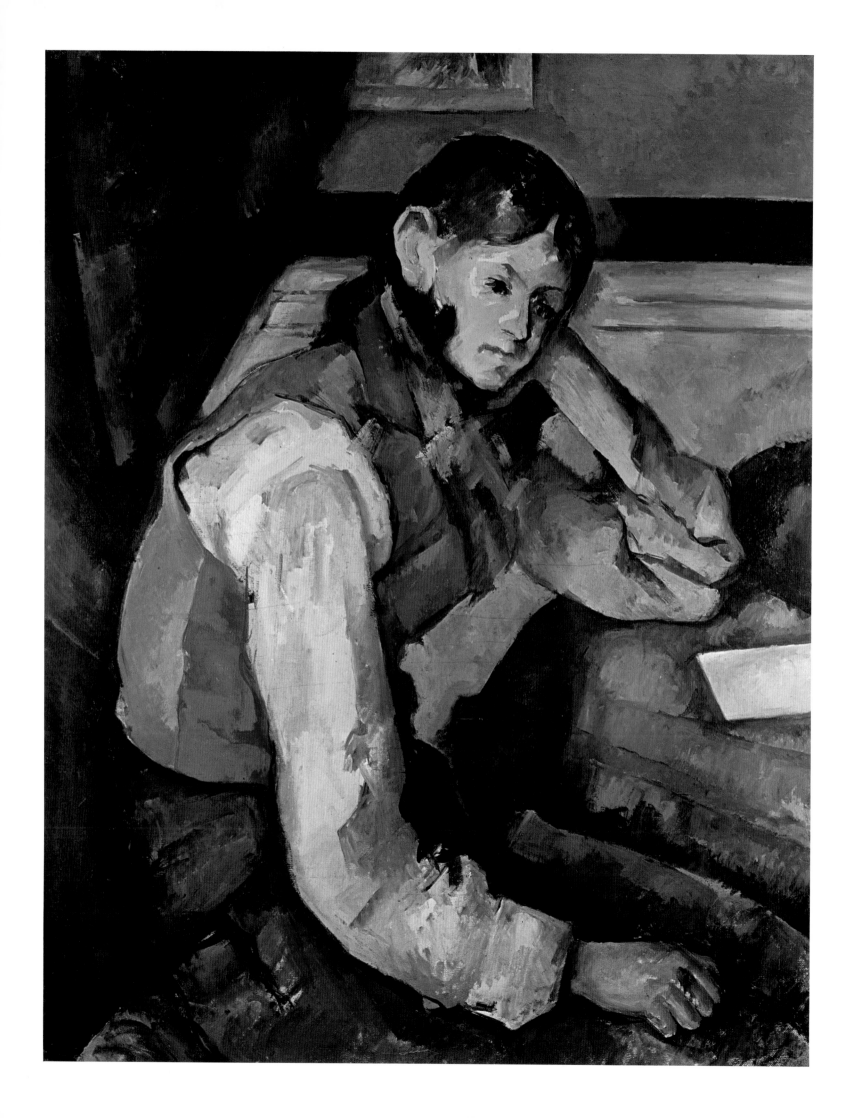

Opposite

197 PAUL CEZANNE
Boy in a red waistcoat, 1890/95.
Bührle collection, Zurich.

198 PAUL CEZANNE
The card players, c. 1885/90.
Musée du Louvre, Paris.

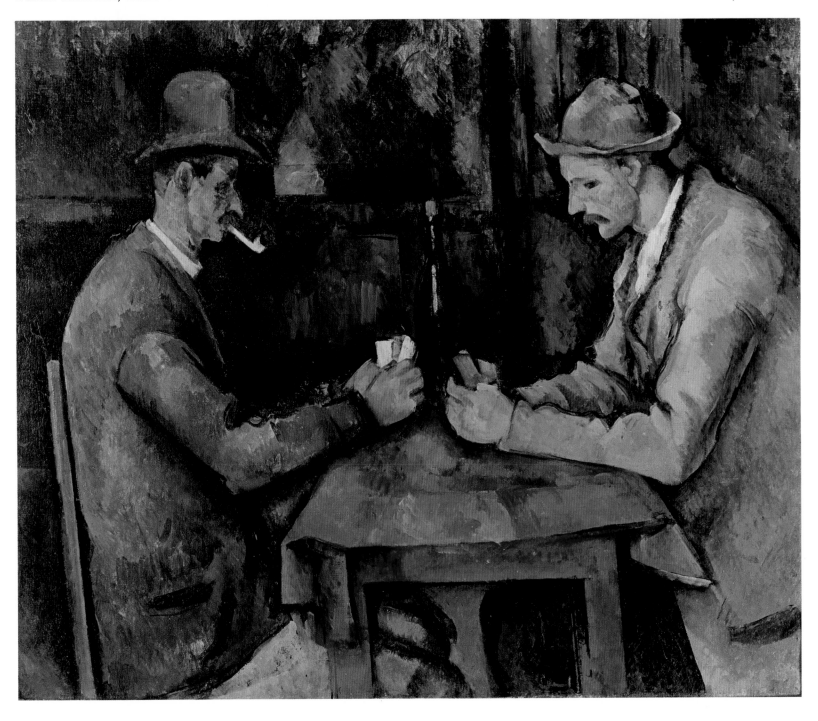

199 PAUL CEZANNE
Rocks in a forest, 1894/98.
Kunsthaus, Zurich.

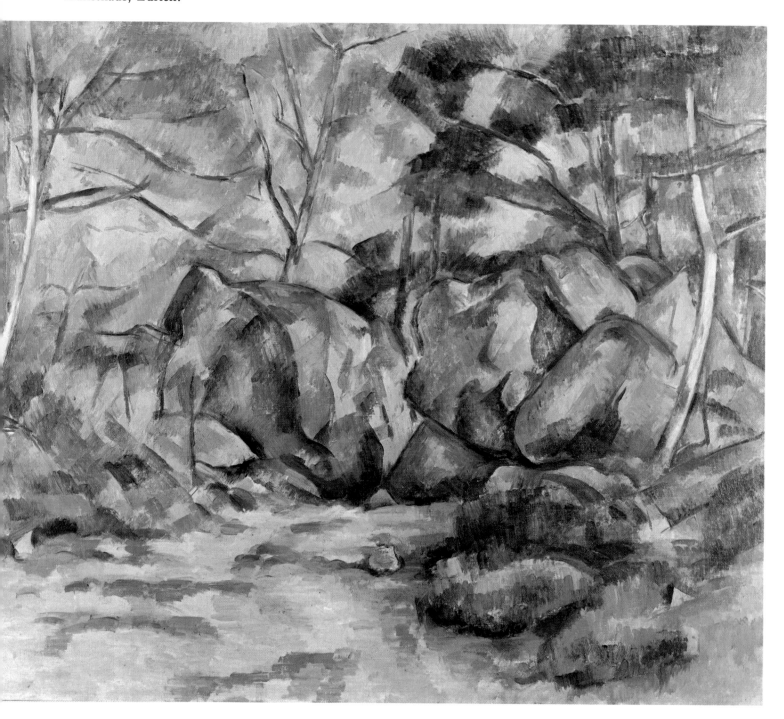

200 PAUL CEZANNE
Still-life with curtain, 1898/99.
Hermitage, Leningrad.

201 PAUL CEZANNE
Montagne Sainte-Victoire, 1904/6.
Öffentliche Kunstsammlungen, Basle.

202 PAUL CEZANNE
Montagne Sainte-Victoire, 1885/87.
Stedelijk Museum, Amsterdam.

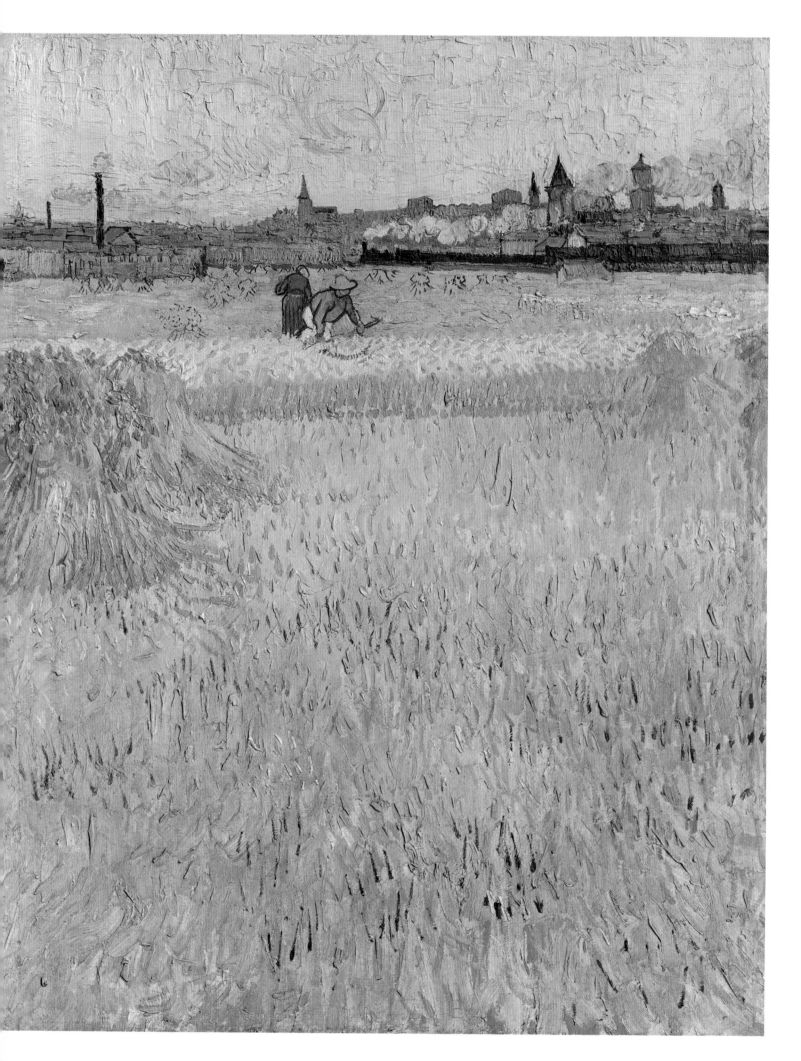

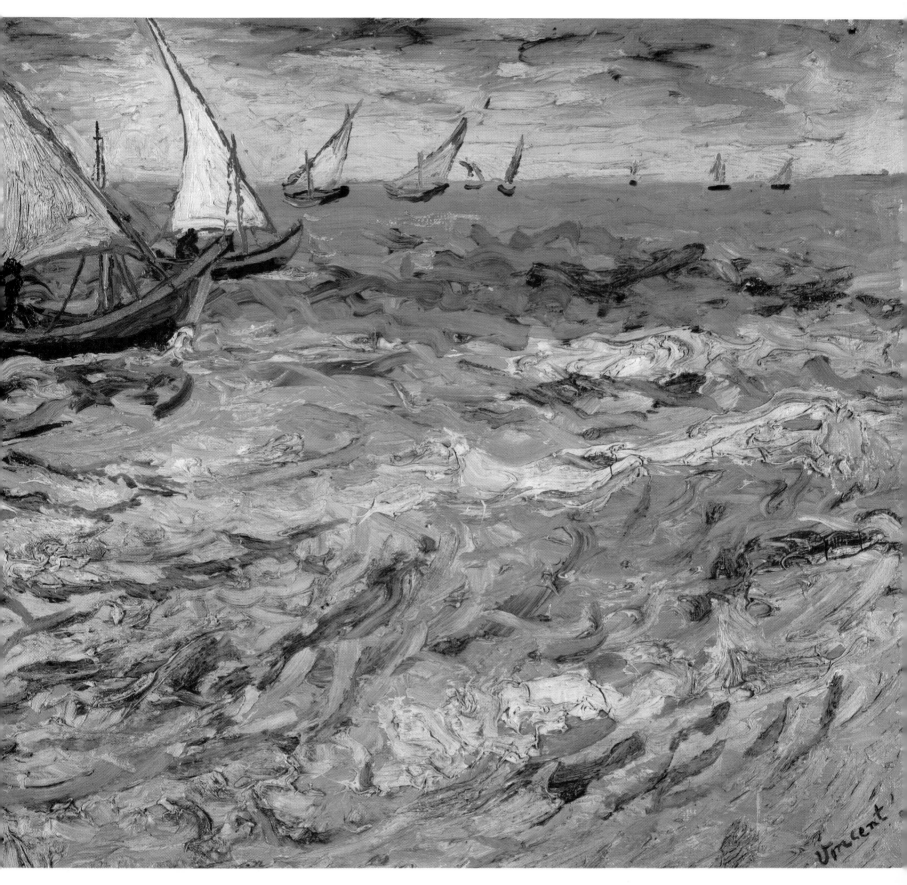

Opposite

203 VINCENT VAN GOGH
The reaper, 1888.
Musée Rodin, Paris.

204 VINCENT VAN GOGH
Seascape from Saintes-Maries, 1888.
Pushkin Museum, Moscow.

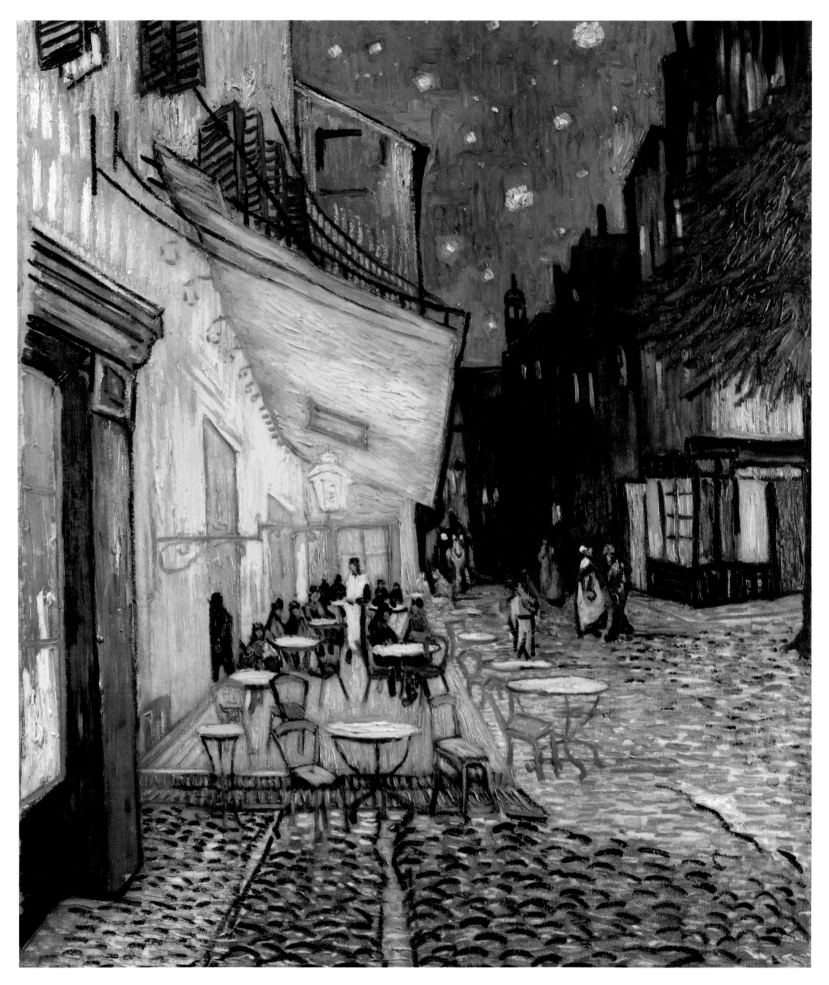

205 VINCENT VAN GOGH
Café at night, Arles, 1888. Rijksmuseum Kröller-Müller, Otterlo.

206 VINCENT VAN GOGH
Sunrise at Saint-Rémy, 1889.
Private collection.

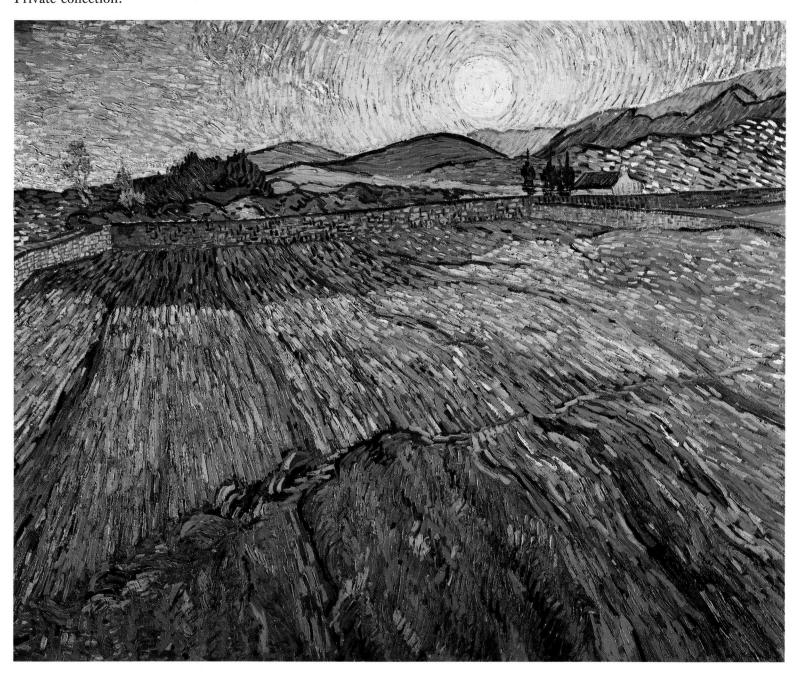

Self-portrait, 1890. Musée du Louvre, Paris.

Biographies of the Artists

JEAN-FRÉDÉRIC BAZILLE: born 1841 Montpellier, died 1870 Beaune-la-Rolande.
Came to Paris in 1862; attended the Atelier Gleyre, where he met Monet; connections with Cézanne, Guillaumin, Sisley and Zola, and especially with Monet and Renoir; most strongly influenced by Courbet. 1865 participation in meetings at Café Guerbois; exhibited in Salon 1866, 1868, 1869 and 1870. Killed in action, 1870.
Pl. 22

LOUIS-EUGÈNE BOUDIN: born 1824 Honfleur, died 1898 Deauville.
Most strongly influenced by Jongkind above all later impressions. Monet's first teacher, in Le Havre. About 1860 settled at Honfleur at the country inn of Saint-Siméon. Connection with the painters of Barbizon. Stayed in Brittany, the south of France, Bordeaux, Belgium, Holland, and Venice. Since 1861 he painted from nature. Took part in first Impressionist Exhibition of 1874.
Pl. 23–5

GUSTAVE CAILLEBOTTE: born 1848 Paris, died 1894 Gennevilliers.
From well-to-do family. Worked first in the atelier of Bonnat and was accepted in 1873 at the École des Beaux-Arts. Connections with the Impressionists, took part in their second exhibition of 1876, became their friend and patron. Came to landscape-painting in 1882 under the influence of Monet, many pictures of the Seine at Argenteuil. His notable collection of Impressionist paintings was left to the State.
Pl. 20, 21

MARY CASSATT: born 1844 Allegheny City (Pennsylvania), died 1926 Mesnil-Théribus near Beauvais.
Daughter of a Pittsburgh banker, came to France in 1868. Travelled in Italy, Spain, and Belgium. Her teacher was Degas. Took part in the fourth Impressionist Exhibition, interested her fellow-countryman, the collector Havemeyer, in the works of the Impressionists. Died nearly blind.
Pl. 174

PAUL CÉZANNE: born 1839 Aix-en-Provence, died 1906 Aix-en-Provence.

From 1862 at the Académie Suisse in Paris, where he met Pissarro and Guillaumin. With Manet at the Café Guerbois, where he met the friend of his youth, Zola, again. 1863–70 worked in Aix and Paris, 1872–74 in Auvers-sur-Oise. Came to *plein-air* paintings through the influence of Pissarro. Participated in Impressionist Exhibitions of 1874 and 1877. From 1882 in Aix-en-Provence. Development of his own style. Vollard devoted a large exhibition to him in Paris in 1895.
Pl. 197–202; ill. in text p. 245

JOHN CONSTABLE: born 1776 East Bergholt, died 1837 London.
Entered Royal Academy School in 1799, studies of Claude Lorraine and Ruisdael. From 1799 onwards in London, summer vacations in the country (Stour Valley). 1819 Associate of the Royal Academy of Arts, and 1829 Royal Academician. 1824 exhibition of his landscapes in the Paris Salon. Influenced Delacroix and Rousseau. His open-air oil-sketches are superior to the studio pictures.
Pl. 4–6

JEAN-BAPTISTE CAMILLE COROT: born 1796 Paris, died 1875 Paris.
Initially a cloth-maker's apprentice, then pupil of Michallon. 1822–5 pupil of Bertin. 1825–8 stayed in Rome. Since then in Paris, in Ville d'Avray and Fontainebleau. Study-journeys in Switzerland, England, and Holland. 1834 and 1842 visits to Italy.
Pl. 10–13; ill. in text p. 11

HENRI-EDMOND CROSS: born 1856 Douai, died 1910 Saint Clair (Var.)
1874 studied at Academy of Art, Lille, whilst also studying law. Came to Paris 1876, represented in Salon in 1881. Joined Seurat and Signac and their *Salon des Artistes Indépendants*, founded 1884. Frequently exhibited there.
Pl. 191

CHARLES-FRANÇOIS DAUBIGNY: born 1817 Paris, died 1878 Paris.
Initial instruction by his father, Edmond-François, and by his uncle Pierre Daubigny. 1835 journey to Italy. 1836 worked in the studio of the restorer Granet, then in the studio of Delaroche. Joined the painters of Barbizon about 1840. Travelled to France, England, Spain, and Holland.
Pl. 9

HILAIRE-GERMAIN-EDGAR DE GAS, known as Degas: born 1834 Paris, died 1917 Paris.
Came from wealthy banking family, resident in Naples since 1789. 1854 entered École des Beaux-Arts, pupil of Ingres and Flandrin. 1856–7 in Rome and Naples. Exhibited at all the Impressionist Exhibitions except that of 1882. Travelled in Italy, England, Belgium, Holland and Spain. 1872–3 stayed in New Orleans.
Pl. 135–157, ill. in text p. 62, 65

ALBERT DUBOIS-PILLET: born 1845 Paris, died 1890 Le Puy.
As a painter he sided with the Impressionists and was a co-founder of the *Société des peintres indépendants*, at whose salon he exhibited. Commandant of gendarmes in Le Puy.
Pl. 189

PAUL GAUGUIN: born 1848 Paris, died 1903 Dominica (Marquesas Is.)
1888 worked in Pont-Aven as leader of a group of artists; formulated and practised 'colour-synthetism' and massive, simplified form. In same year with van Gogh in Arles. 1891 travelled to Tahiti (until 1893); autobiography *Noa-Noa*. 1895 second journey to Tahiti. Inspiration of primitive art of the South Seas.
Pl. 192–6, ill. in text p. 243

VINCENT VAN GOGH: born 1853 Groot Zundert (North Brabant), died 1890 Auvers-sur-Oise.
1869–76 employed by the picture-dealers Goupil, for whom his brother Theo also worked, then as teacher and lay-preacher. 1877–8 studied theology, then pastor in the Borinage and missionary in Wasmes. First artistic works. In the early period, pictures of peasants and labourers; landscapes in dark colouring. 1885 at the Antwerp Academy. 1886 moved to Paris. Encounter with Impressionism. Friendship with Gauguin and Émile Bernard. To Arles in February 1888; October 1888 together there with Gauguin. Intermittent attacks of mental trouble and internment in asylums of Arles and Saint-Rémy. May 1890 to Auvers-sur-Oise.
Pl. 203–7, ill. in text p. 247

JOHAN BARTHOLD JONGKIND: born 1819 Latdorp near Ootmarsum, died 1891 Côte Saint-André (Isère). Pupil at The Hague Academy. From 1845 in Paris, began work with Isabey. 1855–60 again in Holland, extreme economic difficulties whilst in Rotterdam.

Returned to Paris, received financial help from a patroness. Rejected by Salon 1863–73. Refused to take part in exhibitions. From 1863 acquainted with Monet. Mental illness towards end of his life.
Pl. 18, 19, ill. in text p. 15

EDOUARD MANET: born 1832 Paris, died 1883 Paris. 1849 entered Atelier Couture; copied in the Paris museums. From 1853 made journeys to Italy, Germany and Holland. In consequence of his love for Spanish art of the seventeenth century (Velazquez, Zurbaran, Murillo) travelled to Spain in 1865. Works hung in Salon from 1861 (but frequent rejections). After the scandal over *Le Déjeuner sur l'herbe* in the Salon, private exhibitions by Martinet in 1861, 1863, 1865. On the occasion of the World Exhibition 1867 held separate showing of his rejected pictures in a booth near the Pont d'Alma. Central figure at the Café Guerbois. After 1870 painted in Bordeaux. 1874 encounter with the Impressionists (Argenteuil). 1882 made Chevalier of the Legion of Honour.
Pl. 52–74, ill. in text p. 42, 45

CLAUDE-OSCAR MONET: born 1840 Paris, died 1926 Giverny (Eure).
Childhood in Le Havre. Introduced to plein-air painting by Boudin. 1859 in Paris, studied at the Académie Suisse; acquaintance with Pissarro. 1860 in Le Havre with Jongkind. 1862 entered the Atelier Gleyre in Paris. Friendship with Renoir, Sisley, and Bazille. 1865 first exhibition in Salon. Until 1870 alternating stays in Normandy and Paris. Influenced by Courbet and Manet. During the 1870 war together with Pissarro in England, admiration for Turner. From 1872–8 resident in Argenteuil. From 1874 on his initiative group exhibitions by the Impressionists. 1880 his first one-man show. From 1878–83 in Vétheuil he made studies of light and atmosphere, in Giverny the series of cathedrals, water-lilies, etc. Travelled in Normandy and the Côte d'Azur, to England and Italy.
Pl. 78–104

ADOLPHE MONTICELLI: born 1824 Marseilles, died 1886 Marseilles.
Italian origin. 1847–9 in Paris, from 1851 in Marseilles, Béziers, Montpellier, and Nîmes. 1856 again in Paris. Friendship with Diaz. Returned to Marseilles because Paris was under threat of siege, lived there in needy circumstances. Influenced van Gogh. *Pl.16–17*

GUSTAVE MOREAU: born 1826 Paris, died 1898 Paris. From 1846 studied at the Academy under François Picot, later under Chassériau. 1853 exhibited in the Salon, 1857–9 studied in Italy. Met Degas and Puvis de Chavannes. Last represented in the Salon in 1880. 1885 journey to Holland. 1888 member of the Académie des Beaux-Arts.
Pl. 14–15

BERTHE MORISOT: born 1841 Bourges, died 1895 Paris.
1860 painted in the open with Corot. 1868 met Manet whilst copying in the Louvre, 1874 married Manet's brother. Several portraits of her by Manet afterwards. 1874 took part in first Impressionist Exhibition, later exhibited with them regularly. Artistically influenced by Renoir after 1880.
Pl. 75–7

HIPPOLYTE PETIT-JEAN: born 1854, died 1929.
Belonged to the artistic circle round Seurat, exhibited 1888 in Brussels, and from 1891–3 with the Indépendants. The Galerie de l'Institut in Paris devoted an exhibition to him in 1955, with the theoretical writing *Sommaire de technologie divisionniste* by G. Pogu.
Pl. 190

CAMILLE PISSARRO: born 1830 St. Thomas (Danish Antilles), died 1903 Paris.
1842–7 studied in Paris, afterwards returned to Antilles. Worked together with the Danish painter Melbye in Venezuela. 1855 back in Paris, worked at the Académie Suisse. Met Monet. Painted in the open, influenced by the art of Corot and Courbet. Exhibited 1863 in the Salon des Refusés and 1864–6 in the Salon. Resided in Pontoise, later in Louveciennes. 1870 in England. In Pontoise with Cézanne. 1884 settled finally in Eragny. 1886–8 contact with the Neo-Impressionists, then returned to former method of painting.
Pl. 26–42, ill. in text p. 38

PIERRE-AUGUSTE RENOIR: born 1841 Limoges, died 1919 Cagnes-sur-Mer.
Originally a porcelain painter, accepted at the École des Beaux-Arts in 1862. Joined the Atelier Gleyre; met Sisley, Bazille and Monet; together they made open-air studies in the Forest of Fontainebleau. Represented in the Salon since 1864. In 1874 took part in first Impressionist exhibition at Nadar's studio. Early

works influenced by Diaz, Courbet and Delacroix. From 1872, impressed by Monet's painting, adopted the impressionistic technique. 1881 and 1882 travelled through Algeria and Italy. Influenced by Ingres (*période ingresque*). 1883–5 travelled in the north and south of France. After 1885 alternating stays in Paris and Essoyes near Troyes, the birthplace of his wife. 1903 resident in Cagnes. Suffered from arthritis but continued working.
Pl. 105–134, ill. in text p. 60

PIERRE-ÉTIENNE THÉODORE ROUSSEAU: born 1812 Paris, died 1867 Barbizon.
1827–8 pupil of Charles Rémond, 1828–9 of Guillaume Lethière. 1834–5 stayed at the Col de la Faucille. From 1836 worked in Barbizon.
Pl. 7–8, ill. in text p. 13

THEO VAN RYSSELBERGHE: born 1862 Ghent, died 1926 Saint-Clair (Var.)
Studied at the Academy in Ghent and from 1881 in Brussels. 1886 influenced by Seurat's painting, adopted Neo-Impressionism. 1887 journey to Morocco, 1890 visited Italy. From 1898 in Paris. From 1910 onwards worked in Saint-Clair.
Pl. 188

GEORGES SEURAT: born 1859 Paris, died 1891 Paris. Connected with Puvis de Chavannes initially. From 1884 connected with Signac, joint development of Neo-Impressionist theory. Main work: *A Sunday afternoon on the Île de la Grande Jatte*, 1885.
Pl. 175–182, ill. in text p. 219, 220

PAUL SIGNAC: born 1863 Paris, died 1935 Paris.
1884 exhibited at the Salon des Indépendants. Met Seurat. Took part in the eighth Impressionist exhibition in 1886. Exhibition in Antwerp 1888. Meeting with the physicist Charles Henry. Signac was the theoretical writer for the scientifically based Neo-Impressionist movement. From 1892 he worked every year in St. Tropez.
Pl. 183–7, ill. in text p. 223

ALFRED SISLEY: born 1839 Paris, died 1899 Moret-sur-Loing.
Of English origin, Sisley lived with his parents, not naturalized, in France. Visited the Atelier Gleyre, met Monet, Renoir and Bazille. His early works were influenced by Corot, Courbet and Daubigny. 1866 at

work in Marlotte, 1867 in Honfleur, then in Bougival and Louveciennes on the Seine; from 1870 he came under the influence of Monet. After a journey to England he lived in Sèvres (1875–9) and in 1882 in Moret. Took part in the Impressionist Exhibitions of 1874, 1876, 1877, 1882. 1894 journey to Rouen. 1897 stay in England.
Pl. 43–51

HENRI RAYMOND DE TOULOUSE-LAUTREC: born 1864 Albi, died 1901 Château de Malromé.
Descended from old French nobility. 1878 and 1879, two riding accidents resulted in fractures of both legs and left him crippled. Took up drawing, initially encouraged by the sports-painter René Princeteau. 1883 studied with Bonnat, 1884–5 with Cormon, together with Anquetin and Bernard. Further development influenced by Degas and by Japanese prints. 1893 first exhibition at Goupil's gallery. 1893 took up lithography under the guidance of Ibels. In ill-health from 1897.
Pl. 158–173, ill. in text p. 71

JOSEPH MALLORD WILLIAM TURNER: born 1775 London, died 1851 London.
1789–93 at the art school of the Royal Academy. At the same time a watercolourist. Studies of Wilson, Claude Lorraine, Poussin, Rembrandt, Ruisdael, and others. 1802 Royal Academician. Travelled abroad, in the Netherlands, the Rhine valley, Switzerland, North Italy, and Venice in particular.
Pl. 1–3

A Selected Bibliography

GENERAL

CHAMPA, KERMIT SWILER. *Studies in Early Impressionism*. New Haven: Yale University Press, 1973.
DAYEZ, ANNE; HOOG, MICHEL; and MOFFETT, CHARLES S. *Impressionism: A Centenary Exhibition*. Exhibition catalogue. Metropolitan Museum of Art, New York, 1974.
HERBERT, ROBERT L. *Neo-Impressionism*. Exhibition catalogue. Solomon R. Guggenheim Museum, New York, 1968.
LÖVGREN, SVEN. *The Genesis of Modernism: Seurat, Gauguin, van Gogh and French Symbolism in the 1880's*. Rev. ed. Bloomington: Indiana University Press, 1971.
NOCHLIN, LINDA, ed. *Impressionism and Post-Impressionism, 1874-1904*. Sources and Documents in the History of Art. Englewood Cliffs, N.J.: Prentice-Hall, 1966.
—— *Realism*. Harmondsworth and Baltimore: Penguin Books, 1971.
REWALD, JOHN. *The History of Impressionism*. 4th ed., rev. New York: Museum of Modern Art, 1973.
—— *Post-Impressionism: From van Gogh to Gauguin*. 3rd ed., rev. New York: Museum of Modern Art, 1978.
ROSKILL, MARK. *Van Gogh, Gauguin and the Impressionist Circle*. Greenwich, Conn.: New York Graphic Society, 1970.
STERLING, CHARLES, and SALINGER, MARGARETTA M. *French Paintings: A Catalogue of the Collection of the Metropolitan Museum of Art,* Vol. III: *XIX-XX Centuries*. New York: Metropolitan Museum of Art, 1967.

SUTTER, JEAN, ed. *The Neo-Impressionists*. Translated by Chantal Deliss. Greenwich, Conn.: New York Graphic Society, 1970.
WHITE, BARBARA EHRLICH. *Impressionism in Perspective*. Artists in Perspective Series. Englewood Cliffs, N.J.: Prentice-Hall, 1978.

BOUDIN

JEAN-AUBRY, G. *Eugène Boudin*. Translated by Caroline Tisdall. Greenwich, Conn.: New York Graphic Society, 1968.

CASSATT

BREESKIN, ADELYN DOHME. *Mary Cassatt: A Catalogue Raisonné of the Oils, Pastels, Watercolors and Drawings*. Washington, D.C.: Smithsonian Institution Press, 1970.
HALE, NANCY. *Mary Cassatt*. Garden City, N.Y.: Doubleday, 1975.
SWEET, FREDERICK A. *Miss Mary Cassatt: Impressionist from Pennsylvania*. Norman: University of Oklahoma Press, 1966.

CÉZANNE

LORAN, ERLE. *Cézanne's Composition: Analysis of His Form, with Diagrams and Photographs of His Motifs*. 3rd ed. Berkeley and Los Angeles: University of California Press, 1963.
REWALD, JOHN. *Paul Cézanne: A Biography*. Translated by Margaret H. Liebman. New York: Simon

and Schuster, 1948.

—— ed. *Paul Cézanne Letters*. Translated by Marguerite Kay. 4th ed., rev. and enl. New York: Hacker Art Books, 1976.

SCHAPIRO, MEYER. *Paul Cézanne*. New York: Abrams, 1952.

DEGAS

BOGGS, JEAN SUTHERLAND. *Portraits by Degas*. Berkeley and Los Angeles: University of California Press, 1962.

GUÉRIN, MARCEL, ed. *Edgar-Germain-Hilaire Degas: Letters*. Translated by Marguerite Kay. Oxford: Bruno Cassirer, 1947.

REFF, THEODORE. *Degas: The Artist's Mind*. New York: Metropolitan Museum of Art, 1976.

GAUGUIN

ANDERSEN, WAYNE. *Gauguin's Paradise Lost*. New York: Viking, 1971.

GOLDWATER, ROBERT. *Paul Gauguin*. New York: Abrams, 1957.

GUÉRIN, DANIEL, ed. *The Writings of a Savage: Paul Gauguin*. Translated by Eleanor Levieux. New York: Viking, 1978.

JAWORSKA, WLADYSLAWA. *Gauguin and the Pont-Aven School*. Translated by Patrick Evans. London: Thames and Hudson, 1972.

VAN GOGH

GOGH, VINCENT VAN. *Complete Letters*. Greenwich, Conn.: New York Graphic Society, 1958. 3 vols.

LA FAILLE, J.-B. DE. *The Works of Vincent van Gogh: His Paintings and Drawings*. Rev., augm., and annotated ed. New York: Reynal, in association with Morrow, 1970.

SCHAPIRO, MEYER. *Vincent van Gogh*. New York: Abrams, 1950.

WELSH-OVCHAROV, BOGOMILA. *Van Gogh in Perspective*. Artists in Perspective Series. Englewood Cliffs, N.J.: Prentice-Hall, 1974.

MANET

HAMILTON, GEORGE. *Manet and His Critics*. New Haven: Yale University Press, 1954.

HANSON, ANNE COFFIN. *Manet and the Modern Tradition*. New Haven: Yale University Press, 1977.

MONET

CHICAGO, ART INSTITUTE OF. *Paintings by Monet*. Exhibition catalogue, 1975.

ISAACSON, JOEL. *Claude Monet: Observation and Reflection*. Oxford: Phaidon, 1978.

SEITZ, WILLIAM C. *Claude Monet*. New York: Abrams, 1960.

——*Claude Monet: Seasons and Moments*. Exhibition catalogue. Museum of Modern Art, New York, 1960.

MORISOT

MONGAN, ELIZABETH, introd. *Berthe Morisot: Drawings, Pastels, Watercolors, Paintings*. New York: Tudor Publishing Co., 1960.

ROUART, DENIS, ed. *The Correspondence of Berthe Morisot*. Translated by Betty W. Hubbard. New York: Wittenborn, 1957.

PISSARRO

ADLER, KATHLEEN. *Camille Pissarro: A. Biography*. New York: St. Martin's Press, 1977.

REWALD, JOHN. *Camille Pissarro*. New York: Abrams, 1963.

—— ed. *Camille Pissarro: Letters to His Son Lucien*. 3rd ed., rev. and enl. Mamaroneck, N.Y.: Paul P. Appel, 1972.

RENOIR

CALLEN, ANTHEA. *Renoir*. London: Oresko Books, 1978.

RENOIR, JEAN. *Renoir, My Father*. Translated by Randolph and Dorothy Weaver. Boston: Little, Brown & Co., 1962.

SEURAT

BROUDE, NORMA, ed. *Seurat in Perspective*. Artists in Perspective Series. Englewood Cliffs, N.J.: Prentice-Hall, 1978.

HERBERT, ROBERT L. *Seurat's Drawings*. New York: Shorewood Publishers, 1962.

HOMER, WILLIAM INNESS. *Seurat and the Science of Painting*. Cambridge, Mass.: M. I. T. Press, 1964.

SIGNAC

CACHIN, FRANÇOISE. *Paul Signac*. Translated by Michael Bullock. Greenwich, Conn.: New York Graphic Society, 1971.

TOULOUSE-LAUTREC

COOPER, DOUGLAS. *Henri de Toulouse-Lautrec*. New York: Abrams, 1956.

STUCKEY, CHARLES F. *Toulouse-Lautrec: Paintings*. Exhibition catalogue. Art Institute of Chicago, 1979.

INDEX

270